ORIENTAL

MW01242986

Orientalism Transposed
The Impact of the Colonies
on British Culture

Edited by
Julie F. Codell and Dianne Sachko Macleod

Routledge
Taylor & Francis Group

LONDON AND NEW YORK

First published 1998 by Ashgate Publishing

Reissued 2018 by Routledge
2 Park Square, Milton Park, Abingdon, Oxon, OX14 4RN
52 Vanderbilt Avenue, New York, NY 10017

Routledge is an imprint of the Taylor & Francis Group, an informa business

A Library of Congress record exists under LC control number:

Typeset in Palatino by Photoprint, Torquay, Devon

ISBN 13: 978-1-138-38669-3 (hbk)
ISBN 13: 978-1-138-38671-6 (pbk)
ISBN 13: 978-0-429-42666-7 (ebk)

Contents

List of Contributors

Leonard Bell teaches Art History at the University of Auckland. His main research interests are the works of travelling artists and photographers and cross-cultural interactions and representation in the Pacific from the mid-eighteenth century to the present. His most recent book is *Colonial Constructs: European Images of Maori 1840–1914* (Auckland and Melbourne, 1992).

Julie F. Codell is Director, School of Art, Arizona State University, and Professor, Art History and Humanities. Her many articles on Victorian art have appeared in *Victorian Studies, Art History, Victorian Periodicals Review, Dickens Studies Annual, Journal of Pre-Raphaelite Studies, Victorian Poetry,* and other journals. Her essays have appeared in several books and encyclopedias. She is preparing a book-length study of Victorian artists' careers and public images, 1880–1914.

Kathryn S. Freeman is Associate Professor of English at the University of Miami, Coral Gables, Florida. She is the author of *Blake's Nostos: Fragmentation and Nondualism in 'The Four Zoas'* (State University of New York Press, 1997).

Barbara Groseclose, Professor of Art History at Ohio State University, is the author of books and essays on American and British art, most recently *British Sculpture* and *The Company Raj: Church Monuments and Public Statuary in Madras, Calcutta, and Bombay to 1858* (London and Toronto, 1995). At present she is completing a book for Oxford University Press on nineteenth-century American painting and sculpture.

Dianne Sachko Macleod is Professor of Art History at the University of California, Davis. Her book *Art and the Victorian Middle Class: Money and the*

Making of Cultural Identity (Cambridge, 1996) was awarded the Jacques Barzun Prize in Cultural History for 1997 by the American Philosophical Society. She is currently working on a book about women collectors in Great Britain, France, and the United States.

Constance Curran McPhee is an independent scholar who lives in New York City. She was born in New Delhi and grew up in London. She received her BA from Princeton University in 1978 and her PhD in the History of Art from the University of Pennsylvania in 1995, writing a doctoral thesis entitled 'The exemplary past? British history subjects in London exhibitions, 1760–1810'.

Romita Ray is a doctoral student in the Department of the History of Art at Yale University. Her dissertation is on the art of the picturesque in British India. Born and brought up in Calcutta, she earned her BA in Art History from Smith College.

Jeff Rosen is Professor of Art History in the Departments of Art and Photography at Columbia College, Chicago, where he teaches the history of photography, modern art, and contemporary art criticism. He has recently published 'Lithophotographie: An Art of Imitation' in *Tamarind Papers* and 'Naming and Framing "Nature" in Photographie Zoologique' in *Word and Image*. He is presently working on a monograph on Julia Margaret Cameron's Orientalism.

Emily M. Weeks is a doctoral student in the Department of the History of Art at Yale University. Her area of research is nineteenth-century British art and especially British artists in Egypt in the 1840s. She received her BA in Art History and Anthropology from the University of Washington in 1995 and her MA from Yale in 1997.

List of Figures

Introduction

Orientalism transposed: the 'Easternization' of Britain and interventions to colonial discourse

Julie F. Codell and Dianne Sachko Macleod

Joanne Punzo Waghorne, in her book *The Raja's Magic Clothes*, notes: 'There have been several decades of discussion about the "Westernization" of India, but near silence on the "Easternization" of Britain'.[1] Finding common cultural ground in royal ceremony shared by England and India, represented by the Indian ceremony of durbar which the English appropriated, she argues that influences during the Raj went in both directions. Insisting that the colonial discourse is historical and dialectic, as well as discursive, we wish to take up this issue of the 'Easternization' of Britain on two levels. The first concerns the ways that colonized people intervened in the hegemonic colonial or Orientalist discourse and negotiated, revised, subverted and re-invented it to serve their own cultural expressions, political resistance and self-representations, while the second charts the manner in which British aesthetic concepts were altered by the colonial experience.

What the title of this book signifies is that the assumptions which underlay what we call Orientalism – a broad set of attitudes towards race generating, and generated by, colonialism – could be inverted by the 'Other'. The colonial discourse was available to all parties in the Empire and was often turned on its head. Sometimes tacit and hushed, these transpositions became more openly resistant as colonialism entered the twentieth century. To transpose means to reverse the order or change the place of, to interchange, to transfer from one side of the equation to another without destroying the relationship between the parts of the equation, to move a musical chord up or down without altering the internal interval structure or to play a musical piece in a new key. In contrast to subversion or even inversion, transposition is carefully and subtly modulated and bespeaks the complex subterranean means by which colonized people were forced to express their needs, traditions, frustrations, limited power and circumscribed authority under British rule. These essays describe the liminal ways through which colonized

people or the British experience of life in the colonies modified British culture and Orientalist assumptions.

Scholars of colonial India have begun to address resistance to colonial authority and the formation of subaltern subjectivity over the last ten to fifteen years, but between subaltern studies and critiques of British colonial practices, there has been little examination of the complex cultural inter-actions of the colonized and the colonizers, a space Lisa Lowe calls the 'heterotopia', a space of otherness and crisis, filled with overlapping, shifting articulations.[2] Focusing on Britons and Indians, each of whom depended on both cultures in their lives, Ashis Nandy argued almost fifteen years ago that 'the experience of colonizing did not leave the internal culture of Britain untouched. It began to bring into prominence those parts of the British political culture which were least tender and humane', becoming increas-ingly and self-consciously 'masculine' and inserting into colonial administra-tion 'new forms of institutionalized violence and ruthless social Darwinism'.[3] Such behaviour changed the British, though with less devastating effects than it had on the Indians, to be sure. Nandy points out that 'the ideology of colonialism produced a false sense of cultural homogeneity in Britain' and 'isolation of cognition from affect ... in the form of a new pathological fit between ideas and feelings'; imperialism became not just political but also 'a religious and ethical theory and an integral part of a cosmology' as the British imputed to themselves 'magical feelings of omnipotence and perma-nence ... a part of the British selfhood'.[4]

Ever since the publication of Edward Said's *Orientalism*[5] twenty years ago, scholars have responded to his ground-breaking study by exploring, criti-quing, expanding and re-defining its suppositions in a wider application of his term to cultural practices and the rhetoric of power. Generally, the criticism of Said's thesis has been directed toward its neglect of historical variations within changing political and administrative colonial policies. Homi Bhabha, for instance, in his studies of mimicry and 'sly civility', argues for more subtle, discursive modes of resistance practised by colonized people.[6] Other scholars likewise insist on a discursivity between the enuncia-tions of colonized and colonizer, recognizing a vast cacophony of multiple voices and intentions. Rosalind O'Hanlon, for one, describes the complex and often convoluted processes of representation of the colonized as she probes discursive interstices marked by 'resistance to the fine meshes of knowledge's disciplinary and normalizing power':

colonialism's discourses came into being as attempts at fields of knowledge precisely as a struggle between at least three parties: The Orientalist scholar, the native informant successful in convincing him of his authority to represent, and those others among the colonized unable to do so, but grievously aware of the potential disadvantages in which this would place them in any future political

structure established under the colonial power. This struggle was the site not only of contested understandings, but also of deliberate misrepresentation and manipulation, in which the seemingly omniponent [sic] classifications of the Orientalist were vulnerable to purposeful misconstruction and appropriation to uses which he never intended, precisely because they had incorporated into them the readings of the political concerns of his native informants. It is this sense of mutuality – not as common contribution, but as struggle and contestation – which is missing from much contemporary discussion of discourse.[7]

The essays in this book explore the extent to which the colonized peoples engaged the Orientalizing discourse, resisting its stereotypes, subverting its epistemology, amending its practices and sometimes even re-applying its stereotypes to the British themselves. These essays are concerned with issues of representation which themselves shaped and generated behaviours of intervention, resistance, compliance, revision and authorship.

The discourses of colonialism are an unstable chorus of conflicts and struggles voiced by multiple participants (not just two dichotomously opposed sides). Indeterminacy actively manifested itself as ambivalence in the representations of subjugated peoples, according to Bhabha, as colonialists recognized their situation, 'tethered to, not confronted by, his [sic] dark reflection, the shadow of the colonized man, that splits his presence, distorts his outline, breaches his boundaries, repeats his actions at a distance, disturbs and divides the very time of his being'.[8] The colonialist's ambivalence arises from the charged distance between colonized and colonizer that is constantly inscribed and re-inscribed by the inherent instability in the imperialist project based on 'the white man's artifice inscribed on the black man's body'.[9]

Another under-examined dimension, along with fear, is the colonizer's desire for the exotic or erotic, the dangerously sublime, for difference itself, for visual and experiential novelty. Beyond mere mimicry, colonized peoples themselves profoundly affected this charged space and transformed the very practices, institutions, and philosophies of the colonizers sometimes through their active voice, sometimes through the complex interplay between colonizers' fantasies and colonized people's ingenuity, and sometimes in the very brilliance of their cultural production. Perhaps the most poignant and tragic example of the latter, recently examined by Annie Coombes, is the case of the anxious and desperate British attempts to coordinate their racial attitudes with the acknowledgement of the beauty and extraordinary technical skill of Benin sculptors. While, on the one hand, British colonizers raided and stole the stunning works of art, ostensibly in retaliation for Benin resistance to colonization, on the other hand, the colonizers hastily created a false 'history' of white origins to explain the quality of these coveted objects while denying

them their origins in Benin culture, a tribute unable to co-exist with bellicose and avaricious imperialist motives.[10]

On a more subtle level, the colonial experience challenged longstanding British aesthetic concepts such as the picturesque and the sublime. When British artists travelled abroad or when British writers read colonial texts in translation, they discovered that their previous practice of leisurely contemplating formal or philosophical premises was boldly interrupted by the intervention of intense emotions, ranging from admiration to terror. This direct confrontation with unfamiliar and powerful experiences made it difficult for artists and writers to maintain the posture of Enlightened reasonableness required for abstract contemplation. The colonial gaze, unlike the disinterested gaze formulated by Immanuel Kant and affected by his followers, engaged in an elaborate dialectic involving imaginative free play, withdrawal, transcendence, subjectivity, commitment and communality.

Historically, the influence of the colonized cultures on Britain is perhaps most readily apparent in the arts: Victorian periodicals, especially art journals, and the international exhibitions of this period, as well as the later advent of department stores, provided rich opportunities for the British public to see a great selection of art from India, Africa, Japan, China and the Middle East. Paul Greenhalgh lucidly presents the conflicting awareness of the high quality and beauty of objects produced by the 'Other' at a time when the fine arts epitomized national unity, noting that international exhibitions structured their presentations of the fine arts to create a 'hierarchical dimension based on race. In social Darwinian terms, the Europeans made fine art; by comparison with Europe India did not, but in the absence of Europe it was allowed to use the label; Africans did not make fine art, but were condemned in advance to be craftspeople only', creating an elitism 'within peoples also'.[11] Nevertheless, despite pejorative categories, European racism and the saturation of these exhibitions with imperial ideology, artists and manufacturers were impressed with the designs and art objects from the colonies, although different effects occurred depending on whether the influences were from the Middle East, India or Africa (which initially had a more profound effect on French art than on British). According to Greenhalgh, 'a significant number of writers found non-Western forms superior to the familiar overcrowded historicism dominating European produce'.[12] The influence on art, architecture and design was varied: simple imitations were combined into pastiches for mass production and consumption (the cheap manufacture of foreign goods was the motive for the creation of British art schools in India to serve the home market's taste for both exotic kitsch and designs for fine cottons to compete with the French silk trade). Artists were liberated from conventions, European modernism was constructed through influences from non-European cultures, and serious scholarship of colonial

art began to develop. That the influence on British artists who ventured abroad was just as profound is apparent in the works of Augustus Earle, Emily Eden, Lady Charlotte Canning, Fanny Parks, Sophia Charlotte Belnos and Marianne North discussed in this volume.

Often unwittingly, British representations, no matter how hegemonic and imperial, were transformed by the unexpected and lived experience of colonialism and the proximity to 'otherness'. Our essayists document instances of intercolonial infiltration that both resisted and authenticated the notion of Empire. Ronald Inden's concept of 'imperial formation',[13] 'a complex polity consisting of overlapping and contending agents related to one another in a "world" whose spokesmen claim universality for it', emphasizes the dialectical nature of interactions between colonizer and colonized that produce this constantly shifting discourse. As Inden points out, colonized regions are not 'constituted in isolation; they have been defined the one in relation to the other', so that

Euro-American Selves and Indian Others have not simply interacted as entities that remain fundamentally the same. They have dialectically constituted one another . . . India has played a part in the making of nineteenth- and twentieth-century Europe (and America) . . . India was (and to some extent still is) the object of thoughts and acts with which this 'we' has constituted itself . . . the consequence of this process has been to redefine ourselves.[14]

Although we agree with this assessment, the emphasis in this book is not simply on the modified British self, but also on the processes by which colonized cultures altered and interrogated Euro-American identities, both individual and national. Our biographic studies of the colonial rulers Sayaji Rao III, Maharaja of Baroda, and Mehemet Ali, Pasha of Egypt, reveal that they set their own agendas while still paying lip-service to their 'masters'. Managing to claim a degree of agency for themselves, they negotiated the terms of both their personal and communal identities. The matter of identity, then, is a product of specific historic circumstances, as biography is shaded by economic and political exigencies.

This book will address several scenarios: the direct influence of the colonies on British social behaviour and ideology; the interventions and indeed dominance by some 'native informants' over British representational practices in word and image; the rich exchanges inscribed by anxiety, ambiguity, mimicry and desire, a vast field marked by theoretical studies that fracture Said's monolithic Orientalism into the multiple instabilities and complexities of colonial discourse; and finally intercoloniality, whereby experiences in one colony influenced British practices of representation in another colony.

This theme of the impact of the colonized on Britain originated as a panel on cross-cultural exchanges between Britain and the colonies at the 1996 College Art Association. We invited other authors to join our original group of participants in order to expand the disciplines represented and cultures studied. As a result, this book is the first cultural study of the ways in which colonized cultures influenced the British and the colonial discourse in art, literature, politics and history. Without softening the reality that colonial domination was attained by a measure of force that was devastating to the colonized peoples, this collection of essays demonstrates that Great Britain was profoundly affected by the cultures it dominated, that colonized people actively intervened, mediated, questioned, and resisted Orientalist authority, and that these strategies were complex and intercolonial.

Julie Codell's essay examines the biographies of Sayaji Rao III, Maharaja of Baroda, an extremely wealthy and Anglicized ruler whose partially autonomous sovereignty of one of the Indian Native States was marked by his reformism. His reign was a conflicting and vacillating combination of imperatives: cooperation with and admiration of Britain, simultaneous with his leadership of the modern Indian nationalistic movement in the first decades of the twentieth century and his vocal attacks on some British policies. Sayaji Rao appropriated British institutions, resisted British encroachment on his power and appealed to all sides of the growing conflicts between colonizer and colonized in the early part of this century. He employed three Englishmen to write biographies of him for consumption in Britain, as well as hired Indian authors to write his biographies for Indian readers. Codell argues that some of his biographers apply to him characteristics of the Victorian sage, while others represent him as the luxurious maharaja, fulfilling British fantasies of the exoticized Other. This splitting of the colonized subject in the biographies was Sayaji Rao's own construction for the dual publics with whom he negotiated his authority and power (both Indian and English). The twin identities he claimed for himself destabilized the role the British expected him to play. Expanding on the theories of the split colonial subject and mimicry articulated by Gayatri Spivak and Homi Bhabha, Codell maintains that this division created not dual but rather multiple selves, which were, in turn, employed by Sayaji Rao and his biographers to negotiate political and social circumstances and gain empathy from British readers for nationalist Indian causes.

Emily Weeks also takes a colonial ruler as her subject: Mehemet Ali, Pasha of Egypt, who, like the Maharaja of Baroda, was an active agent in the creation of his public identity. Focusing on David Wilkie's 1841 portrait of Mehemet Ali, she simultaneously examines the limits and uses of Said's concept of Orientalism. While this portrait, on the surface, appears to be a logical expression of Orientalism and thus another example of Britain's

imperialist projections which silence the Other, Weeks argues that, instead, the image epitomizes the intervention and reversal of that discourse by the colonized subject. Although Mehemet Ali introduced Western education into his country and courted tourism and trade, he harboured dreams of nationalism and independence. His decision to be portrayed in Ottoman draped pants and slippers was in flagrant defiance of the prevailing dress code which insisted on boots, frock-coats and trousers. As Weeks evaluates the iconography of the portrait, it becomes clear that Mehemet Ali controlled his representation to convey a separate identity for himself and express his solidarity with Egyptian nativism.

Dianne Sachko Macleod correspondingly reveals that Ottoman clothing was used subversively by British women in a manner that inverted the equation between colonizer and colonized. Inspired by British women travel writers who published laudatory accounts of the enviable civil liberties possessed by Ottoman women, which included the right to refuse conjugal sex, to divorce and to inherit property, a number of Victorian and Edwardian women boldly wore Turkish trousers on the streets of London as an act of resistance and a sign of independence. Like the colonized imperial subject, these cross-cultural cross-dressers desired more individual liberty, both bodily and in the body politic. The adoption of clothes that Westerners considered 'mannish' signalled a challenge to gender boundaries and a rejection of the confining social norms that inhibited women from participating in public life. Drawing on recent theories of transvestism, Macleod contends that men at the same time found a release from repressive Victorian standards of masculinity in cultural Otherness which created a space for revisionist constructions of male identity.

Romita Ray also cites instances of colonial travellers who continued to wear Indian dress after their return to Britain and thus blurred the boundaries of their identity. She adds a further dimension to the rhetoric of clothing and performance discussed by Macleod, Weeks and Codell when she notes that the dazzling appearance of Indian princes at Queen Victoria's court helped produce an imperial aura. Quickly incorporated into a masquerade-like ritual, the exotic presence of colonial Others in the mother country became an essential element in communicating the grandeur of the Empire.

Ray's primary subjects, however, are the memsahibs who produced art in India for a British audience. She analyses the visual images created by five Anglo-Indian women – drawings and book illustrations as well as references in journals, letters and travelogues – which reconstructed notions of India for viewers at home. Although they arrived in the subcontinent equipped with the complacent visual vocabulary of the picturesque, their artistic efforts contradictorily fluctuated between Edenic evocations that eradicated cultural

and social differences and more confrontational representations of divisions in class, caste and religion. In other words, the colonial gaze of these 'ladylike' artists did not consistently follow a genteel trajectory that segregated aesthetics from the realm of the social and the political.

Leonard Bell continues this exploration of the colonial gaze by examining the problematics of looking, or of viewing and being viewed in particular colonial situations. He demonstrates that as a result of cross-cultural contacts, British aesthetic conventions and practices were either brought into question or modified by the experiences of British artists travelling in various colonized parts of the southern hemisphere in the 1820s. Augustus Earle, probably the most widely travelled British artist of the period, produced images which undermined the standard structure of the sublime, picturesque and pastoral modes. Like the art of Ray's memsahibs, Earle's illustrations for travelogues and paintings are marked by a certain instability due to the artist's practice of inserting himself into the composition in a narrative capacity. Bell argues that even though Earle subscribed to the ethics of Empire as the apogee of human development, he nonetheless introduced ambivalent and inconsistent elements into his art when he parodied the efficacy of the European sublime or suggested that his British brethren might be responsible for the displacement of the Aborigines. Bell's focus is on the transformative impact of firsthand experiences of colonized places and peoples on British values and cultural practices.

Kathryn Freeman takes up the theme of the sublime in connection with her discussion of the sway of the Orient over British translations of Sanskrit texts. The force and power of these foreign works not only threatened the fundamental principle of the European construction of the sublime – the distancing of the subject from the fearful or awesome object – but it also more broadly challenged the Enlightenment's insistence on the existence of a single God and the validity of a separate and autonomous ego in all men and women. Freeman reveals that Eastern texts altered the concept of the Romantic sublime: William Blake embraced *The Bhagavad Gita*, exhorting his readers to overcome their feelings of separation and fear, and Charlotte Smith found poetic inspiration in visual descriptions of the East. A social critic like Blake, Smith investigated the Indian sublime, which led her to condemn the economic impetus behind British colonization, an issue which also concerns our remaining essayists.

Barbara Groseclose argues that the 1759 victory in Canada, which effectively secured North America for the British, aided artists at home in imagining the terms of Empire in India. Beginning with a brief, pointed discussion of circumstances behind the British triumph in Canada in which she reads both the general implications of defeating the French and the consequent lionization of the British commander General James Wolfe as the

material for nationalist identification, Groseclose goes on to examine two monuments to Wolfe that conspicuously advance the ideas of nationalism. She then compares Great Britain's conquest of Canada with its conquest of India through an analysis of painting and sculpture produced to memorialize Joseph Moorhouse, a young soldier who sacrificed his life to protect the economic interests of the East India Company. Yet these works of art employ imagery that transposes the terms of nationalism by which Wolfe was memorialized for his Canadian victories into appeals for 'patriotic' service in India which disguised Britain's shift from an economic to a moral imperative. In her conclusion, Groseclose explores why it is cogent to claim that the construction of Empire in Canada informed the lineaments of art in India. She suggests that to recast the colonial site as impelling rather than receiving imperial differentiation aids the post-colonial project of re-imagining Empire. Her suggestions reveal the possibility of cracking the monolith 'Empire' through an examination of intercoloniality which replaces the way scholars have diagrammatically constructed the processes of imperial art, as radiating from a core outward, with a more complicated constellation in which one colonial site influences another.

Constance McPhee also examines the patriotic rewriting of historical events in India through the intercolonial experiences of Mather Brown, an artist who lived through the Revolutionary years in his native Boston before moving to England where he produced large-scale history paintings celebrating Britain's triumphs in India. Delving into the national past to find analogies to justify Britain's imperial project, Brown ingeniously compared the plight of the Little Princes in the Tower with that of the young sons of Tipu Sultan whom the British held hostage until the Indian leader bowed to their terms following his defeat in the Third Mysore War. No punishment was too great for the 'villain' who dared provoke the East India Company and who was ultimately responsible for the death of Joseph Moorhouse. Moreover, by making Lord Cornwallis the hero of his composition, Brown strives to restore the loss of national pride caused by Cornwallis's inglorious defeat at Yorktown in the American Revolutionary War. The fact that Brown borrows from Benjamin West's celebrated painting *The Death of General Wolfe* provides another instance of intercolonial interaction, in this case the not-so-subtle comparison between Tipu Sultan's surrender and Wolfe's triumph over the French in Canada. McPhee explores this and other representations by Mather Brown which collapse the medieval into the contemporary in order to justify Britain's global aggressions.

Jeff Rosen focuses on a little-known group of photographs of contentious subjects produced by Julia Margaret Cameron. Rosen argues that the reason for their neglect is the popular preference for her personal albums at the expense of her intellectual efforts. Certainly her portrait of Edward John

Eyre, the governor of Jamaica who was recalled after he had presided over the Morant Bay riots in which British troops killed and flogged almost one thousand natives, cannot be classified with Cameron's photographs of her daughter or her allegorical figures. Nor can her images of British spies masquerading in native dress or her disturbing tableaux of the young prince Alamayou of Abyssinia and his British keeper, who re-enact the conflict which drove the prince's father to commit suicide, be grouped with her imaginative or family images. Rosen argues that in this body of work Cameron produces double articulations that at once affirm and critique the 'justice' of British imperialism. This essay addresses many of the themes central to this volume: interventions in the name of patriotism, tensions between colonizer and colonized, the rhetoric of clothing and performance and anxieties caused by inconsistencies in the imperialist endeavour.

Notes

1. Joanne Punzo Waghorne, *The Raja's Magic Clothes: Re-Visioning Kingship and Divinity in England's India* (Philadelphia: University of Pennsylvannia, 1994): 11.

2. Lisa Lowe, *Critical Terrains: French and British Orientalisms* (Ithaca: Cornell UP, 1991): 15.

3. Ashis Nandy, *The Intimate Enemy: Loss and Recovery of Self Under Colonialism* (Delhi: OUP, 1993): 32.

4. Ibid., 34–5.

5. Edward Said, *Orientalism: Western Concepts of the Orient* (London: Penguin, 1978).

6. Homi Bhabha, 'Of Mimicry and Men', *October* 28 (1984): 125–33; 'Sly Civility', *October* 34 (1985): 71–80.

7. Rosalind O'Hanlon, 'Recovering the Subject: Subaltern Studies and Histories of Resistance in Colonial South Asia', *Modern Asian Studies* 22 (1988): 217.

8. Bhabha, 'Interrogating Identities', in Homi Bhabha, ed., *Location of Culture* (New York: Routledge, 1994): 44.

9. Ibid., 45.

10. Annie E. Coombes, *Reinventing Africa: Museums, Material Culture and Popular Imagination in Late Victorian and Edwardian England* (New Haven and London: Yale UP, 1994): 9–28.

11. Paul Greenhalgh, *Ephemeral Vistas: The Expositions Universelles, Great Exhibitions and World's Fairs, 1851–1939* (Manchester: Manchester UP, 1988): 209.

12. Ibid., 147; see also Partha Mitter, *Much Maligned Monsters: A History of European Reactions to Indian Art* (Chicago and London: University of Chicago Press, 1977): 223.

13. Ronald Inden, *Imagining India* (Oxford: Basil Blackwell, 1990): 2.

14. Ibid., 3.

I

Identity, agency and masquerade

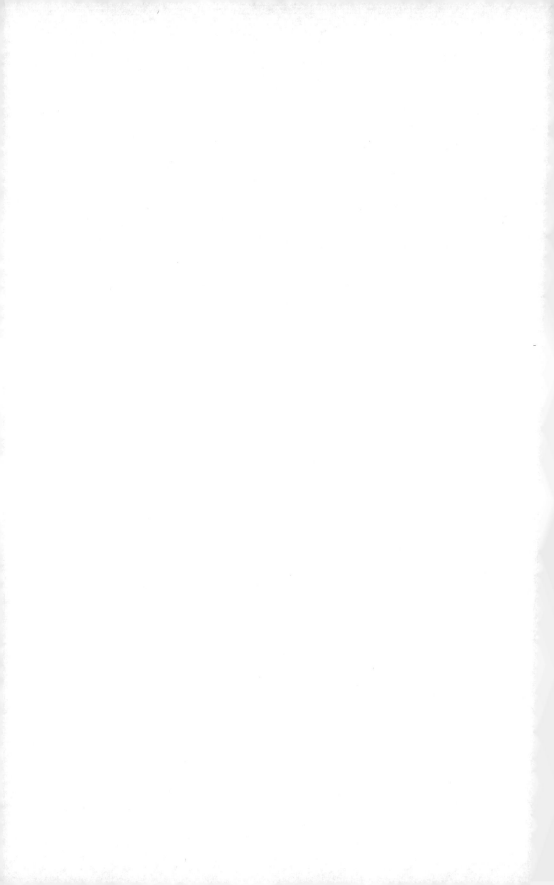

Resistance and performance:
native informant discourse in the biographies of
Maharaja Sayaji Rao III (1863–1939)[1]

Julie F. Codell

Much colonial and post-colonial theorizing is rooted in the assumption that the Other has been denied the opportunity to speak but was instead 'spoken for' by the colonizer. However, at the turn of the last century leaders of colonized countries in the British Empire published essays in periodicals and had their lives described in biographies, their bodies represented in photographs and their public speeches and addresses published, sometimes in England, sometimes in their native countries. Dominated by Orientalist discourses and their desire to reach a European audience, they negotiated Orientalist assumptions, as they diplomatically carved out a language of resistance. As native informants – aristocratic or bourgeois élites – they revised European political and social rhetoric, appearing to seek approval from the colonizer who validated the power they enjoyed. Sometimes in conflict with indigenous subaltern forces, they often represented their 'people' in Orientalist terms as anti-progressive, ignorant and superstitious. However, they were just as often sympathetic to subaltern resistance which they employed in their own negotiations with British power to construct a subjectivity located between imperialist hegemony and subalternity, however unstable and internally contradictory this interpellation often was.

'Native informant' has often been applied pejoratively to those who sided with the colonizer and failed to identify with subaltern interests. Gayatri Spivak presents the dilemma of the native informant, historically 'treated as the objective evidence of the founding of so-called sciences like ethnography, ethno-linguistics, comparative religion, and so on'. In this regard the colonizer as Orientalist knower 'has all of the problems of selfhood' while the informant, the object of knowledge, 'seems not to have a problematic self . . . the dominant self can be problematic; the self of the Other is authentic without a problem, naturally available to all kinds of complications'.[2] However, in their own writings published in the British press and in their

heroizing lifewritings, English-educated native informants spoke their identities as complicated, internally contradictory and always rhetorical.

As Mrinalini Sinha and others have argued, 'colonizer' and 'colonized' were both unstable terms defining heterogeneous groups constructed out of historical 'alliances across various axes of power' and subject to changing material conditions.[3] Intersections of economic, political, social and gendered values and forces were uneven, and groups aligned differently depending on circumstances. The British-educated Indians once considered the bulwark of colonial administrative policy in the first half of the nineteenth century were later rejected by the British after 1857 as British policy moved from 'Anglicism' to Orientalism, and the Indian élite moved from collaboration to resistance.[4] In establishing a social and political site for themselves, élite native informants intervened in the discourse of Orientalism, applying Orientalist stereotypes to subalterns or even to the British themselves, to serve their own fluctuating political ends.

I will examine the case of the representation of the Maharaja of Baroda, Sayaji Rao III Gaekwar (or Gaekwad),[5] who commissioned biographies of himself from his British employees (complete with photos of himself and of Baroda), wrote directly to a British audience, travelled widely in Asia, England and America, modelled his administrative policies and practices on British and American public institutions and participated in Indian nationalist movements. His biographies range from representing him as (1) idealized, post-Enlightenment reformer, following Victorian biographical conventions, (2) Orientalized, luxurious, exotic raja, and (3) nationalistic resister against British power.[6] The constructed 'maharajas' who emerge from these texts, whose formations Sayaji Rao controlled, are creations of a flexible informant discourse. Depicted as a 'perfect blend' of Indian and Englishman, Sayaji Rao emerged from biographical texts and his published speeches[7] as exemplary of a syncretic Indian élite culture, both a modern, Europeanized reformer admired by viceroys and Queen Victoria and a nationalist denounced by British authorities in India. His biographies' variations reflect his own multiple, desiring selves, moving always within, and often determined by, frameworks of the continuously shifting political configurations of the Raj.

Sayaji Rao's hybrid imperial subjectivity and intermediary role grew out of Baroda's relations with British authority, including the practices beginning in the late eighteenth century of finding élites in Indian society 'who could be made to see that they had an interest in the maintenance of British rule'.[8] Educated and crowned by the British, he became an outstanding reformer, promoting universal education, women's equality, an end to the caste system, public libraries, museums, roads – a model of modern progressive leadership heroized in popular Indian (Dandekar, Chavda, Gaekwad[9]) and

English (Aiyer, Rice, Sergeant, Widgery, Weeden[10]) biographies. When Maharajah Khanderao, the previous ruler, died in 1870, the British questioned the leadership capability of his son Malharrao, who was given until 1875 to 'reform' himself. He failed, according to the British, so they installed his twelve-year-old cousin, who became Sayaji Rao III on 28 December 1881. The boy's Anglicized education was carried out by Professor Tanjorker Madhavrao from Madras University (later Sayaji Rao's Dewan and granted the title 'Raja' by the British), two other Indian teachers and F.A.H. Elliot, son of a former Acting Governor of Madras.[11] What constituted education was no doubt 'clouded by a colonial view of Indian society'[12] and many such ' "enlightened" Indians did not challenge the forms, content and texts of the knowledge that colonial administrators had assembled as appropriate curricula'.[13] All his life Sayaji Rao replicated British school curricula and adhered to the ideas of his British tutors' selected texts, which he applied to Baroda through his extensive educational reforms. For him, as for many others educated in British ways, 'bourgeois individuality, equality and security of property' were applied in India in such a way that educated Indians were socialized to condemn subaltern Indians and identify with the colonial state.[14]

The romantic story of Sayaji Rao's sudden ascension became exemplary of the British policy of Paramountcy: limited self-rule even in Native State principalities such as Baroda, whose authority, granted by Britain's paramount power, was nevertheless controlled by the British despite 'self-rule'. Indirect Rule, introduced in the 1840s and applied after 1858 to semi-autonomous Native States such as Baroda, still permitted British interference. Loyal to Britain during the Mutiny, Baroda nevertheless experienced increasing intervention into its politics from the British government, continuing the pattern of intervention begun by the East India Company before 1857.

Biographies of Sayaji Rao exist in the context of the larger history of Baroda–British relations. Modern historians consider Sayaji Rao 'an extremely popular and effective ruler . . . of autocratic temperament' who surrounded himself with good advisers, maintained consistent reformism, reduced the budget for bureaucracy and increased it for social and educational institutions and public works'.[15] Baroda's greatest stability came from its landowning peasants whose official voice in the bureaucracy assured that there was much less peasant agitation in Baroda than in neighbouring Gujarat, though Sayaji Rao tolerated and employed nationalists who shared his resistance to the British.[16] Histories of Baroda are markedly different according to whether historians are British or Indian. F.A.H. Elliot, tutor of the young Maharaja and his lifelong friend and counsellor, ends his historical narrative in 1879 as Rao is preparing for his reign. What is most

important in his book is his account of the removal of Malharrao Gaekwar. Elliot attributes to Malharrao intrigues, abductions of married and unmarried women, plots to plunder districts, overtaxing farmers until lands were abandoned, poor relations with bankers and 'ignorant and rapacious' councillors. A treaty allowed the British to 'exercise a certain restraint' in the event of the misbehaviour even of independent princes, so that after warnings and an alleged unsuccessful poisoning of the official Colonel Phayre in which Malharrao was implicated, an inquiry was held. Though it did not find conclusive evidence against Malharrao, Her Majesty's Government sought other grounds for deposing him: 'his notorious misconduct, his gross misgovernment of the State, and his evident incapacity to carry into effect necessary reforms'. Thus the British removed Malharrao for political rather than criminal reasons, but remove him they did, while avoiding censure by supplanting him with a blood relative. Elliot believed the change allowed Baroda to begin to participate in 'general progress'.[17]

V.K. Chavda tells a very different story and the title of his work – *Gaekwads and the British: a Study of their Problems* – reflects his critique of England.[18] Chavda considers the British an obstacle, not a conduit, to Baroda's modernity. Tracing relations back to the days of the East India Company, Chavda sees increasing interference, first from the Company (see also Fisher,[19] who corroborates this view), and later from the British government which violated prior treaties between the Company and Baroda governments. Colonel Phayre was

out to discredit Malharrao Gaekwad on not so very serious grounds, if not insignificant or trifling, and thus justify his own meddling into the internal administration of his State ... The predecessors of Malharrao themselves had started raising their heads against the obnoxious incursions of the British Residents in their internal domain.[20]

Chavda traces reformism in Baroda to mid-century maharajas who built public buildings and instituted social reforms, and thus dilutes the reformist role of Sayaji Rao for which the British took credit; instead he places Sayaji Rao's reformism in a prior Baroda 'tradition'.[21] Chavda criticizes the Paramountcy for erasing the traditional legitimacy of Native States and 'any definite constitutional relationship between the British Government and the Governments of the Indian Native States', ultimately to control Baroda's foreign affairs, taxation, residency privileges and defence.[22]

Chavda argues that the authority and autonomy of the Native States were constantly threatened by the British.[23] The submission of Baroda to these policies under protest and the refusal of the British to negotiate meant that many agreements were hostile, rather than cooperative, and the struggle

against British interference was ongoing, antedating the Mutiny.[24] Consistently with these views, Chavda represents the British as an irrational government motivated by greed.[25] Unlike Elliot, Chavda reveals multiple claims to the throne and diverse opinions about whose descendants and whose adoption should succeed, including differences of opinion among the British authorities.[26] The decision to adopt and educate Sayaji Rao, in 'the best interests of Baroda',[27] also 'afforded a greater intervention in the internal affairs of the State by the British Government, at the same time it showed its beneficial effects in the efficiency of administration, prosperity of the State, eradication of some of the social evils, provision of justice to all'.[28] Ambivalently, he condemns British Machiavellian practices of cloaking actions in moral language, appropriating Indian customs, refusing to divulge details of decisions, and practising 'divide and rule' methods,[29] while admiring that 'people of such a tiny island could establish and own a vast empire extending throughout the surface of this planet'.[30] Chavda's conclusion reflects the contradictions inherent in Sayaji Rao's position and the conflicts between adherence to, and imitation of, British social and political practices simultaneous with resistance to British interference.

British Biographies Under the Raj

Ambiguities and contradictions saturate biographies of Sayaji Rao as they do the histories of Baroda. Most of Sayaji Rao's biographers emphasize his reforms as improvements of Indian society: new civil and criminal codes, land rents, custom duties, reduced palace costs and increased revenues for public works (libraries, museums, schools, charities, hospitals, roads), land reform, and a permanent Irrigation Department in 1900. He instituted elective councils in 1893, ended purdah, and in 1902 allowed Hindu widows to remarry.[31] His legal reforms extended the British 'magisterial' rhetoric and use of law as 'the most effective and the most valued domain for the dispensation of the new truths of colonial rule',[32] reflecting his application of the lessons he learned from his British education and his attempt to turn the logic of such reforms into justification for Indian self-rule. His much-admired decrees were copied and executed in British India, and his systems of governing replicated the 'modalities', to use Bernard Cohn's word, for the British systems of shaping, ordering and classifying information, transforming knowledge into administrative instruments – reports, statistics, histories, legal codes.[33] Sayaji Rao conducted interviews, surveys, census-taking, demographic studies and extensive revisions of legal statutes. The institutions he developed – universities, charities, rural boards – became sites where power could be exerted in India after 1880.[34]

Philip Sergeant's 1928 biography, written directly with the help of the Maharaja, whom Sergeant knew and interviewed and who provided him with primary documents for the biography, negotiates ambiguities and contradictions. Sergeant had been a close friend of Sayaji Rao,[35] and his 'Maharaja' is an empathetic construction of conflicting circumstances: great wealth and social power but severely limited by Indirect Rule; Indian traditions working against the success of the social Darwinian 'human experiment' of his being plucked out to rule. The decadence of Indian rajas ('life of ease, extravagance and dissipation') was a condition he had to overcome through near-evangelical individual effort: he 'flouted tradition' and 'put aside resolutely the temptation to follow the easy road ... overcoming obstacles by steady persistency [sic] and ever searching for new ideas', meriting 'the affection of his subjects, the admiration of educated and discerning Indians, and even some measure of appreciation from the rest of the world, not apt to give much attention to the rulers of Indian States ... A will like his does not bow to accidents.'[36] Sergeant condemns four generations of Gaekwads for having 'reduced the State's credit and prosperity to a low level',[37] bribery and incompetence. He thus represents Sayaji Rao as distinct from his predecessors, in contrast to Chavda's argument that his predecessors were progressive and resistant to unwarranted British interference. Sergeant's account of Malharrao's reign echoes Elliot's, though it is highly critical of Colonel Phayre.[38]

One of the most interesting features of Sergeant's biography is the occasional aside he employs to reveal the Maharaja's personal feelings and intimate thoughts and to differentiate the Maharaja from other more stereotypically Orientalized Indians: his boyhood was 'a very solitary one, in which he had no friends or companions of his own age. He was never permitted to forget the fact that he was "the Maharaja". Those about him were mostly subservient, ill-educated, and ill-paid.'[39] His ambition to spend a year at Oxford 'remained, like so many of his aspirations, "bottled up" '.[40] Sergeant quotes a series of letters only the Maharaja could have provided. Such asides attempt to encourage his British readers' empathy with the Maharaja.

Sergeant insists on both the harmony and the conflicts between British and Indian values. The Maharaja's marriage,[41] though arranged (Indian), was nonetheless happy, an assurance that satisfied Victorian biographical conventions of individual agency and domestic bliss. Another source of harmony is the Dewan Sir T. Madhavrao, a British-educated professor, 'very staunch in his support of the Paramount Power, whose might, reason, and justice he emphasises. The best way to conciliate the British Government, he says, is to govern the State well.'[42] Sergeant is candid about tensions between Baroda and an irrational Britain: Sayaji Rao was prohibited from equipping his army, 'asked to keep his forces efficient without being permitted actually

to make them so does not seem to him reasonable'.[43] Strained relations between Dewan Madhavrao and Sayaji Rao reflected their different attitudes toward the British. Madhavrao was a trouble-shooter for the British, becoming Dewan in Travancore and in Baroda, both during periods of upheaval and change.[44] Sergeant, however, splits the Maharaja's reformism from British influence. Being a reformer was 'innate in him rather than implanted by his teachers . . . he did not want an outside stimulus to urge him in the direction of reform'.[45] Sergeant thus erases and dilutes British 'progressive' influences on him. The Maharaja's reformism was rooted in his character, not initiated by the British or their Dewan.[46]

Sergeant's biography repeatedly argues that the ascetic, civic Sayaji Rao is unique among maharajas. Ironically, Sayaji Rao's unique abilities to lead without British interference are attributed to his 'Englishness' and his distance from 'Indian' ways: his attachment to system,[47] his long hours of work, 'his toleration of expressions of opinion contrary to his own,' a tolerance 'unique among Indian Princes'[48] and his rejection of the usual raja's luxury (a contrast which allows Sergeant to indulge his British readers' Orientalism while defending Sayaji Rao). Neither despotic nor corrupt, Sayaji Rao was thus un-Indian, or at least un-maharaja-like. Sayaji Rao was British in his leisure, too: riding, lawn tennis, billiards, long walks and hunting.[49] He considered himself 'more Western than Oriental', standing 'in a gap between two civilisations, Western progress and Indian tradition', in his own words quoted by Sergeant.[50] Sayaji Rao was much respected by the Viceroy, Lord Dufferin, who bestowed on him the GCSI, the Star of India order designed for Indians and Anglo-Indians.[51]

Sergeant's descriptions of Baroda's diversity and complexity – Hindu, Muslim, Catholic, and speaking Marathi, Gujarati, Hindustani, English, Persian, and Arabic, all united by the Maharaja's tolerance and encouragement of harmony – represent Baroda as an empire writ small.[52] To complete this replication of Empire, the Maharaja, desiring to recreate a Pantheon or Westminster Abbey, built a Temple of Fame to honour former Gaekwars and commemorate his own Golden Jubilee. His officers created an officers' club in his honour.[53] These analogies served to demonstrate how Anglicized the Maharaja was. On his first trip to England, he was invited to call on Queen Victoria at Windsor Castle to be invested with the insignia of the Order,[54] in a new 'medievalized' ritual created to structure and hierarchize visits from Indians to England (Victoria built a durbar room at Osborne House[55]). In England, he was invited to hunt and socialize with peers and speak at meetings of professional societies.

However, the Maharaja was not a British puppet. Sayaji Rao criticized the British practices of removing rajas they did not like and of imposing severe restrictions on cotton and salt production which reduced revenues needed to

finance reforms and develop the Indian economy. He publicly disagreed with Lord Curzon's policies and led a series of Indian conferences on social and cultural policies (in 1930 the Indian Princes chose him to lead a conference in London). During the 1903 Durbar for Edward VII's coronation Sayaji Rao felt the requests made of the maharajas demeaned them and he at first refused to participate in Curzon's scripted procession and Durbar.[56] Sergeant feels this 'illustrates a marked characteristic of the Maharaja – his insistence on the rights and dignity of the Indian Princes, and his opposition to innovations calculated to lessen these. It is obvious that such an attitude is in no way inconsistent with complete loyalty to the Paramount Power ... under the Curzon regime there was a tendency to misinterpret the attitude'.[57]

Sergeant plays on British identification with Enlightenment 'rights and dignity' and thus modifies Sayaji Rao's nationalism, refashioning it in constitutional and humanist terms. Sayaji Rao persistently complained about having to secure British approval for travel and to include in his entourage a political officer.[58] He worried about the threat from the British during his absence: 'The Residency ... is ever on the watch to take advantage of any seeming defects in our native administration.'[59] At Curzon's request that the Princes assist the British military fighting anywhere in the Empire, the Maharaja suggested a compensatory Indian voice in all European councils.[60]

Sergeant's mildly defiant Sayaji Rao nevertheless attracts British hostility. In 1910 he was singled out as the only ruler who was tepid in his determination to eliminate sedition, when he was eulogized by a radical Indian newspaper. He believed his tremendous popularity was one reason he was taken to task.[61] When King George and Queen Mary attended their Coronation Durbar at Delhi, Sayaji Rao's errors of bowing only to the King and turning his back too soon on the King and Queen, his unadorned Westernized dress without the Star of India sash (Princes were supposed to don 'Indian' dress) and his carrying and swinging an English walking stick provoked virulent charges of sedition against him in British newspapers.[62]

Sergeant's biographical subject fully participated in the Orientalizing discourse and employed it to distinguish himself from subaltern radicalism and from Gandhi, who so threatened the British. A Hindu, Sayaji Rao nevertheless reformed practices he felt 'savour more of the corruption of priestly times than of the Vedas'.[63] He distinguished himself as enlightened, unlike his subjects 'so sunk in ritual as never to understand the principles of their religion. In their apathy they fall in blindly with the interested inventions of the priests.'[64] Reforms were enforced slowly to avoid popular opposition,[65] a typical practice of the ruling classes.[66] Sergeant claims that his attempts to reform the caste system were more successful than Gandhi's

because the Maharaja had the power to institute changes.[67] Sergeant aligns Sayaji Rao with Gandhi's anti-caste positions but distinguishes him from Gandhi by his moderate reformism. Sayaji Rao's resistance is presented as modified, diplomatic and motivated by a desire to 'improve' his society.

Sergeant's distinction between Sayaji Rao and Gandhi pits an Anglicized native informant against what his British readers would have considered a radical resister: Gandhi, whose early career was marked by his utter loyalty to, and identification with, the British during the Boer War,[68] was later critical of the entire post-Enlightenment project – of science, progress and European concepts of reform and civilization.[69] He also opposed 'English rule without the Englishman' through the Indian perpetuation of English institutions and concepts. Gandhi blamed modernity and industrialization for exploitation, disease, unemployment, endless consumption and ruthless competition.[70] Refuting the idea that Gandhi's position was to engage and advance subaltern political interests, however, Partha Chatterjee argues that Gandhi's ideology was rather 'an intervention in the elite-nationalist discourse of the time',[71] thus intervening in the discourse by which Sayaji Rao and other maharajas promoted Victorian notions of progress and industrialism.

Sayaji Rao's ambivalent position and difference from radical nationalism is apparent in his opposition to constitutional democracy. He was criticized by Indians for failing to institute democracy and not allowing the Assembly he created to become representative, not simply advisory.[72] In his view, Indian backwardness was due to lack of education, 'not because Indians have inferior reasoning power to Europeans (for this he will not allow)', but Indians must still 'show also some willingness to contribute towards the cost of the benefits which they enjoy' for democracy to be instituted.[73] He did restore decentralized village government and local boards.[74]

Sergeant joins British reformism and Indian nationalism in his theme of the statehood of India. The Maharaja's reforms are presented as systematically working towards national identity. Thus, he could argue for Indian independence according to 'principles of the English political tradition'[75] just as he could resist Curzon on the basis of Enlightenment 'rights and dignity'. Sayaji Rao's subduing of the uprising of the animist Kaliparaj in Naosari is an example of how reforms – e.g., encouraging temperance, creating schools and credit societies – were employed to justify his pacification 'in the backward section of his subjects', just as the British justified their pacification. In this way he could also distinguish between those willingly modernized and those 'Orientals' still requiring the Maharaja's intervention to move them from tribal to national identity.[76] Sergeant employs such examples of 'primitive' behaviour to explain why Sayaji Rao moved slowly towards democracy in a state beset with mass illiteracy and ignorance.[77] 'Orientalism' thus served to justify his autocracy.

Sergeant ventriloquizes Sayaji Rao's own words from an article he wrote for *The Nineteenth Century and After*, another indication that Sergeant is not only speaking for, but also on behalf of, the Maharaja and with his cooperation.[78] In this article Sayaji Rao presents himself as a mediator, beginning with a brief description of his palace as a blend of two cultures – part English house, part Indian palace. Thus he begins his essay with his intermediary position, assurances of fiscal responsibility and accommodations to European culture. He details his average day: Hindu devotions blend with reading Herbert Spencer, Gibbon, Greek and Roman history, philosophy, Bryce's *Democracy*, Mill, de Tocqueville, Shakespeare, Bentham and Maine on ancient law, a reading list fit for an Englishman. Even his meals combine European and Indian dishes while maintaining a 'European character' in materials and manner of serving. Time with his wife and children punctuates his long hours of administrative work, demonstrating to his British readers his adherence to domestic life, the work ethic and utilitarianism ('pleasure ... pains'): 'Business has become a passion to me, and my work for the people a real pleasure; so I have spent more personal pains than, strictly speaking, I need have done.' He also comments on his subjects' religious 'ritualistic and narrow point of view' which perpetuates their 'prejudices and sentiments'; he distances himself from these, proclaiming that the most important religion they could have is 'the love of their country'.[79] His advocacy of nationalism and progress, Victorian articles of faith, was an appeal to his British readers.

Sayaji Rao's most interesting and radical statement is his reverse Orientalism. Citing the cliché that India is mysterious and irrational, he re-ascribes these attributes to the British government. He blames the Resident for problems generated by 'needless intervention' which 'multiplies and accentuates the slight inconveniencies of my absence into serious difficulties, and creates new ones ... India is said to be land of anomalies, inconsistencies, and surprises ... nowhere is the truth of this remark more forcibly brought home than in the dealings of the British Government with Native States.' He does not need British 'intervention', since his reformism is based on English models of administration, public education and philanthropy. Flattering his British readers by appealing to their Enlightenment rationalism, he also 'irrationalizes' the British government in India as feudal and hysterical.[80]

Finally, he commends England for granting self-government to Australia and hopes this will also be granted to India; he was no doubt aware of the dual categories of colonies – non-white dependent and British independent – and their different treatment by the British, differences he strategically elides.[81] He further praises his readers for their 'high moral condition and greater strength of character' but roots British character in education rather than in race to argue that such developments are possible in India. In his

own speeches he dispelled notions of racial inferiority, while arguing that what India needed was European science and industrialism.[82]

Stanley Rice's biography of Sayaji Rao is even more idealizing than Sergeant's. Rice, an Oriental scholar, had been a Private Secretary to Sayaji Rao following his retirement from the Indian Educational Service.[83] He led a committee to reorganize local boards in Baroda in 1928 and his findings were published as *Mahal Panchayas* in 1929.[84] Dedicated to the people of Baroda, Rice's biography argues that Sayaji Rao is unique, both unlike the ordinary maharaja and distinct from the British, whose influence is acknowledged. Rice heroizes Sir T. Madhavrao, F.A.H. Elliot and Sayaji Rao who 'never let go the cardinal idea that his life belongs primarily to the State'.[85] As 'the architect of his own fortunes', Sayaji Rao is a consummate individualist despite his corrupt predecessors (though Colonel Phayre is also criticized).[86]

Despite his disclaimer that the Maharaja had not read a word of the biography, Rice quotes him regarding the first visit of the Prince of Wales to India and includes 'intimate impressions' as Sergeant does, lamenting, for example, that Sayaji Rao missed the pleasures of domestic life because of his devotion to the State.[87] Most of Rice's information comes from the annual Baroda State Administrative Reports published by the Maharaja's government and from Sayaji Rao's published writings: *Early Trips, Selected Letters* and *Notes on the Famine Tour*.[88] Rice devotes a chapter to the Maharani and the rearing of their children, portraying her as an emancipator, student of English literature, and gracious hostess,[89] and the Maharaja as anxious parent – increasing the masquerade of intimacy beneath the masquerade of objectivity.

Rice presents issues 'through Indian eyes' and offers a criticism of Eurocentricity, perhaps a sign of attitudes pervading British colonial administration in the 1920s and 30s. He laments the loss of traditions in the modernization process, indicts British prejudices and acknowledges the growing Indian independence movement.[90] He sympathizes with the Maharaja's feelings upon 'being thwarted in this unwarrantable manner by men whose only justification was that they did not see things as he did', reminding his British readers that 'Indian ways are not always English ways, and not on that account necessarily worse.'[91] On the Maharani's difficulty in abandoning the habits of purdah Rice writes: 'to the woman who has been brought up to them and has known nothing else it is probably as hard to appear in public before male eyes as it would be for one of us to walk down Piccadilly in a loin-cloth'.[92] He relates the specific troubles the Maharaja and his entourage encountered in their travels: to maintain purdah, have their food prepared according to custom and religion, and maintain caste rules. Criticizing the characterization of Indians as stubborn and irrational, Rice devotes

entire chapters to Indian disputes with Britain to explain the Indian per-
spective on national sovereignty and their resistance to British interference. He
even argues that 'The British Government in India is a foreign Government.'

Rice nevertheless retains Orientalized attitudes and distinguishes Sayaji
Rao from both subalterns and radical nationalists. For him the residents of
Baroda remain 'backward' in comparison to their Maharaja.[93] Sayaji Rao's
own Orientalizing of rural Baroda tribes – 'the naturally credulous peasants'
he calls them[94] – distinguishes him from the people. Rice recounts the
resistance among Indians to the Maharaja's reforms to encourage his readers'
appreciation of the difficulties of bringing progress to Baroda.[95] The rise of a
vehement nationalism in Baroda, in Rice's view, was promoted by 'degen-
erate youths who handled pistol and bomb' and by editors in a 'campaign of
calumny'. Rice defends Sayaji Rao against charges of disloyalty and repre-
sents him as cooperating with the British to eliminate sedition. Rice even
describes the British as irrational in expecting maharajas to do more than
they were doing to ferret out nationalists.[96] Ever promoting Sayaji Rao to his
British readers, Rice portrays him as exemplifying modern progress not only
for Baroda, but for India: 'He was, indeed, recognized as the foremost
champion . . . of Indian advanced thought, in his earnest pleading for the
outcast masses, and in his denunciation of the cruelty and tyranny of caste
. . . more than a Maharaja; he is an institution'.[97]

In these biographies intended to gain sympathy for Sayaji Rao, the ideal
colonial administrator – loved by his subjects and ruling without violence
(Tidrick) – is complemented by the 'great man' figure of popular Victorian
biography – self-sacrificing, stalwart, heroic, dutiful. However, this model
was not entirely at home in the luxurious palaces of the Maharaja or in
British fantasies of India. Another image of Sayaji Rao appears in the 1911
day-in-the-life biography by the Rev. Edward Weeden, Sayaji Rao's friend of
twenty years and a young Oxford graduate when he joined Sayaji Rao's staff
in 1889 as a Reader. Whereas Sergeant and Rice, in line with their construc-
tion of the 'reformer', assure readers that Sayaji Rao no longer travels with
30 valets and all his clothes but with just one valet and few changes of
clothes, and has reduced the palace staff from 200 servants to 40, Weeden
dramatizes the wealth and luxury of the Maharaja's life.[98] One of the richest
men in the world, he had 'a fabulous revenue at his disposal': a pearl
necklace worth £500 000, the ninth largest diamond in the world, called Star
of the South, a large tapestry of jewels on silk, Belfast linen, Brussels lace,
Irish lace, walls covered with tapestries and brocades, gold and silver plates
(periodically sent to Bond Street to be melted down and redesigned in the
latest style), 50 elephants, a household 'perfectly managed by a vast machin-
ery of clerks and departments', rooms devoted to billiards and bowling, and
several palaces.[99] Sayaji Rao's world of luxury and pleasure (many hunts of

tiger, small game and birds, and much polo) is an Englishman's fantasy: 'However sadly the Englishman may take his pleasures at home, he certainly manages to enjoy himself in India.'[100] The Maharaja also had an international entourage: a French cook; an English *maître d'hôtel*; a Mr Pluck, once butler to a former Governor of Madras; an American, Miss McLean, who read to him and conducted a salon; an American Director of Commerce who restored old tramcars for Baroda. His daughter had a 'little English maid'[101] and his wife an English companion, Miss Tottenham. With this colony of Europeans Sayaji Rao discussed Spencer, Swinburne, Rossetti and Keats.[102]

Weeden's 'wealthy, exotic Maharaja', Sergeant's and Rice's Anglicized reformer and Rice's Indian nationalist fashion multiple personae out of Sayaji Rao's native informant 'dislocations',[103] partly blended in Weeden's depiction of 'a despotic monarch [Indian] governing constitutionally [English]'. The Maharaja's reforms were 'gifts' to subjects unable ever to repay or even fully comprehend the value of such 'gifts'. These unreciprocated gifts become a kind of potlatch whose surplus value ironically reinforces Western Orientalism. Despite, or even because of, the gift of reformism, persistent 'Indian' ways are highlighted: his subjects, failing to understand progress, 'salaam profoundly as he passes . . . incapable of appreciating what he does for them'.[104] Weeden's description of Baroda's subjects' 'superstitions' echoes Sayaji Rao's own distinctions between himself and his subjects on religion. Despite his twenty-year friendship with the Maharaja, Weeden's biography is dominated by his erotic preoccupation with the Maharani and their daughter (whose bodies, clothes and conversations he fetishizes) and his general infatuation with India (his minimal clerical duties barely keep him from 'becoming a devotee of Vishnu or Siva').[105] Steeped in his own fantasies, Weeden ignores topics of Indian nationalism or relations with the British.

The very experience of living in India reinforces and authorizes Weeden's text-based Orientalism: India is unreal, 'living in fairyland'; Indian women recall harem paintings, 'in which the skill of Leighton and of Alma-Tadema seemed mingled together to weave a magical web of beauty'; and the Hindus are intrinsically unreliable, 'naturally a suspicious race; their instinct is to mislead, and they have raised dissimulation to a fine art'.[106] Sayaji Rao's gift of progress, unreciprocated by 'mediaeval' Indians, replicated colonized differences between British and Indian practices. Within the discourse of Orientalism, Sayaji Rao is a 'good' Indian – Anglicized, economical, reformist, 'scientific', 'progressive', and acculturated. A man within 'history' and its corollary, 'progress', he is thus unlike other Indians who are superstitious, sycophantic, backward, uneducated, passive, unchanging and poor. Sayaji Rao lives in both English time (historical, modern, scientific in Sergeant and Rice) and Indian time (pre-historical, traditional, mythic, erotic in Weeden).

This temporal disparity exemplifies Homi Bhabha's notion of the time-lag in which the colonized live in an eternal past, while the colonizer is always progressing to the future. The colonial time-lag is at the centre of the myth of modernity and propels the desire to 'progress'. This time-lag is 'between the "Great Event" and its circulation as an historical sign of the "people" or an "epoch", that constitutes the memory and the moral of the event as a narrative, a disposition to cultural communality, a form of social and psychic identification'.[107] The master narrative of modernism (progress, technological development, democracy) in its co-existence with 'third world culture' constructs a time-lag in which non-modern cultures are written out of history, out of modernity and into a timeless primitivism – Edenic, simple, and fixed. The time-lag is 'the temporal caesura, which is also the historically transformative moment, when a lagged space opens up in-between the intersubjective "reality of signs . . . deprived of subjectivity" and the historical development of the subject in the order of social symbols'.[108] These 'transformative moments' are variously colonial, reformist and nationalist in Baroda's case; the British biographies of Sayaji Rao position him in the 'historical development of the subject in the order of social symbols', which are generated by Raj hegemony but which also exist on a continuum from Anglicized to nationalist.

For Indian élites a time-lag existed between the subaltern or 'traditional' population and Native Informants. Native Informants 'exist' in the allegedly pre-historical state, as a colonized, unproblematic self[109] of which they are made aware by their Anglicization and against which they feel obliged to defend themselves. Thus his biographers are careful to distinguish Sayaji Rao from his Indian subjects. Bhabha's time-lag and its concomitant writing out of history of non-Western cultures helps explain the multiple meanings of Sayaji Rao's modernization for British interpretations of his personae from ascetic reformer to exotic Oriental. The time-lag constructed between 'primitive' India and 'modern' England allowed Sayaji Rao to intervene and link them through reformism. But his notion of progress included Indian autonomy (e.g., control of native industries, army and local police and independence) and aligned him with Indian nationalism. Designed to appeal to British readers, his commissioned biographies reinforced a second lag between 'mediaeval' India and 'modern' India which, as the synthetic Anglicized raja, Sayaji Rao mediated for his Indian subjects and his British colonizers.

The time-lag splits open identification through its interrogation – to which 'we' does the speaker belong?[110] – propelling a desire to 'establish the cultural boundaries of the nation so that they may be acknowledged as "containing" thresholds of meanings that must be crossed, erased, and translated in the process of cultural production'.[111] Sayaji Rao's crossings are exemplified in his vacillations between his identifications with the British,

with the Indian élite and even, in his flirtation with nationalism, with the Indian subaltern. Weeden's Orientalized Maharaja enjoys Indian luxury and pleasure in an Edenic, enclosed, atemporal world. Sergeant's and Rice's modern reformist Maharaja replicates English values – work, domesticity, progress, empiricism, loyalty – while being moderately and 'understandably' (Rice) nationalistic.

Indian Biographies After the Raj

Indian biographies of Sayaji Rao within the last thirty years reveal a third persona, the radical nationalist who covertly defied British control while disguised as a British sympathizer. V.K. Chavda's populist 1972 biography builds on the work of his English predecessors' anecdotal presentations, but contradicts their portrait with that of a thoroughly conscious figure who controlled his behaviour, alternately provoking and soothing British anti-pathy. Chavda also draws on other Indian biographies by Chimanlal in Gujarati and by G.S. Sardesai and by Daji Nagash Apte, both in Marathi, for Indian readers only. While in Chavda's biography Sayaji Rao remains very English in tastes, blends English and Indian ways and is a split personality characterized by conflicting duties, he is also *disguised* as Britain's friend while remaining essentially resistant and nationalistic. In this way, he is a striking reversal of the imperial commonplace of the British traveller (Burton, or Kipling's Kim) disguised as an Oriental or gone native. Chavda argues that Sayaji Rao out-Englished the English: he was 'more than a match for them. Not only did he become an independent-minded ruler but also he went further than the Indian Government on the path of progress ... a nation-builder, to the great surprise and even chagrin of the British'.[112]

On the other hand, Sayaji Rao's Orientalizing of Indians' 'want of real thrift, want of energy and enterprise, of legitimate ambition and high ideals; passiveness, fatalism and supineness in the face of certain calamity'[113] is permeated by Victoriana – Smilesian thrift, Oriental stereotypes ('passiveness', 'fatalism', 'want of energy and enterprise') and evangelical ideals ('ambition and high ideals'). In Chavda's representation of 'The Seditious Prince'[114] in conflict with the British, he defends Sayaji Rao not on the grounds that he was not seditious (the defence used by Sergeant and Rice), but on the grounds that Sayaji Rao was too diplomatic 'to stake his State in a foolhardy manner' by mis-bowing to the British King or supporting seditious newspapers.[115] Chavda's biography includes material from the four volumes of Sayaji Rao's speeches and addresses in the chapter entitled 'The Princely Preacher', which encompasses in the figure of Sayaji Rao the Indian raja without the propensity to luxury and the evangelical Englishman without the propensity to contrition.

Perhaps the most revealing source for understanding the nature of Sayaji
Rao's intervention in Orientalist discourse is his great-grandson Fatesingh-
rao P. Gaekwad's biography of him, published in 1989. This well-
documented biography, based on historical evidence kept classified by the
British until the 1960s, explains both how Sayaji Rao hired or coaxed Rice,
Weeden and Sergeant to write his biographies to counter British attacks on
him as seditious, as well as the limits on the content of those biographies
during the Raj. An Indian journalist commissioned to write a biography did
such a poor job that Sayaji Rao refused to publish the three-volume biog-
raphy in 1913, indicating how carefully he constructed and negotiated his
public image during the Raj. Gaekwad goes further than Chavda in present-
ing Sayaji Rao as a nationalist, fully conscious of when and how to use
nationalism and threats of sedition and when to back off. Even Sayaji Rao's
cultural patronage was politically charged: his patronage of Indian music
and art, promotion of the study of Indian languages and publication of
Indian literature in his Oriental Series appear as resistances to the British
manipulation of Indian languages as instruments of power and rule and to
the writing of Indian history as means for 'proving' the 'decay' of Indian
culture and defining Indian 'traditions'.[116]

Sayaji Rao rewrote the British discourse on the very topics the British
appropriated – language, Indian history and customs. Giving voice to Indian
perspectives on Indian culture, language and history and pushing the logic
of British reformism to its conclusion of citizen rights and justice meant
that

As Sayajirao grew and his social reforms spread and took root, the angrier the
British got. On top of all this, he both openly and surreptitiously hobnobbed with
the known enemies of the Raj in India and abroad, and leaders of the Congress
party. I think there is enough circumstantial evidence which goes to prove that he
must have substantially financed the Congress party here and enemies of the Raj
abroad. When he was repeatedly warned by the British not to see these people, he
asked them to furnish him a list of names of persons he should not see. This list he
used to the best of his advantage. He sent in a reply saying that a couple of persons
were his bankers, two others were his personal jewellers, few were old friends and
the rest were his subjects who came to pay their respects to him. In this, he was
abetted by his Maharani Chimnabai II who met these people somewhere in Europe,
particularly in Switzerland.[117]

Both Chimnabai II and Sayaji Rao appear as active, complex, intentional
figures, rather than the demure or apologetic figures, respectively, described
in English-authored biographies.

Gaekwad argues that Sayaji Rao preceded Gandhi in promoting the
elimination of caste and the eradication of untouchability,[118] a comparison
very different from the one in Sergeant's biography which defends Sayaji

Rao as less radical than Gandhi. Gaekwad instead aligns Sayaji Rao with Gandhi, citing speeches in which he sympathetically mentioned Gandhi, at a time when such a reference was considered seditious by the Raj, and his refusal to arrest Gandhi when he marched through a Baroda district en route to Dandi to resist the salt laws. As Ranajit Guha points out, there were 'many shades of compromise between collaboration and dissent which were so characteristic of élite nationalism' in Sayaji Rao's and in Gandhi's cases.[119]

Sayaji Rao's English biographers place him closer to collaboration with a demand for his 'rights', while his Indian biographers magnify his dissent. Perhaps the most extreme claim in Gaekwad's biography is that Sayaji Rao intentionally turned his back on George V: Fatesinghrao quotes Dewan Sir V.T. Krishnamachary 'that his Ruler had categorically stated that he had intentionally dressed and behaved in the manner that he did'. The notorious Durbar incident had been, in Fatesinghrao's view, an intentional gesture whose meaning was not lost 'on those for whom it was intended', though it miscarried, resulting in excessive British outrage, charges of treason and surveillance by Scotland Yard. 'The great nationalist that he was', Sayaji Rao refused to see Curzon off when the Viceroy left India: 'Many Princes went to Bombay, but there was no question of Sayajirao personally seeing him off. Instead, he sent a cryptic telegram to Curzon: "Bon Voyage, may India never see the likes of you again." '[120]

According to Gaekwad, the British officials Warren Hastings, Colonel Phayre and Sir Lewis Pelly[121] were thoroughly unscrupulous. Those who picked Sayaji Rao to be Maharaja were motivated by the desire to control and subordinate him:

So, ostensibly in the interests of Baroda, they set out to play Pygmalion with a vengeance, determined, much like Professor Higgins, to show that they could, within a span of six years, transform an unlettered rustic lad into a thoroughly accomplished autocrat, whom they could proudly hold up as a model before the princes of India, and who, at the same time, would prove to be loyal, dutiful and subservient to his overlords.[122]

Sayaji Rao's 'solid, middle-class' education as a reformer was the outcome of his English teachers reminding him of the laziness of Indians until he became obsessed with system and order and incapable of spontaneity.[123] Calcutta itself symbolizes 'an unending succession of British victories and Indian humiliations ... There was nothing for an Indian to see here, except to read the success story of his conquerors and to stand with bowed head at the reminders in marble of the blunders and shortcomings of his fore-bears.'[124] Gaekwad's criticism of Madhavrao as a British lackey of whom 'Sayajirao was never a great admirer'[125] is consistent with his attack on the British and his dissociation of Sayaji Rao from them. The British-identified

Madhavrao is held responsible for giving away rights of Baroda to the British – salt industry, arms manufacture and the right to purchase arms from the seller of choice.

Fatesinghrao maps the increasing hostility between Sayaji Rao and the British and even attributes the length of Sayaji Rao's stays in Europe to his desire to avoid being in India for visits by Curzon or the Prince and Princess of Wales in 1905, an absence that upset Curzon but not Edward VII.[126] He resisted protocol at the Durbar for Edward VII by speaking rather than simply bowing, and he avoided the Queen's birthday celebrations, too.[127] He stayed abroad to avoid conflicts with hostile Residents, such as Biddulph.[128] His 'special affinity for the intellectuals of Poona'[129] aligned him with outspoken nationalists. Furthermore, Sayaji Rao possessed 'a mature understanding of how the minds of the officials of the Raj worked',[130] a reverse Orientalism in which the Maharaja had the colonizers figured out. He used the excuse of purdah, which he opposed, to resist the demands that the Maharani call on British officials' wives,[131] avoiding contact with British officials in as many ways as possible. At times he was more direct, arguing to the Resident that he could hardly be expected to police disaffection with the British unless they did the same against those slandering the Gaekwad, or hiring as his Dewan a man who 'crossed swords with Lord Curzon'.[132]

In the context of the other princes' political dealings, Sayaji Rao was more resistant to, and openly defiant of, British authority than the majority of princes who were themselves mobilized by the British to help contain and suppress nationalist uprisings and the Civil Disobedience movement.[133] The majority of princes aligned themselves with the British against the growing numbers of critics of British policies.[134] Negotiating a position between increasing Indian criticism of the British and retaining control of their provinces, the princes supported a Federation at their First Round Table Conference, held, not surprisingly, in London in 1930, which Sayaji Rao attended.[135]

Fatesinghrao's biography includes incidents which do not appear in previous biographies, such as secret government reports on Sayaji Rao, lists of seditionists,[136] being named in the divorce case of Statham vs. Statham, and the corruption and bankruptcy of the Villiers Companies which invested money for the Baroda government at a loss of Rs 7 000 000. Such events would not have served Sayaji Rao's purpose of gaining the sympathy of his British readers during the Raj. Ultimately by withdrawing from politics and limiting his activities to cultural development, he became a favourite son once again.[137] Fatesinghrao, with the assistance of officials in the Thatcher government, sifted through many secret government documents kept classified beyond the usual thirty-year period.[138] The British constantly plotted to remove him, writing secret reports attacking him and Elliot, conspiring with

one of his own dewans against him and framing his assistant Bapat,[139] but they were thwarted by Sayaji Rao's clean living, popularity, smooth running of his government while he was away, and the acceptance, and even appreciation, of him by Victoria, Edward VII and George V. Even his reformism appears to Fatesinghrao to have affronted the British: 'To them it was an article of faith that the Raj was the best system of Government for any country other than England, a system that could not be improved upon . . . a "native ruler" aspiring to match that performance was presumptuous; to talk of improving upon the system was rank heresy.'[140]

Fatesinghrao's Maharaja is a sophisticated match for the Raj,

a careful man who had trained himself to exercise self-control even in the face of provocation, so that, however much the Resident and his assistants suspected that he was sympathetic towards the nationalists, they never had any direct evidence . . . Not that Sayajirao made any secret of his real sentiments before those whom he regarded as his real friends.[141]

He was even given to potlatching the British: he supported the British with money (Rs 4 000 000) and soldiers during World War I, demonstrating his loyalty in spite of the Raj's treatment of him. Similar images of Sayaji Rao appear in essays in a centenary commemorative volume published in 1964.[142] While most of these essays praise his reformism and reminisce about his rule, some information – such as his desire to maintain Indian languages and limit the use of English and his independence from Britain – supports his Indian biographers.[143] Sayaji Rao sold his family home in Poona 'for a nominal sum to Lokamanya Tilak who was at that time the patriot most feared by the British Government'[144] and hired extreme nationalists such as Sri Aurobindo as his Private Secretary and Swami Nityanand Saraswati, the leader of Arya Samaj, as his adviser.[145] Interestingly, Nanavati describes the 1911 Durbar incident as a 'shock from which Sayaji Rao had never recovered',[146] a description which seems inconsistent with Fatesinghrao's description of this incident as intentional. Munshi describes him as shattered after the 1911 incident but explains this effect as due to the fact that 'No one then stood by his side. His pride was shattered', as Baroda was temporarily placed under British officers.[147]

Colonial Mimicry and Multiple Selves

Sayaji Rao's biographies raise the issue of mimicry through Anglicization.[148] While Sayaji Rao did not suffer the alienation of many who were Anglicized and returned to their native country after an English education, only to be aliens at home and never completely trusted to serve England abroad (e.g., the case of Bipin Chandra Pal),[149] he was treated by the British as someone

Bhabha describes as part menace, part mimic, part destabilizer of British identity who could out-British his colonizers by insisting they practise the Enlightenment they preached. Mimicry underscores the indeterminacy and ambiguity of the colonial discourse which is replicated in the colonial only in part and only by part, as camouflage both distinguishes oneself from the background and makes possible an immersion in it. The Anglicized Indian returns the gaze of the British oppressor whose surveillance is returned incompletely, disrupting the colonizer's sense of identity as wholeness. Colonial presence is mirrored as partial, fragmented and thus, like the fetish, both elides and represents lack, serves to salve and to disturb at the same time.[150] Fragmenting colonial authority, mimicry thus differentiates it, denies its authority and appears as a menace, a parodic threat to the order, just as Sayaji Rao's reformist aim to create a government better than the Raj crossed the boundaries and thresholds that define and separate nations and distinguish centres of power to annoy the British.[151] Educated in British Enlightenment epistemology, he turned its precepts on the British, goading them to advocate and fulfil their Enlightenment project in India. Thus, 'the authoritative control which the British tried to exercise over the new social and material technologies was taken over by Indians and put to purposes which led to the ultimate erosion of British authority . . . as they refused to become specimens in a European-controlled museum of an archaic state in world history'.[152]

Despite his Anglicized behaviour, down to his emphasis on law, bureaucracy and 'recordation' (J.S. Mill's term for the extensive record-keeping of the East India Company[153]), Sayaji Rao also enunciated India, resisting mere imitation. This is most apparent in Sayaji Rao's mimicry of the confessional mode, as in his essay in *The Nineteenth Century*, in which he 'confesses' and offers to British surveillance his life and activities, all the while defending them and demonstrating the irrationality of British rule in a language of 'sly civility' (a term Bhabha borrows from British missionary discourse[154]). If Sayaji Rao's behaviour can be described as mimicry, it also had a substance – the rationalizing of the British whose Enlightenment systems and motives were both played out (through civil service and through reformist maharaja mimic men) in India and simultaneously denied to Indians (by denying Indian authority and independence). He recognized the syntax of deferral of colonial discourse whereby Britain recorded and inscribed events in India while denying their Indian significance.[155]

Representing his own subjectivity through commissioned biographies, he re-invested British practices with a logic that the British did not actually pursue in their own behaviour in India, as they hardly intended to fulfil Enlightenment utopianism there. Hybridity strategically reverses domination and subverts it, becoming a form of resistance.[156] Instead of fixing the

subject, the Anglicization of Sayaji Rao participated in the subject's elisions, slippages of identity, resistance to British authority and return of the gaze to the colonizers. Perhaps mimicry helps explain why at various times – his allowing nationalists to teach in Baroda, incorrectly bowing to the King, travelling a great deal, seeking Western medical cures – the British so vehemently attacked him, much to his own rhetorical bewilderment as portrayed in his biographies: 'If the effect of colonial power is to produce "hybridization", this undermines colonial authority because it repeats it differently; other, repressed knowledges enter unawares and effect a transformation.'[157]

Sayaji Rao's control of these biographies reclaimed the Indian as a conscious subject-agent to produce 'new forms of knowledge of South Asian societies . . . ways of conceptualizing the nature of resistance and its possibilities in a deeply coercive social context'.[158] Insisting that Sayaji Rao's reforms were his and not inspired by the British, Rice and the Indian biographers argue for indigenous reformism based on Indian values, traditions and rate of change. Thus, Sayaji Rao could desire his sons to attend Oxford, but complain that this education did not prepare them to rule India.[159] For him the British represented both an irrational government and the object of his desire, as he filled his court with European retainers who indulged their own eroticized fantasies of India and wrote biographies of him.

Through his paid biographers, biography became a site for his multiple selves to function politically and engage both Indian and British readers. Spivak outlines the convoluted relations of colonialism in terms of 'progress' and 'modernization' and the intermediary role of those Indians who co-ruled India with British support but were forced to succumb to increasingly restrictive policies.[160] Despite their relatively small numbers, the British ruled repressively because 'the indigenous élite found that wonderful structure of repression a structure that they could identify with and could use to actually entrench their own position. And as a sort of by-product . . . the production of the colonial subject.'[161] For Spivak the possibility of neutral dialogue between equals under colonialism was 'an idea which denies history, denies structure, denies the positioning of subjects'.[162] Sayaji Rao recognized the illusion of such a dialogue. He criticized the British for denying equal status to maharajas while he adhered to European rationalism, thus exposing contradictions within post-Enlightenment Western ideology. He even replicated these contradictions in his own resistance to total democracy in Baroda. His reformism exemplified the 'notion of fracture' at the heart of nationalism:

The way in which semiotic fields are tapped for cultural self-representations, in fact, always covers over the dislocation between the kinds of axiomatics that are being

used, and what it is in the 'culture' that constitutes the hidden agenda of the suppression of ideological production . . . the fracture goes either in the direction of Utopianism, or in the direction of a golden-age complex.[163]

In Sayaji Rao's case utopian reformism concealed dislocations represented by attempts to join conflicting ideologies of European rationalism, limited Indian power, Indian nationalism and subaltern resistance to reforms both Indian and British.

In his early speeches, which he delivered in English, Gujarati, and Marathi, depending on the circumstances and audiences, Sayaji Rao encouraged Indians to commit themselves to industry along the lines of Western European manufacture. He admonished them to move from 'favour and privilege'[164] to 'equity and justice'[164] even to abandon their customs:

If, then, our customs put us at a disadvantage in the struggle for life, it is useless to persist in them merely because they are our own or old. And lastly we learn that we must not exaggerate the importance and probable effect of social reform, since it is only one of the aspects of readjustment. We must advance socially, economically, and politically if we wish to reorganise our society so as to survive.[165]

Indulging in Darwinian and Spencerian views, Sayaji Rao talked about survival of the fittest, struggle and competition,[166] believing that centuries of self-contained economic and social patterns no longer served an India now competing in a global market:

Science has forced down barriers and made us merely one district of the ever-narrowing world . . . We must strive for a more elastic and efficient economic organisation; we must give up customs which keep us physically weak or unenterprising, and especially those institutions or prejudices which divide man from man, caste from caste, religion from religion. Increased communication and inevitable mutual contact urge us on the road with or without our consent.[167]

He quoted Kingsley's advice not to seek religious asceticism without philanthropy, not to refrain from serving the common good in favour of saving their 'dirty little souls'.[168] Many of his speeches focus on health and education as ways to accomplish his goals of industrialization and reinvention of customs. He sought to replace the caste system with the club system so popular among British males; clubs for him meant open enrolment, and thus the 'mutual knowledge and respect' necessary to eradicate caste and untouchability.[169] His saturation with British cultural paradigms is even reflected in his purchase of Tennyson's house, Aldsworth, in Surrey.[170] Not surprisingly, in many speeches he praised the Raj in ambiguous terms: 'I would emphasise my deep and constant appreciation of the fact that upon the British Empire rest the foundations of the well-being of my State',[171] which was both true and an annoyance to him! He argued not from Indian

inferiority but from Indian lack of science and modern industry[172] and praised the Japanese who learned from the West without destroying their own traditions.[173] He insisted he was not a blind admirer of the West:

> I would not for a moment have you think, my friends, that I return from the West a convert to Western ideals, or in any sense a pessimist concerning the future of India. There are many defects in the Western civilisation. . . . There is the eternal conflict between capital and labour which is becoming more acute as time goes on . . . the air is surcharged with the miasmic spirit of greed . . . the love of display, and the sordid worship of material wealth and power.[174]

Sayaji Rao appears superficially bifurcated – colonizer and Other. Bhabha and Spivak identify this split self in the native supplanting the colonizer as an 'informant' or 'translator' of cultures in both directions. But this dichotomy oversimplifies the situation. Sayaji Rao both secured and destabilized multiple identities of English and Indian, mediating the authority of Orientalist categories according to the representation he sought to project in each circumstance. Rosalind O'Hanlon describes the complex, convoluted representations by colonized and colonizer as a mixture of voices not always in harmony:

> This struggle was the site of contested understandings, deliberate misrepresentation and manipulation, in which the seemingly omnipotent classifications of the Orientalist were vulnerable to purposeful misconstruction and appropriation to uses which he never intended, precisely because they had incorporated into them the readings of the political concerns of his native informants. It is this sense of mutuality – not as common contribution, but as struggle and contestation – which is missing from much contemporary discussion of discourse, with its assumption that new fields of knowledge had only to be enunciated, for them to elicit mute obedience from those whom they purported to know.[175]

Photos of Sayaji Rao in his biographies represent him as multiple individuals in various English and Indian styles of dress (official; decorative; modern; civil and military; British suit; Indian princely uniform; see Figures 2.1–2.4).[176] Sayaji Rao's views were mirrored and reinforced by biographers as much in his service as was his European entourage. Sayaji Rao further participated in a discourse of the landed aristocracy who identified with the English and also in that of the intellectuals educated into English culture.[177] What they shared of their respective discourses was a move from social to political reforms, signified by the priority of independence. The shifting position is exemplified in his tolerance and employment of anti-British faculty at Baroda University, though he abandoned this when the British threatened his power (as did other princes).[178] His determination to seek independence was provoked by British subordination of Indian to British interests which 'increasingly forced the colonial government to siphon off

Indian resources and prevented the implementation of policies favourable to Indian interests',[179] thus failing to reward their own Indian informants, as reflected in Sayaji Rao's complaint that imposed limits hindered those very reforms encouraged by the British.

The 'maharajas' of his biographies and published writings represent the discursive 'simultaneity and struggle'[180] of informant speech shaped by a Maharaja who moved readily and pragmatically from subordination to resistance to alliance both to Indian and to British spheres of influence. Such ambiguities, shifts and manoeuvres are a manifestation of the historical exigencies that 'any political decision could be reached only by a cautious and continuous mediation through a maze of divergent and often conflicting interests ... any important politician was the representative of an extremely wide and heterogeneous network of interests ... his role was not only to represent these interests, but to mediate them'.[181] Co-optation marked native informant discursivity within colonial discourse. Sayaji Rao's biographers mirror and construct Sayaji Rao's multiple, not binary, positions under varying circumstances, as well as their readers' ideologies, racial stereotypes and national identities. Other colonial rulers also wrote for British periodicals, published their speeches and addresses and were biographical subjects, and this literature merits further examination to understand more fully the complex nature of British colonial discourse, which became increasingly non-British after 1900.

Notes

1. I wish to thank my colleagues who helped me on this paper: Mr Ranjitsingh Sayajirao, great-grandson of Maharaja Sayaji Rao III; my colleague Professor Mookesh Patel, School of Art, Arizona State University; two colleagues at the National Institute of Design in Ahmedabad, India, Professors Tridip Suhrud and Krishna Patel; Romita Ray at Yale University; and Dr Timothy Wilcox.

2. Gayatri Chakravorty Spivak, *The Post-Colonial Critic: Interviews, Strategies, Dialogues*, ed. Sarah Harasym (London and New York: Routledge, 1990): 66.

3. Mrinalini Sinha, *Colonial Masculinity* (Manchester: Manchester UP, 1995): 1.

4. Ibid., 4–6.

5. Baroda is now called Vadodara; I will use Baroda, its older name, for this paper, since all my documents and histories are pre-Independence. Baroda is in modern Gujarat. The family name is now spelled Gaekwad, rather than the older form Gaekwar.

6. Biographies of maharajas and other colonials were common.

7. Publication of speeches and addresses was a regular British practice, e.g., in the cases of Balfour, Stanley Baldwin, Kipling, Edward VII, Gladstone, and became common throughout the colonies. Other prominent nationalists whose speeches were published include Jawaharlal Nehru, Madhav Rao Sindia of Gwalior, Bharat Ram, Zulfikar Ali Bhutto, Nelson Mandela, V.V. Giri, Subhas Chandra Bose, Nirmal Chandra Chatterjee, Prafulla Nath Tagore.

8. Bernard S. Cohn, 'The Command of Language and the Language of Command', *Subaltern Studies* IV (Delhi: OUP, 1985): 283.

9. Vishvanath Pandurang Dandekar, *Sayajirava Gayakavada* (in Marathi; New Delhi: n.p., 1962); Vidya K. Chavda, *Sayaji Rao Gaekwad III* (New Delhi: Thomson Press, 1972); Fatesinghrao

Gaekwad, Maharaja of Baroda, *Sayajirao of Baroda: The Prince and the Man* (Bombay: Popular Prakashan, 1989).

10. H.R. Aiyer, *His Highness Sayaji Rao III, Maharaja Gaekwar of Baroda (The Story of his Life)* (Book VIII: Men of Today Series; Baroda: C.S. Raja and Co. [193?]); Stanley Rice, *Life of Sayaji Rao III, Maharaja of Baroda* 2 vols; (London: Humphrey Milford, 1931); Philip W. Sergeant, *The Ruler of Baroda: An Account of the Life and Work of the Maharaja Gaekwar* (London: John Murray, 1928); Rev. Edward St Clair Weeden, *A Year with the Gaekwar of Baroda* (London: Hutchinson and Co., 1912; Alban Widgery, *Goods and Bads: Outlines of the Philosophy of Life of Sayaji Rao* (Baroda: n.p., 1920).

11. Sergeant, *The Ruler of Baroda*: 31; F.A.H. Elliott, *The Rulers of Baroda* (Delhi: Baroda State Press, 1934): 256–8.

12. Krishna Kumar, *Political Agenda of Education. A Study of Colonialist and Nationalist Ideas* (New Delhi: Sage Publications, 1991): 13.

13. Ibid., 14.

14. Ibid., 15.

15. David Hardiman, 'Baroda: The Structure of a Progressive State', in Robin Jeffrey, ed., *People, Princes and Paramount Power* (Delhi: OUP, 1978): 114–17.

16. Ibid., 124–6.

17. F.A.H. Elliott, *The Rulers of Baroda*: 241–58.

18. Vidya K. Chavda, *Gaekwads and the British: A Study of their Problems (1875–1920)* (Delhi: University Publishers, 1921).

19. Michael Fisher, *Indirect Rule in India* (Delhi: OUP, 1991): 209, 223.

20. Chavda, *Gaekwads and the British*: 25.

21. Ibid., 5.

22. Ibid., 15–16; see also Gyan Prakash, 'Writing Post-Orientalist Histories of the Third World: Perspectives from Indian Historiography', *Comparative Studies in Society and History* 32/9 (1990): 388–91.

23. Chavda, *Gaekwads and the British*: 37–42.

24. Ibid., 36; see also Fisher, *Indirect Rule in India*: 305, 444.

25. Chavda, *Gaekwads and the British*: 146.

26. Ibid., 147–50.

27. Ibid., 153.

28. Ibid., 155.

29. Ibid., 176.

30. Ibid., 175.

31. Sergeant, *The Ruler of Baroda*: 51–81, 92, 115.

32. Nicholas B. Dirks, 'From Little King to Landlord: Colonial Discourse and Colonial Rule', in Dirks, ed., *Colonialism and Culture* (Ann Arbor: University of Michigan Press, 1992): 177; Cohn, *Colonialism and its Forms of Knowledge: The British in India* (Princeton: Princeton UP, 1996): 57–75.

33. Cohn, *Colonialism*: 5–12.

34. Michelguglielmo Torri, ' "Westernized Middle Class", Intellectuals and Society in Late Colonial India', *Economic and Political Weekly* 25/4 (1990): PE-3.

35. Chavda, *Sayaji Rao Gaekwad III*: 109.

36. Sergeant, *The Ruler of Baroda*: v-vi.

37. Ibid., 6.

38. Ibid., 16.

39. Ibid., 38.

40. Ibid., 84.

41. Ibid., 40–43.

42. Ibid., 47.

43. Ibid., 52.

44. Ibid., 66–7.

45. Ibid., 188.

46. Ibid., 197–8, 233.

47. Ibid., 60.

48. Ibid., 58.

49. Ibid., 64.

50. Ibid., 196.

51. Ibid., 78, 80.

52. Ibid., 177.

53. Ibid., 179.

54. Ibid., 84–5.

55. Cohn, *Colonialism*: 119–21.

56. Sergeant, *The Ruler of Baroda*: 110–11.

57. Ibid., 111.

58. Ibid., 113. One of the most mysterious statements by Sergeant in the context of the death in early manhood of the Maharaja's first three sons and Sayaji Rao's adherence to Western cures and ideas about health is that 'there is also an insidious element in the teaching of the West which it requires an exceptionally strong character to resist' (164). This hints that seeking cures in the West is seductive but not always successful or even rational, a kind of Orientalizing and exoticizing of Western medicine. Suffering from gout, Sayaji Rao sought cures, but upon his return to Baroda, his health always collapsed (165). He even took a house in Paris which became his office away from home (167). His lengthy stays in England included a busy social life and many invitations to speak in public, in which speeches he always restated his loyalty, insisting that he was 'a colleague of the Empire' (168), not its servant.

59. Ibid., 94–5.

60. Ibid., 114.

61. Ibid., 128.

62. Ibid., 130–38; Cohn, *Colonialism*: 127–9.

63. Sergeant, *The Ruler of Baroda*: 212.

64. Ibid., 213.

65. Ibid., 220–21.

66. Ranjit Guha, 'Dominance without Hegemony and its Historiography', *Subaltern Studies* VI (Delhi: OUP, 1987).

67. Sergeant, *The Ruler of Baroda*: 215.

68. Guha, 'Dominance without Hegemony': 252–3.

69. Partha Chatterjee, 'Gandhi and the Critique of Civil Society', *Subaltern Studies* 3 (Delhi: OUP, 1984): 153–7.

70. Ibid., 158–61.

71. Ibid., 176.

72. Sergeant, *The Ruler of Baroda*: 194.

73. Ibid., 195–6.

74. Ibid., 257.

75. Torri, ' "Westernized Middle Class" ', PE-2.

76. Sergeant, *The Ruler of Baroda*: 271.

77. Ibid., 272.

78. Gaekwad, Sayaji Rao, 'My Ways and Days in Europe and in India', *The Nineteenth Century and After* 49 (1901): 215–25; Sergeant, *The Ruler of Baroda*: 88.

79. Sergeant, *The Ruler of Baroda*: 215–18.

80. Ibid., 220–21.

81. Ibid., 224.

82. Gaekwad, Sayaji Rao, *Speeches and Addresses of Sayaji Rao, the Third Gaekwar of Baroda, 1877–1938*, 4 vols. (Cambridge: Cambridge UP, 1927–38): I 88–90. The editor of the first two volumes of Sayaji Rao's speeches, Alban Widgery, a British philosophy professor at Baroda University, also wrote drafts of many of those speeches which the Maharaja worked into final form, see Widgery, 'An Appreciation', in J.M. Mehta, *Maharaja Sayajirao III*: 3. One of the most esoteric tributes to Sayaji Rao is Widgery's *Goods and Bads: Outlines of a Philosophy of Life, being the substance of A Series of talks and Discussions with H.H. the Maharaja Gaekwar of Baroda*, published in Baroda in 1919. This is a philosophical survey of topics of physical, intellectual, aesthetic, moral and religious values concluding with a definition of 'the good life'.

83. Gaekwad, *Sayajirao of Baroda*: 304, 357.

84. Chavda, *Sayaji Rao Gaekwad III*: 57.

85. Rice, *Life of Sayaji Rao III*: I 1–2.

86. Ibid., I 2, 13.

87. Ibid., I 42, 50.

88. Ibid., I 76–93, 94–111, 109, 145–54.

89. Ibid., I 119.

90. Ibid., I 46, 162, 161.

91. Ibid., I 163, 165.

92. Ibid., I 72.

93. Ibid., I 74.

94. Ibid., I 110.

95. Ibid., II 27–9.

96. Ibid., II 1, 5, 7.

97. Ibid., II 184, 281.

98. Ibid., II 36–40; Sergeant, *The Ruler of Baroda*: 68–71; Weeden, *A Year with the Gaekwar of Baroda*.

99. Weeden, *A Year with the Gaekwar of Baroda*: 32, 100, 117, 310–11.

100. Ibid., 250.

101. Ibid., 89.

102. English servants employed by maharajas were not unusual; Valentine Prinsep mentions working-class European servants in *Imperial India* (London: Chapman and Hall, 1879): 95. Other features of Sayaji Rao's life such as being English-educated, selected by the British and adopted by the reigning Queen were also common (see Prinsep, 183–4, 301, for similar biographical patterns among other rajas).

103. Spivak, *The Post-Colonial Critic*: 52.

104. Weeden, *A Year with the Gaekwar of Baroda*: 52–3.

105. Ibid., 85.

106. Ibid., 7, 163, 113.

107. Homi Bhabha, ' "Race", Time and the Revision of Modernity', *The Oxford Literature Review* 13 (1991): 202.

108. Ibid., 200.

109. Spivak, *The Post-Colonial Critic*: 66.

110. Bhabha, ' "Race", Time and the Revision of Modernity': 204.

111. Bhabha, ed., *Nation and Narration* (London and New York: Routledge, 1990): 4.

112. Chavda, *Sayaji Rao Gaekwad III*: v.

113. Ibid., 54.

114. Ibid., 103ff.

115. Ibid., 109.

116. Cohn, 'The Command of Language': 316.

117. Gaekwad, *Sayajirao of Baroda*: ix.

118. Ibid., viii.

119. Ibid., 342, 361, 256.

120. Ibid., x, 239.

121. Ibid., 21, 35–7, 39.

122. Ibid., 49.

123. Ibid., 101.

124. Ibid., 98.

125. Ibid., 64.

126. Ibid., 191, 198, 199.

127. Ibid., 197, 110.

128. Ibid., 160.

129. Ibid., 105, 216.

130. Ibid., 107.

131. Ibid., 116.

132. Ibid., 215, 220.

133. Barbara N. Ramusack, 'The Civil Disobedience Movement and the Round Table Conferences: The Princes' Response', in B.R. Nanda, ed., *Essays in Modern Indian History* (Delhi: OUP, 1980): 112.

134. Ibid., 119.

135. Ibid., 126–38.

136. Gaekwad, *Sayajirao of Baroda*: 272–6.

137. Ibid., 285ff.

138. Ibid., 252.

139. Ibid., 165ff.

140. Ibid., 150, 187.

141. Ibid., 219.

142. J.M. Mehta, ed., *Maharaja Sayajirao III Centenary Commemoration Volume* (Baroda: Maharaja Sayajirao UP, 1964).

143. V.T. Krishnamachari, 'Introduction', and Manilal B. Nanavati, 'Maharaja As I Knew Him', in Mehta, *Maharaja Sayajirao III*.

144. Sardar K.M. Pannikar, 'Maharaja Sayajirao – A Pathfinder of Modern India', in Mehta, *Maharaja Sayajirao III*: 59–60.

145. Shri K.M. Munshi, 'Sayajirao Gaekwad: Memories', in Mehta, *Maharaja Sayajirao III*: 67–8.

146. Nanavati, 'Maharaja As I Knew Him': 30.

147. Munshi, 'Sayajirao Gaekwad: Memories': 69.

148. Bhabha, 'Of Mimicry and Men', *October* 28 (1984): 125–33.

149. Benedict Anderson, *Imagined Communities* (London: Verso, 1983): 92–3.

150. Bhabha, 'Of Mimicry and Men': 129, 131.

151. Bhabha, *Nation and Narration*: 10.

152. Cohn, 'The Command of Language': 329.

153. Bhabha, 'Sly Civility', *October* 34 (1985): 71–3.

154. Ibid., 77–8.

155. Ibid., 73.

156. Robert Young, *White Mythologies: Writing History and the West* (London: Routledge, 1990): 148–9.

157. Ibid., 148.

158. Rosalind O'Hanlon, 'Recovering the Subject: Subaltern Studies and Histories of Resistance in Colonial South Asia', *Modern Asian Studies* 22 (1988): 190.

159. Sergeant, *The Ruler of Baroda*: 108.

160. Spivak, *The Post-Colonial Critic*: 97–8.

161. Ibid., 77.

162. Ibid., 72.

163. Ibid., 52–3.

164. Sayaji Rao, *Speeches*: I 173.

165. Ibid., I 170–71.

166. Ibid., I 223.

167. Ibid., I 171.

168. Ibid. I 174.

169. Ibid., II 271.

170. Gaekwad, *Sayajirao of Baroda*: 325.

171. Sayaji Rao, *Speeches*: II 350.

172. Ibid., I 179.

173. Sergeant, *The Ruler of Baroda*: 92–3.

174. Sayaji Rao, *Speeches*: I 217.

175. O'Hanlon, 'Recovering the Subject': 217.

176. Sergeant, Rice and Weeden include photographs of Sayaji Rao dressed in both British and Indian clothes and at various stages of his life. His palace, elephants, university complex, gold and silver cannons, carriages, car, construction projects and family are also represented in the photos to offer both intimacy and exotic attractions to the largely British readers of these biographies.

177. Torri, ' "Westernized Middle Class" ': PE–6–7.

178. Ramusack, 'The Civil Disobedience Movement': 117.

179. Torri, ' "Westernized Middle Class" ': PE-8.

180. O'Hanlon, 'Recovering the Subject': 217.

181. Torri, ' "Westernized Middle Class" ': PE-9.

2.1 Solomon J. Solomon, *His Highness The Maharaja Sayaji Rao III Gaekwar of Baroda, GCSI*

2.2 His Highness Maharaja Sayaji Rao III Gaekwar of Baroda

2.3 The Maharaja Sayaji Rao III in middle age

2.4 The Maharaja Sayaji Rao III in 1925

About face: Sir David Wilkie's portrait of Mehemet Ali, Pasha of Egypt

Emily M. Weeks

In 1841, the Scottish artist Sir David Wilkie painted his last picture, a portrait of Mehemet Ali, then the Pasha of Egypt (Figure 3.1). Given current academic trends, it is tempting to use Edward Said's concept of 'Orientalism' in order to interpret this Orientalist painting.[1] The act of Wilkie painting the Pasha would then be damned as an act of imperially motivated taxidermy, rather than considered a harmless artistic encounter. Wilkie would be identified as a representative of Britain's colonial project, a scheming and aggressive agent of Empire determined to 'capture' the Pasha's likeness for Western political and visual consumption.[2] Mehemet Ali would, in turn, become merely a location for colonial concerns, a repository, a manifestation of Western anxieties, fears and fantasies. His passive, mute body would be valuable only for the reflection it offered of the political desires of nineteenth-century England.[3] Regarded as no more than an excuse for Wilkie's self-portraiture, and seen as a helpless victim of the artist's brush, Mehemet Ali would require no further biography. The Pasha could then be quickly and conveniently dismissed by the modern scholar, explained away by Said's Orientalist discourse.

The limitations of this reading, however, should be clear. The West, omnipotent and ever-present, inevitably becomes the real focus of scholarly interest and attention. It is Wilkie – and the British Empire he represents – who become central to the art-historical analysis. But what of the Eastern sitter, and the Eastern world *he* represents? Can we really be satisfied with the cursory glances they have been paid and this lopsided 'interpretation' of Wilkie's important picture?

While it would be incorrect to assert that all such 'Said-ian' readings of Orientalist works of art (literature and photographs included) are without *any* truth, it would also be incorrect to read in all Orientalist paintings *only* Said's Orientalist discourse. By automatically equating the two terms,

'Orientalist painting' with 'Orientalism', without first bothering to consider the individual artists and subjects involved, and the particular circumstances surrounding each work's creation, non-Western subject matter is always unfairly treated. It is denied any complexity, any depth, any value that does not rely on a Western presence. 'Mehemet Ali', to use the example at hand, is made an object in Sir David Wilkie's Eastern still-life; his own actions, passions, desires, and personality are considered inconsequential to the art-historical narrative and are thus ignored.

Fortunately, scholars in a variety of disciplines are now thinking more critically about the discourse of Orientalism and are seeking to find alternative lenses through which to view Orientalist works of art. Lisa Lowe has illuminated for us the heterogeneity of Orientalism and its changing definitions through time. She has argued, and I think rightly, for the historicity and protean nature of this phenomenon.[4] Sara Suleri has endeavoured to reveal the *complicities* involved in colonial encounters – those simultaneous feelings of attraction and revulsion and the real, though often unacknowledged, *desire* for 'contamination' on the part of the Western imperialist.[5] Finally, dissatisfaction with Said's discourse has led Homi Bhabha to refute the very terms 'West' and 'East', and other such simple binary oppositions, and to point out the danger of ourselves 'Occidentalizing' in the heat of Orientalist debates.[6]

But *specific* examples of how, why and where Said's Orientalism fails to work are still too few and far between. Nowhere is this truer than in the realm of visual arts, as has been implied.[7] Recently, however, John Mackenzie has taken an important step toward rectifying this situation. In his book *Orientalism: History, Theory and the Arts*, Mackenzie attempts 'an overview of a major debate and a reassessment of the manifestations and influence of the Orient in the pictorial and plastic arts, architecture, design, music and the theatre between the late eighteenth and twentieth centuries'.[8] Lamenting the 'loss of innocence' that occurred after the publication of Said's book, Mackenzie seeks a broader and more sympathetic definition of 'Orientalism'.[9] He demands another approach to the arts of empire, one that does not impose twentieth-century notions on nineteenth-century paintings, and involves 'a clearer periodisation, a closer relationship to event, mood, fashion, and changing intellectual context, an effort to comprehend authorial influence and audience reaction, and above all the multiple readings to which they can be subjected'.[10]

Because so ambitious, Mackenzie's *Orientalism* is necessarily broad in its arguments. It is a survey, rather than a careful consideration of specific works of art that do not fit Said's paradigm. But by laying the groundwork, Mackenzie's book now makes such an in-depth, case-by-case approach possible.

The critical analysis of a single painting, in this case Wilkie's portrait of Mehemet Ali, reveals that the equation of the terms 'Orientalist painting' and 'Orientalism' is a problematic one. It not only complicates a 'popular' Saidian reading of a work of Orientalist art, but demands a complete revision of it. This is not a painting about Wilkie and the West, but rather a biographical sketch of Mehemet Ali and a history-in-miniature of nineteenth-century Egypt. In its details lies a wealth of information about the past actions, present situation, and future political desires of the Pasha. It brings to light his clever courtship of England and his adamant opposition to Egypt's nominal overlord, the Ottoman Sultan, and thereby illustrates Mehemet Ali's desire for Egyptian independence and international recognition. Moreover, in the circumstances surrounding this portrait's creation, aspects of the Pasha's vigorous personality and strong character are brought to light. It is *he* who becomes central to the story, he who is the active agent, and Sir David Wilkie who becomes a marginal figure. In short, a reversal – or 'about face' – of the expected colonized/colonizer, East/West relationship occurs, and Said's framework suffers greatly for it.

The 1841 painting shown in Figure 3.1 was not Wilkie's only depiction of Mehemet Ali, nor was it his first. A small, unfinished watercolour sketch preceded it by a few days, and was to act as a study for the larger work (Figure 3.2).[11] In the watercolour, Mehemet Ali grips his sword. He is shown to the knees, his body enclosed in an oval frame, and he wears the red Turkish fez. The oil version retains some of these features, but is more striking for its departure from them. The oval frame is gone; the hand no longer grips the sword. Mehemet Ali is shown full-length. His dress is more carefully observed and recorded. It is now more easily identified as Egyptian. Why were these changes made? And, more significantly, who demanded them?

Wilkie's large portrait of the Pasha arrived in London shortly after the artist's death in 1841.[12] When it was hung in the 1842 Royal Academy exhibition, it attracted a great deal of attention, primarily because of its subject matter. Prince Puckler Muskau commented later that Mehemet Ali had been a subject of 'daily conversation' in England at this time.[13] Progressive Victorians admired this self-made man and the ambitious social and economic reforms he had single-handedly enacted in Egypt over the last few decades. As early as 1827, Josiah Condor had stated: 'That Mohammed Ali [sic] is an extraordinary man cannot be disputed . . . his restless activity and spirit of enterprise . . . justly entitle him to be considered as one of the most accomplished . . . and one of the greatest of Mohammedan princes, that have ever vaulted into a throne.'[14]

It was natural that the countenance, and not merely the politics, of the Pasha should be of great interest to the Victorian public as well. Visitors to

Egypt lucky enough to have an audience with the Pasha described his features in painstaking detail, down to the shapes of the bumps on his head.[15] Body type – or physiognomy – was thought to be a reliable indicator of personality, intelligence, and social status in Victorian England, and was therefore given much attention.[16] Portrait 'reading' was a popular pastime for men and women and, for those who could not go to Egypt, to now have the opportunity to read the features of Mehemet Ali for themselves must have been exciting indeed.

A critic writing on the 1842 exhibition in the *Athenaeum* had this to say:

There is force and despotism, not merely in his shrewd eyes and firm lips, but in the attitude and in the hands which grasp nervously, with scimitar-like fingers, the elbows of the chair . . . It was a fine bit of coquetry, more pardonable in the colourist than warranted by the nature of the subject, to introduce the glass full of innocent flowers so near the sword-point of the peremptory Lion of Alexandria.[17]

This negative interpretation of Wilkie's painting is curious, for it in no way recognizes the political message Mehemet Ali had intended to send, or the impression he had wished to make on the British public. When read from the Pasha's point of view, in fact, this portrait should speak of negotiation, compromise, and diplomatic goodwill toward England, not force and despotism.

The Pasha's commission for this portrait was largely the result of nineteenth-century travel woes. Wilkie had been travelling in the Holy Land with the art dealer William Woodburn and planned to leave Jerusalem in April, visit Beirut briefly, and then return home. However, reports of plague at the port in Jaffa resulted in an unexpected diversion to Egypt. Wilkie, not anxious to attempt the long overland route via Malta and Marseilles, decided to remain in Alexandria until the next steamer for London was due to depart.

Mr Green, the local agent for the P & O steamer company, soon informed the artist that the Egyptian Pasha Mehemet Ali had heard of his arrival and desired a meeting. On May 5, Woodburn and Wilkie went to the Pasha's summer palace and were presented to the Pasha, who was seated in the garden. Wilkie wrote, 'On being told I had painted the Sultan [of Turkey, Abd-ul-Mejid, at Constantinople] the previous year, he asked if I had it here; on telling him it was gone to England, said he was desirous of having a copy of it . . . His Highness then desired I would make a picture for him of himself . . .'.[18] Wilkie, with nothing else to do for the time being, and art materials at the ready, agreed.

On 14 May 1841, Wilkie wrote of the Pasha to his brother Thomas: 'His Highness is an interesting character, has a fine head and beard, and I think makes the best portrait I have met with in my travels. He took much interest in it, and appeared with his attendants pleased with it.'[19] The Pasha's

pleasure did not come without some hesitation, however. During the sittings, four in all, the Pasha voiced repeated concerns and complaints. He even went so far as to leap up, seize the brush from Wilkie's hand, and try to alter any feature he disliked.[20] Translators explained to Wilkie that Mehemet Ali thought he looked 'too young' in the picture, and that the 'marks in the brow and round the eyes ought to be made stronger'.[21] Wilkie had deemphasized the age lines in these areas, a practice he had undoubtedly grown accustomed to in his position as a society portraitist and as Painter-in-Ordinary to England's royal family.[22] Wilkie later recorded that, 'my answer [to the Pasha's dissatisfaction] was, that I wanted to paint his expression and features rather than little details, in order to give my flat picture life and movement'.[23] Mehemet Ali seemed satisfied with this explanation, though he still insisted on periodic checks of Wilkie's progress.

Also troublesome to the Pasha had been the initial position of his left hand. Wilkie had first painted the Pasha's hand upon the hilt of his sword, as is seen in the watercolour sketch (Figure 3.2). But Mehemet Ali complained. He reputedly declared that this 'menacing gesture' was inappropriate, because the British had 'deprived [him] of [his] sword' at the recent Battle of St Jean d'Acre.[24] Wilkie altered the composition as Mehemet Ali wished, repainting the hand in the more acceptable 'pacified' position seen in the subsequent oil version.

This last compositional change, though small, is important for two reasons. First, it reveals, as does the account of the creation of this portrait as a whole, something of the forceful and energetic character of Mehemet Ali. It demonstrates that the artist did not 'capture' the Pasha's likeness, nor 'stuff and mount' him, nor 'victimize' him, as Said's 'Orientalist' encounter would demand. Mehemet Ali would not allow this. The sitter was as involved in the compositional decision-making as the artist himself. The act of the Pasha's portrait being painted was therefore not a process wherein one dominant (Western) figure exercised and maintained influence and control, but rather one in which an entire process of negotiation, dissent, and compromise was acted out.

Second, this alteration of the hand provides a clue to Mehemet Ali's political ambitions and intentions in commissioning this portrait. Why was he so anxious to appear less 'menacing' to the British public? Why have his portrait painted at all after his recent defeat in the Battle of St Jean d'Acre? On a less profound but equally important level in terms of his political motivation, why is the Pasha wearing those clothes and why is he sitting in a large elbow chair?

To appreciate the significance of these questions, it is first necessary to recount some of the historical events that allowed Mehemet Ali to become

the Pasha of Egypt. When Wilkie painted this portrait in 1841, Mehemet Ali had been the virtual dictator of Egypt for over thirty years. Before his rule, Egypt had been a country nearly forgotten. It had been repeatedly occupied and overshadowed by other empires – first the Roman, then the Byzantine, Arab, and Ottoman. At the end of the eighteenth century, however, Egypt was brought to international attention by two great soldiers of fortune, the Corsican Napoleon Bonaparte and the Macedonian Mehemet Ali.[25]

Jean Léon Gérôme's 1863 portrait of Napoleon (Figure 3.3) makes a striking contrast with Wilkie's portrait of the Pasha. Both depict foreign conquerors of Egypt, but one epitomizes domination and conquest, the other, placid deliberation. One figure is set boldly in an Egyptian landscape, the other sits on a chair, placed in no obvious geographical location. Napoleon's eyes are averted, looking to other, unspecified lands that may soon be his. His profile, meant only to be stared at and admired, is worthy of a Roman coin. Mehemet Ali, on the other hand, looks at us, though indirectly. His lips are curled into a bemused half-smile. He does not challenge us, nor aggressively confront us. Rather, he coyly courts us. We are ignored by the one figure, and made the object of flirtatious interest – even desire – by the other. These differences are important, for they are the result not only of aesthetic decisions made on the part of the respective Western artists, but of political ones made on the part of their ambitious patrons as well.

Napoleon's invasion of Egypt in 1798 quickly attracted the attention of England. Egypt, strategically located along East–West trade routes, was now coveted for the access it offered to India. This French action also attracted the attention of Egypt's nominal overlord, the Ottoman Sultan. British and Ottoman Turkish forces united in 1802 to drive the French out.[26] They were aided by an Albanian contingent led by Mehemet Ali. Napoleon fled, the British and Turks returned home with their anxieties temporarily relieved, and Mehemet Ali remained in Egypt.[27]

Though nominally subject to the Ottoman Emperor, Mehemet Ali declared himself the independent sovereign of Egypt in 1806. Five years later he massacred the entire Mamluk guard, 500 strong, in the courtyard of his Citadel in Cairo. These soldiers, descendants of Circassian slaves, had taxed and administered the country for centuries in the name of the Ottoman Emperor. Now, their reign was ended in a single blow.[28] In 1831, exploiting his growing power, Mehemet Ali invaded Palestine and Syria with thoughts of an Egyptian Empire stirring in his mind.[29] This aggressive act again worried Ottoman and English powers. Thus, on 4 November 1840, England and Ottoman Turkey, with aid from Austria, joined forces against Mehemet Ali in Syria at the Battle of St Jean d'Acre, and soundly defeated him. After considerable negotiations, Mehemet Ali was granted hereditary rule of Egypt, but was deprived of all territories outside it.[30]

Ever the cunning diplomat, Mehemet Ali saw in his defeat a window of opportunity. Since he was in a less threatening position now, 'deprived of his sword' as it were, British favour might gradually be regained. The Pasha had long realized that temporary aid from Britain, both financial and administrative, could help Egypt modernize and become a world power. Egypt could then embark more effectively on the campaign for Empire he so desired. Anxious to show his admiration for Western ways, and with these political ends in mind, Mehemet Ali courted Europe, France, and England in particular, extending invitations to foreign diplomats, promoting tourism, and strengthening political ties. Western educational systems were implemented, a printing press established, Western trade encouraged, and Western industries introduced.[31] When Wilkie was to see him in 1841, he was warned that the Pasha was 'fond of receiving travellers, whom he overwhelmed with questions' about their respective countries.[32]

As with the execution of Wilkie's portrait, these political policies of Mehemet Ali represent an inversion of the traditional East/West power relationship demanded by Said's discourse of Orientalism. Egypt, in 1841, was not a helpless nation awaiting its inevitable colonization, but rather one working hard to resist it. The Pasha was down for now, perhaps, after his defeat in Syria, but he was by no means out of the political picture. In the Middle East, and, as Mehemet Ali hoped, soon in the world at large, Egypt was determined to become a powerful force – a colonizer – itself.

Due to the climate of increasing closeness between England and Egypt encouraged by Mehemet Ali in these years, news between the countries travelled fast. Word of Wilkie's portrait reached the London press by 19 May 1841 – that is, less than two weeks after the first of the sittings.[33] Before his departure from Alexandria, Wilkie had recorded the stipulations of the commission: he was to put the finishing touches on the oil painting in London, have it framed there, and then send it back to the Pasha. He was also granted permission to make a copy of it to remain in England.[34] Though Wilkie died on the voyage home, and these intentions were never realized, they are worth noting. They reveal that this portrait was created with a dual function in mind: it was meant to send a specific political message to an audience in England, as well as to one in Egypt.

Both in Egypt and in England, Wilkie's portrait of Mehemet Ali would have served important ideological functions. To better determine what these were, it is helpful to look at this picture in conjunction with Wilkie's portrait of the new Ottoman Sultan Abd-ul-Mejid, the very painting that had inspired the Pasha's commission (Figure 3.4). The two pictures actually hung side-by-side at the Royal Academy exhibition of 1842, making a comparison between them inevitable.

Abd-ul-Mejid is represented with sword in hand, perhaps a reference to his recent victory over Mehemet Ali at the Battle of Acre. He is in proper French military uniform and his beard is closely cropped, both features representative of the new Western dress codes enforced by the Ottoman sultans from 1829. These decrees forbade traditional Eastern dress, requiring boots instead of slippers, trousers instead of baggy pants, frock-coats instead of caftans. Long beards were forbidden and the fez was required head-wear.[35]

The clothes of Mehemet Ali now take on greater significance. He wears the fez, in obedience to the Ottoman decrees, but is otherwise in traditional – and forbidden – Egyptian dress. His beard is full, not cropped. He wears slippers, not boots. He wears baggy pants, not trousers. A separate identity is claimed and established through sartorial means. Wary Egyptians, perhaps still unsure of this foreign usurper and uncomfortable with the vigour of his reforms, might have found comfort in this peacefully posed figure, dressed in familiar clothing. His Egyptian dress, moreover, would have offered them a timely symbol of nationalism around which to rally. This was no 'Frenchi-fied' Abd-ul-Mejid, but a man who took pride in the indigenous traditions of his adopted country. By choosing to be painted in this way, Mehemet Ali could forcefully, deliberately, and yet unaggressively and without fright-ening potential political allies, express Egypt's solidarity and claim its independence. And he could do so in a language that would have been understood immediately, by any nation, in 1841.

The differences in poses between the two figures would have been noted by a physiognomically minded Victorian public as well. Abd-ul-Mejid looks to the side, as if distracted. He is perched tensely on the edge of an embroidered couch. Mehemet Ali sits on a piece of furniture also, but here is where the similarity ends. His frontal pose, a position connoting authority since antiquity, demands attention. He sits placidly, but not idly. He is attentive and watchful. Though he looks askance at the viewer, he never releases him from his line of vision. The viewer is forced to remain aware of the Pasha, and centralize him- or herself in front of this impressive presence. Unlike Abd-ul-Mejid, Mehemet Ali is not a diminutive figure lost upon a large field of patterned fabric. He dominates the picture. He is, in effect, enthroned.

The actual 'throne' depicted here was a gift from Moses Montefiore, and a favourite of the Pasha's.[36] Its inclusion in this portrait is important for two reasons. It not only elevates Mehemet Ali to a dignified status in Western eyes, as Wilkie assured him it would, but also serves as a powerful reminder of the Pasha's Western reforms.[37] Mehemet Ali could, through his enthroned pose and his clothing, satisfy two needs at once – he could be viewed as both

Egyptian and Western, as he needed to be in order to send the appropriate messages of political propaganda to his two separate audiences.

The repositioning of Mehemet Ali's hand away from the sword, the Egyptian dress, and the chair are, then, important clues to the portrait's political meaning. But there is one more element left to consider. The lack of background is significant as well: it thwarts any attempt to lock Mehemet Ali safely into the East. Though it was painted in a large Turkish room of his summer palace, replete with Islamic patterns and designs, no Eastern details are included at all.[38] The 'innocent' flowers on the right, the only intruders in the otherwise bare background, are not particularly exotic. They are not even placed in an 'Oriental' vase. No cultural barrier has been erected. West and East are allowed to overlap and merge into one, just as the Pasha would have wished.

This absence of cultural separation, during an age obsessed with racial and social barriers, is, I would argue, what doomed the success of Mehemet Ali's message in Victorian England. The critic in the *Athenaeum* (see above, p.49) felt acute discomfort when encountering this portrait not because Mehemet Ali's political message *failed* to be understood, but because it succeeded all too well. He recognized in the Pasha's coy gaze and half-smile, his confident attitude, his Western throne, and his ambiguous setting, Mehemet Ali's desire to engage and become a part of Europe – England more specifically. Furthermore, and most distressingly, the critic realized that Mehemet Ali intended to enter his Western world as the powerful ruler of an independent country, rather than as a bruised or backward, 'good colonial', subject. Mehemet Ali would not yield power to the artist while his portrait was being painted, just as he would not let others play political games without him. The critic was troubled not merely because Mehemet Ali seemed to *him* a threatening figure, but because he, in this portrait, presented a threat to the entire British Empire.

Thus we have read this image of Mehemet Ali not as another example of Said-ian 'Orientalism', but rather as a reversal, or 'about face', of it. The East/West, colonized/colonizer dichotomy Said introduced has been turned inside out and upside down, first in the artistic encounter between the artist and his subject, and then in the very politics of Mehemet Ali. The Pasha's strength of character, his clever diplomatic manoeuvring, and his astute use of Western means – from Western industries to portrait painting – to achieve his own ends, can no longer be ignored. The story behind this painting is clearly not one of a Western aggressor and his Eastern victim. Something much more interesting and complex was at work during its creation. This alternative interpretation should encourage scholars in a number of disciplines to look again, this time more carefully, at individual works of art and the particular circumstances of their creation. Only then will we realize that

'Orientalist paintings' do not necessarily smack of 'Orientalism', and that a single theory can never satisfactorily explain a wide variety of visual images.

Notes

1. 'Orientalist painting' is meant throughout this paper in its broadest, most politically neutral, and least controversial sense. It refers to pictures by European and American artists of the Middle East and Africa, especially those executed in the late-eighteenth to early-twentieth centuries. Since the publication of Edward Said's book *Orientalism* (New York: Vintage, 1978), such pictures have been the object of renewed interest among scholars, art historians in particular, for the messages of imperialism they are believed to contain. Due to the powerful influence of Said's argument, 'Orientalist painting' and 'Orientalism' have become nearly inseparable terms. For a reading of Orientalist paintings that takes Said to heart, see, for example, Linda Nochlin, 'The Imaginary Orient', in *The Politics of Vision* (New York: Harper and Row, 1989), 35–59.

2. Though I am loath to resort to the binary terms of 'West' and 'East', as they essentialize vastly different regions, ignore the interpenetration and influence of cultures on one another, and falsely simplify complex political/social/cultural realities, their widely recognized geographical meanings continue to make them useful in Orientalist debates. Until I discover alternative ways in which to designate these areas that will be as readily understood, I will use these terms with the hope that the reader understands that I mean neither to privilege the former term over the latter, nor unconsciously 'Occidentalize'/'Orientalize' myself.

3. It has now become a commonplace to refer to the East as a 'mirror' of the West. The opening lines of Thierry Hentsch's book *Imagining the Middle East* (Montreal: Black Rose Books, 1992) are a case in point: 'This book is not about the Orient. It is about us' (ix). In closing, Hentsch reiterates this view in equally plain terms: 'If this book has demonstrated anything, it is that for a long time the West took interest in the Other without realizing that its real interest was in itself; that it represented it in order to create its own identity, that it denigrated it in order to reassure (or frighten) itself, that it dreamt of it to escape itself' (205).

4. See Lisa Lowe, *Critical Terrains: French and British Orientalisms* (Ithaca: Cornell UP, 1992). Though I agree with Lowe that Orientalism (and imperialism itself) is not a monolithic construction, consistent throughout time, I differ with her in the explanation of why this is. Lowe argues that the 'profoundly heterogeneous' nature of Orientalism is due to the changing notions *of the French and British*, and is caused by political and social changes *in Europe* (ix [italics mine]). Though she also acknowledges the heterogeneity of the Orientalist object, 'whose contradictions and lack of fixity mark precisely the moments of instability in the discourse' (x), she does not credit it with the same formative and/or productive power as that of Europe. Lowe leaves the Orientalist object as only a marker, even if a less essentialized one. In contrast, I wish to argue for the *active* role of the Orientalist object in the development and change of Orientalism, and for its ability to influence the discourse through its own constant evolutions. That is, if there are indeed many different Orientalisms through time – and at the same time – this is due to the changing mentalities and agendas not only of *Western* countries, but of *Eastern* ones, as well.

5. See Sara Suleri, *The Rhetoric of English India* (Chicago: Chicago, UP, 1992).

6. See Homi Bhabha, ed., *The Location of Culture* (London and New York: Routledge, 1994).

7. I would like to point out two works on Orientalism in art and architecture that prove exceptions to the rule. In the opening essay of *The Orientalists: Delacroix to Matisse* (London: Royal Academy of Arts, 1984), Mary Anne Stevens writes: 'Some commentators have tried to view all Orientalist manifestations as an aspect of cultural imperialism. Yet, the evidence would suggest that this is too simplistic an interpretation of both Western visitors' intentions and their artistic work. The Western approach to the Orient was neither unchanging, without its own inconsistencies, nor closed to the influence of observation' (19). More recently, Mark Crinson has concerned himself with British architecture in the Middle East. While his book *Empire Building: Orientalism and Victorian Architecture* (London: Routledge, 1996) is narrow in scope, its approach provides useful alternatives to traditional 'Said-ian' readings, applicable to a variety of disciplines. Importantly, Crinson historicizes his analysis, recognizing that the impact an object has, how it is understood, and how effective it is, changes with time and place (10). Egypt, for example, is identified as a country where Britain exercised only 'informal imperialism', and thus, Crinson argues,

architecture here must be treated differently from that in true British colonies (2–3). Also important is Crinson's concern with the public, and his realization that objects (in this case, buildings) were not always oriented toward a Western crowd – which itself was complex and heterogeneous – but often contained messages meant for Western and Eastern audiences both (7–9). Finally, Crinson is careful to point out the local resistance that was often encountered during a building's construction, and the impact this dissent had on the final design (230). In doing so, he grants the East, as too few do, a more active and influential role in the imperial project, as manifested in the arts.

8. John Mackenzie, *Orientalism: History, Theory, and the Arts* (New York: St Martin's Press; Manchester: Manchester UP; 1995): xi.

9. Ibid. 'Orientalism [in the 80s]', Mackenzie writes, 'came to represent a construct, not a reality, an emblem of domination and a weapon of power. It lost its status as a sympathetic concept, a product of scholarly admiration for diverse and exotic cultures, and became the [literary] means of creating a stereotypical and mythical East . . .' (xii). Another complaint Mackenzie has regarding Said's discourse is the limiting roles it offers the East. Homi Bhabha has commented on this as well: 'There is always, in Said, the suggestion that colonial power and discourse is possessed entirely by the coloniser, which is a historical and theoretical simplification'. See Bhabha, 'The Other Question: the Sterotype and Colonialist Discourse', in *Literature, Politics, Theory,* ed. Francis Barker *et al.* (London: Methuen, 1986): 160.

10. Mackenzie, *Orientalism*: 39.

11. This sketch was used as the frontispiece of Wilkie's posthumous publication, *Sir David Wilkie's Sketches in Turkey, Syria and Egypt, 1840–41,* drawn on stone by Joseph Nash (London: Graves and Warmsley, 1843). The original watercolour is part of the Searight Collection, housed in London's Victoria and Albert Museum.

12. William J. Chiego, ed., *Sir David Wilkie of Scotland (1785–1841)* (Raleigh, NC: North Carolina Museum of Art, 1987): 270. Wilkie died in June aboard the ship 'Oriental', after travelling in the Holy Land. He was buried at sea, an event memorialized by J.M.W. Turner in the painting *Peace: Burial at Sea.*

13. Prince Puckler Muskau, *Egypt Under Mohammed Ali* (London: n.p., 1845): 102.

14. Josiah Condor, *The Modern Traveller*, vol. V (London: n.p., 1827): 162.

15. Chiego, *Sir David Wilkie*: 270. To take but one example from 1841: 'His stature is undersized [5'2"], and his figure . . . is now rather stooped, and corpulent . . . He has . . . [a] lofty forehead and aquiline nose, with the flexible brow so strongly indicative of quick changes of thought and passion.'

16. For more on the Victorian practice of portrait reading, see Marcia Pointon, *Hanging the Head: Portraiture and Social Formation in Eighteenth-Century England* (New Haven: Yale UP, 1993).

17. *Athenaeum* (7 May 1842): 411.

18. Chiego, *Sir David Wilkie*: 268. Mehemet Ali might not have been quite so keen on having this particular artist memorialize him on canvas had he heard contemporaries' opinions of Wilkie's ability as a face-painter. A state portrait he had painted of Queen Victoria was called 'so atrocious' that the Queen '[could] not send it as a present abroad' (57). Equally unflattering were the words of the 1st Earl of Ellesmere, who referred to Wilkie's venture into the field of portrait-painting as a 'national misfortune' (49). Of course, choice was not an issue for the Pasha – Wilkie was the only royal portraitist in Alexandria at the time.

19. Allan Cunningham, *The Life of Sir David Wilkie with His Journals, Tours and Critical Remarks on Works of Art and a Selection from His Correspondence*, vol. 3 (London: n.p., 1843): 493.

20. Sarah Searight, *The British in the Middle East* (London: Weidenfeld and Nicolson, 1969): 172.

21. Chiego, *Sir David Wilkie*: 268.

22. In 1823, Wilkie succeeded Sir Henry Raeburn as the King's Limner for Scotland, a position that entailed much portrait-painting. Similarly, when he succeeded Sir Thomas Lawrence to the title Painter-in-Ordinary to King George IV (a position he retained under William IV and Queen Victoria), it was portraiture that occupied most of his time. In total, Wilkie created 150 portraits of royal and aristocratic figures. For more on Wilkie as a portraitist, as well as contemporaries' opinions of his ability and the artist's own genuine dislike of the practice, see H.A.D. Miles's essay 'Wilkie as a Portraitist: Observations on "A National Misfortune" ', in Chiego, *Sir David Wilkie*: 49–58.

23. Cunningham, *The Life of Sir David Wilkie*: 468–9. Wilkie's intention to suggest the 'general effect' of the Pasha's countenance rather than its details is also typical of contemporary theories on portraiture. In his comments on painting (written in 1830 but never published), Wilkie wrote: 'In truth, a strictly accurate likeness is by no means necessary for recognition.' He seems to have taken to heart Joshua Reynolds's Fourteenth Discourse (1788) (in Joshua Reynolds, *Discourses on Art*, Robert R. Wark, ed., New Haven, CT: published for the Paul Mellon Center for British Arts, London, by Yale UP, 1975), like so many other painters working in England at the time, repeating almost verbatim Reynolds's recommendation that the 'idea' of the sitter should be painted, rather than the exact physical likeness. For a good discussion of Reynolds's theories of portraiture and their influence on the English portrait tradition, see David Piper, *The English Face* (London: National Portrait Gallery, 1978).

24. Wilkie, *Sketches*, plate I.

25. J.C.B. Richmond, *Egypt 1798–1952: Her Advance Towards a Modern Identity* (London: Methuen, 1977): 17. The French had no vested interest in Egypt itself at this time, but saw its value as a piece on the diplomatic chessboard. Egypt was correctly recognized as a vital shipping link between East and West. Holland, Denmark, Sweden, and other countries with trading interests in this area of the world would be grateful for any action that would resist England's maritime despotism. Such allies could later benefit France, as Napoleon sought to oust England from the East by force, eventually control world shipping between Europe and the Far East himself, and spread French civilization towards India and up the Nile into Africa.

26. The British desired to prevent Turkey's disintegration at the hands of Russia and other foreign powers, and thus were willing to help prop up its tottering Empire for the time being. The possibility of an Eastern 'power vacuum' might disrupt the political balance that had been carefully constructed there and that met with their approval. The favour with which recent Ottoman sultans regarded the British promised policies conducive to British goals. If Egypt could be kept within the Ottoman Empire, even if only nominally, access to India would be ensured. Moreover, the trials, tribulations, and expense of administering (another) overseas colony would be avoided.

27. Valentine Chirol, *The Occident and the Orient* (Chicago: University of Chicago Press, 1924): 71–2.

28. Richmond, *Egypt 1798–1952*: 40. Though ruling 'in the name of' the Ottomans, in reality the Mamluks answered to no one and enjoyed a virtual reign of terror in Egypt.

29. Today, the former province of Syria comprises Syria, Lebanon, and parts of Israel and Jordan.

30. For a good, detailed account of the events of this complicated affair, see Frederick Stanley Rodkey, 'The Turco-Egyptian Question in the Relations of England, France and Russia, 1832–1841', *University of Illinois Studies in the Social Sciences* 11 3–4 (1923): *passim*. For a more recent overview, see M.S. Anderson, *The Eastern Question 1774–1923: A Study in International Relations* (London: Macmillan, 1974): 77–109.

31. Richmond, *Egypt 1798–1952*: 65. Amazingly, given Egypt's later situation and its present state, Mehemet Ali initiated these reforms without the incurrence of any substantial foreign debt.

32. Chiego, *Sir David Wilkie*: 270.

33. Ibid., 270.

34. Ibid., 268. A London newspaper reported in September that the portrait was sent back to the Pasha, with a price-tag of 200 guineas, and was soon returned. However, Chiego writes, and I agree, that this 'seems unlikely' (270).

35. Enid M. Slatter, 'The Princess, the Sultan and the Pasha', *Art and Artists* (Nov 1987): 16.

36. See Frederick William Robert Stewart, Lord Castlereagh, Marquess of Londonderry, *A Journey to Damascus, through Egypt, Nubia, Arabia Petraea, Palestine and Syria* (London: Henry Colburn, 1947): I, 223–4. Sir Moses Montefiore (1784–1885), a British citizen of Italian origin, was a philanthropist and champion of the Jewish cause at home and abroad. His first visit to Egypt, and audience with Mehemet Ali, was in 1827. His goal of establishing Jewish colonies in Syria led him to return to the Middle East in 1839, and to request another meeting with the Pasha. A third audience was held in September 1840, when Montefiore pleaded on behalf of Jewish prisoners held in Damascus. For a brief biography of Montefiore, see the *Dictionary of National Biography*, vol. xiii (1909): 725–7. For accounts of Montefiore's travels in and around Egypt, see Lady Judith Cohen Montefiore's *A Private Journal of a visit to Egypt and Palestine by way of Italy and the Mediterranean* (1836), 8 vols. (Jerusalem: Yad Izhak Ben Zvi, 1975), and *The Diaries of Sir Moses*

and Lady Montefiore (1890), Lewis Loeuve, ed., London: Jewish Historical Society of England: Jewish Museum (1983).

37. Chiego notes that Mehemet Ali first wished to be seated upon a divan, but Wilkie objected to this, explaining that though this was 'most picturesque', he thought to European eyes this 'wanted dignity' (268). Wilkie also wrote that he was first asked to paint the Pasha's portrait in the *chiouch* [kiosk] of the summer garden, but the light was objectionable (268). Both of these features (the kiosk and the divan) would have given the portrait a decidedly more 'Eastern' look, and would also seem to indicate that the portrait's compositional arrangement was not entirely dictated by Mehemet Ali. However, I think there is sufficient evidence to support my claim that Mehemet Ali was indeed an active participant in the painting's overall creation. What is more confusing is that it was *Wilkie* who argued in favour of the chair. He had, if Kenneth Paul Bendiner's argument is correct, pro-Turkish sentiments, and would therefore have felt no obligation to present the Pasha to the British public in a positive light. Why knowingly honour Mehemet Ali in this way, and deliberately aid him in his attempt to 'put his best face forward' in England? It would seem that just as Mehemet Ali's status as a 'colonized' object is problematic, so too is Wilkie's status as a Western colonizer.

38. Chiego, *Sir David Wilkie*: 268. Because Wilkie signed and dated this portrait, the argument that the portrait simply wasn't 'finished' at the time of the artist's death, and that a detailed background was intended by him, is not a convincing one. Furthermore, when it was exhibited in 1842, a commentator remarked that, unlike the portrait of Abd-ul-Mejid, this portrait had been 'completed by Wilkie' (270).

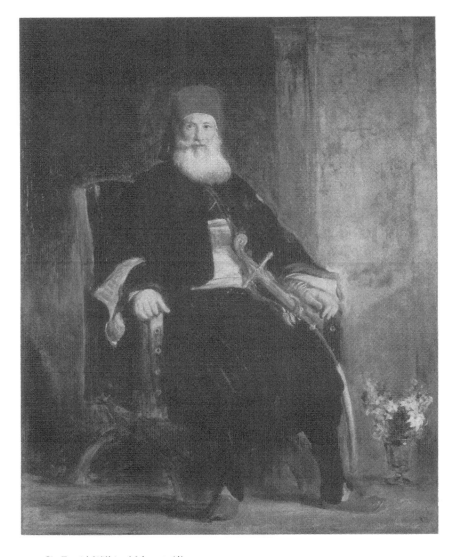

3.1 Sir David Wilkie, *Mehemet Ali*

3.2 Sir David Wilkie, *Mehemet Ali*

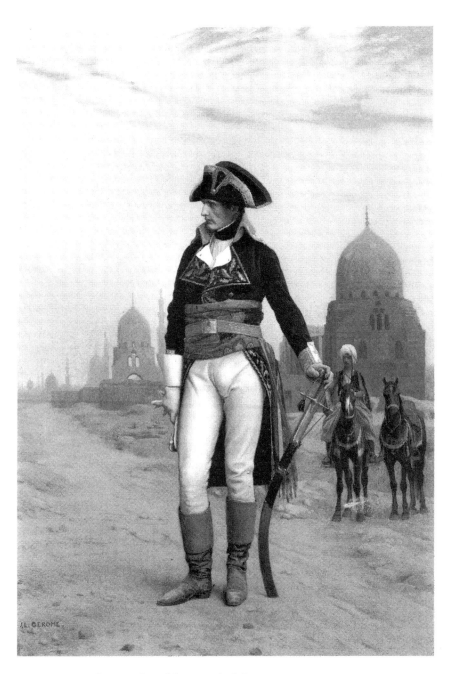

3.3 Jean Léon Gérôme, *General Bonaparte in Cairo*

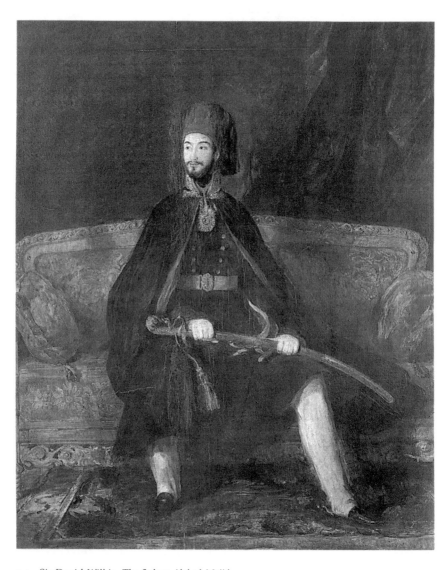

3.4 Sir David Wilkie, *The Sultan Abd-ul Mejid*

Cross-cultural cross-dressing:
class, gender and modernist sexual identity

Dianne Sachko Macleod

> Vain trifles as they seem, clothes have, they say, more important offices
> than merely to keep us warm. They change our view of the world and
> the world's view of us.[1]

A good deal has been written about the emergence of the New Woman in
Great Britain's late Victorian years. Less attention has been paid, however, to
the liberating effect of imperialism on the redefinition of female identity.
Such a relationship might seem paradoxical considering the masculine
flavour and patriarchal structure of the imperialist enterprise and the
subjectivity of colonized people. Such a relationship between British women
and their colonial counterparts might even seem absurd – after all, what
could women who were passive and sheltered possibly contribute to
dynamic and sophisticated Western females? Yet, instead of perceiving
Middle Eastern[2] women as prisoners of the seraglio, many British women
travellers envied their right to refuse conjugal sex, to own property, to enter
into contracts and to divorce their spouses. The writings of these inveterate
voyagers were often couched in the language of contemporary arguments
over the plight of married women in Britain, and conveniently ignored their
imperial 'other's' lack of educational, religious, and social freedom. None-
theless, in picturing the harem as a place of female autonomy, women
travellers in the Ottoman Empire provided an alternative discourse to the
male representation of the harem as a site of sexual submission. From a
postcolonial perspective, the Ottoman Empire itself can be construed as a
willing female partner – fertile, available, and mute – for its patriarchal
British consort. Ottoman intellectual Ahmet Mithad complained, in 1889, of
the dolorous European history of relations with his homeland, particularly
the misrepresentation of the women of his country. He ridiculed the typical
Western account of the Turkish woman:

[a] lovable person lies negligently on a sofa. One of her slippers, embroidered with pearls, is on the floor, while the other is on the tip of her toes. Since her garments are intended to ornament rather than to conceal, her legs dangling from the sofa are half-naked and her belly and breasts are covered by fabrics as thin and transparent as a dream ... This is the Eastern woman that Europe depicted until now ... It is assumed that this body is not the mistress of her house, the wife of her husband, and the mother of her children, but only a servant to the pleasures of the man who owns the house. What a misconception![3]

Women travellers, on the other hand, refuted the stereotypical image of the Turkish woman as odalisque, love object and slave. Julia Pardoe, after visiting Istanbul, complained of the inaccuracy of male descriptions of the daily life of Turkish women, in *The City of the Sultan and the Domestic Manners of the Turks in 1836*: 'There is no intimate knowledge of domestic life, and hence the cause of the tissue of fables which, like those of Sheherezad have created *genii* and enchanters *ab ovo usque ad male* in every account of the East.'[4] Eager to set the record straight, Pardoe and other women who ventured Eastward wrote authentically detailed accounts which contradicted male fantasies of harem life written by such travellers as James Silk Buckingham and Edward William Lane.

Many women travellers adopted the Turkish female style of dress while they were abroad and continued to wear it on their return to England as a gesture of independence. Whereas slim trousers and draped 'harem' pants were acceptable items of both male and female attire in Turkey, when imported Westward they threatened carefully coded gender distinctions. Trousers, after all, symbolized male freedom of movement, independence and lack of restraint, in contrast to female dress which was weighty, uncomfortable and impeded action. It was precisely because they wished to claim some of these advantages for themselves that female reformers adopted bifurcated garments. In discovering an appropriately 'feminized' male costume in the far reaches of the Ottoman Empire, British women inverted the Western male sexual stereotype of the Turkish harem woman when they appropriated what was perceived as men's clothing by the Western mind. Thus, when progressive aristocrats such as Lady Mary Wortley Montagu, Lady Archibald Campbell (Janey Campbell) and Lady Ottoline Morrell appeared in long pants in society, their act was more than a matter of raiding exotic closets to make a fashion statement: cross-cultural cross-dressing allowed them to stretch the boundaries of their gender and to distance themselves from the constricting norms of Victorian and Edwardian sexual stereotypes. While the correlation between dress reform and the public battle for women's rights is well documented,[5] fewer scholars have delved into the relationship between fashion, especially non-Western clothing styles, and the redefinition of gender.

Turkish trousers were a symbol of liberation to American women as well. Amelia Bloomer featured them under a short dresslike tunic in her celebrated alternative outfit to constricting corsets and crinolines.[6] Physician Mary Edwards Walker, two decades later, in 1871, also promoted the practicality of long pants for women. Walker argued that:

In Turkey, the fact is recognized, that the women's limbs are flesh and blood, as well as the men's, and are therefore susceptible to the influences of the weather and need to be well protected; and hence the custom of the sexes dressing nearly alike. Those who would find fault with the men of that country, for *allowing* the women to dress like them (instead of wearing our most fashionable clothes, or rather those of Paris), would immediately be credited with weak or bad motives.[7]

These early feminists should not be viewed as mere dress reformers. Clothing, to them, was an obstacle that had to be overcome before they could assume an active role in public life, contrary to the claims made by scholars such as David Kunzle who, in *Fashion and Fetishism*, maintains that 'it is significant that no important feminist . . . regarded the dress reform question as paramount'.[8] It is true that Amelia Bloomer and her suffragist comrade Elizabeth Cady Stanton eventually gave up wearing trousers in public; however, Mary Edwards Walker's style of dress became increasingly masculine until she reached a point in the 1890s when she regularly appeared in a gentleman's full evening dress to promote the notion that a woman's status was on a par with a man's.[9]

The association between 'mannish' dress and female emancipation was locked into the minds of conservative Parliamentarians such as Mr Smollett, who vehemently protested the second reading of the Married Women's Property Bill in 1875. He pontificated:

the agitation was brought into Great Britain by an importation of turbulent women from America where it had been going on without any good result for something like half a century. Those ladies came over to champion 'Woman's Rights', and proclaim the equality of the sexes; and to show they had a right to do so they assumed, or rather usurped, male attire – they clad themselves in breeches. They were called 'Bloomers' . . . But although this distinctive dress was discontinued, the type of the strong-minded woman still survived.[10]

Firmly believing that husbands should continue to control their wives' property, including their inheritances, and should prevent them from entering into contracts on their own, Smollett succeeded in mustering support in Parliament by raising the frightening spectre of women in trousers demanding 'equality of the sexes'. Thus the passage of the Married Women's Property Act was delayed until 1882.[11]

While the Bloomer costume faded away, the liberating significance of Turkish trousers did not vanish for women who wished to expand the

narrow social definition of female gender identity. Transgressive clothing continued to be worn in élite circles by aristocratic women who were undaunted by the backlash of public opinion. Their audacity was applauded by a number of like-minded men who were also intent on realigning the markers of their gender. James McNeill Whistler and Oscar Wilde, for instance, sought recourse in cultural 'otherness' to free themselves from stifling mainstream stereotypes of masculinity. Traditional dress also signified repression to these male modernists who were searching for new modes of expression to convey their desire for social and artistic freedom.

Many males in the second half of the nineteenth century rebelled against the controlling Victorian ideal of manhood. Scholars in the emerging field of masculinities are revealing that stringent social expectations of behaviour produced anxieties in men as well as women.[12] Joseph Kestner, for instance, in *Masculinities in Victorian Painting*, maintains that ' "masculinity" refers to the constructed ideologies defining male subjectivity, including those establishing male dominance, masculine hegemony and patriarchy'.[13] The Victorian concept of the ideal male was especially pervasive, from the 'muscular' Christianity of Dr Thomas Arnold, which invaded the private spiritual realm, to the much-publicized notions of the British soldier and gentleman, which permeated the far-flung corners of the Empire. While it is well established that both masculinity and femininity are socially constructed and interactive categories, less well-documented is the disillusionment with the Victorian cult of progress which was apparent as early as the 1860s among businessmen such as Whistler's patron Frederick Richards Leyland who retreated into his private temple of aestheticism, where he sought solace in the 'unmanly' comforts of music, painting, and reverie.[14] A similar pattern of withdrawal occurred in America in the last quarter of the nineteenth century in the wake of industrialization, urbanization, and economic competition.[15] More public in their disregard for conventional sexual categories, Whistler and Wilde theatrically announced the arrival of a modernist mobility of gendered identities that was to continue to be played out in the drawing-rooms of the sexually ambiguous Bloomsbury circle, where traditional notions of 'masculine' and 'feminine' dress melded into one another much in the manner anticipated by Janey Campbell in the 1880s.

Cross-cultural cross-dressing occurred at three distinct points in British history which coincided with the growth of imperialism. The first transpired in the early eighteenth century at a time when Britain's interest in the Ottoman Empire was more mercantile than political. The need for on-site representation led to the arrival of Lord and Lady Montagu in Turkey, where he served as British ambassador while she explored the hidden female sphere and vividly recorded her impressions. Piqued by curiosity, Mary Wortley Montagu was one of the first British women to succumb to the

comforts of Turkish trousers. This exploratory stage in relations between East and West was marked by the continuing arrival of women travellers who persisted in probing the secrets of the harem and comparing its way of life to that practised in the British female sphere. Their writings marked the initiation of a discourse of gender identity in which the race and customs of the imperial 'other' became liberating conditions for the female sex.

A second, more aggressive phase began after Russia attacked Turkey in 1877, prompting vigorous debate in Britain over whether or not a display of military power was required to defend its sphere of influence. In this climate of questioning and reassessing national identity, a similar appraisal of the configuration of gender was taking place in the private enclaves of Chelsea and Surrey. Janey Campbell, encouraged by her admirers Wilde and Whistler, directed her Pastoral Players in staging scenes from Shakespeare's *As You Like It*, in which she cast herself as the young male Orlando. Although she modified her theatrical persona off stage, she nonetheless projected the androgynous look of 'a young prince in the Arabian Nights', according to Vernon Lee.[16] Deploying the hauteur and indifference with which members of her class regarded convention, Janey Campbell snubbed fashionable tight-lacing and crinolines in favour of her own version of the sartorial comforts enjoyed by the male sex.

In its third manifestation, cross-cultural cross-dressing became a more multicultural affair in the wake of the disintegration of the Ottoman Empire and Great Britain's accelerated quest for colonies. To facilitate statements about their identity, women such as Lady Ottoline Morrell combined Turkish trousers and harem pants with the high fantasy designs of the Ballets Russes. As Susan Gubar contends, 'Cross-dressing in the modernist period is therefore not only a personal or sexual statement on the part of women; it is also a social and political statement that exploits the rhetoric of costuming to redefine the female self.'[17] Other members of Ottoline Morrell's Bloomsbury circle carried this dictum a step further when they transformed the exotic 'other' into a vehicle for gender change. While the central character in Virginia Woolf's novel *Orlando* still relies on Turkish clothes to signify liberation from Western norms, the alteration in gender which s/he undergoes is permanent, unlike Lady Ottoline's transient costuming.

Drawing on theories of transvestism, I shall argue that cross-dressing was not necessarily a sign of covert homosexuality but was more often an overt attempt by women to approximate men's social liberties. Gender researcher John Money maintains: 'Since dressing is traditionally gender-coded almost everywhere on earth, cross dressing is one highly specific act of gender crosscoding.'[18] Perceiving Ottoman women as progressive rather than as exhibits in the petrified space of male fantasy, advocates of women's rights appropriated Turkish trousers as an emblem of freedom. In 'Costumes of the

Mind: Transvestism as Metaphor in Modern Literature', Sandra Gilbert argues that to female modernists, 'costume creates identity', unlike male modernists such as James Joyce and D.H. Lawrence who, she maintains, differentiated between clothing and self.[19] Yet the same cannot be said about earlier male modernists like Whistler and Wilde, who viewed costume as a strategic weapon in the battle against gender restrictions. They inverted the process initiated by female reformers when they 'feminized' their attire in a move to claim a new sense of social agency for themselves. In appropriating the female art of expressing personal identity through clothing, they indulged in a form of 'transvestic fantasy' which Marjorie Garber defines as a 'complex interplay, slippage, and parodic recontextualization of gender markers and gender categories' which is 'kept in play by displaying a rhetoric of *clothing, naming,* and *performance* or *acting out'*.[20] Theatricality was a central trope in the unfolding pageant of modernism, both in the on-stage starring roles of Janey Campbell and Oscar Wilde and in the behind-the-scenes showmanship of Whistler and Lady Ottoline Morrell who were important character actors in the staging of modernism's emancipatory sexual drama.

* * * * *

Relations between Britain and the Ottoman Empire hark back to the reign of Queen Elizabeth I. Although the Empire was not colonized by Britain, it was nevertheless important from an imperialist perspective as a buffer zone between the West and Russia and as a trading partner. Beginning in the sixteenth century, England imported carpets, silks, cotton, oils and spices for which it exchanged armaments and tin.[21] To oversee this lucrative arrangement, the Levant Company was founded in 1581 as a parallel to the East India Company and Royal African Company, thereby extending Britain's sphere of economic influence to the southeast. The significance of the Ottoman Empire to the monarchy can be measured by the fact that it warranted the highest level of diplomatic representation – an ambassadorship.

The appointment of Lord Wortley Montagu as British representative to Constantinople in 1717 was fortuitous in that it gave his wife the opportunity to pursue her interest in the intellectual and social development of women. Describing her impressions in a series of 'Embassy Letters', Lady Mary introduced a genre of travel writing in which British women countered the condescending and patronizing reports of male observers. Despite the advantages of their social class, women such as Lady Mary nonetheless were deemed inferior to men according to British law; thus, they more readily identified with their imperial counterparts whom they perceived as superior to them in many ways. In a letter to her sister, Mary Montagu marvelled over

the control that Turkish women had over their own money, especially their right to take it with them after a divorce, along with a financial settlement paid them by their husbands. She admiringly observed:

Tis very easy to see they have more Liberty than we have ... Neither have they much to apprehend from the resentment of their Husbands, those Ladys that are rich having all their money in their own hands, which they take with 'em upon a divorce with an addition which he is oblig'd to give 'em. Upon the Whole, I look upon the Turkish Women as the only free people in the Empire.[22]

Viewing her subject through the lens of personal experience, Mary Montagu does not focus on the Ottoman woman as an inconsequential chattel, but as a model of emancipation. Far from the *flâneur*-like pose of disinterested spectator adopted by male travellers, she embraced the customs of Turkish life. 'What is so intriguing about the feminine discourse', notes Billie Mellman, 'is not its "separateness" but the dynamic interchange between it and the hegemonic orientalist culture.'[23]

The interchange in Lady Mary's case was both feminist and social. A portrait of Mary Wortley Montagu painted around 1720, shortly after her return to England, captures her in full Ottoman regalia from turban to trousers (Figure 4.1). Waxing enthusiastic over her 'Turkish habit' in a letter to her sister, Lady Montagu wondrously describes each part of her dress:

The first piece of my dresse is a pair of drawers, very full, that reach to my shoes, and conceal the legs more modestly than your Petticoats. They are of a thin rose-coloured damask, brocaded with silver flowers, my shoes of white kid Leather, embroider'd with Gold ... The Headress is compos'd of a Cap, call'd Talpock, which is in winter of fine velvet embroider'd with pearls or Di'monds and in summer of a light shineing silver stuff.[24]

The outfit in which Mary Montagu appears in Jervas's portrait, however, is a modified version of the costume described in this letter. While she maintained the long trousers, tunic, and *talpok* that she wore in Con-stantinople, she discarded some of her more lavish accessories, perhaps as a concession to London society. In another portrait attributed to J.-B. Vanmour (1713–16, Figure 4.2) Lady Mary appears in an ensemble which more closely corresponds to the accoutrements of the attire she described to her sister. In this version, she wears a tight-fitting bustier, or *antery*, an open caftan and a jewel-encrusted belt-cum-girdle, topped by a long ermine-trimmed *curdée*. Lady Mary explains:

The Antery is a wastcoat made close to the shape, of white and Gold Damask, with very long sleeves falling back and fring'd with deep Gold fringe, and should have Diamond or pearl Buttons. My Caftan of the same stuff with my Drawers is a robe exactly fitted to my shape and reaching to my feet, with very long strait falling

sleeves. Over this is the Girdle of about 4 fingers broad, which all that can afford have entirely of Diamonds or other precious stones . . . The Curdée is a loose Robe they throw off or put on according to the Weather, being of a rich Brocade (mine is green and Gold) either lin'd with Ermine or Sables; the Sleeves reach very little below the Shoulders.[25]

Mary Montagu's fascination with the luxurious texture, colouring and design of Turkish garments is a reversal of the standard relationship between colonizer and the colonized. Instead of attempting to convert the women she encountered to her superior way of thinking, she was awed by the greater freedoms they possessed – both bodily and in the body politic. It is Lady Mary's sororial admiration for Turkish women that is the primary text of her portraits and which overrides the initial impression of her as a Westerner in masquerade. That the British traveller benefited from her encounter is evident in Mary Montagu's alliance with the emerging feminist movement on her return to England.[26] She visibly displayed her allegiance to Ottoman values by wearing Turkish clothing as a sign of women's liberation.

Many women concurred, both in this early phase of cross-cultural cross-dressing and in its later expressions. Eastern traveller Julia Pardoe continued to affect Turkish dress after her return to England, as did Sophia Lane Poole, Isabel Burton, Anne Blunt and Isabella Bird Bishop.[27] Like Mary Montagu, these subsequent writers drew comparisons between Turkish and British women, concluding that the wives of their countrymen had less privacy and less control over reproduction and suffered more exploitation in their own middle-class parlours.[28] Fanny Janet Blunt, for instance, who spent twenty years in the Ottoman Empire, expressed her awe over the legal status of Middle-Eastern women when she marvelled that, 'should a lady possess any property the husband cannot assume any right over it, nor over any of the rest of her belongings. The wisdom and generosity of this . . . cannot be too highly commended.'[29] Writing in 1878, four years before the passage of the Married Women's Property Act, Blunt clearly perceived her Turkish sisters as more advantaged than her countrywomen. In continuing to wear Turkish attire in England, then, she and other female travellers visibly demonstrated their admiration for Ottoman women and their civil liberties.

In England, in the final quarter of the nineteenth century, unconventional women such as Lady Archibald Campbell opened up a space between the limpid conservatism of ladylike femininity and subversive sexualities. In addition to parading around London in the 'Arabian nights' costume described by Vernon Lee, Janey Campbell holds the distinction of being 'the only woman in society' to wear 'dual garments, a skirt cut like very full trousers . . . of yellow gauze at a ball at Marlborough House', according to society hostess Lady Walburga Paget, who reported the event in shocked tones.[30] The impact of Janey Campbell's appearance in trousers at the Prince

of Wales's residence can perhaps be measured by the fact that as recently as 1996 the society editor of an American newspaper expressed her surprise that a female guest wore 'evening pants' at the Cotillion debutante ball.[31] Given this conservative contemporary response, one can well imagine how stunned Janey Campbell's peers were by her avant-garde challenge to the more rigorous Victorian social protocols.

Janey Campbell's interest in Middle Eastern clothing was undoubtedly fanned by the steady stream of written accounts published by women travellers and by debates over the 'Turkish Question'. As someone who entertained pro-Turkish Prime Minister Disraeli in her home in the midst of the crisis prompted by Russia's invasion of Turkey,[32] Janey Campbell would have been familiar with the issues surrounding Disraeli's contentious decision to send the British fleet to the Dardanelles as a show of force.[33] The Ottoman Empire was not an abstract political entity to Disraeli, but a locale where he had travelled and embraced local customs in 1830–31, even to the extent of indulging in cross-cultural dressing. He confessed: 'I am quite a Turk, wear a turban, smoke a pipe six feet long, and squat on a divan.'[34] Furthermore, Disraeli brought Arab clothing back with him to England and enjoyed wearing it at costume balls.[35]

Janey Campbell's acquaintance with Disraeli is an indicator of the exalted circles in which she moved. Her immediate family, moreover, was notorious for its disregard of social boundaries. Her husband's older brother, the Marquess of Lorne, was married to Princess Louise, Queen Victoria's unorthodox youngest daughter, while his younger brother's wife, Lady Colin Campbell, riveted the popular press with her suit for divorce.[36] The ensuing trial brought questions of women's conjugal and property rights to the fore by drawing attention to the socially colonized position of women in British society. In comparison, their subjugated sisters in the Middle East were still considered better off. 'The interest in the marital status of the Muslim woman', Mellman notes, 'reflects the contemporary discussion in Britain on the rights of the married woman', adding that 'the travellers' intense interest in legal and economic rights of the *hanim* persists down to the First World War'.[37] Rather than campaigning publicly for women's rights, however, Lady Janey Campbell focused her energies on expanding the definition of her gender.

Janey Campbell's class and intellect made her more confident about poaching on male terrain and less dependent on the need to be perceived as feminine. Although Vernon Lee was attracted to her sexual ambiguity, there is nothing to indicate that Janey Campbell's desire to approach the male/female cusp was in any way homoerotic. Cross-dressing, as Shari Benstock observes in her study of the lesbian community in early-twentieth-century

Paris, implied a set of assumptions 'to which heterosexual as well as
homosexual women might give support', particularly among the upper
classes.[38] Janey Campbell did not abandon her traditional role as wife and
mother; rather, from her privileged position in society she taunted the rigid
construction of gender that was in force in the 1870s and 80s.

Soon after she married Lord Archibald, Janey Sevilla Callander pushed the
boundaries of propriety when she allowed Whistler to paint her, in 1883, in
an unconventional pose in *Arrangement in Black: La Dame au Brodequin Jaune*
(Philadelphia Museum of Art). The artist captures her in the act of
raising her long skirt to reveal the erogenous zone of her ankle, which is
highlighted by the bright yellow of her fashionable high-heeled half boot.
Janey Campbell's husband's relatives complained that she appeared like 'a
street walker encouraging a shy follower with a backward glance'.[39] Lord
Archibald, nervous about the notoriety surrounding the pending divorce
proceedings against his brother Lord Colin (whose wife accused him of
infecting her with syphilis), rejected the portrait. It would be tempting to
speculate that Lord Archibald's decision was influenced by his awareness
that Turkish women placed a pair of yellow slippers outside the entrance to
the harem when they wanted to refuse sex.[40] A more likely explanation,
however, is that he feared that neither his family nor his wife's could
withstand another scandal: Janey Callander's thrice-married grandfather
enjoyed an extended extra-marital affair which was also the subject of a
court case.[41] But it would be a mistake to equate the boldness of Janey
Campbell's expression with raw sexuality. Critic Theodore Duret, who
witnessed her peremptory behaviour one day in Whistler's studio when she
demanded changes in her portrait, believed that it was this defiant aspect of
her personality that intrigued the artist. He reflected: 'Tall and svelte, she
turned her head to throw a final look before leaving, the personification of
haughty elegance.'[42] For her part, Janey Campbell felt that Whistler had
caught an essential aspect of her being. Years later, when the artist wrote to
inform her that her portrait had won prizes in Paris and Munich and had
been purchased by the Philadelphia Museum of Art, she replied: 'it is *my* red
ribbon and *my* gold medal of recognition to read your remarks about the
picture and to hear that it is the *Brodequin Jaune – The Yellow Buskin – moi je*
and not Lady Archibald Campbell who has achieved undying fame in the art
galleries of Philadelphia'.[43] Obviously pleased with Whistler's tribute to her
spirited nature, Janey Campbell, unlike her husband, was not cowed by
convention. Her disregard of social proprieties made her just as irresistible to
Oscar Wilde as to Whistler. Both men were willing parties to her experiments
in gender crosscoding.

Oscar Wilde's estimation of Janey Campbell can be construed from the fact
that he commissioned her to write the opening article for the inaugural issue

of his *Woman's World* magazine after he assumed editorship in 1888. Titled 'The Woodland Gods', her essay describes a series of outdoor performances by her amateur theatrical group, the Pastoral Players, which she staged near her home at Coombe Hill Farm in Surrey between 1884 and 1886. Vernon Lee, who was in the audience when Janey Campbell produced Fletcher's *Faithful Shepherdess* in the summer of 1885, conveyed her enthusiasm to her mother:

I have never seen anything more beautiful than this play . . . performed in this way by a number of exquisitely dressed amateurs in a real park, walking on hay, among the rustle of leaves, with little groups lounging quite far in the distance, beautiful spots of colour among the green, and those people acting in a graceful, childish, immature way, as if there to amuse themselves rather than others . . . I am inclined to think Lady A. must be a very clever, delightful, fantastic, wayward creature . . . I am dying to know her.[44]

Lee was granted her wish and was elated when Janey Campbell turned up at their meeting unconventionally dressed 'in a very bright blue paper dress suggestive of divided skirts and ulster to match, and a blue cap'.[45] Her androgynous clothing apparently struck a sympathetic chord with Lee who, as a lesbian, would presumably have sympathized with Janey Campbell's efforts to overcome the limitations of her sex. Acting out the 'transvestic fantasy' defined by Garber, Janey Campbell combined a rhetoric of clothing and performance in a challenge to gender roles.[46]

Janey Campbell's signature theatrical work was her cross-dressed performance in the role of Orlando in *As You Like It*, which she staged three times between July 1884 and May 1885. Featuring photographs and drawings of herself costumed as the young Orlando in her article in *Woman's World*, she uses her text as an occasion to defend the right of women actors to play Orlando like other male Shakespearean characters who have been played by the female sex. Janey Campbell reasons: 'Orlando has been neglected . . . It seems remarkable that whilst Hamlet, Romeo, even Shylock, and many other male Shakespearean characters have been played by women, we do not hear that Orlando has ever been included in the number.'[47] Moreover, she maintains that the role warrants a woman's touch because of Orlando's 'tender solicitude' and 'woman's gentleness', qualities which were to inspire Virginia Woolf's novel of that name forty years later.[48]

So successfully did Janey Campbell identify with her character that the photographs of her in this role which appeared in *Woman's World* recently led a contemporary critic to the mistaken conclusion that they were representations of 'comely young men in costume' and, as such, are indicative of Wilde's 'covert homosexual discourse'.[49] One can easily understand how this error could have occurred for, in the lead photograph of Janey Campbell as

Orlando (Figure 4.3), her boyishly short curls accord with the masculinity of her long leather leggings and tunic, thus effectively neutralizing sexual difference. Janey Campbell, albeit in a theatrical milieu, demonstrates the point which Judith Butler makes about the performative character of gender when she explains:

> That gender reality is created through sustained social performances means that the very notions of an essential sex and a true or abiding masculinity or femininity are also constituted as part of the strategy that conceals gender's performative character and the performative possibilities for proliferating gender configurations outside the restricting frames of masculinist domination and compulsory heterosexuality.[50]

Although Butler is describing contemporary enactments of gender identification, Janey Campbell paved the way for such revisionist theorizing by bringing her cross-dressed performance to the public and by daring to draw more attention to woman's desire to claim male prerogatives. Theatricality permitted an imaginative leap at this early stage in the history of the modernist recontextualization of gender.

Whistler and Wilde were in awe of the theatrical and androgynous Janey Campbell, whose aristocratic bearing added an unassailable gloss to her gender crosscoding. Whistler's response to her coltish but intractable appearance as Orlando is evident in the oil sketch for which he asked her to pose (Figure 4.4). Legs arrogantly astride and arms confidently crossed, Campbell-cum-Orlando was clearly as fascinating to Whistler as she was to Wilde. After seeing this portrait, Wilde, it is said, 'went about declaring ... Lady Archie more charming than Rosalind, and Mr. Whistler an incomparable artist'.[51] In a letter to Whistler, Wilde referred to her as 'my lovely and *spirituelle* Lady Archie', while on another occasion he inquired, 'And the Moon-Lady, the Grey Lady, the beautiful wraith with her beryl eyes, our Lady Archie, how is she?'.[52] Eve Sedgwick defines this kind of shared male attraction toward the same female as triangulation – a form of male–male desire which expresses itself through a woman.[53] She attests to its prevalence in Victorian society, where many men deluded themselves about the erotic nature of their feelings for one another.[54] Thaïs Morgan comments on a comparable phenomenon when she describes the poet Algernon Charles Swinburne as someone who was attracted to masculinized women 'as a defensive detour around the dangers of homoerotic desire' in order to redeem what he felt about his own identity as a feminized man.[55] Whistler was asked to reenact his role in the triangle in 1890 by the notorious Comte Robert de Montesquiou who begged the artist to introduce him to Janey Campbell when he came to London.[56] Whistler apparently complied, as Montesquiou saw her again later that year in Saint-Moritz.[57] The model for

Proust's Baron de Charlus and Huysmans's Comte des Esseintes, Montesquiou shared his British friends' disdain for bourgeois definitions of gender, adoration of nonconformist society women, passion for cross-cultural markers of liberty and predilection for effeminate clothing.[58]

Like Montesquiou, neither Whistler nor Wilde was reticent about flaunting his liminal masculinity through his wardrobe. A visitor to Whistler's studio described his surprise at the sight that greeted him: 'Mr. Whistler, dressed wholly in black velvet, with knickerbockers pantaloons stopping just below the knees, black silk stockings and low pointed shoes, with silk ties more than six inches wide and diamond buckles.'[59] And artist John Lavery noted with some amusement that, 'when [Whistler] got in front of the glass to brush his hair he behaved exactly like a woman settling her permanent wave'.[60] More puzzling is Whistler's cross-dressed self-portrait sketch, *The White Feather*,[61] in which he represents himself in a floor-length woman's dress in a vertical format similar to the one he chose for his portrait of Janey Campbell.[62] While there is no evidence that Whistler actually wore women's clothing in public, both he and Wilde carried fans or flowers and favoured costumes with flowing lines stitched in rich fabrics. Whistler also sported kimonos at home, while Wilde regularly appeared in knickerbockers, tight stockings, and loose 'feminine' collars.[63] Bordering on the parodic, Whistler's and Wilde's epicene behaviour was an exaggerated but analogous version of the more discreet explorations of sexual identity that were occurring in British society.

For early twentieth-century cross-dressers, the dark shadow of the imperialist 'other' continued to cast an alluring spell. The dusky far-off corners of the Empire offered a haven from British rules and regulations and a means of confounding them. To women, Turkish trousers continued to symbolize emancipation, nonconformity and an expansion of sexual identity: Lady Ottoline Morrell and Virginia Woolf exulted in the seductiveness of the East. 'Female modernists', observes Susan Gubar, 'escaped the strictures of societally-defined femininity by appropriating the costumes they identified with freedom.'[64]

One of the costumes that Lady Ottoline Morrell associated with freedom was the tunic-topped pair of Turkish trousers favoured by Mary Montagu and those women who followed her route Eastward.[65] As late as 1909, travel writer Lucy Mary Garnett, in *Home Life in Turkey*, pointed out the Ottoman woman's civic advantages: she could inherit without trustees and sue whomever she wished, because 'no doctrine of *couverture* exists for her'.[66] Still considered more progressive than her British counterpart, the Turkish woman and her style of dress continued as an emancipatory model. Lady Ottoline, though, claimed that it was the designs of Leon Bakst for the costumes of the Ballets Russes which inspired her to devise her trouser

outfit.[67] This third flowering of cross-cultural cross-dressing struck a more multivocal note, following the dissolution of the Ottoman Empire and the assimilation of its symbols into the theatrical costumes of Bakst and the high-fashion *jupes-culottes* of Parisian designer Paul Poiret.[68]

Obeying Oscar Wilde's dictum that life should imitate art, Ottoline Morrell devised a theatrical setting for her reconfiguration of gender and indulged in a similar form of performativity as Wilde when she appeared in 'tight silk trousers and a straight knee-length tunic' at the gatherings she orchestrated for Bloomsbury's literary luminaries at Garsington, her country retreat.[69] She also favoured the divided skirt worn by Janey Campbell (Figure 4.5). As Gilbert notes, 'there has always been a tradition of theatricality associated with the expensive clothing of aristocrats'.[70] But unlike Janey Campbell, Lady Ottoline devised her own plots and wrote her own scripts for her intimate *mises en scène*. She applied a theatrical metaphor to her life, writing that it 'is a perfect performance. To those who are beautiful and gay it is not difficult, the applause always complimentary and laudatory. Unfortunately, try as I might, I could never learn my proper part.'[71] Insecure because of her limited education and her lanky appearance, which Gertrude Stein described as 'looking like a marvelous feminine version of Disraeli and tall and strange',[72] Ottoline Morrell crafted a role for herself in which she could hide behind her clothes. Sensing that she was acting a part, David Garnett remarked, after attending one of her parties, 'the circus clown had been rather beautifully dressed in a silk tunic and trousers'.[73] Ottoline Morrell's flamboyance, nonetheless, should not distract from the contribution she made to the Bloomsbury aesthetic in her role as cross-cultural cross-dresser and champion of the marginal and the taboo.

While some writers have accused Morrell of possessing a 'masculine libido', the issue was not as clearly resolved in her own mind.[74] Not as lithe or as delicate as the nineteenth-century balletic *danseuses en travesti* who cross-dressed to perform as toreadors or sailors in skin-tight trousers, Ottoline Morrell more closely resembled androgynous modern dancers such as Nijinsky (whom she befriended) who successfully managed to transgress 'rigid categories of masculinity and femininity'.[75] Although Lady Ottoline confessed that she found the idea of marriage a 'humiliation', explaining that it ran against the grain of women's 'strong intuitive feeling of pride in their solitary life', she frankly admitted in her journal that, 'somehow there is something in me, the best and most imaginative, that I cannot give to women. They are too personal; they don't really feel the fundamental things as strongly as a man does.'[76] And while she delighted in lending Lytton Strachey her clothes, she also enjoyed extra-marital affairs with Roger Fry, Bertrand Russell and Henry Lamb.[77] Lady Ottoline's costumes signified the

crustaceous layers of her ambivalent identity: her wardrobe contained flowing caftans and conventional frocks as well as divided skirts and Turkish trousers.

Lady Ottoline's friend Virginia Woolf was much less equivocal about the relationship between clothing and sexual identity. In her novel *Orlando*, she forges together the Ottoman Empire's historic attractions represented by Lady Mary Wortley Montagu's travels, Lady Janey Campbell's transsexual costuming and role playing and Lady Ottoline Morrell's theatricality. '*Orlando*', according to Kari Lokke, 'revisits the history and development of British literature from the Renaissance to 1928 in the spirit of feminist parody in order to free its heroine – and by extension its author – from the burden of this largely masculine tradition.'[78] Turkish clothes remain central to Woolf's project: when her male character travels to Turkey and undergoes a miraculous sex change, the female Orlando dresses in Turkish coats and trousers.[79] Cross-cultural cross-dressing symbolizes Orlando's power to recreate him/herself, an act which Carol Smith-Rosenberg maintains constitutes Orlando as 'the ideal feminist hero of the New Women artists'.[80] But in donning the signature costume of the Ottoman Empire, Orlando joins the larger rank and file of British women who, since the eighteenth century, had appropriated it to signify emancipation from civic codes, social bondage and gender constraints.

The publication of *Orlando* in 1928 coincided with the lowering of the voting age of females to 21 in Great Britain. Women's unselfish involvement in World War I successfully turned Parliament in their favour and also won acceptance for the trousers they had worn to facilitate their war work. No longer associated with subversive sexualities, trousers entered the realm of everyday fashion, leaving Ottoman harem décor to be appropriated by consumer culture. Liberty's advertised fabrics with exotic names such as 'Tabdar', promising 'the brilliant colours of the Orient', while teashops and boutiques decorated with Middle-Eastern motifs cropped up in the West End.[81] By 1919, Somerset Maugham was already bemoaning the shift away from the muted tones of Aestheticism toward the bolder and freer hues of the Eastern Empire. Despite his firsthand experiences as a colonialist, he censoriously intoned, in *The Moon and Sixpence*: 'Mrs. Strickland has moved with the times. Gone were the Morris papers and gone the severe cretonnes, gone were the Arundel prints that had adorned the walls of her drawing-room in Ashley Gardens; the room blazed with fantastic colour.'[82] What had once been a locus of transgression among an élite group of cross-cultural cross-dressers who longed to stretch social boundaries by assimilating Ottoman values, was now standard fare in the polite parlours of middle-class housewives.

Notes

1. Virginia Woolf, *Orlando* (New York: Harcourt Brace: 187, 1928): 187.

2. Although the 'Orientalism' rubric is often applied to the Middle East, I do not intend to adopt it in this chapter, in order to avoid confusion with the way the artists in the Aesthetic and Bloomsbury groups used the term to signify Asia. Instead I shall employ the more specific designation 'Ottoman Empire' to refer to the area known today as the Middle East.

3. Ahmet Mithad, *Avrup'da Bir Cevelan* (Istanbul: Terc uman-a Hakikat-i Gazete, 1980; translated in Zeynep Çelik, 'Colonialism, Orientalism and the Canon', *Art Bulletin* 78 (1996): 202–5).

4. Quoted by Billie Mellman, *Women's Orients: English Women and the Middle East, 1718–1918: Sexuality, Religion and Work* (London: Macmillan, 1992): 67.

5. Stella Mary Newton, *Health, Art and Reason: Dress Reformers of the Nineteenth Century* (London: John Murray, 1974).

6. See Sarah Levitt, 'From Mrs Bloomer to the Bloomer: The Social Significance of the Nineteenth-Century English Dress Reform Movement', *Textile History* 24 (1993): 27–37; Claudia Brush Kidwell and Valerie Steele, eds, *Men and Women: Dressing the Part* (Washington DC: Smithsonian, 1989).

7. Mary Edwards Walker, *Hit* (New York: American News Company, 1871): 62–3.

8. David Kunzle, *Fashion and Fetishism: A Social History of the Corset. Tight-Lacing and other Forms of Body-Sculpture in the West* (Totawa, NJ: Rowman and Littlefield, 1982): 41.

9. Susan Gubar, 'Blessings in Disguise: Cross-Dressing as Re-Dressing for Female Modernists', *Massachusetts Review* 22 (1981): 479–81.

10. Quoted by Newton, *Health, Art and Reason*: 66–7.

11. L. Crispin Warmington, ed., *Stephens Commentaries on the Laws of England* (4 vols; London: Butterworths, 1950): I 41–2.

12. See R.W. Connell, *Masculinities* (Berkeley: University of California, 1995); Maurice Berger *et al.*, eds, *Constructing Masculinity* (New York and London: Routledge, 1995); Joseph A. Kestner, *Masculinities in Victorian Painting* (Aldershot: Scolar Press, 1995).

13. Kestner, *Masculinities in Victorian Painting*: 5.

14. Dianne Sachko Macleod, *Art and the Victorian Middle Class: Money and the Making of Cultural Identity* (Cambridge: Cambridge UP, 1996): 295.

15. Mary Blanchard, 'Boundaries and the Victorian Body: Aesthetic Fashion in Gilded Age America', *American Historical Review* 100 (1995): 39.

16. Peter Gunn, *Vernon Lee: Violet Paget, 1856–1935* (London: OUP, 1964): 128–9.

17. Gubar, 'Blessings in Disguise': 478.

18. John Money, *Gay, Straight, and In-Between: The Sexology of Erotic Orientation* (New York: OUP, 1988): 102.

19. Sandra M. Gilbert, 'Costumes of the Mind: Transvestism as Metaphor in Modern Literature', *Critical Inquiry* 7 (1980): 391.

20. Marjorie Garber, *Vested Interests: Cross-Dressing and Cultural Anxiety* (New York: Routledge, 1992): 134.

21. Lisa Lowe, *Critical Terrains: French and British Orientalisms* (Ithaca: Cornell UP, 1991): 36.

22. Lady Mary Wortley Montagu, *The Complete Letters of Lady Mary Wortley Montagu*, ed. Robert Halsband (2 vols; Oxford: Clarendon, 1965): I 328–9.

23. Mellman, *Women's Orients*: 10.

24. Lady Mary Wortley Montagu, *The Complete Letters*: I 326–7.

25. Ibid.

26. Lowe, *Critical Terrains*: 36. See also Marcia Pointon, *Hanging the Head: Portraiture and Social Formation in Eighteenth-Century England* (New Haven: Yale UP, 1993): 142.

27. Mellman, *Women's Orients*: 119.

28. Ibid., 121.

29. Ibid., 109.

30. Lady Walburga Paget, *The Linings of Life* (2 vols; London: Hurst & Blackett, 1928): I 264.

31. *San Francisco Chronicle*, 23 December 1996.

32. Jehanne Wake, *Princess Louise: Queen Victoria's Unconventional Daughter* (London: Collins, 1988): 206.

33. C.C. Eldridge, *Victorian Imperialism* (Atlantic Highlands, NJ: Humanities Press, 1978): 113–14.

34. Quoted in Barbara Burman Baines, *Fashion Revivals* (London: Batsford, 1981): 168.

35. Ibid., 167.

36. G.H. Fleming, *Lady Colin Campbell: Victorian 'Sex Goddess'* (Gloucester: Windrush, 1989).

37. Mellman, *Women's Orients*: 106.

38. Shari Benstock, *Women of the Left Bank: Paris, 1900–1940* (Austin: University of Texas Press, 1986): 180–81.

39. Richard Dorment and Mary Macdonald, *James McNeill Whistler* (London: Tate Gallery, 1994): 211.

40. Billie Mellman, *Women's Orients*: 121.

41. See 'Sir James Campbell', *Dictionary of National Biography*. Janey Callander's grandfather, Sir James Callander, adopted the surname Campbell in order to inherit his cousin's estate.

42. Dorment and Macdonald, *James McNeill Whistler*: no. 103, note 11.

43. Janey Campbell, 21 September 1895: Whistler–Campbell Correspondence, Glasgow University Library B.P.II.

44. Gunn, *Vernon Lee*: 127.

45. Ibid.

46. Garber, *Vested Interests*: 134.

47. Janey Sevilla Campbell, 'The Woodland Gods', *The Woman's World* 1 (1888): 5–6.

48. Ibid., 6. Beverly Ann Schlack, in *Continuing Presences: Virginia Woolf's Use of Literary Allusion* (University Park: Pennsylvania State UP, 1979), also lists Ariosto's *Orlando Furioso* as a progenitor of Shakespeare's *As You Like It* and thus, Woolf's *Orlando* (120).

49. Laurel Brake, *Subjugated Knowledge: Journalism, Gender and Literature in the Nineteenth Century* (London: Macmillan, 1994): 133, 144. However, when submitting the accompanying illustrations to his publisher, Wilde clearly states that they are photographs of Janey Campbell, writing: 'I send you the photographs of Lady Archibald Campbell – one for frontispiece, two for setting into the article. Also three drawings by Godwin to be set into the text – like marginal sketches'; Oscar Wilde, *The Letters of Oscar Wilde*, ed. Rupert Hart-Davis (London: Rupert Hart-Davis, 1962): 205.

50. Judith Butler, *Gender Trouble* (New York and London: Routledge, 1990): 141.

51. Frank Harris, *Contemporary Portraits* (London: Methuen, 1915): 101.

52. Oscar Wilde, *The Letters of Oscar Wilde*: 102, 121.

53. Eve Sedgwick, *Between Men: English Literature and Homosocial Desire* (New York: Columbia UP, 1985): 25.

54. Ibid., 179.

55. Thaïs E. Morgan, 'Violence, Creativity and the Feminine: Poetics and Gender Politics in Swinburne and Hopkins', in Anthony H. Harrison and Barbara Taylor, eds, *Gender and Discourse in Victorian Literature and Art* (De Kalb: Northern Illinois UP, 1992): 85.

56. Edgar Munhall, *Whistler and Montesquiou: The Butterfly and the Bat* (Paris: Flammarion, 1995): 60.

57. Whistler–Campbell Correspondence, Glasgow University Library B.P.II; 19 October 1890.

58. Munhall, *Whistler and Montesquiou*.

59. Deanna Marohn Bendix, *Diabolical Designs: Paintings, Interiors and Exhibitions of James McNeill Whistler* (Washington DC: Smithsonian, 1995): 132.

60. Sir John Lavery, *The Life of a Painter* (London: Cassell, 1940): 116.

61. Eric Denker, *In Pursuit of the Butterfly: Portraits of James McNeill Whistler* (Washington DC: Smithsonian, 1995): 84; Whistler–Campbell Correspondence, Glasgow University Library B.P.II.

62. See Denker, *In Pursuit of the Butterfly*: Fig. 3:30.

63. Kunzle, *Fashion and Fetishism*: 152.

64. Gubar, 'Blessings in Disguise': 478.

65. Miranda Seymour, *Ottoline Morrell: Life on the Grand Scale* (London: Hodder & Stoughton, 1992): 168, 238.

66. Quoted by Mellman, *Women's Orients*: 109.

67. Seymour, *Ottoline Morrell*: 168.

68. See Peter Wollen, 'Fashion/Orientalism/the Body', *New Formations* (1987): 10, and Valerie Steele, *Fashion and Eroticism: Ideals of Feminine Beauty from the Victorian Era to the Jazz Age* (New York and Oxford: OUP, 1985): 227.

69. Seymour, *Ottoline Morrell*: 168. I am grateful to my former student Martha Brundin for her research into Lady Ottoline Morrell and Garsington.

70. Gilbert, 'Costumes of the Mind': 392.

71. Lady Ottoline Morrell, *Ottoline: The Early Memoirs of Lady Ottoline Morrell*, ed. Robert Gathorne-Hardy (London: Faber and Faber, 1963): 90.

72. Gertrude Stein, *The Autobiography of Alice B. Toklas* (New York: Literary Guild; rpt Vintage, 1961): 123.

73. David Garnett, *The Flowers of the Forest* (London: Chatto & Windus, 1955); quoted in Seymour, *Ottoline Morrell*: 207.

74. Walter Turner, *The Aesthetes* (London: Wishart, 1927); quoted in Seymour, *Ottoline Morrell*: 354.

75. Lynn Garafola, 'The Travesty Dancer in Nineteenth-Century Ballet', in Lesley Ferris, ed. *Crossing the Stage: Controversies in Cross-Dressing* (London: Windrush, 1989): 104.

76. Lady Ottoline Morrell, *Ottoline at Garsington: Memoirs of Lady Ottoline Morrell, 1915–1918*, ed. Robert Gathorne-Hardy (London: Faber and Faber, 1974): 120, 151.

77. See Jan Marsh, *Bloomsbury Women: Distinct Figures in Life and Art* (London: Pavilion, 1995): 63, and Frances Spalding, *Roger Fry: Art and Life* (London: Granada, 1980): 143.

78. Kari Elise Lokke, '*Orlando* and Incandescence: Virginia Woolf's Comic Sublime', *Modern Fiction Studies* 38 (1992): 239.

79. Woolf, *Orlando*: 153.

80. Carroll Smith-Rosenberg, 'Discourses of Sexuality and Subjectivity: The New Woman 1870–1936', in Martin Duberman *et al.*, eds, *Hidden from History: Reclaiming the Gay and Lesbian Past* (New York: New American Library, 1989): 278.

81. Martin Battersby, 'Diaghilev's Influence on Fashion and Decoration', in Charles Spencer, *The World of Serge Diaghilev* (London: Paul Elek, 1974): 161.

82. Somerset Maugham, *The Moon and Sixpence* (New York: G.H. Doran, 1919): 277.

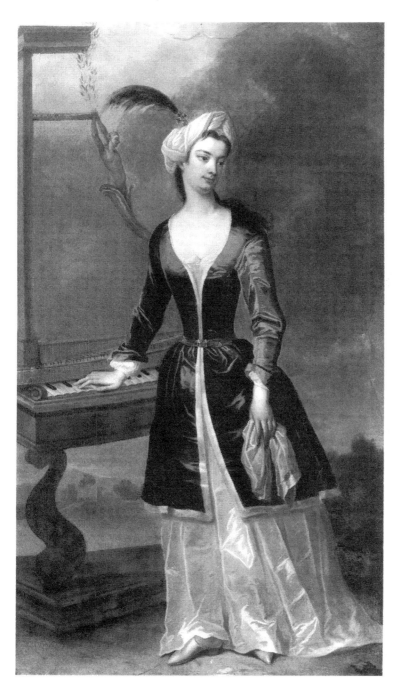

4.1 A. Charles Jervas, *Lady Mary Wortley Montagu in Turkish Dress*

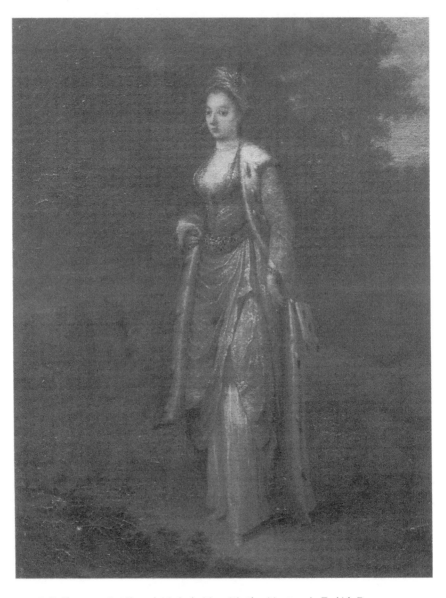

4.2 J.-B. Vanmour (attributed to), *Lady Mary Wortley Montagu in Turkish Dress*

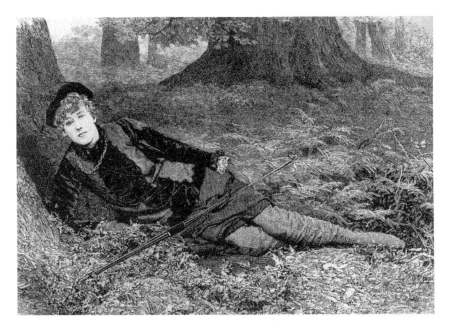

4.3 'Lady Janey Campbell as Orlando', in the *Woman's World*

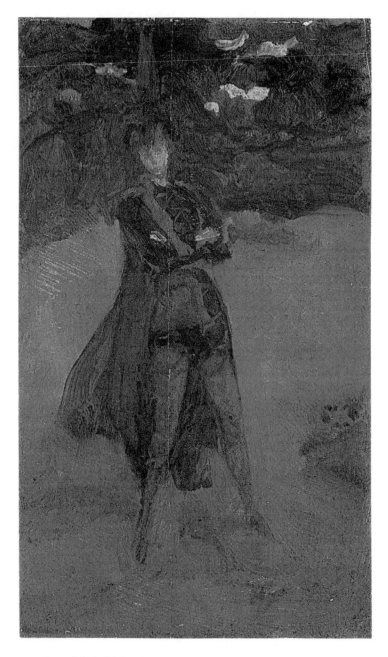

4.4 James McNeill Whistler, *Note in Green and Brown: Orlando at Coombe*

4.5 Lady Ottoline Morrell in Bedford Square, 1909

II

The aesthetics of the colonial gaze

The memsahib's brush: Anglo-Indian women and the art of the picturesque, 1830–1880

Romita Ray

'The memsahib's brush' focuses on Anglo-Indian women as artists and travellers in the colonial Indian landscape.[1] For most British women stationed in the subcontinent in the nineteenth century, sketching and painting were confined to genteel pastimes undertaken in privacy. Yet a simple hobby to keep the eye and hand occupied proved to be an agreeable solution for adjusting to a foreign landscape. Observing people, places and events comprised the first step towards settling down in an unfamiliar environment. And recording them helped articulate the individual's location within a new set of cultural structures and social systems. Not surprisingly, a stream of travel manuals published at the time encouraged would-be memsahibs to keep themselves busy with paper and paint. In effect, boredom, sloth or homesickness were meant to be conquered in their new colonial setting. Bearing this goal in mind, Emma Roberts, a well-seasoned traveller and author of several publications on India, cautioned her readers to cultivate 'active and industrious habits', among which drawing 'is perhaps the . . . independent and . . . useful accomplishment . . . There can never be wanting subjects for the pencil in a country, and amid a people so truly picturesque.'[2]

By the early nineteenth century, recording scenes in South Asia went hand-in-hand with journeying through the country. Artists who jotted details of their natural surroundings for mementos to be sent home or for private albums of gathered memories, were a varied group, belonging to the military, the Civil Service, or Archaeological and Survey departments. Memsahibs too used the opportunity to paint picturesque scenery, setting aside domestic boundaries to step outside and draw.[3] Art-making in the colonial setting coincided with the development of theories of the picturesque in England and with the promotion of picturesque tours to scenic spots tucked away in Scotland and Wales. Just as amateur artists armed with

Claude glasses and sketch-books visited celebrated picturesque sites throughout the country, so too did their counterparts in India find visually appealing locations to fill their sketch-pads. Over time, a landscape aesthetic originally attached to Scottish, Welsh and English environs eventually came to signify the foreign qualities of the colonial setting. Emily Eden, who travelled in India for six years, commented on this matter, comparing India with 'a constant theatrical presentation' where 'everything is so picturesque and utterly un-English'.[4]

An important outcome of the artistic interest in the Indian picturesque was that it offered colonial Britons a chance to come to grips with their foreign surroundings on their own terms. Because the picturesque was deeply involved in analysing man's relationship with nature, artists and aesthetes first focused on the physical geography of their new setting.[5] Yet they encountered a terrain whose boundaries often shifted according to the East India Company's political decisions and the Crown's control over the area from 1858 onwards. Picturesque views, however, represented the colonial landscape as an aesthetically pleasing still-life instead of a politically unstable mass of land. The infamous Mutiny of 1857 might have escalated anxieties about social relations between Indians and Britons, but it had little effect on how natural settings were shown through the picturesque lens.

For memsahibs, painting scenic spots gave them a chance to escape from crowds of native strangers as well as from the curiosity of other Anglo-Indians to the solitude of the outdoors.[6] Drawing a river, meadow or flower, however, frequently evoked nostalgic memories of places they had left behind in Scotland, England or Wales. The occasional recollection of the homeland within the colonial space inevitably depended on comparisons between the two settings. Was there a spot of England that could be glimpsed in India? Or was the subcontinent an entirely different environment? By instinctively evaluating their new surroundings in this manner, colonial Britons were encouraged to contemplate upon their sense of belonging to India. And as much as they grew accustomed to the climate, flora and fauna of an unfamiliar landscape, they also extended their picturesque scrutiny to indigenous peoples and other Anglo-Indians. Observing the human body led in turn to a heightened awareness of the social and cultural institutions which surrounded their subjects and indeed themselves.

It is the memsahib's sense of place and identity, revealed in her picturesque renderings of the subcontinent, that forms the main subject of my paper. How did the memsahib's brush enable her to locate herself in an unfamiliar country? Did the picturesque highlight and/or dissolve social distinctions between Indian and Anglo-Indian communities? What strands of colonial histories did they inscribe for British audiences at home? In what contexts did viewers come across their visual records?

In this paper, I examine these questions through paintings and prints produced by five British women who visited India at different times between 1830 and 1880. Their themes grew out of situations, people and places they came across, depending on what opportunities their social class afforded them in the subcontinent. Emily Eden, for instance, visited India as the Empire's First Lady when she accompanied her brother Lord Auckland during his tenure as Governor-General (1836–42). Her connections allowed her to approach Indian monarchs and aristocrats, some of whom willingly posed for her artistic pursuits. Lady Charlotte Canning, Viceroy Charles Canning's wife, hailed from similar social circles and lived through the Sepoy Mutiny of 1857, dying in Barrackpore in 1861. In contrast to the other artists discussed here, she kept her drawings for her personal perusal, sharing them only with close relations and friends. Unlike Lady Canning, Fanny Parks, a middle-class Englishwoman who had spent more than twenty years in the subcontinent, published her personal memoirs as an illustrated travelogue.[7] Few memsahibs matched her richly detailed accounts of their Indian experiences, but one woman rivalled her eye for intricacy. This was Sophia Charlotte Belnos, the only professional artist among the cluster of female painters discussed here, who had set up an art studio in Calcutta by the middle of the nineteenth century.[8] Forty years after Mrs Belnos published her first book, Marianne North, a wealthy unmarried Victorian who counted Edward Lear (also a fellow explorer of India) among her friends, carved a niche for herself among London art lovers with her painted views of India.[9] North visited Jamaica, North America, Brazil, Japan, and Java before she finally arrived in the colonial subcontinent in 1877. India inspired her to produce over 200 paintings of trees and flowers, as well as of buildings, to be later displayed among other drawings in the gallery named after her in the Royal Botanic Gardens at Kew.[10]

The circulation of these colonial narratives, whether drawings or written texts, within India and Britain as well as between the two countries, points towards the very routes through which the search for British national identity was channelled to the Empire's larger playground. It is difficult, however, to chart every instance of colonialism transposed. Images of India comprised a barrage of associations rather than a neatly packaged set of signs and symbols. At times the culture of Empire that poured back into Britain created definite impressions, as in exhibitions held in art galleries and the Crystal Palace.[11] At other times the effects were more nebulous, especially if they involved personal preferences for things Indian or simply a curiosity about events in the colonies. George Franklin Atkinson, who served in the Bengal Engineers between 1840 and 1859, humorously reviewed the situation in a poem in *Curry and Rice* (1860), his book about a fictitious Anglo-Indian station:

What varied opinions we constantly hear
of our rich Oriental possessions;
What a jumble of notions, distorted and queer,
Form an Englishman's 'Indian Impressions!'[12]

The mass of land known as 'India' was perceived in a variety of ways by different audiences at home and abroad. Some clung to their ideas about the country as an exotic space packed with caparisoned elephants and bejewelled maharajas, whereas more sophisticated spectators could trace the connections between Indian and European Antiquity. The possibilities were endless. The outcome, however, was the same – an 'imagined community' labelled as the British Empire, an amalgam of English, Scottish, Irish, and Welsh placed alongside Bengali, Punjabi, Bihari, Tamil, Kashmiri, Andhra, Assamese, Carnatic, and Gujerati peoples.[13]

The Memsahib Travels

Every memsahib, no matter how long or briefly she lived in India, was first and foremost a traveller in the colonial subcontinent.[14] So were the records she produced, for they too journeyed from India to Britain where they reached eager readers and art lovers. Thus the movement of ideas and impressions via letters, diaries and journals formed the initial basis of colonialism transposed. An illustration by Fanny Parks from her two-volume journal, *Wanderings of a Pilgrim, in Search of The Picturesque, During Four-and-Twenty Years in the East; with Revelations of Life in The Zenana* (London, 1850), brings the phenomenon of travel in colonial spaces to the forefront (Figure 5.1). We observe a group of camels gathered around a pool with books hanging from their necks as a spider crawls forward, a volume caught between its legs. A closer examination reveals that the books can indeed be recognized as Parks's memoirs as well as Captain Mundy's popular illustrated volume of Indian manners and scenery, Major Luard's well-known drawings of India, and Emily Eden's portfolio of portraits of Indian people and princes.[15] Parks's work highlights the density of motion packed into traversing the Indian subcontinent, the influx and outflow of movement (both actual and ideological), of journeys begun, concluded and continued. And these aspects are embedded in the figure of the camel, a motif which itself reflects the many acts of travelling. Just as the sturdy animal finds its way through desert sands, the illustrated book survives a journey of its own through a network of readers in India and Britain.[16] The camel garlanded with books can also be seen as a parallel to the artist's figure, the latter chalking out an individual route amidst the paths taken by other British visitors. It is therefore appropriate that the picture of book-bearing camels

serves as a frontispiece to Parks's written narrative because it sets the tone for her own 'wanderings' through word and image.

In its most widely understood form, the act of travelling signifies a movement from one physical point to another, while the traveller becomes a repository for memories of time and place gathered at each spot along the journey's route. If enthusiastic enough, he or she documents those individual moments, eventually creating a long trail of records that are variously labelled travel narratives, journals, memoirs or sketches. When these are transmitted to other observers, another trail of looking and recording commences, resulting in a fresh corpus of records, viewers, and, possibly, newly inspired travellers as well. Parks's composition scratches at the surface of several types of movement built into a journey: of motion through geographical regions, of an imaginary movement through imagined spaces, and of a movement of ideas and observations associated with real or fantasy landscapes. Simon Schama notes that landscapes 'are culture before they are nature; constructs of the imagination projected onto wood and water and rock':

> But it should also be acknowledged that once a certain idea of landscape, a myth, a vision, establishes itself in an actual place, it has a peculiar way of muddling categories, of making metaphors more real than their referents; of becoming, in fact, part of the scenery.[17]

Following this logic, Parks's actual journey through a tangible physical terrain has been reinvented as an imaginary construct in which a group of camels hover in some invented oasis to quench their thirst at the water's edge. The books swinging from their necks, however, allow us for a moment to step out of this fantasy desert. They name the paths taken by well-travelled Britons and guide us to their clusters of memories gathered in recognizable spots.

Parks's journals were not her only venture to bring India within the reach of nineteenth-century London. In the wake of her publication, she produced yet another piece of writing that remapped the tracks covered by her predecessors as well as by her contemporaries. This time, however, the contents of her book were designed for a diorama shown in the Asiatic Gallery on Baker Street in London.[18] Like her memoirs, her handbook for the *Grand Moving Diorama of Hindostan, Displaying the Scenery of the Hoogly, the Bhagirath, and the Ganges, From Fort William, Bengal, to Gangoutri, in the Himalaya* (London, 1851?) was meticulously researched. But even amidst this new setting old connections surfaced in the introductory page which informs us that the 'whole of the Scenes of the Diorama have been arranged by Lieutenant Colonel LUARD, from his own original and unpublished sketches, taken during a residence of fourteen years in India'. Luard, in turn, based the

'scenes' for the diorama upon original paintings made by Sir Charles D'Oyly, James Prinsep, and George Chinnery, all eminent artists who had worked in India. Parks's own contributions are acknowledged beneath their works as 'the original sketches of . . . the Author of "Wanderings of a Pilgrim, during Four-and-Twenty Years, in the East" '. More importantly, she relies on an identity that is no longer simply English, even though it has been relocated in the homeland. Instead, she presents herself as a colonial creature, a 'pilgrim' shaped by her experiences in the 'East', ready to create a visual spectacle – a journey of the eye and mind – for audiences in London.

But the first indication of her desire to identify herself as Anglo-Indian is found on the title pages of her books. Fluent in Hindustani and Persian, Parks refrained from naming herself in English, resorting instead to a signature in the Perso-Arabic script.[19] An easier way to step into Indian shoes was to wear native outfits while dressing up for a costume party or posing for a photograph.[20] Following in the footsteps of bold eccentrics such as Lady Mary Wortley Montagu and Lady Hester Stanhope, known for donning their Turkish and Egyptian robes, Marianne North also put on 'flowing draperies of cashmere wool . . . with spiky cocoa-nut branches running into [her] head' during her visit to Sri Lanka in 1877.[21] Coaxed by Julia Margaret Cameron into wearing the outfit, she posed for the famous photographer dressed in this manner. The resulting image blurred her English identity even though it presented her with her left hand resting upon her chest, a motif distinctly borrowed from eighteenth-century portraiture. In her analysis of Lady Montagu's portraits, Marcia Pointon discusses the concept of a 'mythicized and idealized body' shaped by artists and authors over and above the 'biological body subject to decay'.[22] Here too, in North's portrait, an English individual is reconstructed with a mythical exterior which is neither English nor Indian nor Sri Lankan, but a combination of all three. The Kashmiri *phiran*-like garment, the covered head and the leaves of the cocoanut palm so common in the Sri Lankan landscape surround an Englishwoman's body, thus revealing the complex scope of Anglo-Indian identity, one whose boundaries varied from individual to individual and from place to place.

By the middle of the nineteenth century, and more so after the Mutiny, to remain staunchly *Anglo* was far more essential than to acquire any habit, tradition, or custom that could be even vaguely labelled *Indian*. Memsahibs stood at the focal point of such concerns since they bore the responsibility of ensuring the future of the British race in India.[23] But in spite of increasingly rigid social limits, they were not entirely immune from their share of cultural hybridity, mythical or real. Their sojourns in the subcontinent often made them look more 'exotic' to fellow Britons who had not ventured out in the world as far as they had. In this respect, the survival of a species in the harsh

setting of a stagnant pool or a scorching desert is of paramount importance in Parks's composition. Her detail of lotus flowers sprouting through the pond's surface speaks most eloquently to this end because the lotus juxtaposes beauty with the mundane. Thriving in stagnant bodies of water, its very form and fragrance find sustenance in the pool's primeval sludge.[24] The flower therefore appears as a visual metaphor for the memsahib's survival in British India. Just as it managed to survive in stagnant water, so too did the memsahib cope with a new physical and social climate. But the difficulty of nagivating through indigenous as well as Anglo-Indian cultures frequently frustrated her attempts to adapt to the colonial environment. Emily Eden, for instance, once complained that the sahibs seated at her dinner table 'talk a great deal of Vizier Ali and of Lord Cornwallis, and the ladies do not talk at all'.[25] Regular correspondence with family and friends at home in England therefore formed a crucial means of erasing the isolation that prevailed in spite of being surrounded by fellow Anglo-Indians. Similarly, an individual's nostalgic recollections of India often helped a newcomer adjust to unfamiliar surroundings. For others, it sparked off a sense of camaraderie based on the comfort of shared places and events.

The survival of predecessors was an important green signal for those journeying to India. Testimonies to previous encounters with the colonial subcontinent remained embedded in different forms of travel literature that were published in Britain. These recommended a variety of routes to explore, scenic areas to visit, and picturesque locations to sketch. Experiences in nineteenth-century India also made a good story to tell, so the memory of colonial life spread by word of mouth as well. Captain Bellew, for instance, reminisced:

Long before the period of my departure arrived – indeed, I may say almost from infancy – I had been inoculated by my mother, my great uncle, and sundry parchment-faced gentlemen who frequented our house, with a sort of Indo-mania. I was never tired of hearing of its people, their manners and dress . . . what respect did the sonorous names of Bangalore and Cuddalore, and Nundy Droog and Severn Droog and Hookahburdars and Soontaburdars, and a host of others, excite in our young minds.[26]

As the Captain's account demonstrates, colonial memory returned to Britain, only to result in a fresh string of travellers' tales which outlined a different crop of Indian experiences.

Parks was conscious of her circle of fellow recorders and certainly aware of aligning her own experiences with theirs. The books portrayed in her work clearly show her attempt to fit into the ranks of writers who had made their mark on eager observers of the British Raj, including herself as well, for she had met Captain Luard and Emily Eden during her Indian sojourn.[27] Her connection with Eden is especially emphasized, since we observe the latter's

volume of portraits looped around the most embellished camel, which is placed centrally in her composition. Memsahibs' letters or diaries often mention the names of other Anglo-Indian women they had met in India. Parks's image, however, stands out as a unique visual example in which one female artist-traveller singles out another, possibly because Emily Eden's elaborate volume, *Portraits of the Princes and People of India* (London, 1844), was the only one of its kind at the time to have emerged from a fellow Victorian memsahib's brush. Fanny Parks would follow six years later with the publication of her journal in 1850.

If Parks's illustration shows an attempt to elevate her status in order to match the reputation of her colleagues, then it can also be viewed as a commentary on the distance between her rung and Emily Eden's on Anglo-India's social ladder. Parks depicts herself in the form of a spider crawling in and out of the Empire's nooks and crannies with her memoir. Though it is a humble creature in comparison to the noble camels standing tall, the insect's roamings are akin to the author/artist's own 'wanderings'.[28] An appropriate mascot, then, for a woman whose journal reads like a dense cobweb of insights into India's social and cultural practices. The shared experience of having been a memsahib at some point in their lives inextricably linked Fanny Parks and Emily Eden, two women who otherwise stood poles apart socially. Their books remained extensions of their personal experiences and shifting identities – both English and Anglo-Indian. The handsome leather-bound volumes might disregard boundaries of class as they sat next to each other on some collector's shelf at home in Britain, but the lives of their authors re-established in England told a different story. There is no evidence that Fanny Parks and Emily Eden met again when they returned to their country. As it is, their connection was rather tenuous in India where Eden mainly socialized within the upper crust. Parks, however, forges a perma-nent link with her by granting her pride of place within the group of itinerant camels. A subtle reflection on how social relations were reordered in the subcontinent in such a way that a middle-class memsahib could cross paths with an aristocratic Anglo-Indian woman, the image unites their absent figures in their common goal to represent the colonial setting to viewers back in Britain.

The Picturesque Colonial Identity

One of the striking features of Parks's picture is that she pays tribute to the visual as well as to written images through her selection of books displayed on the camels' necks. But in contrast to Parks's presentation of Anglo-Indian life to the British public, Emily Eden depicts a different, more privileged point of view.[29] Published in London two years after her return from the

colonial subcontinent in 1842, her volume is a sweeping vision of Indian royalty, political leaders, servants associated with royal households, and even royal pets she encountered during her stay. The 'princes' recorded in her book were mainly political characters crucial to the British imperial enterprise, and took up more space than the 'people' she observed. Of these princes, the Sikh rulers understandably formed the majority, due to the time she spent in the Punjab when the Maharaja Ranjit Singh and Lord Auckland signed a treaty to curb the Russian presence in Afghanistan.

By the middle of the nineteenth century, Indian monarchs were carefully ranked and placed under the scrutiny of political agents selected by the British. They had sworn allegiance to Queen Victoria and were forbidden to wage war against each other or the British in the hope of increasing their domains. Such a shrewd political move allowed colonial overlords to exercise control through the princes of the Raj, since the latter still represented centres of power for their local subjects.[30] Their grip on the popular imagination remained intact as the lavish trappings of princely India were retained by local royal families and feudal lords to maintain a semblance of social prestige. The British were no less susceptible to their pomp and pageantry. Emily Eden herself noticed the 'fabulous background of jewelled magnificence' of princes who had decked themselves with 'diamonds and caparisoned their horses with emeralds and gold'.[31] Royal India, as the name of her book suggests, was clearly regarded as a separate category, removed from the 'people' of the subcontinent.

Her preference is immediately obvious in her title page, where a young aristocrat identified as the 'Son of the Nawaub of Banda' appears enframed by a lattice window (Figure 5.2). Sparkling large brown eyes, rosy lips and cheeks, tiny feet in red socks peeping out beneath him and prominent dimples in his right hand proclaim him a vulnerable child. This impression is contradicted by his sword, encased in a deep red sheath and dutifully held upright at his waist. But the official gesture only reveals the irony underlying this show of princely power. The dimpled hand that grasps the sword in this case is truly powerless, for Banda hardly rivalled the overwhelming British Raj. Thus the sword, stripped of its capacity to protect, is simply reduced to an emblem signifying princely stature. All the hauteur and fragility of crumbling Indian monarchies come together in this diminutive yet proud figure of a boy-prince.

Emily Eden's portraits of Indian royalty reflect the long-established British fascination with maharajas and nawabs.[32] Indian/British monarchical rituals shared the basic principle of maintaining a glittering front, be it in a durbar, coronation, or royal procession. In her extensive study of the Tondaiman rulers of Pudukkottai in Trichinopoly, Joanne Punzo Waghorne points out that Victorian Britain and India shared a common fascination with

the 'world of ornamentation' found in courtly life in the subcontinent.[33] Bejewelled Indian princes would contrast sharply with the mournful figure of the English Queen, Sovereign of the British Empire. But, as Waghorne suggests, 'it was the *presence* of the Indian princes "at court" in Trichinopoly, Madras, Delhi, and at last in London that turned the dowdy and faltering British monarch into a real queen'.[34] The aesthetics of ritual, dress and decoration validated the carefully balanced structures of power within the different kingdoms, between rajas, nawabs, feudal lords, British Residents, Indian subjects, Anglo-Indians, and finally, their relationship with the Queen herself. Princely India not only reiterated to what extent the British held sway over the subcontinent – it also enabled Anglo-India to identify its own stage of regal spectacle.

Indian royalty had initially attracted the scrutiny of English audiences almost a century earlier, when British artists stationed in South Asia began recording portraits of nawabs and maharajas. By the second half of the eighteenth century, European painters had developed an important relationship with Indian connoisseurs. Native aristocrats stepped into their circle of patronage, providing a critical economic base for them while gaining an entry into the visual arena that displayed portraits of British monarchy and nobility. According to Mildred Archer, George Willison gave Britons back home their first taste of royal India's grandeur. Muhammad Ali, the Nawab of Arcot, commissioned the artist to paint his portraits, two of which were presented by the patron himself to George III and to the East India Company's House in Leadenhall Street. Full-length portraits of the Nawab, his son and grandson were later sent to England to be shown at the Society of Artists in 1777 and 1778.[35] Such exhibitions enabled Indian rulers to be shown alongside their European counterparts in several publicly accessible areas as well as in more exclusive royal apartments.

Eden's portable portfolio, however, brought princely India a step closer to British viewers safely ensconced in their armchairs at home. An interesting comparison between her drawings and the tradition of miniature painting raised by Adyanath Mukhopadhyay may shed further light in this direction. Mukhopadhyay notes that Maharaja Ranjit Singh's portrait painted in profile contains a hint of the style detectable in Indian miniature paintings in which the sitter's face is usually portrayed in such a manner.[36] Although Eden certainly admired the renderings of Indian miniature painters, their direct impact on her portraits is questionable.[37] What is certain, however, is that her small-scale drawings, like miniature paintings, pulled Indian royalty into the intimate world of British book-lovers. Published more than a decade before the subcontinent was officially taken over by the Crown of England, Eden's portraits set a striking precedent for the overwhelming interest in Indian royalty that could be found among collectors of Victorian bric-à-brac.[38] From

turbans to photographs of princes, a range of objects plucked out of their contexts in India were brought back to Britain, functioning as curios for a cabinet or conversation pieces on drawing-room tables.

Here then was a chance to 'own' princely India, handsomely packaged within a series of snapshot-like images. Traditional portraiture fixes a person within a painting by providing clues to his/her place in society. The lattice border encircling Banda's heir takes this concept even further by framing the colonial native.[39] It compels the viewer to focus entirely on the image that leaps out of the centre of the page, thereby enabling a British spectator to let his/her eye roam over the figure resplendent in opulent regalia. The sitter, however, can only be looked at, but cannot look back. The lattice pattern itself is based on the principle of directed vision. A popular design for screens constructed in the *zenana* or women's quarters, it was an ingenious device that shielded women from an encroaching male gaze while allowing the former to look on unhindered. Its filigree design spun a web of delicate miniature openings, each a window to the world on the other side. Transposed into Eden's portraits, the lattice therefore made voyeurs out of British readers.[40]

Whether her subject is an aristocrat or an ordinary person, Eden emphasizes the external characteristics of the human figure. In Sher Singh's portrait, for instance, she depicts him wearing a gold silk tunic, crimson shawl and bejewelled turban – coloured details which stand out against the pale washes she uses in the background. The experience of painting this lavish portrait is recorded in her letters: 'Shere Singh came to my tent to sit for his picture – such a gorgeous picture! all over diamonds and emeralds . . . He made a very good picture.'[41] A 'good picture' inspired by the ornamentation of the princely body reveals to what extent the picturesque – originally a landscape aesthetic – was applied to the human exterior in the subcontinent. As examined earlier, the idea that Indian aristocrats were worthy of drawing because of their visually appealing qualities (aside from their generous patronage) had already developed in the late eighteenth century when their portraits were exhibited in art academies in London. Their costumes rivalled the elaborate attire seen in European courts, but their foreign status made them objects of picturesque interest rather than simply sitters for portrait painters. In Britain, however, members of the English monarchy were never described as 'picturesque', although the rural poor and the lower economic orders of London often earned that label.

By the beginning of the nineteenth century, the picturesque lens extended to other kinds of indigenous bodies as well, as seen, for instance, on the first page of Mrs Sophia Charlotte Belnos's *Twenty-Four Plates Illustrative of Hindoo and European Manners in Bengal* (London, 1832). A brahmin shown reading in the shade of a banyan tree reveals the artist's ethnographic interest in the

different hierarchies which marked native societies (Figure 5.3). Belnos's work was preceded by François Baltazard Solvyns's *A Collection of 250 coloured etchings; descriptive of the manners, customs, character, dress, and religious ceremonies of the Hindoos* (published in Calcutta between 1796 and 1804), and later followed by William Tayler's *Sketches Illustrating the Manners & Customs of the Indians & Anglo Indians* (London, 1842). A plethora of Company paintings available in the early nineteenth century also presented various social classifications of Indians.[42] In her analysis of the memsahib's relationship with the picturesque, Sara Suleri notes: 'From the extensive body of journals, memoirs, letters and fiction written by Anglo-Indian women, it becomes evident that outside the confines of domesticity, one of the few socially responsible positions available to them was the role of female as amateur ethnographer.'[43] Belnos's work blends colonial ethnography with the picturesque lens by placing the brahmin beneath the banyan tree, one of the most popular motifs of landscape painting in British India. With its spreading branches and aerial roots drooping to the ground, the tree consistently appealed to scores of British artists from the Daniells to the photographer Samuel Bourne.[44] In Belnos's image, a distant mosque can be glimpsed through its enframing hanging roots, reminding experienced viewers of similar architectural studies published by William Hodges and the Daniells in the late eighteenth and early nineteenth centuries.

By the time the artist produced this picture, certain prescribed motifs were hailed as picturesque by observers of the colonial setting, including banyan trees, ruined mosques and even brahmins. To be familiar with such a range of visual vocabulary, she must have turned to other prints of the Indian landscape, like those made by Hodges, which were readily available at the time in the local art-market, or to the works of Solvyns and the Company painters.[45] Belnos apparently utilized them to position what Inderpal Grewal considers fundamental to the picturesque, 'the human against nature'.[46] The native body is therefore absorbed into the framework of an English landscape aesthetic only to be reproduced as colonial Indian. In this sense, Belnos's picture shares a strong similarity with Emily Eden's frontispiece. Both include motifs which had become synonymous with India. Each image, therefore, enables the viewer to experience a leap in his or her imagination, to leave Britain for a moment and to journey to India if only through the mind.

But the ability to imagine the subcontinent relied heavily upon the vast amount of visual material and literature on different social, political and cultural dimensions of the Raj that had already gained a foothold in Britain. In such surroundings, the images corresponded to motifs inextricably linked with India and at the same time triggered off other associations with that part of the Empire. The figure of the brahmin, for example, may have led to

questions about the caste system, a topic which preoccupied historians, theologists and diarists alike throughout the British Raj and which is brought up by Belnos herself. Her choice of imagery corresponds with social movements which had evolved during the thirty years preceding her publication. Fuelled by critical religious issues such as the suppression of *suttee* and *thagi*, the foundation of the *Brahmo Samaj*, and the activity of the Serampore missionaries, colonial overlords were busy evaluating government policies in British India between 1815 and 1837, just around the time when Belnos's book was emerging for the public to read.

In the light of such intense policy-making, the picture of the brahmin could also have instigated discussions in several other areas of interest to the British Raj, including archaeology, Hindu mythology, iconography and domesticity. It was the last category that especially shaped Anglo-Indian identity in an intimate setting. Indigenous commodity culture had gradually infiltrated the British colonial lifestyle, creating its own stereotypes of what sahibs and memsahibs looked like, how they lived, and what objects filled their homes. Belnos's brahmin sheds some light on this navigation between British and indigenous societies. Upon closer investigation, we find a *hookah* placed beneath the umbrella next to him. Known as the *hubble-bubble* in Anglo-Indian circles, it was a native smoking pipe also used by British sahibs and even by some memsahibs when they settled in the colony.[47] It was therefore responsible for stamping the European body with a mark of an Indian exterior, and by the beginning of the nineteenth century an Englishman with a *hookah* in hand formed a popular visual stereotype of the nabob, a wealthy Anglo-Indian who had amassed his fortune in the subcontinent.[48] Local merchants such as Hamilton and Company, established in Calcutta in 1808, began to supply *hookahs* to clients, manufacturing an elaborate sample for the 1867 Paris exhibition.[49] Although this commodity went on display in Europe, the actual habit of smoking a *hookah* gradually appeared less socially acceptable among Anglo-Indians, especially after the Mutiny when sahibs and memsahibs became acutely conscious of their British roots. The connotations were not surprisingly very negative, reiterating the already popular belief that nabobs were a lascivious, decadent lot, squandering their wealth on wine, women and opium in the colonies. Such stereotyping, together with the events of 1857, propelled a serious evaluation of national identity and culture within Anglo-Indian society, especially from the middle of the nineteenth century onwards. And the adoption of certain habits deemed originally Indian instigated the fear that English men and women were stepping dangerously close to the 'other', so much so that they were beginning to resemble natives in taste and lifestyle.

One of the criticisms levelled by current scholars at the vogue for the Indian picturesque is that it filtered out any traces of conflict between British

and native peoples. Suleri, for instance, remarks that 'the picturesque becomes synonymous with a desire to transfix a dynamic cultural confrontation into still life'.[50] Historically, the Sepoy Mutiny stands out as one of the most prominent racial clashes witnessed in the nineteenth century. Every song of praise about India dissolved into a stream of invective published through the British press in 1857. Letters sent to relatives and friends recounted tales of horror and conveyed tidings of sorrow. But even in those moments of acute grief, when the moral challenge of ruling India was shaken to its roots, Anglo-Indian survivors developed their own methods of reconfiguring their lives in the subcontinent. It was here that the picturesque functioned as a tool to erase the memories of a ravaged landscape. Lady Charlotte Canning, for example, produced a series of delicate watercolours that remained distanced from any signs of the violence which had so recently rocked the country. In a picture painted in 1858 at Coonoor, a hill station in South India, she depicts a valley stretching out into the plain below. Although only a year had passed since the uprising had started in Meerut, her work shows the calm solitude of an idyllic landscape. Suleri also remarks that 'the picturesque assumes an ideological urgency through which all subcontinental threats could be temporarily converted into water-colours and thereby domesticated into a less disturbing threat of belonging'.[51] The picturesque, as it emerged from Lady Canning's brush, filtered out any signs of the upheaval which had occurred so recently, albeit in a different part of the subcontinent. In this sense, the watercolour contrasted sharply with her journal entries and letters mailed to close relations and Queen Victoria. Into those she poured her feelings about the havoc created by rebellious Sepoys, unruly British soldiers, and the opinions of the press.[52] But more importantly, her view of the Coonoor valley highlighted the landscape that had *not* suffered. Instead of depicting burned-out towns and ravaged environs, the artist turned to the lush green hills of Coonoor. Here, the landscape aesthetic emerges as a remarkable tool which helped her survive beyond the horrors of the recent past. The geography itself came to be associated with her eye for the picturesque rather than with morbid memories of the Mutiny. Over time, the specific spot where she recorded this scene came to be labelled 'Lady Canning's Seat' on account of her frequent visits to it.

How and where did the picturesque situate the question of identity in the colonial landscape if the aesthetic tradition is believed to have had a subsuming effect? The use of a simple object like the *hookah* reveals the extent to which a practical knowledge of indigenous class, caste, and religious boundaries had emerged within British society domiciled in the colony. Different kinds of smoking pipes were utilized by separate castes and religious groups. But if the picturesque drew attention to those distinguishing characteristics, as seen for instance in Belnos's illustrated volume, then it

also visually dissolved indigenous social borders for British viewers. This can be seen at work in Eden's book in which a portrait of Ranjit Singh appears in the same context as a study of a servant from Government House, just as the brahmin occupies the first page of Belnos's publication to be later followed by a view of two Muslim women. Rival class, caste and gender categories have been eradicated in order to present a more homogenized version of India, echoing the manner in which any evidence of political turmoil remained absent in picturesque views of the subcontinental landscape.

A basic understanding of the social distinctions within native peoples was critical for running the domestic front, since most Anglo-Indian households relied on the efficiency of Indian servants. Eden's portrait of a uniformed native standing before a bookcase in Government House shows just how the aestheticization of the domestic made him more acceptable within the Anglo-Indian home. The domestic was a liminal figure, straddling both Anglo and Indian social spaces. His identity has the added component of being colonized, more Anglicized, by virtue of being in close contact with a British household. The gesture of the book-in-hand in his portrait further intensifies the moment of contact between a local native and a European area of influence. He is shown as the outcome of what Jenny Sharpe describes as 'the civilising mission' which 'performed the ideological work of producing a native desire for Western knowledge and, by extension, for British rule'.[53] Here, the dressing of the body to designate a specific domestic status establishes him as a native associated with a British household. It separates him from his fellow countrymen by giving him an official foothold within an Anglo-Indian home-away-from-home, a veritable *sanctum-sanctorum* usually to be protected from prying native eyes. At the same time, for him to be accepted within that sphere, he must be aestheticized in a suitable manner. In this sense, the dress code followed in British domestic establishments that depended on large groups of servants was re-fashioned for the Anglo-Indian household. 'Every servant at Government House is a picture by himself', observed Eden, 'in his loose muslin robes, with scarlet and gold ropes round his waist, and his scarlet and gold turban over masses of black hair.'[54]

Thus, the external attributes of the Indian body override any distinctions of caste or creed. The British interest in Indian castes and trades rose throughout the nineteenth century, whether it be from a pragmatic point of view, as seen for instance in Captain A.H. Bingley's *Caste Handbooks for the Indian Army, Part I: Rajputs* (Simla, 1898), or from a Victorian ethnographer's perspective, demonstrated in T. Broughton's *The Costume, Character, Manners, Domestic Habits, and Religious Ceremonies of the Marathas* (London, 1813), Mrs Belnos's *The Sundhyas, or the Daily Prayers of the Brahmins* (Allahabad, 1851), and H.H. Risley's *The Tribes and Castes of Bengal* (Calcutta, 1891). Clay models

of caste and professional categories, including 'a sadhu musician, government employee, Muslims, pandits and a coolie', brought back to England as souvenirs, also shed light on the vast spectrum of social categories.[55] But the visual restructuring of indigenous religious/social borders was an inevitable outcome of the British attempt to package neatly the subcontinent's complicated history for audiences at home. It was necessary to analyse the Indian identity before the British could locate themselves within the colonial landscape. Hence the extensive output of visual and written information about Indians as well as Anglo-Indians in South Asia. Scenes of India, as found in all the works examined here, needed to be sifted, sorted and labelled to form a miniature representation of the country's geography and history. The picturesque therefore provided a valuable visual conduit through which images of the subcontinent could be condensed and transported back to audiences in Britain.

These drawings and their growing circulation reveal an increased familiarity with Indian surroundings, so much so that even the interiors of domestic landscape had become the focus of artistic scrutiny.[56] Eden and Belnos are two artists who produced such intimate views, and by the time they drew their images, contact between natives and Britons had already caused enormous interest among observers of British Indian society. The colonial divide was no longer viewed as an impenetrable wall, and sahibs and memsahibs encountered the same kind of scrutiny previously only trained on indigenous peoples: to what extent was their Anglo-Indian identity Indianized? This question seems to have perplexed most Britons stationed in the subcontinent well beyond the turn of the century. If it signified British measured against the colonial 'other', it also meant British measured against themselves at home as well as in the colonial setting. Children were especially used as the yardsticks for such cultural self-evaluation and, in the process, as targets for social stereotyping by their own community. The colonial climate was believed to have a debilitating effect on them, as seen for instance in Fanny Parks's observation that the 'children of Europeans in India have a pale sickly hue, even when they are in the best of health; very different from the chubby brats of England'.[57] Once again, we find a preoccupation with the aesthetics of the body to describe the colonial infant. A rare picture of Victorian childhood in Bengal portrayed by Mrs Belnos shows the potential threat that even Indian society was thought to impose upon Anglo-Indian children. The artist depicts two European infants, accompanied by their *ayah* or maid, watching a street entertainer perform tricks with a goat (Figure 5.4). A new generation of Britons stands at the brink of a savage domain, the primitive clearly hammered home by the marked resemblance between the trainer and his monkeys. Anglo-Indian parents

concerned about the effects of the colonial setting on their children's con-
stitution and character often sent them back home to England to live with
close relatives or attend boarding schools. The popular notion of a Victorian
family, complete with husband, wife and children, therefore underwent a
radical reconstruction in India. Kinship patterns once re-ordered stretched
between Britain and the subcontinent, causing, as Nupur Chaudhuri has
noted, a 'breaking up [of] the cohesion of Anglo-Indian families ... They
[memsahibs] could either stay with their husbands in India or return to
Britain with their children and leave their husbands behind.'[58]

The Return of a Picturesque Eden

By the end of the nineteenth century, however, while the events of 1857 had
not been forgotten, India had found a new footing within British cultural
memory as an Edenic space. In June 1882, the Marianne North Gallery
opened in the Royal Botanic Gardens at Kew to exhibit an outstanding array
of a Victorian woman's botanical illustrations, painted during her extensive
travels.[59] North's drawings merge the scientific with the picturesque, the
result of the artist's eye focused as much on the landscape as possible.
Referring to her painstaking details, Anthony Huxley notes, 'One might say
that Marianne North used her brush as the modern botanical traveller uses a
camera.'[60] Her paintings of a multitude of colonial flora went on display at a
time when Kew was deeply involved with satellite botanical gardens set up
in the colonies, including Calcutta's scientific institution. In 1884 the Royal
Gardens were poised to restructure botanical research in India under Sir
Joseph Hooker's supervision.[61] Hooker, a former visitor to the subcontinent,
was also instrumental in extending a permanent home to North's paintings
(albeit at her own expense) and specimens at Kew.[62] Thus, what began as a
private art exhibition in her flat on Victoria Street was reviewed by the *Pall
Mall Gazette* and *The Studio*, and finally turned into a public display of
natural history.[63]

Amidst the flora North painted, the rhododendron is the most consistently
mentioned flower in Anglo-Indian artist/authors' memoirs (Figure 5.5). On a
trip to Simla in 1838, Eden observed that 'red rhododendron trees bloom in
every direction, and beautiful walks like English shrubberies cut on all sides
of the hills. Good! I see this is the best part of India.'[64] In North's close-up of
the *Rhododendron nilagiricum*, a variety that grew in south-west India, the
slopes of the Nilgiri Hills and woodlands appear beyond the branches of its
bush. The view is enriched with sentimental associations – a memory of
picturesque England discovered on Indian soil. For Anglo-Indians, the
attraction towards hill stations, whether Darjeeling, Ootacamund or Simla,
was a response to a yearning for familiar climates, flora and fauna left

behind at home.[65] Thus British nostalgia overlapped with the Indian pictur-
esque, forming a vision of Empire that finally returned to Kew through the
renderings of a memsahib's brush.

The gallery, however, presented the entire gamut of North's works – from
her paintings of Brazilian flowers to her drawings of Indian plants, demon-
strating what Susan Faye Cannon describes as the Victorian attempt 'to
stabilize the world'.[66] On a round through the densely packed exhibition
space, the visitor found a collection that brought the colonies literally to his/
her doorstep. In contrast to the large-scale exhibitions held in London and
Paris from 1851 onwards, Marianne North's display was a permanent
fixture. Serious botanists, students, artists, or simply curious onlookers,
could all visit the Kew exhibition to get a lighthearted lesson in colonial
geography and natural history.[67] But collections such as these, as Mieke Bal
points out, 'especially when publicly accessible, appear to "reach out" . . .
through this complex and half-hidden aspect they in fact "reach in", helping
the collector – and, to a certain extent, the viewer – to develop their sense of
self while providing them with an ethical or educational alibi'.[68] By travel-
ling through the array of exotic flora and fauna, a visitor could draw
comparisons with the local environment. Such an experience naturally
cemented a sense of belonging to Britain because it evoked memories of
one's immediate surroundings. At the same time, it enabled a viewer to look
at exotic plant specimens in painted form, a safe way to explore selected
examples inside a small space without having to step into the actual
geographical areas to which they belonged. Thus the distance between
Ceylon, Singapore, Borneo, Japan, Java, New Zealand, Australia, Chile,
Brazil, Jamaica, America and India collapsed as scenes of these places were
stuffed into the building designed by James Fergusson. The Marianne North
Gallery had become a British nucleus, representative of all the far-flung
destinations to which Britons had travelled by the late nineteenth century.

This permanent exhibition of Indian plants in London takes centre stage
among the examples of transposed colonialism investigated in this paper.
Unlike the illustrated volumes examined here, it was publicly accessible,
thereby dissolving not only cultural distances but also class distinctions
within British audiences eager to catch a glimpse of the colonial setting. The
tangible Indian presence within one of Britain's most important botanical
collections reveals that the Raj was critical to a sense of British national
identity. No longer were visits to other parts of the Empire the only means to
understand the scope of British rule. Visitors could turn to their own nation's
capital to 'discover' the flora of the subcontinent. Thus the Marianne North
gallery epitomized the return of the British involvement in South Asia to the
familiar cultural space of the homeland. James Fergusson, its designer, was a
noted authority on Indian architecture, and his link with the gallery was

bound to invoke the cultural proximity between the Empire and Britain. But the picturesque remained at the crux of even this instance of colonialism relocated in London. Closely attached to the art of English gardening, the landscape aesthetic had come full circle from a foreign landscape to the country of its origin, in the shape of a scenic Eden situated in the Royal Botanical Gardens.

Conclusion

In this study, I have examined the impact of the picturesque on the drawings of memsahibs and its eventual return to London through visual and written impressions as well as through objects from the colonial surroundings. The most important, overarching contribution of the picturesque was that it enabled British audiences to visualize the subcontinent. Without this pictorial component, it would have been impossible to forge a sense of belonging with India while still remaining attached to Britain. As Bernard Cohn points out, for Anglo-Indians, their 'anchorage in society was a double one'.[69] But the picturesque did more than simply reiterate the British link with two cultural spaces. It focused the aesthetic lens on the points of social contact between two groups of peoples, the ramifications of such meetings, and the ways in which the systems of beliefs found within the separate cultures mingled and shaped both sides of the colonial divide. It gave Britons a tool with which they could observe the native geography and peoples, and at the same time view themselves against the backdrop of such a setting.

I have shown that Anglo-Indians as much as indigenous peoples formed a crucial channel for transposed colonialism, for they represented the extent to which the 'other' had already been inscribed on British identity in the subcontinent. That these social encounters have been investigated through drawings and paintings produced by memsahibs ironically reflects their own position within colonial society. The most prominent locus of concerns about the diffusion of the British race and values in the subcontinent, Anglo-Indian women were in reality a sharp contrast to the popular nineteenth-century stereotype of indolent creatures willing to dismiss their domestic and moral duties while based abroad. Instead, they socialized, built a home, gave birth to future generations of the Empire's leadership, recorded their impressions and kept in touch with family and friends at home. In short, they actively participated in the very cycle through which colonial culture was relocated in England. As seen here, their letters, diaries and illustrated travelogues channelled valuable impressions of the Raj to observers back in Britain. But even their opinions were complicated by their individual positions in colonial society. Emily Eden's portfolio therefore focused on princely subjects Mrs Belnos would never have had the opportunity to meet in India.

Such social distinctions reveal that Anglo-Indians did not simply comprise a homogenous group of peoples, and that the manner in which they transported images of their second home back to Britain corresponded with their opportunities to access certain kinds of subjects in certain places in the subcontinent. Yet their mode of description remains the most unifying, if not distinctly patriotic element throughout these social/cultural distinctions. Recording scenic views of peoples and places reaffirmed British nationalism even as such pictorial articulation addressed the differences between and within native as well as Anglo-Indian societies. With roots embedded in a landscape aesthetic, such a visual approach borrowed from British artists and aesthetes at home indeed enabled Britons to see how their native culture was being shaped beyond Europe, and how it would return to mingle again with its picturesque origins.

Notes

I would like to thank Susan P. Casteras, Esther da Costa Meyer, Nilanjana Dasgupta, Nancy Marshall, Kara Olsen and Sharmila Sen for their insightful comments offered at various stages of this paper. I am also grateful to the staff of the Victoria Memorial, Calcutta, for granting me permission to examine Emily Eden's original drawings and watercolours housed in their collection.

1. The term 'memsahib' was used to designate a European woman stationed in India. I utilize it for the British woman in the colony. See Henry Yule and A.C. Burnell, *Hobson-Jobson: The Anglo-Indian Dictionary* (Ware, Herts: Wordsworth Editions, 1996): 567. Likewise, the term 'sahib' was used for European men living in the subcontinent. See Yule and Burnell: 781–2.

2. Emma Roberts, *The East India Voyager or Ten Minutes Advice to the Outward Bound* (London: J. Madden and Company, 1839): 22–3.

3. For an informative survey of the picturesque movement in India, see Mildred Archer, *British Drawings in the India Office Collection* (London, 1969: HMSO, Volume I): 18–24.

4. Violet Dickinson, *Miss Eden's Letters* (London: Macmillan, 1919): 264.

5. Malcolm Andrews, *The Search for the Picturesque: Landscape Aesthetics and Tourism in Britain, 1760–1800* (Aldershot: Scolar Press, 1989): 39.

6. I use the term 'Anglo-Indian' in its nineteenth-century context when it was used to designate Britons stationed in the colonial subcontinent.

7. Sara Suleri, *The Rhetoric of English India* (Chicago: University of Chicago Press, 1992): 82–3.

8. Anjali Sengupta, *Cameos of Twelve European Women in India* (Calcutta: Rddhi; 1984): 121–3.

9. Lear visited India between 1873 and 1875. His Indian journals are in the collection of the Houghton Library at Harvard University.

10. Ray Desmond, *Kew: The History of the Royal Botanic Gardens* (Kew: Harvill Press, 1995): 260.

11. See Paul Greenhalgh, *Ephemeral Vistas: The Expositions Universelles, Great Exhibitions and World's Fairs, 1851–1939* (Manchester: Manchester UP, 1988): 59–63.

12. George Franklin Atkinson, *Curry and Rice: or the Ingredients of Social Life at 'Our' Station in India* (London: n.p., 1860). Poem follows title page. See also Archer, *British Drawings*: I, 95.

13. I specifically draw upon Benedict Anderson's seminal discussion of the 'imagined world' of a nation 'conjured up' by its citizens who are largely unknown to each other. See Benedict Anderson, *Imagined Communities: Reflections on the Origin and Spread of Nationalism* (New York: Verso, 1991): 22–6.

14. The very mode of travelling in India altered radically in the second half of the nineteenth century. By then, the long road and river journeys experienced by Emily Eden were replaced by

less arduous railway travel. Lord Dalhousie's modernizing schemes set down in the Minute of 1853 assured a new improved form of transportation, allowing visitors such as Marianne North to move along fresh tracks laid down across the country. See Percival Spear, *India, Pakistan, and the West* (New York: OUP, 1967): 97; C.A. Bayly, *Indian Society and the Making of the British Empire* (Cambridge: Cambridge UP, 1988): 132–3.

15. Roberts sheds some light on the extent to which British followers of the colonial scene were familiar with these artist/author's works. See *The East India Voyager*: 47, where she writes:

> To Major Sherer, Major Archer, and Captain Mundy, the reading public are indebted for some very entertaining volumes illustrative of Indian manners and Indian scenery, and the drawings of Major Luard, of Lieutenant White, Captain Jump and others, are justly esteemed as highly valuable additions to the portfolios of the lovers of art.

For Captain Mundy's observations of the Indian picturesque, see Mildred Archer, *Indian Painting for the British 1770–1880* (London: OUP, 1955): 4–5.

16. Travelling in India was an arduous affair even after railway systems were established by the middle of the nineteenth century. See for example, Margaret MacMillan, *Women of the Raj* (London: Thames and Hudson, 1988): 66–88.

17. Simon Schama, *Landscape and Memory* (London: HarperCollins, 1995): 61.

18. For information about other dioramas, panoramas and cosmoramas in nineteenth-century London which depicted Indian places and events, see Richard D. Altick, *The Shows of London* (Cambridge, Mass., and London: Belknap Press, 1978): 177, 212.

19. Janet Dunbar, *Golden Interlude: the Edens in India 1836–1842* (London: John Murray, 1955): 115. See also Emily Eden, *Up the Country* (London: Virago, 1997): 44. In her letter dated Thursday, December 7, 1837, Emily Eden records a meeting with Mrs Parks in which the latter offered to act as interpreter for the Eden sisters during their visit to the Baiza Bai, a dowager queen of Gwalior.

20. Pratapaditya Pal and Vidya Dehejia, *From Merchants to Emperors: British Artists and India, 1757–1930* (Ithaca and London: Cornell UP, 1986): 67–9.

21. Marianne North, *Recollections of a Happy Life* (London: Macmillan, 1892): I, 315. See also Laura Ponsonby, *Marianne North at Kew Gardens* (Exeter: Webb and Bower, 1990): 61–3.

22. Marcia Pointon, 'Killing Pictures', in John Barrell, ed., *Painting and the Politics of Culture: New Essays in British Art* (Oxford and New York: OUP, 1992): 40.

23. For a more extensive discussion of this issue see for instance Vron Ware, *Beyond the Pale: White Women, Racism and History* (London and New York: Verso, 1992): 35–44.

24. The imagery of the lotus is particularly significant in Hindu and Buddhist mythologies. Both regard it as the embodiment of purity and eternity. For a more detailed explanation, see V.S. Naravane, *The Elephant and the Lotus: Essays in Philosophy and Culture* (New York: Asian Publishing House, 1965): 231–40.

25. Eden, *Up the Country*: 71.

26. Captain Bellew, *Memoirs of a Griffin* (London: n.p., 1813): 7–8.

27. See Fanny Parks, *Wanderings of a Pilgrim, in Search of the Picturesque* (London: Pelham Richardson, 1850): 7, where she describes her opinion of his drawings. They met on the *Marchioness of Ely*, a ship that was bound for Bengal. For Fanny Parks's meeting with Emily and Fanny Eden, see Eden, *Up the Country*: 44.

28. See Parks, *Wanderings of a Pilgrim*: 26. Insects were to remain the bane of colonial Indian life, a circumstance that Parks and others describe with the eye of a memsahib well accustomed to stumbling upon them in unsuspecting hiding places: 'The insects are of monstrous growth, such spiders! and the small-lizards are numerous on the walls of the rooms, darting out from behind pictures, &c.'

29. Emily Eden's original watercolours and sketches later converted into prints for publication are in the Victoria Memorial, Calcutta, India.

30. Thomas R. Metcalf, *An Imperial Vision: Indian Architecture and Britain's Raj* (Berkeley and Los Angeles: The University of California Press, 1988): 105.

31. Dunbar, *Golden Interlude*: x.

32. This appears to continue today throughout Europe and North America where Indian restaurants sport grand titles such as *Royal India, Bombay Palace, Taj Mahal* and *Durbar*, while they dole out greasy chicken tikka masala and poor replicas of Hyderabadi Biryani (once a royal dish) to their unsuspecting clients.

33. Joanne Punzo Waghorne, *The Raja's Magic Clothes: Re-visioning Kingship and Divinity in Britain's India* (University Park, Pennsylvania: Pennsylvania UP, 1994): 12–13.

34. Ibid., 84.

35. Mildred Archer, *India and British Portraiture 1770–1825* (London: Phillip Wilson, 1979): 100–103. See also Bayly, *The Raj: India and the British 1600–1947* (London: National Portrait Gallery, 1990): 181–2. The tradition of full-length oil paintings of Indian royals continued even after Emily Eden's book was published, as seen for instance in Franz Winterhalter's portrait of Maharaja Dalip Singh (1854).

36. Adyanath Mukhopadhyay, *Emily Eden's Sketches in Victoria Memorial, A Descriptive Catalogue* (Calcutta: Victoria Memorial, 1988): 5, fig. 44.

37. Ibid., 2.

38. Waghorne, *The Raja's Magic Clothes*: 2.

39. See Paul Mitchell and Lynn Roberts, *Frameworks: Form, Function and Ornament in European Portrait Frames* (London: Merrell Holberton, 1996): 21. Also, John Sweetman, *The Oriental Obsession: Islamic Inspiration in British and American Arts and Architecture 1500–1920* (Cambridge and New York: Cambridge UP, 1987): 11.

40. See Pal and Dehejia, *From Merchants to Emperors*: 199, 210; also Bayly, *The Raj*: 320. Photography, when it arrived in India towards the mid-nineteenth century, yet again focused the aesthetic lens upon the native aristocracy. By then, maharajas themselves had turned into avid photographers, and added a new dimension to the concept of colonial vision and voyeurism.

41. Eden, *Up the Country*: 223.

42. G.H.R. Tillotson in Bayly, *The Raj*: 141–51. Mrs Belnos would later produce her book on rituals performed by Hindu brahmins, entitled *The Sundhyas, or the Daily Prayers of the Brahmins* (Allahabad, 1851).

43. Suleri, *The Rhetoric of English India*: 75.

44. Pal and Dehejia, *From Merchants to Emperors*: 108, 194, figs. 99, 202. For a view of William Daniell's *The Banyan Tree* (1833), see *Landscape Paintings in the Victoria Memorial Collection, Chiefly by European Artists* (Calcutta: Victoria Memorial, 1991): 39.

45. Pratapaditya Pal, *Changing Visions, Lasting Images: Calcutta through 300 Years* (Bombay: Marg Publications, 1990): 130.

46. Inderpal Grewal, *Home and Harem: Nation, Gender, Empire and the Cultures of Travel* (Durham and London: Duke UP, 1996): 100.

47. Yule and Burnell, *Hobson-Jobson*: 423–4. For a detailed discussion of smoking in India, see also Spear, *The Nabobs: A Study of the Social Life of the English in Eighteenth-Century India* (Calcutta: Rupa, 1991): 98–100.

48. For illustrations of such figures, see Stuart Cary Welch, *Room for Wonder: Indian Painting during the British Period 1760–1880* (New York: American Federation of Arts, 1978): 89; Pal and Dehejia, *From Merchants to Emperors*: 61, 64; Bayly, *The Raj*: 178.

49. Deborah Swallow, 'The Raj: India 1850–1900', in John Guy and Deborah Swallow, eds, *Arts of India: 1550–1900* (London: Victoria and Albert Museum, 1990): 217.

50. Suleri, *The Rhetoric of English India*: 76.

51. Ibid., 75–6.

52. Charles Allen, *A Glimpse of the Burning Plain: Leaves from the Indian Journals of Charlotte Canning* (London: Michael Joseph, 1986): 51–95.

53. Jenny Sharpe, *Allegories of Empire: The Figure of Woman in the Colonial Text* (London and Minneapolis: University of Minnesota Press, 1993): 58. See also Nirad C. Chaudhuri, 'The Influence of British and European Literature on Hindu Life', in Robert Cecil and David Wade, eds, *Cultural Encounters, Essays on the Interactions of Diverse Cultures Now and in the Past* (London: The Octagon Press, 1990): 55–71.

54. Dickinson, *Miss Eden's Letters*: 264.

55. Bayly, *The Raj*: 223, 287, 288; figs. 282, 283, 364, 365. See also Mildred Archer, *Company Drawings in the India Office Library* (London: HMSO, 1972): 7, for the kinds of indigenous figures that attracted British painters.

56. Archer, *Company Drawings*: 8.

57. Parks, *Wanderings of a Pilgrim*: 144.

58. Nupur Chaudhuri, 'Memsahibs and Motherhood in Nineteenth-Century Colonial India', *Victorian Studies* 31 (4), Summer 1990: 533–4.

59. Ponsonby, *Marianne North at Kew Gardens*: 124.

60. See Anthony Huxley's introduction to *A Vision of Eden: The Life and Work of Marianne North* (New York: Holt, Rinehart and Winston, 1980): 12.

61. Desmond, *Kew: The History*: 294. For a brief survey of Kew's role in the foundation of the Calcutta Botanic Garden, see Richard H. Grove, *Green Imperialism: Colonial Expansion, Tropical Island Edens and the Origins of Environmentalism, 1600–1860* (Cambridge: Cambridge UP, 1995): 333–48.

62. Susan Morgan, *Place Matters: Gendered Geography in Victorian Women's Travel Books about Southeast Asia* (New Brunswick, NJ: Rutgers UP, 1996): 108. See also her chapter on Marianne North: 91–132.

63. Ponsonby, *Marianne North at Kew Gardens*: 76; Professor J.P.M. Brenan's preface in *A Vision of Eden*: 7.

64. Eden, *Up the Country*: 125.

65. See Dane Kennedy's chapter which explains the significance of hill-stations built by the British in India, in *The Magic Mountains: Hill Stations and the British Raj* (Los Angeles and Berkeley: University of California Press, 1996): 39–62.

66. Susan Faye Cannon, *Science in Culture: The Early Victorian Period* (New York: Dawson and Science History Publications, 1978): 1.

67. For a brief description of Kew's policies regarding admission of the public, see Desmond, *Kew: The History*: Appendix 4, especially p. 389.

68. Mieke Bal, 'Telling Objects: A Narrative Perspective on Collecting': 105; also Jean Baudrillard, 'The System of Collecting': 12; in John Elsner and Roger Cardinal, eds, *The Cultures of Collecting* (Cambridge, Mass.: Harvard UP, 1994).

69. Bernard S. Cohn, *An Anthropologist among the Historians and Other Essays* (Oxford: OUP): 1996 424.

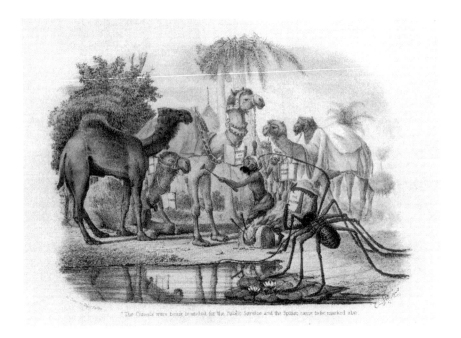

5.1 Fanny Parks, 'The Camels were being branded for the Public Service and the Spider came to be marked also', illustration, *Wanderings of a Pilgrim, in Search of The Picturesque, During Four-and-Twenty Years in the East; with Revelations of Life in The Zenana*

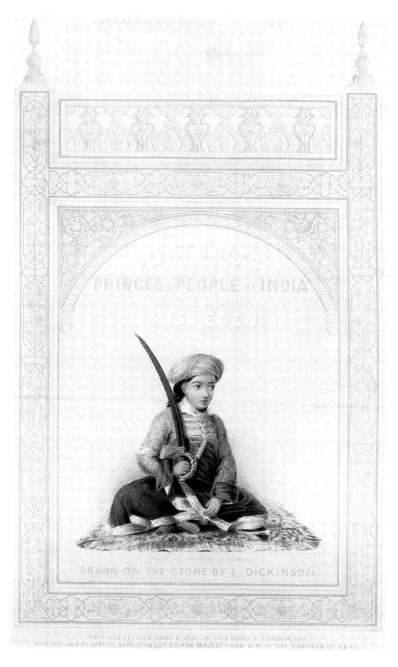

5.2 The Honourable Emily Eden, 'Son of the Nawaub of Banda'. Title page,
Portraits of the Princes and People of India

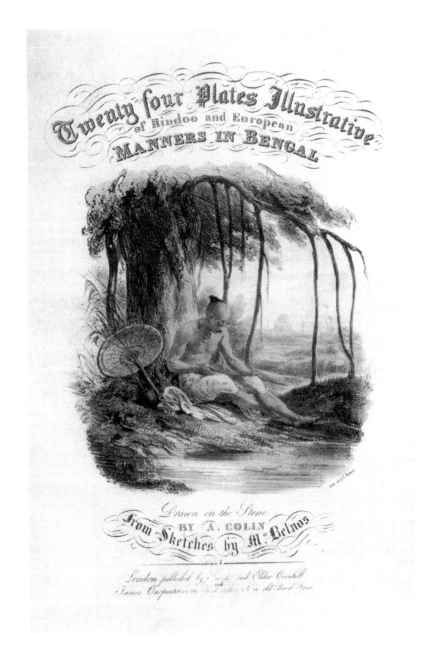

5.3 Mrs S.C. Belnos. Title page, *Twenty-Four Plates Illustrative of Hindoo and European Manners in Bengal*

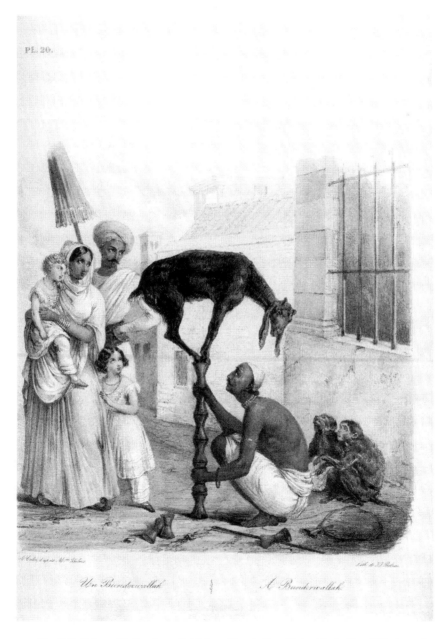

5.4 Mrs S.C. Belnos, 'A Bunderwallah' from *Twenty-Four Plates Illustrative of Hindoo and European Manners in Bengal*

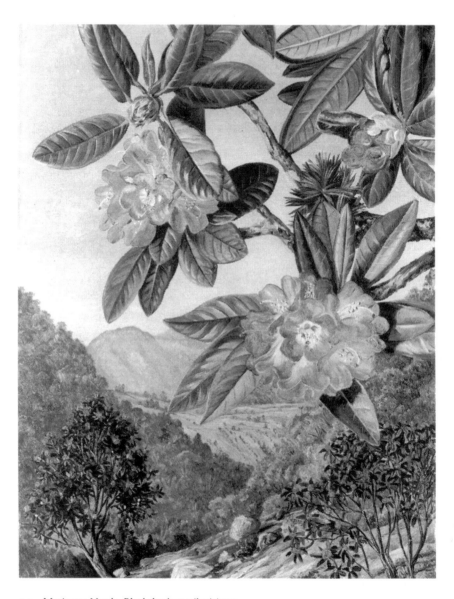

5.5 Marianne North, *Rhododendron nilagiricum*

To see or not to see: conflicting eyes
in the travel art of Augustus Earle

Leonard Bell

Outside of New Zealand and Australia the English artist Augustus Earle
(1793–1838) is not well known.[1] Yet he was probably the most widely
travelled artist in the first half of the nineteenth century, a period in which
increasing numbers of European artists were working, temporarily or per-
manently, in other parts of the world – the Middle East, North Africa, India
and, in fewer numbers, South America, Australasia and Southern Africa, as
well as, of course, those parts of the still 'new' America recently occupied or
explored. Earle spent time in North Africa and the Mediterranean (1815–17),
America (1818), Peru (1820), and Brazil (1821–24), eight months on Tristan da
Cunha in the South Atlantic (1824), Australia (1825–8), with a six-month
sidetrip to New Zealand, before returning to England, via Guam, Malaya
and India, in 1829.[2] He was appointed the official artist on *H.M.S. Beagle* in
1831 for the now famous voyage on which Charles Darwin was the natural-
ist, though he (Earle) left the ship in Montevideo and returned to England
because of ill-health in 1832 – a consequence, perhaps, of the arduous, at
times life-risking travels he had earlier undertaken. Earle had been to places
rarely or never before visited by European artists, notably New Zealand and
Tristan da Cunha, then called 'The Inaccessible'. He described it as: 'one of
the most remote parts of the globe, separated from the rest of the world by
thousands of miles ... an island little better than a savage one'.[3] He did not
stay there willingly. He and his dog had been left behind by the ship on
which he was en route from Brazil to Capetown. He wrote of his time on
Tristan da Cunha as an imprisonment: 'I station myself upon the rocks,
straining my eyes with looking along the horizon in search of sail, often
fancying the form of one where nothing is ... I retire to my lodging with
increased melancholy and disappointment.'[4]

Earle's self-portrayal in *Solitude, watching the horizon at sunset ... Tristan da
Cunha, in the South Atlantic* (Figure 6.1), taken in isolation, may seem an

exercise in narcissistic self-absorption, but, as his written narratives and many of his other paintings show, his travelling self was more down-to-earth than romantic. He was open to new and different views, and exploration of a body of work he produced during or as a result of his travels reveals that still-standard characterizations of, and assumptions about, European representations of landscapes, peoples and events in colonized places in the nineteenth century may be inadequate and flawed. What were in fact complex and heterogeneous sets of interactions and exchanges have often been simplified and homogenized.[5] For instance, it has generally been overlooked that European artists could produce images that went against the grain; that even if most of their images may have contributed to the mapping and conceptual fixing of newly encountered or occupied lands that were fundamental to projects of imperial control and expanding power, images were nevertheless produced which raised questions about these projects and the relationships they involved.

In relation to this, I will consider Earle's unconventional and most unusual inclusion of himself, or a stand-in, as a primary subject in a significant number of his travel pictures, in contrast to the usual and conventional separation, either through exclusion or marginalization, of the executive artist from that which he or she had otherwise represented.[6] This feature of Earle's work can be related to his not infrequent practice of introducing elements into his pictures that undermined or disrupted the unities of the conventionally sublime, picturesque and pastoral, and the standard roles and functions of figures in landscape and genre painting in late-eighteenth- and early-nineteenth-century British and European art. This practice suggests his recognition that the pictorial models and aesthetic categories so frequently 'imposed' by European artists on non-European places and their inhabitants, in attempts, perhaps, to render the unfamiliar familiar or to neutralize the troubling and intractable, were not necessarily adequate or appropriate for representing 'truths' of those situations as he experienced or perceived them. With these works of Earle's it is possible to investigate the problematics and complexities of looking, of viewing and being viewed, in various colonial and imperial locations. It is probably fair to say that conventional pictorial models or representational strategies, including recent colonial discourse theory and postulations about the 'colonial gaze', have been largely blind to the problematics and complexities of such interactions.

The Figure of the Travelling Artist: In and Out of the Picture

These claims, which may sound bold, need qualification. To set Earle up as a subversive anti-imperial hero would be to romanticize and misrepresent

him. In fact, while some of his paintings can be read as representing and critiquing aspects of European colonizing and imperial activities, Earle was not opposed to the British imperial project overall. Indeed he subscribed to the notion of an enlightened, benevolent colonialism as a progressive stage in human social evolution that would benefit humankind generally. And some of his other paintings, or engraved and lithographic reproductions of them, were used to promote and make known the British colonization of Australia and New Zealand. Rather the paintings by Earle discussed in this essay complicate any simple and single reading. His paintings manifest a variousness, a multidimensionality or open-endedness in terms of possible meaning and functions, which point to the transformative effects that artists' engagements with different places and peoples could have on European artistic practices. 'It is a desirable thing', wrote Earle, 'and one only to be acquired by travelling, to be able to accommodate oneself to the society Providence may throw us amongst.'[7]

In one of his oil paintings in which Earle represents himself endeavouring so to behave, *The Meeting of the Artist and the Wounded Chief Hongi, Bay of Islands, New Zealand, 1827* (c.1835, Alexander Turnbull Library, Wellington),[8] there is an anomalous detail in the centre foregound – an open book, the pages seemingly blank. Could this book refer to a book that would be created from the sketches made on, or as a result of, Earle's travels – the world rendered in terms of pictures for or in a book? And there is a sketchbook beside the artist in that picture too, while in another oil painting, *Bougainville Falls, Blue Mountains, New South Wales* (c.1827, National Library of Australia, Canberra), Earle places himself in the centre foreground making a sketch of an Aborigine posed before a waterfall in the left near-midground. What we have here could be seen as parts or bits of the world the artist was bringing into visibility; parts of the world which would supposedly be made visible – created – for the European audience in paintings or book illustrations.

Certainly during his journeys Earle followed the standard procedure of travelling artists, making small drawings and watercolours and collecting 'field notes' from which images for exhibition or book publication could be made once the artist was back home, where there were large audiences and markets for such material. A huge number of illustrated travel books were published in the years between 1770 and 1850.[9] These were large, often expensive books devoted to specific places like India, Brazil, South Africa and New Zealand, and they typically featured either full-page engravings or lithographs with accompanying letterpresses. These books were primarily vehicles for visual images, images that catered to prevailing tastes for the picturesque, exotic and novel and for the spectacle. Some illustrated travel books had a scientific dimension, contributing to the documentation and

organization of knowledge about the world beyond Western Europe, through the imaging of peoples and places as objects of knowledge, effectively constituting, or attempting to constitute, a 'physiognomy of the earth'.[10] Generally, illustrated travel books and travel paintings could be seen as a means by which Europeans structured and narrated the world, or attempted to do so.

In Earle's case there were several publications and exhibitions which were based on, made use of, or reproduced selections of his travel sketches: *Views in New South Wales and Van Diemen's Land* (1830), *Sketches Illustrative of the Native Inhabitants and Islands of New Zealand* (1838), and three panoramas, painted by Robert Burford from Earle's drawings, which were staged in London, of Sydney and environs (1830), Hobart and environs (1831), and the Bay of Islands, New Zealand (1838). There were engravings after Earle's sketches in Maria Graham's *Journal of a Voyage to Brazil and Residence There* (1824). What is now probably Earle's best-known book, *A Narrative of a Nine Months Residence in New Zealand in 1827, together with a Journal of Residence in Tristan da Cunha* (1832), though, does not belong to the genre of the illustrated travel book, in that it has only six engravings, which are very secondary to the 350-page text.[11] At the time of his death Earle was reportedly working on, or had planned, an ambitious illustrated travel book, in which many of his paintings would have been reproduced, probably in full-page hand-coloured lithographs, the favoured medium for illustrated travel books by the late 1830s. If a manuscript was ever completed, it is lost. Nevertheless, it is possible to get a sense of what the book would have been like from the sketches which survive from his travels, and which were titled and listed in a document that referred to a planned book, *A Voyage Round the World*.[12] What could this book have amounted to? Compiled from his sketches, might the book have been primarily a collection of separate images, simply descriptive of landscapes, indigenous peoples and their material culture and other inhabitants, picturesque and exotic: an exercise in the ethnological and geographical documentation of various parts of the world? Would it have been primarily a collection of images otherwise visually self-contained, fundamentally random or incidental in their relations to one another, which comprised no narrative sequence? Would these images have been linked only by the fact that they were produced by the same person, resulting from his visits to various parts of the world, and geared to consumption back 'home'?

There is an obvious narrative of a straightforward kind that presents itself when one surveys or looks through Earle's paintings representing scenes and peoples in Brazil, Tristan da Cunha, Australia, New Zealand, Malaya and India. It has been possible to do this in an exhibition of his paintings from the National Library of Australia that travelled in Australia and New

Zealand during 1995 and 1996. While they can be viewed as self-contained descriptions of places, peoples, events, however discontinuous they may be, these images can also be linked as episodes in a single passage, a series of movements from one place to another, a passage self-evidently involving movement in time and space. The images can be arranged chronologically. Viewers can see episodes in the artist's story of his passage round the world, of his being in various places, most of them 'new' and 'unknown' to his fellow Europeans – a picaresque tale of adventure, in which the central character or protagonist is the executive artist himself, whether in or out of the picture.

In this respect, a key element in Earle's travel pictures which primarily serves to link the various pictured scenes or visualized episodes, and thus facilitate a narrative fabric, is the recurrent appearance of the central protagonist himself, or a stand-in for him.[13] Earle not infrequently included himself *in* the picture. He is a visible presence in his story, rather than being outside, or 'above', that story as a conventional omniscient or sovereign author. These recurrent appearances in the pictures operate as a kind of leitmotif.[14] The figure of Earle functions as a determinant of how viewers see or experience what is otherwise depicted, as a figure who guides the narrative. As noted earlier, in terms of artistic practices and conventions in the eighteenth and early-to-mid-nineteenth centuries, it was most unusual, almost unprecedented, for a travelling artist to do this: to include him/ herself *in* the picture as *part* of the scene or event depicted, as distinct from being absent or separate from, or a detached observer of, the scene or event depicted.[15] Certainly there are a few earlier watercolours and drawings by other artists that do include the figure of the travelling artist sketching the scene or prospect: William Daniell's *Thomas and William Daniell viewing Bijaigarh, Uttar Pradesh – in India* (1790, P & O Collection) and Jacques-Louis Denon's *The Artist Sketching in Upper Egypt* (c.1798, British Museum), for instance. In these images, though, the depicted artist is separate from the scene being sketched. In contrast, in Earle's work the artist figure participates in the scene or event depicted. He is a character in the anecdote or implied narrative of the single image, or in a narrative comprised of a group of associated or interconnected images.

A Theoretical Aside

Before exploring further who Earle's 'I' may have been, or rather what effects or functions he or it can be seen to have besides authenticating the scenes or events depicted, I will briefly consider a popular interpretive approach to, or characterization of, European visual representations of places and peoples outside Europe, or subject to European (including American) colonial or

imperial expansion or designs.[16] It is an interpretive approach that was first articulated in relation to written representations by Edward Said and Mary Louise Pratt. In *Imperial Eyes: Travel Writing and Transculturation* (1992), and in an earlier essay in 1985, Pratt argued that a certain prevalent mode of European travel writing, in particular scientific and 'informational' accounts, was characterized by the separation of the observing self from what and who was being observed: The observing self was absent or detached from the representation, while at the same time acting as its overseeing or mastering eye/I. Such European authorial presence functioned as a kind of omniscient eye – the 'monarch of all I survey';[17] 'a kind of moving collective eye on which sights/sites register', so that 'narration functions as a sequence of sights and settings'.[18] This 'moving collective eye', this travelling eye, is inspired by Foucault's panoptic 'eye of power', involving 'a visibility organised ... around a dominating overseeing gaze';[19] that is, an eye of surveillance and control that symbolically takes over or possesses that which it looks upon or over, including places not yet actually taken over or occupied by imperial Europeans.

With pictures by European artists in newly, and not so recently, colonized places, it would not be difficult to find images to substantiate this interpretation, or which appear to do so. Examples of such panoptic panoramic landscapes include Thomas Cole's *View from Mt Holyoake, MA, after a Thunderstorm: The Oxbow* (1836, Metropolitan Museum, New York)[20] and Nicholas Chevalier's later *View of Akaroa* (1866, Canterbury Museum), a watercolour by a widely travelled artist who was commissioned by the Canterbury Provincial Council in New Zealand to make landscape images which could be used to promote the potential of the place for investment and immigration.[21] Paintings of Earle's, such as his *Distant View of the Bay of Islands* (1827, National Library of Australia), have also been characterized as examples of a dominating, colonizing eye, as panoptic panoramas.[22]

Pratt does allow for other modes of travel writing, notably what she calls 'sentimental, experiential' writings, in which the writer 'is positioned at the center of a discursive field rather than on the periphery'. She argues, though, that even if 'he is composed of a whole body rather than a disembodied eye', he too 'is constructed as a non-interventionist European presence'.[23] In contrast, writings on visual representations have tended to be totalizing – asserting or implying a unified, monolithic 'Western' 'eye', mind and self. I would argue that this does not necessarily tell the whole story, or afford the only view that can be taken of these representations of places and peoples by travelling European artists. The 'imperial eye' so constructed is a singular, unitary eye, which generally excludes or marginalizes other dimensions of meaning and effect, other ways images may function, the nuances or complexities of seeing. Indeed this construction could itself be seen as a

dominating, perhaps colonizing eye that, unwittingly, may serve to re-inscribe the discourse of imperial domination it is critiquing. It can reduce or simplify what close and detailed intra-, inter- and contextual examination of specific works or groups of works by travelling artists can show to be plural and conflicting, in various geographical locations and social and historical circumstances. Further, there can be a play of differing or conflicting eyes not just in the works of one artist, but within a single image by an artist. And those differing optical eyes, or ways things can be seen, may correlate with either conflict or ambivalence, instability or change within the alphabetical I, the I of the self, or the absence of an ascertainable unitary and omniscient authorial self. These various selves/eyes, and the construction of the various stories they allow, may problematize the ways of seeing and the certainties of proponents of all-powerful 'imperial eyes'.

Something Different

To exemplify my argument I will examine just a small selection of specific paintings by Earle – that Earle who was one of the few travelling artists who broke the rules by recurrently including himself in the picture as part of the scene or event depicted and as a central participant in the story, whatever that story may be. I advance what might be called a narrative of the eye, of seeing, not necessarily just that of Earle, but also that of the viewers and the depicted (other) subjects – a narrative of the problematics of looking, of beholding, in respect of images of travel and spectacle and the exhibition, publication and marketing of those images. Earle's apparent tendency was either to subvert or to bring into question conventional modes of apprehension of place and/or experience, or to complicate the business of looking, beholding and the representation of what was beheld. The figure of Earle himself is a key element in these processes.

View on the Summit at Tristan da Cunha (1824, Figure 6.2) can be related to an account in Earle's *A Journal of Residence on the Island of Tristan da Cunha* of a trip into a mountainous region with the local inhabitants to hunt goats. The watercolour features Earle as a watching figure, with his back to the viewer in the right foreground and hands raised in an indeterminate gesture. He is not pointing. It is almost as if he is semaphoring before, and towards, the barren, bleak, lava-strewn mountainscape, responding to some activity in the landscape in which he is a participant. His gesture differs from the conventional gestures of unambiguous wonder and awe (arms outstretched at the level of the chest before the figure) of the typical spectator figure looking at a sublime or spectacular landscape. Earle's rendering of the landscape and the placement of the small figure, head tilted upwards towards and dwarfed by this landscape, may at first glance appear to be an exercise in the sublime,

as if the viewers are being offered an experience of a volcanic landscape, rugged, awesome, massive and frightful to behold.[24] Indeed in his *Journal*, Earle wrote of the 'near perpendicular' mountains, especially in relation to the 'boundless horizon': 'The prospect was altogether very sublime, and filled the mind with awe.'[25] However, there may be differing and conflicting eyes and voices at work here. With *View on the Summit at Tristan da Cunha* a reading or response in terms of the conventionally sublime is undercut by the activity of the other figures in the painting at whom the eyes and gesture of the figure/Earle, both as spectator and participant, are directed. These are small figures two-thirds of the way up the picture to the left of centre: a man chasing goats along a ridge. These figures are tiny in relation to the picture space, but absurdly large in terms of any illusionistic representation of actual space, given the enormous distance Earle's and the viewers' eyes otherwise traverse.

What is imaged here is a deromanticized experience of place, the possibility of sublime experience undermined, perhaps satirized through parody by that anecdotal detail to which the figure of Earle is responding rather than, or as well as to, the sublime potential of the mountainscape. There is a comedic, rough-edged, 'down-to-earth', sceptical, unsentimental quality, a characteristic of much of Earle's travel work, which brings to mind both that current in English art and illustration epitomised by Hogarth and Rowlandson, and the mid-eighteenth-century Scottish writer Tobias Smollett's fundamentally anti-heroic and anti-romantic[26] novels of sea travel and adventure. It is perhaps not coincidental that Rowlandson drew cartoons of Smollett's novels and that among Earle's surviving watercolours are depictions of scenes from Smollett's *Peregrine Pickle* and *Roderick Random*. The latter has been characterized as a novel in which the author wittily subverted generic conventions with an admixture of elements of irony, satire, parody, realism, autobiography and travel narrative.[27]

Earle, I have noted, was an unwilling visitor to Tristan da Cunha, having been abandoned there by his ship. This experience he characterized as 'miserable imprisonment', absurd, frustrating, boring, deflating. That is, he did not romantically 'lose' himself in the 'otherness' of the place. He was not 'elevated' by the experience. He wanted to get away from the island as soon as possible. Yet at the same time he enjoyed and appreciated the company of the local inhabitants, who, he noted, were not given to admiring 'sublime scenery'.[28] The names they gave to that scenery might suggest this – 'Ridge-where-the-goat-jump-off', for example.[29] Earle characterized the inhabitants, mostly former British sailors, as independent-minded, with the 'honest roughness of British tars'.[30] Their lack of concern with aesthetic niceties and categories, with literary or artistic romanticizations, is suggested, perhaps, by another Earle watercolour, *Man Killing Albatross* (1824, National Library of

Australia) which represents an event which took place on the same trip. Many albatrosses were killed for practical purposes with no negative consequences, perhaps disturbingly for those steeped in Coleridge's *The Rime of the Ancient Mariner* (written about twenty-five years earlier).

View on the Summit at Tristan da Cunha can be seen then to parody, and bring into question, sublime experience and the model of the sublime for the representation of the mountainous. Parody, often a constituent element in dual or multi-voiced narratives, involves the inclusion of meaning-producing elements (like the man chasing goats) that are opposed to, or in conflict with, the semantic intent of the model to which the discourse or image otherwise appears to belong,[31] in this case the mountainous sublime. However, parody does not necessarily just involve a simple ridicule and rejection of the model or target text. It can be a more complicated relationship. There can be a kind of accord between the parody and the target, with the text or image having a doubleness of effect.[32] So, for example, you have here a picture that presents both the sublime *and* a subversion of the sublime. This doubleness points to a questioning of received models, a questioning of the suitability of a particular model in relation to the representation of an experience of a non-European place, one which is very different from European places and the experiences to be had in those places which originally generated that model or in which that model was formulated. That is, examination of Earle's paintings reveals shifting, contrasting perspectives or views of the same place and experience by the one or single narrator/ artist figure. His works, collectively and individually, offer not a monologue, but a dialogue – immediately with himself, and one also open to the responsive viewer.

It might be apt, now, to look again at *Solitude, watching the horizon at sunset . . . Tristan da Cunha, in the South Atlantic.* (See Figure 6.1.) Decontextualized, this might strike the viewer simply as romantic stock-in-trade, with its single solitary figure, abandoned, contemplating the sea and his predicament.[33] However, given Earle's reported feelings about Tristan da Cunha, in relation to which the sea represented less the source of sublime experience or the emotionally 'oceanic', and more the pragmatic means (the arrival of a ship) of escape or release from boredom and time wasted, *Solitude* too can take on a parodic, deromanticized dimension. Flaubert's later satiric entry 'Sea', in his 'Dictionary of Received Ideas' comes to mind: 'Bottomless. Symbol of infinity. Inspires deep thought.'[34] And a later painting, *Morning After the Shipwreck* (1829, Neue Pinakothek, Munich) by the German 'Romantic' artist Johan Dahl, offers some intriguing parallels and some striking differences in treatment that further suggest the parodic, deromanticized element in Earle's work. Dahl's painting, too, has a seated figure accompanied by a dog on a rocky shorefront in the right foreground with the sea beyond. Dahl's figure,

though, smaller in relation to the picture space, is hunched over, face buried in his hands – the very type of despair – before a raging, stormy sea.

Scudding before a heavy westerly gale off the Cape (1824, Figure 6.3) has Earle en route to Australia, after rescue from Tristan da Cunha. This picture is composed with the boat cut off in mid-deck across the foreground so that it effectively continues into the viewers' space. That was a very unusual, unconventional compositional device in the mid-1820s. It is something one associates more with artists like Degas, and which Earle used also to striking effect in another painting from his voyage, *Speaking (or Hailing) a vessel off the Cape of Good Hope* (1824, National Library of Australia). With *Scudding before a heavy westerly gale off the Cape* the viewers are on the boat too, surging through heavy seas, an experience conventionally charged with the colours of romantic adventure. Yet the figure of Earle in the left foreground, identifiable by his well-documented dog companion at his feet, is not looking at what we, the viewers, are otherwise looking at. He is not immersed in the experience that such looking offers. In contrast, he is turned away, looking into a book – a sketchbook or a book that could stand in for, or anticipate, the books through which the parts of the world he travelled in would be brought into visibility and thus produced. The presence of the book, and Earle's absorption in it, could connote the primary or central mediating function of books, of images and texts, in Europeans' apprehension of these worlds. The book, or Earle's immersion in it while otherwise in the midst of travel, could connote, too, the differing registers of meaning those journeys involved – the looking both outward and inward: 'To wander about in the world . . . is also to wander about in ourselves.'[35]

This play on looking and not looking, seeing or not seeing, or on differing kinds of looking, lookings which may be in conflict, is a recurring element in Earle's travel images. It is an element that serves to link and interrelate what otherwise might appear to be disparate and self-contained or separated images. It is exemplified by *A Native family of New South Wales sitting down on an English settler's farm* (Figure 6.4) and *Wellington Valley, New South Wales, looking east from Government House* (Figure 6.5) (both 1826–27), both pictures in which Earle's self is not included in the picture, but is nevertheless part of the picture. Here signs of authorial and observing presence (the viewers' too) are not effaced or suppressed or removed, even if author or observer is not literally *in* the picture. In both pictures, a strategically placed Aboriginal figure looks directly back at the viewer and at the executive artist. What is presented is a highly charged and dramatic exchange of looks. In *A Native family of New South Wales* the family is placed between the viewer and the background building, a farmhouse, upon the verandah of which several European figures stand looking towards the Aborigines and also at, or

towards, the viewer. It is a complicated interplay of looks and lookings. The Aborigines, by implication dispossessed, are sitting down on a colonist's farm, with the male colonist presented in an aggressive/defensive pose, arms tightly folded across his chest, constituting a barrier. The Aborigines constitute a barrier too, or disrupt any comfortable or unified view of what would otherwise be a domesticated colonial landscape. While the male Aborigine has his back to the viewer (a refusal to engage?), the returned look of the female Aborigine effectively brings the viewer into the picture, establishing a relationship among viewer and artist and that which is viewed. It is a relationship that could have posed awkward questions to viewers about their relationships to these figures, both dispossessed Aborigines and European settler colonists, and their respective situations. Earle could have been suggesting that colonial viewers, including himself, bore some responsibility for Aboriginal dispossession and its consequences. The European group in the background could function as a kind of mirror of the European viewer.

Both collectively and individually, Earle's travel sketches, his imagings of various places, peoples and events round the world, can be construed as having a socially satiric or critical cast to them in a manner reminiscent of Hogarth or Rowlandson. This quality of Earle's work might have served to make colonial settlers or English viewers uncomfortable by bringing into question the widespread, almost universal belief in the rightness of the colonial settler project, involving, as it did, dispossession of the Aboriginal peoples and the notion that Australia was an unoccupied waste-land, a 'terra nullius'.[36] Yet in apparent conflict with this quality in his work, Earle could elsewhere write negatively or disparagingly about Aborigines, while his sketches and paintings reveal or connote a range of evaluations and characterizations, sometimes ambiguous or difficult for the viewer to fathom.[37] This quality could correlate with, or suggest, ambivalence or conflict within Earle himself. Without entering into an analysis of Earle's psyche, it is as if there were several selves, eyes or voices within Earle, as if there were never a single, unitary personality who produced the sketches. After all, there can be contradictory voices within any person's self, which can embody a diverse range of attitudes and responses to the world.

In *Wellington Valley* the foreground Aboriginal figure looking back at the observing artist or viewer offers a range of possible meanings. Perhaps he just happened to be standing there in that way in a landscape which Earle was simply documenting topographically.[38] However, the prospect spread out before the viewers' eyes was a section of the 'wilderness', about three hundred miles from Sydney, that had been transformed into productive pasturage, 'civilized', even if, ironically, it was in fact a recently (1823) established convict settlement.[39] Immediately, then, Earle's prospect might

appear to belong to a standard type of landscape representation (the 'wilderness' 'civilized') in colonial-settler situations[40] – a type which represented the colonizers' quests to establish a unity between themselves and the places they had occupied. However, in contrast to Earle's painting, that landscape type conventionally featured no impediments to the 'imperial eye', no displaced Aborigines. The upright Aboriginal figure in *Wellington Valley*, his back to the ordered and controlled landscape, holds in his right hand a stick, with which he points at or touches the ground at his feet. It is a proprietorial gesture suggesting his claim to land that is clearly occupied by Europeans, as denoted also by the verandah edge to the left. Again, this figure's returned look, in drawing the viewer into a relationship, could function as a kind of challenge, raising questions about the nature of that relationship and the occupancy of that land, unsettling any sought-for unity between colonists and place.

While it may be difficult to prove definitively that Earle's travel sketches were intentionally sustained by such a line of thought or questioning, images like these nevertheless allow such a view, irrespective of authorial intention. Crucial to such a view are the meanings or connotations of various kinds of looking and exchanges of looks. That Earle *could* engage in both unflinching representation and critique, including self-critique, of particular kinds of looking or viewing is suggested by a watercolour he produced in Brazil, *Punishing negroes at Cathabouco, Rio de Janeiro* (c.1822, Figure 6.6). Earle spent about four years in Brazil. The sketches he produced there were varied in subject and treatment of subject: portraits of people of various ethnicities, landscapes both rural and urban, and genre scenes or images of contemporary social life, some of which exemplify well how satirical, socially critical and Hogarthian Earle's eye could be.[41] I noted earlier that several of his sketches were reproduced in Maria Graham's *Journal of a Voyage to Brazil* (1824), a book critical of the institution and practice of slavery, which was not abolished in the British Empire until 1833, in Brazil until the 1890s. The illustrations after Earle in Graham's book include slave markets in which black slaves are being maltreated.[42]

While it was not unusual for British and other European writers and artists to criticize and protest against the practice of slavery in the Americas in the nineteenth century, what was unusual was how Earle addressed the representation of the cruelties and barbarism of slavery. *Punishing negroes at Cathabouco* represents the flogging of a slave in a prison yard. It is so staged as to concentrate the focus on this cruel and brutal act through a sense of entrapment, with the enclosed shallow space and the circle of figures round the centralized act at which all the figures are looking intently, with one exception. This is a detail that is easy to overlook, to *not* see, but it is a crucial

detail. Just to the left of the flogger, between him and the standing white overseer, there is a seated figure, head down, hand out before his face, hiding his eyes, not looking at or blocking what the others in the picture and the viewers of the picture are looking at. His hand is stretched out, as if he wants to push away the scene being played out before him. It is a very eloquent gesture, but it is by no means unambiguous. One writer has suggested that it signifies shame,[43] but the traditional gestures for shame, and for grief, have the hand or hands over the eyes, on the face or the head. The gesture could simply denote revulsion,[44] horror or shock, that this figure should be seen as a kind of choric figure whose gesture is designed to cue the viewers to regard the flogging as barbarous. This effect, though, is established clearly by such features as the stances and caricatural renderings of the faces of the torturer, overseer and some of the spectators. Certainly the gesture is made for us, the viewers, rather than for the other characters in the depicted scene. The figure hiding his eyes could be regarded as a stand-in for Earle. He, the executor of the painting, is gesturing, speaking to us, the viewers. It is a gesture of not looking, perhaps 'should not be looking', that again establishes relationships among artist and viewers *and* the depicted figures and the situation or event depicted.

Earle's image, then, can be seen to raise questions about these relationships. In one sense, viewers of the image are like the viewers of the flogging, voyeuristically complicit, participating in this spectacle even if at a remove, however cruel and repellent they may find it. The gesture of the hand shielding the eyes could suggest that in looking – and thus participating – viewers become complicit, that perhaps viewers should not look in this way, that some acts in their cruelty and brutality are both too awful to look at and beyond visual representation, and that to represent them visually, whatever the intentions of the artist and attitudes or viewpoints of the audiences for such images, is to reinscribe those acts, to make them into spectacle. Whether that is or is not a consequence of such representations, though, depends on the specific contexts and manners in which the images are seen and used. Whatever the gesture connotes, Earle nevertheless, obviously, made the picture for viewers to look at. As such, this painting too suggests conflicting views (and/or voices) within Earle and, by extension, within the colonial project overall. The artist's eye is both outside and separate from what is depicted, a kind of sovereign gaze, and also, represented by his stand-in, proximate to the event, inside the picture yet not looking, unable to look. Certainly that figure, hands before his eyes, disrupts the act of looking. He functions as an obstruction and question mark to any unified, unproblematic, sovereign looking. Seen this way the image can function as a kind of self-critique or self-questioning for artist and viewer. It can represent a

recognition that eyes or lookings are not innocent in such circumstances – that the picturing projects of travelling artists (and later photographers and film-makers) in certain parts of the world may objectify their subjects, contribute to their subordination, render the cruel, brutal and horrific the stuff of spectacle, or even make such events or conditions 'good to look at'.[45]

On the other hand, in setting up this duality of looking/not looking, should look/should not look, Earle was more effectively looking 'truth' in the eye – more forcefully bearing necessary witness to the barbarity of slavery than those other picturings of punishment of slaves in South America, which, whatever the intentions of the artists, presented scenes to be looked at without problematizing that looking as Earle's image does. In other representations of flogging in Brazil or the Caribbean in the 1820s through 1840s, with plenty of spectators in the picture, by or after Rugendas, Debrett, Landseer and Verdier for example,[46] the activity of describing is marginalized and authorial presence is suppressed or effaced. Those viewing eyes remain detached, separate from that which is observed and represented, and thus could be seen in terms of the 'imperial eye'. In contrast, Earle's imagings are anchored in the observing self, a self that was part of the scene or event depicted. The act of imaging and its problematics are foregrounded in his picturing project, so that the executive artist and viewers can be seen, respectively, to be part of, or drawn into, that which is represented, however those participations and relationships are evaluated and whatever dilemmas they pose, or posed, to the viewer and the artist.

Close scrutiny of Earle's travel art, then, brings into question the notion of a unified, monolithic Western 'imperial eye'. Rather, contradictoriness, reformulation or complication of received models and standard views, even uncertainty, in response to 'new' sights, sites and experiences emerge as prime characteristics of this work. I would suggest further that these features may not be unique or limited to the work of a perhaps idiosyncratic or eccentric Earle, that they may also be symptomatic of an overlooked or unexplored aspect of the works of other European artists who engaged with non-European peoples and places subject to imperial interests or control. The images produced, that is, rather than being unproblematic constituents of projects of domination or a will to dominate, may turn out to be pluralistic in their meanings and modes of operation, split even with doubts or questions about the projects the artists were otherwise participants in or observers of, to the extent that totalizing constructions like the 'imperial eye' appear insufficient in addressing the complexities and the imponderables of cross-cultural exchanges and relationships in particular contexts in the colonial period.

Notes

1. Note, though, recent comment on Earle's *Distant View of the Bay of Islands* in W.J.T. Mitchell, 'Imperial Landscape', in Mitchell, ed., *Landscape and Power* (Chicago: University of Chicago Press, 1994): 24–7, and on his travel pictures generally in Michael Jacobs, *The Painted Voyage: Art, Travel and Exploration 1564–1875* (London: British Museum Press, 1995): 101, 133. Jacobs reproduces three Earle paintings.

2. For Earle's biographical details see Harold Spencer, 'Augustus Earle: A Study of Early Nineteenth Century Travel Art and its Place in English Landscape and Genre Traditions' (Harvard): PhD thesis, 1967; Eric McCormick, introductory essay and annotations in Augustus Earle, *Narrative of a Nine Months' Residence in New Zealand and Journal of a Residence in Tristan da Cunha* (London: OUP, 1966); Anthony Murray-Oliver, *Augustus Earle in New Zealand* (Christchurch: Whitcombe & Tombs, 1968); Jocelyn Hackforth-Jones, *Augustus Earle: Travel Artist* (Martinborough, New Zealand: Alister Taylor, 1980).

3. Augustus Earle, *Narrative of a Nine Months' Residence in New Zealand in 1827, together with a Journal of Residence in Tristan da Cunha, an Island situated between South America and the Cape of Good Hope* (London: Longman, Rees, Orme, Brown, Green and Longman, 1832): 339, 289.

4. Ibid., 335–6, Fig. 1.

5. For instance, Linda Nochlin, 'The Imaginary Orient', *Art in America*, May 1983: 118–31, 186–90; Rani Kabbani, *Europe's Myths of Orient: devise and rule* (London: Macmillan, 1986); Griselda Pollock, *Avant-Garde Gambits: Gender and the Colour of Art History* (London: Thames and Hudson, 1992). Note, though, John Mackenzie's *Orientalism: History, Theory and the Arts* (Manchester: Manchester University Press, 1995), which critiques Nochlin and Kabbani, and Mitchell, 'Imperial Landscape', in which a beginning is made to the investigation of the interactive complexities of 'imperial' landscape representation.

6. 'To see or not to see' is a provisional and in itself still incomplete exploration of just some specific aspects of Earle's global picturing project. More broadly it is part of my research into the phenomenon of travelling European artists and the nature of their engagements with, and representations of, various parts of the southern hemisphere from the late eighteenth into the twentieth century.

7. Earle, *Narrative*: 296.

8. See Leonard Bell, 'Augustus Earle's *The Meeting of the Artist and the Wounded Chief, Hongi, Bay of Islands, New Zealand, 1827* and his depictions of other New Zealand encounters: Contexts and Connections', in Jonathan Lamb, Bridget Orr and Alex Calder, eds, *Voyages and Beaches: Europe and the Pacific 1769–1840* (Honolulu: University of Hawaii Press, forthcoming).

9. See J.R. Abbey, *Travel in Aquatint and Lithography 1770–1860: From the Library of J.R. Abbey* (London: Dawsons, 1972); Barbara Stafford, *Voyage into Substance: art, science, nature and the illustrated travel account 1768–1840* (Cambridge, Mass: MIT Press, 1984).

10. Stafford, *Voyage into Substance*: xx.

11. The two later editions, in 1909 and 1966, did not include these engravings.

12. See Hackforth-Jones, *Augustus Earle*: 45. Most of Earle's watercolours and drawings from his travels which are still extant, about 180, were never published, exhibited or reproduced in his lifetime. The bulk of these are in the Rex Nan Kivell Collection, National Library of Australia, Canberra. For a listing of these see Hackforth-Jones, *Augustus Earle*. He did have an exhibition of his painting in Sydney in 1826, which included a small number of his Tristan da Cunha watercolours.

13. In these pictures Earle, or a figure who can be seen as the Earle of his travels, can be identified from scenes and events described in his written narratives, or by the co-presence of the dog, which could be seen as an attribute of the Earle figure.

14. Examples of Earle's picturing of his presence include, besides *The Meeting, Bougainville Falls* and the six watercolours examined in this paper, *View from the Summit of the Cacavada Mountains, near Rio de Janeiro* (1821–24), *Governor Glass and his Companions, Tristan da Cunha* (1824), two titled *Tristan da Cunha* (1824), *Rafting Blubber at Tristan da Cunha* (1824), *A North Easter Tristan da Cunha* (1824), *A Bivouack, Day Break on the Ilawarra Mountains* [New South Wales] (1827), *Entrance of the Hokianga River* [New Zealand] (1827), *Distant View of the Bay of Islands* [New Zealand] (1827) – all in the Rex Nan Kivell Collection, National Library of Australia.

15. It was highly unusual for a travelling artist to represent him- or herself engaged in some activity. Those late-eighteenth-early-nineteenth-century paint'ngs and drawings by European artists in or of non-European places, which include the figure of the artist sketching, can be related to that landscape image-type in European art going back to the seventeenth century, which has an artist figure on the periphery of the scene sketching that landscape scene otherwise represented. There are several other examples of mid-nineteenth-century travelling artists including themselves as participants in the activities or events they are otherwise representing – for instance, Catlin in the USA in the 1830s and Thomas Baines in South Africa and Australia in the 1850s and 1860s – but images of this kind constitute a tiny minority overall of the images produced by travelling artists.

16. See, for example, Nochlin, 'The Imaginary Orient'; Albert Boime, *The Magisterial Gaze: Manifest Destiny and American Landscape Painting c. 1830–1865* (Washington and London: Smithsonian Institution Press, 1991); Alan Wallach, 'Making a Picture of a View from Mount Holyoke', in David Miller, ed., *American Iconology* (New Haven and London: Yale UP, 1993): 80–91; Timothy Mitchell, 'Orientalism and the Exhibitionary Other', in Nicholas Dirks, ed., *Colonialism and Culture* (Ann Arbor: University of Michigan Press, 1992): 289–317.

17. Mary Louise Pratt, 'Scratches on the Face of the Country or, What Mr Barrow saw in the Land of the Bushmen', *Critical Inquiry* 12, 1 (1985): 124.

18. Pratt, *Imperial Eyes: Travel Writing and Transculturation* (London and New York: Routledge, 1992): 59.

19. Michel Foucault, 'The Eye of Power', in *Power/Knowledge: Selected Interviews and Other Writings 1972–77* (Brighton: The Harvester Press, 1977): 52.

20. See Wallach, 'Making a Picture'. Cole's painting includes an artist at work in the centre foreground. In a 'commanding' vantage point, he is separate from the landscape he is depicting. The painting, though, allows other more subtly inflected readings. See, for example, Angela Miller, *The Empire of the Eye: Landscape Representation and American Cultural Politics, 1825–75* (Ithaca and London: Cornell UP, 1993): 39–49.

21. For Chevalier see Leonard Bell, 'Nicholas Chevalier: The Fortunes and Functions of his Paintings', *Art New Zealand* 44 (1987): 78–81; 'Nicholas Chevalier's Journey through Canterbury in 1866: Contexts and Connections', *Bulletin of New Zealand Art History* 14 (1993): 97–106.

22. See Marion Minson, *Encounter with Eden: New Zealand 1770–1870: Paintings and Drawings from the Rex Nan Kivell Collection, National Library of Australia* (Wellington: National Library of New Zealand, 1990): 28; Alex Calder, 'Maning's Tapu: Colonialism and Ethnography in New Zealand', *Social Analysis* 38 (1996): 14.

23. Pratt, *Imperial Eyes*: 78.

24. For British eighteenth- and nineteenth-century art and the sublime see, for instance, Andrew Wilton, *Turner and the Sublime* (London: British Museum Publications, 1980); Peter Bicknell, *Beauty, Horror and Immensity: Picturesque Landscape in Britain* (Cambridge: Cambridge UP, 1981); James Twitchell, *Romantic Horizons: Aspects of the Sublime in English Poetry and Painting* (Columbia: University of Missouri Press, 1983); Simon Schama, *Landscape and Memory* (London: Fontana, 1996), in particular 447–8 and his comment on the mountainscapes of John Robert Cozens.

25. Earle, *Narrative*: 325–6.

26. George Kahrl, *Tobias Smollett: Traveller-Novelist* (Chicago: University of Chicago Press, 1945).

27. John Skinner, *Constructions of Smollett: A Study in Genre and Gender* (Newark and London: University of Delaware Press and Associated University Presses, 1996): 18–24.

28. Earle, *Narrative*: 328.

29. *The Oxford Companion to the English Language*, 1992, p. 1056.

30. Earle, *Narrative*: 328.

31. Mikhail Bakhtin, *Problems of Dostoyevsky's Poetics* (Minneapolis: University of Minnesota Press, 1984): 193.

32. Linda Hutcheon, *A Theory of Parody: The Teachings of Twentieth Century Art Forms* (London: Methuen, 1985): 32ff.

33. Hackforth-Jones, *Augustus Earle*: 17, interprets *Solitude* simply in terms of 'Romantic melancholy, in which "castaway" subject matter and expressions of gloom and solitude . . . were popular themes'.

34. Gustave Flaubert, 'Dictionary of Received Ideas' [compiled from 1850], in *Bouvard and Pécuchet* (Harmondsworth: Penguin, 1976): 325.

35. Paul Auster, *The Invention of Solitude* (London and Boston: Faber and Faber, 1988): 166.

36. For the colonial notion that Australia was a 'terra nullius' see, for instance, Alan Frost, 'New South Wales as a Terra Nullius: The British Denial of Aboriginal Land Rights', *Historical Studies* 19, 77 (1981): 513–23; Henry Reynolds, *Frontier: Aborigines, Settlers and Land* (Sydney: Allen & Unwin, 1987) and *Law of the Land* (Ringwood, Victoria: Penguin, 1987).

37. Earle, *Narrative*: 258–9, characterized the 'natives of New Holland' as 'of the lowest grade – the last link in the great chain of existence which unites man with monkey. Their limbs are long, thin, and flat with large bony knees and elbows; a projecting forehead, and pot-belly. The mind, too, seems adapted to this mean configuration: they have neither energy, enterprise, nor industry; and their curiosity can scarcely be excited.' Yet the Aborigine figures in his paintings can be cast positively, both in terms of their appearance and activity – as in his *Desmond, a New South Wales Chief* (1825–7, National Library of Australia) and in *Bougainville Falls, Blue Mountains, New South Wales*, for example. In contrast the treatment of the figures in other paintings – his *Native Camp of Australian Savages* (1828, National Library of Australia), for example – is consistent with his written characterization cited above, while his *Bungaree, a Native of New South Wales* (c.1826, National Library of Australia), for example, is a complex and ambiguous representation, which disallows any single straightforward characterization or interpretation. That is, Earle's textual and pictorial characterizations or evaluations do not necessarily correlate. The placing of Australian Aborigines at the bottom of the social evolutionary scale or a racial hierarchy was standard among Europeans throughout the nineteenth century.

38. There are two watercolours by Earle (National Library of Australia) featuring a single standing Aboriginal figure in a bare, flattish landscape. The figure in one of these is almost identical to the figure in *Wellington Valley*, but located in different surroundings.

39. Hackforth-Jones, *Augustus Earle*: 100.

40. See, for example, Tim Bonyhady, *Images in Opposition: Australian Landscape Painting 1801–1890* (Melbourne: OUP, 1985): Bell, *Colonial Constructs: European Images of Maori 1840–1914* (Auckland and Melbourne: Auckland UP and Melbourne UP, 1992); David Bunn, ' "Our Wattled Cot": Mercantile and Domestic Space in Thomas Pringle's African Landscapes', in Mitchell, ed., *Landscape and Power*: 127–74.

41. E.g. *Portrait of the Riding Master to the Empress, Brazils, Rita, a celebrated black beauty at Rio de Janeiro, The Bananas, Brazil's, View near Rio de Janeiro, Games at Rio de Janeiro, during the Carnival* – all in the National Library of Australia.

42. *Slave Market at Rio Janeiro Gate*, frontispiece, and *Gate to Slave Market at Pernambuco*, 106, Maria Graham, *Journal of a Voyage to Brazil and Residence There during part of the years 1821, 1822, 1823* (London, 1824).

43. David James, 'An English Painter in First Empire Brazil, with a catalogue of the Brazilian works of Augustus Earle' (trans. G. Brodsky), *Revista do patrimonio Historico ed Artistico Nacional* 12 (Rio de Janeiro, 1955).

44. Hackforth-Jones, *Augustus Earle*: 37.

45. Note: Walter Benjamin, 'Address at the Institute for the Study of Fascism' (Paris, 1934): '[The Camera] is now incapable of photographing a tenement or a rubbish heap without transfiguring it. It has succeeded in turning abject poverty itself, by handling it in a modish technically perfect way, into an object of enjoyment'. Quoted in Susan Sontag, *On Photography* (New York: Farrar, Strauss and Giroux, 1978): 107.

46. For reproductions of these see Hugh Honour, *The Image of the Black in Western Art: From the American Revolution to World War One*, Part One (Houston: Meril Foundation, 1989). The depiction of floggings of slaves in Brazil by Jean-Baptiste Debret (1826), Johann Rugendas (1827–35) and Charles Landseer (1825–6), as well as Earle's, are reproduced on pp. 142–3, while Marcel Verdier's painting (1843–9), which was exhibited at the Paris Salon of 1849, is reproduced on p. 152.

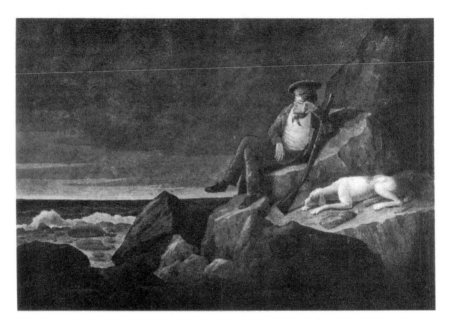

6.1 Augustus Earle, *Solitude, watching the horizon at sunset, in the hopes of seeing a vessel, Tristan da Cunha, in the South Atlantic*

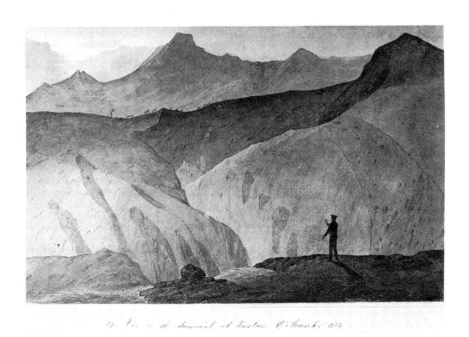

6.2 Augustus Earle, *View on the Summit at Tristan da Cunha*

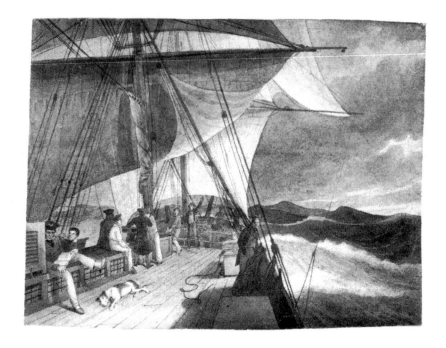

6.3 Augustus Earle, *Scudding before a heavy westerly gale off the Cape, lat. 44 deg*

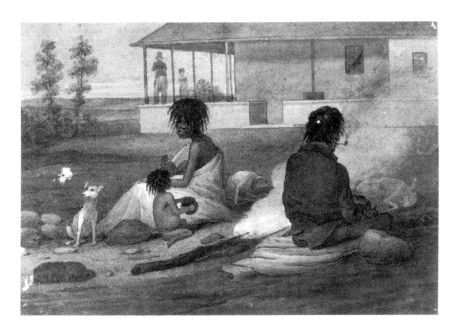

6.4 Augustus Earle, *A native family of New South Wales sitting down on an English settler's farm*

6.5 Augustus Earle, *Wellington Valley, New South Wales, looking east from Government House*

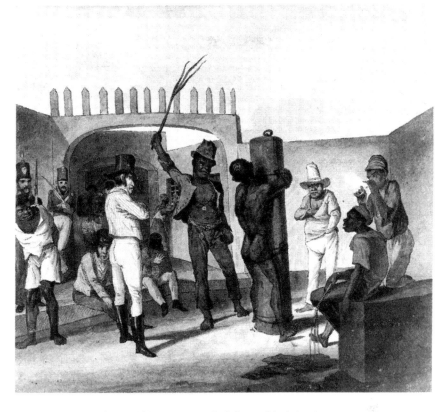

6.6 Augustus Earle, *Punishing negroes at Cathabouco, Rio de Janeiro*

'Beyond the stretch of labouring thought sublime': Romanticism, post-colonial theory and the transmission of Sanskrit texts

Kathryn S. Freeman

As the first Europeans to translate major Sanskrit texts, the late-eighteenth-century British Orientalists[1] were celebrated by scholars of the 1950s to the 1980s for exploding earlier misrepresentations of the East.[2] More recently, post-colonial theorists have redescribed this period of British Orientalism – namely, that defined by the formation of the Asiatic Society of Bengal – as ideologically and territorially driven both to appropriate and to distort India's intellectual history.[3] In spite of this extreme shift in perspective, both approaches blur the phenomenon of Orientalism, representing the scholars and politicians involved with the Asiatic Society as though they were all of a single mind. Orientalism, however, was neither a fixed nor a unanimous school of thought: though lasting only about fifty years (1784–1835), it underwent significant change marked by two phases. Its early phase began with William Jones's inception of the Asiatic Society in 1784 and lasted until his death in 1794, while the second phase included H. T. Colebrooke's succession to Jones as director and ended with the Anglicist movement, whose objective was 'completely supplanting indigenous learning with British scholarship imparted through the English language', inaugurated by Thomas Macaulay's 'Minute on Education in India' of 1835.[4]

During the early period of Jones's Asiatic Society, the ambivalences and anxieties of the Orientalists travelled to England with their introductory essays and Sanskrit translations, influencing a Romantic sublime fraught with political and epistemological uncertainty. For poets in England, the startling discovery of these texts resounds through much of their writing, as in the case of Charlotte Smith, whose *Beachy Head* simultaneously denounces the atrocities of British imperialism while exulting in the visionary imagination India had come to represent. For William Blake, the imagery of the Eastern texts echoes through his own mythos, providing for him a means of linking East and West through the nondual, human divine he held to be the

origin of the Judeo-Christian tradition lost in the Enlightenment.[5] By tracing what became an Eastern sublime for British readers of the early renderings of Indian texts, I argue here that the pursuit of transmitting Indian thought to England was informed by a host of competing motivations on the part of the Orientalists, including their political anxieties and their ambivalence toward Enlightenment epistemology which they saw the Indian texts as both challenging and duplicating.

India's ancient texts were received by the British with responses ranging from enthusiasm to horror, most often simultaneously. Revealing the paradox behind this double view is the ubiquitous use of the term 'sublime' in late-eighteenth- and nineteenth-century descriptions of the Sanskrit texts. The concept of the sublime had gained increasing significance in aesthetic philosophy during the period through an already wide range of competing definitions and representations, including those of Hume and Burke in the eighteenth century and Wordsworth and Kant in the nineteenth century.[6] As applied to Indian texts, 'the sublime' suggests that, more than being used as an honorific, it was a means to place these texts under a particular rubric within the Western aesthetic tradition. Yet even as these descriptions evoke the sublime, they express the awareness that the texts elude this concept. When Warren Hastings introduces Charles Wilkins's translation of *The Bhagavad Gita*, he warns that there are passages 'elevated to a track of sublimity into which our habits of judgement will find it difficult to pursue them'.[7] While Jones calls the Hindu epics 'magnificent and sublime in the highest degree',[8] he depicts Narayana in his own Hymn to that deity as 'beyond the stretch of labouring thought sublime'.[9] Both Hastings's and Jones's descriptions of the texts suggest that what makes them 'sublime' is the inability to 'pursue them' with 'labouring thought'. The Sanskrit texts, in other words, challenged the Enlightenment mind accustomed to reading philosophical, aesthetic and theological texts through the discursive faculties, which were felt to offer no guidance in a realm seen to be beyond the parameters of Western logic. India thus gave new and troubling meaning to the aesthetic category of the sublime. As it emerged through the late-eighteenth-century British reading of Sanskrit texts, the Indian sublime stood apart from the spectrum of European sublimes in its perceived nondualism.[10] By seeming to dissolve the separation between subject and object, the Indian texts were seen to challenge the fundamental condition of the sublime: the necessity of the subject's safe distance from the object of terror embodying the sublime.

What is it about the Indian texts that connotes sublimity to the British but breaks this rule of safe distance? Sanskrit has no comparable term for the sublime, whose Latin etymology, 'under the limen', orients the subject relative to what Blake would call the 'bounding line', the threshold between

the self and the dissolution of selfhood.[11] Even Burke, who, according to Frances Ferguson, 'connects the sublime with death in order to attest to the genuineness of sublime emotions', adds what Ferguson calls a 'safety net – the condition that danger and pain must not "press too nearly"'. As Ferguson points out, this 'safety net' 'threatens to render the sublime into something of a shell game'.[12] Thus, for the Burkean sublime, maintaining this separation and therefore the identity of the subject is all-important.

Sara Suleri, noting that Burke's description of India as remote and obscure made it 'the age's moral example of the sublime', points to the paradox of Burke turning the sublime on its head by cataloguing the uncategorizable, in which Burke creates the rhetorical effect of India embodying 'colonial terror'.[13] A significant element of the terror experienced by the British is the threat the Sanskrit texts posed to the heart of Enlightenment epistemology: the twin principles of the primacy of the individual's separate and autonomous ego on the one hand and the separation of a single God from the phenomenal world on the other.[14] When the British writers superimpose the nondualism they find in the Sanskrit 'sublime' onto their Enlightenment tradition the effect is one of profound ambivalence, revealed in the simultaneous attraction to and repulsion from the state they are calling sublime.[15]

The aesthetic and epistemological fear associated with the Indian sublime is thus inextricably involved with the political anxiety these texts produced, as witnessed by the range of readers who registered their responses to the Indian sublime, from government officials such as Burke and Hastings – themselves at odds with each other, as will be discussed – to those poised for epistemological and political revolt, to others, such as Jones, who appear to be in both camps at once.[16] Jones's contradictory roles shed light on the nature of this array of ambivalent Indian sublimes as represented by so wide a spectrum of British readers. Even as Jones's contradictoriness sets him apart from the other Orientalists, it embodies elements that illuminate the ambivalences comprising the Orientalist phenomenon. Addressing these apparent contradictions – including Jones's participation in the British governing of India, his advocacy of and groundbreaking work in Sanskrit study as well as his continued involvement with reform in England and expression of enthusiasm for the revolutionary energy in America and Europe – helps to complicate the question of the Orientalist phenomenon.[17]

At the heart of Jones's apparently contradictory stance regarding his role in India's government is his strongly expressed discomfort about political involvement with Hastings and Burke. In a letter to Burke dated February 1784, Jones states,

Mr. Hastings was at Nuddeea on Tuesday in [sic] his way to Lucknow. The precise object of his journey I know not, as I disclaim all political connexions whatever in

India, thinking them wholly inconsistent with the judicial character; and I promise you, that you shall never hear of any change in my conduct.[18]

A letter to the second Earl Spencer two months later, in which Jones writes of his hopes for 'parliamentary reformation', offers insight into his attempts to extricate himself from the political entanglements of Hastings and Burke:[19]

> The bishop tells me that, when he met [Burke] in the summer, he said 'If I *hear*, that *Jones sides* with *Hastings*, I will do all in my power to have him recalled.' What! if he *hears* it only, without examination and without proof: Besides, he ought to know, that, as a judge, I *side* with no man; that I have indeed an equity-*side*, a common-law-*side*, an ecclesiastical *side*, and an admiralty-*side*, but I am *quadrilateral* by act of parliament, and no power on earth, while I continue, in my present station, shall give me a *political side*. What have I to do with politicks? It is my sole duty to convey law, or what I believe to be law, as through a channel.[20]

Jones clearly struggled to avoid any conscious politicization of his work in India, including both the scholarly and the judicial. The letter carefully distinguishes his duties as a judge from the politics of British rule in India, a realm in which he associates the purchasing of opinion with the plundering of colonial wealth.[21]

In spite of Jones's expressed denial of any political motivation behind his own work in India, the proliferation of Indian sublimes during the period – including his own – points not only to the intersection of the aesthetic and political, but to the inevitable Westernizing of the Sanskrit in its transmission. With this doubleness particularly on the part of Jones in mind, and as Suleri's observations about Burke's Indian sublime attest, the variation among British responses at the end of the eighteenth century can be seen to complicate Edward Said's representation of European imperialism in Asia. Dealing only fleetingly with the period, Said denounces the scholarship of the Asiatic Society by projecting onto it the prejudices of Europeans who had no firsthand knowledge of the language or literature. In *Orientalism*, Said reduces the motives of Jones and the Asiatic Society to such phrases as '[w]hat the Europeans took from the classical oriental past', 'stripping it of its veils', and claiming their goal 'was to gather in, to rope off, to domesticate the Orient and thereby turn it into a province of European learning'.[22] Even in *Culture and Imperialism*, his 1993 revision of his argument in *Orientalism*, Said echoes his earlier dismissal of the Orientalists under the rubric of imperial conquest, describing them as

> the great scholar figures for whom service in India was an opportunity to study an alien culture – men like Sir William ('Asiatic') Jones, Charles Wilkins, Nathaniel Halhed, Henry Colebrooke, Jonathan Duncan . . . belonged to principally commercial enterprises, and they seemed not to feel . . . that work in India was as patterned and economical (in the literal sense) as running a total system.[23]

While these descriptions are partially true, they disregard the differences among the Orientalists, particularly Jones and Colebrooke.[24] By contrast to Jones's attempts to dissociate himself from the politics of British rule in India, Colebrooke fed the repressive energies of the British government's later attempts to distort the differences between East and West with the aim of denigrating the philosophy of the Eastern texts.

More recent post-colonial scholarship has helped to account for the double bind of the early Orientalists. Madhava Prasad argues that power does not entirely reside in the colonizer,[25] while Rosane Rocher writes that Said's 'collapsing the entire history of orientalism into a single discourse' disregards the 'intimate concatenation of political and intellectual concerns'.[26] Homi Bhabha, emphasizing the ambivalence of English colonialism when he says that it 'speaks in a tongue that is forked, not false', explains that '[m]imicry is ... the sign of a double articulation; a complex strategy of reform, regulation and discipline, which "appropriates" the Other as it visualizes power ... The *ambivalence* of mimicry ... does not merely "rupture" the discourse, but becomes transformed into an uncertainty which fixes the colonial subject as a "partial" presence.'[27] Such acknowledgement of a 'double articulation' helps to account for the means by which the Orientalists transmitted knowledge of a culture that threatened the foundations of Western power while simultaneously Westernizing it.

This recent scholarship has thus helped to complicate the earlier post-colonial approach to the period by emphasizing the difference between the colonial and post-colonial situation. Suleri, challenging Said's position, notes that 'if colonial cultural studies is to avoid a binarism that would cause it to atrophy in its own apprehension of difference, it needs to locate an idiom for alterity that can circumnavigate the more monolithic interpretations of cultural empowerment that tend to dominate current discourse'.[28] The flow of influence from the colony to the motherland is thus a crucial factor in reassessing the exploitation of the colony by the colonizer, however insidious or unconscious it may have been.

Certainly, the positions of Rocher, Bhabha, Suleri and Prasad more adequately account for the doubleness of the early period of Orientalism, showing that a distinction must be drawn between the silencing of 'minority discourse' by the colonizer and the complex layering of intellectual and political motives underlying the Orientalists' Sanskrit transmissions. With this problematizing of the Orientalist agenda in mind, then, one can return to the question of what was at stake for the British government in the Orientalist project. An answer suggests itself through the occasion of Orientalism's demise with Macaulay's 1835 'Minute on Education in India'. In his dramatic reversal of the Orientalist promotion of the Eastern languages in

'native' education, Macaulay condemned as 'wrong philosophy' the major
Sanskrit texts. Parliament, Macaulay claimed,

never would have given the honourable appellation of 'a learned native' to a native
who was familiar with the poetry of Milton, the Metaphysics of Locke, and the
Physics of Newton; but that they meant to designate by that name only such
persons as might have studied in the sacred books of the Hindoos all the uses of
cusa-grass, and all the mysteries of absorption into the Deity.[29]

While Macaulay's examples of Milton, Locke and Newton as subjects worthy
of study should not be surprising, what is revealing is the knowledge he
betrays about the Sanskrit texts he claims never to have read. For Macaulay,
most antithetical to Western thought about these texts is their 'absorption
into the Deity', or their apparent nondualism. Macaulay's contrast between
West and East therefore pits the deism of Enlightenment thought against the
perceived nondualism of the East.

Macaulay's speech shows not only his own obvious antipathy for all
things Eastern, but it reveals, retrospectively, his precursors' ambivalence
towards Sanskrit philosophy: in spite of their celebration of India's language
and culture, the intellectual pursuits of the Orientalists are paradoxical in
both their motives and effects. Although discussion of the Orientalists'
Sanskrit transmission has been conspicuously absent from most recent
treatments of the British in India during the period, a handful of critics have
addressed Orientalism in terms of the educational controversy that followed.
Gauri Viswanathan, for instance, points out that Orientalism indirectly
participated in the Anglicist reaction against it, shrewdly observing that
Macaulay's Anglicism extends rather than reacts against Orientalism: 'It
would be more accurate to describe Orientalism and Anglicism not as polar
opposites but as points along a continuum of attitudes toward the manner
and form of native governance, the necessity and justification for which
remained by and large an issue of remarkably little disagreement.'[30] Yet
while it is persuasive to suggest that Orientalism feeds Anglicism, the
conflicting impulses with which Orientalism itself was fraught need to be
considered. Certainly, the distortions of Colebrooke in his transmissions of
Sanskrit texts contributed to the conscious exaggeration of the cultural and
ideological rift between East and West perpetuated during this later period.
With Colebrooke in mind, it is evident that Orientalism spawned such
powerful figures in the Anglicist movement as James Mill, who had never
seen India nor read its texts but whose 1817 *History of British India* was an
influential Utilitarian treatise claiming, among its many cultural distortions,
that India and China were 'tainted with the vices of insincerity; dissembling,
treacherous, mendacious, to an excess which surpasses even the usual
measure of uncultivated society'.[31]

In contrast to the blatant distortion of Colebrooke's brand of Orientalism, the contradictoriness of both Wilkins and Jones is thus marked by a far more complex and ambivalent response to the Sanskrit texts. Such ambivalence is epitomized by the circumstances of Wilkins's rendering of *The Bhagavad Gita* into English in 1784. Not only is it significant that the introduction to Wilkins's translation was written by Warren Hastings, then governor-general of Bengal, but that Hastings's letter introducing the *Gita* was addressed to Nathaniel Smith, Chairman of the East India Company, thus filtering the transmission of Indian texts through the Company. Hastings was made governor-general of Bengal in 1772 after the East India Company had left Bengal in ruins, disempowering the Bengal government and yet refusing to accept administrative responsibility. Horace Walpole denounced the Company, saying, 'We have outdone the Spaniards in Peru ... We have murdered, deposed, plundered, usurped – nay, what think you of the famine in Bengal in which three millions perished being caused by a monopoly of the servants of the East India Company?'[32] Viswanathan, tracing the history of the Company's involvement in India's government, notes that by 1757 it

had already become virtual master of Bengal and its territorial influence was growing steadily despite numerous financial problems besetting it ... Not until the last quarter of the eighteenth century, when reports of immorality and depravity among Company servants started pouring in, did Parliament find an excuse to intervene, at which point, in the name of undertaking responsibility for the improvement of the natives, it began to take a serious and active interest in Indian political affairs.[33]

The duplicity behind Hastings's success in not only restoring Bengal but also promoting the Asiatic Society is often noted, Hastings admitting that 'the quickest route to the heart of a people is through the language of the country'.[34] Viswanathan, however, criticizing Kopf's assertion of what she terms the 'benign and productive' nature of the Orientalists' influence, emphasizes the political agenda behind Hastings's endorsement of Orientalism.

Though the case of Hastings is transparent, as Viswanathan shows, that of Jones and Wilkins is not so. The twin phenomena of the British government in India and the pursuit of transmitting Indian philosophy and texts to England have a complex relationship that eludes assigning them straightforward causal connections. One element of the riddle, for instance, is that Orientalism had an explosive effect on the continent as well as in England, one Hastings could not have anticipated although the Orientalists' ambivalence informs even the most devoted British 'imitators' of the Eastern text. Furthermore, only three years after writing his introduction to the *Gita*, Hastings was impeached for the English abuses of India. Leading the

prosecution with a vengeance was Edmund Burke himself.[35] Thus, Orientalism was fraught with ambivalence from its inception. Without Hastings's encouragement, Wilkins might not have involved himself with the study of Sanskrit, nor might Jones have been encouraged to pursue his study of comparative language and philosophy which ultimately led to what we know as philology and organized comparative mythology.

A crucial element of Orientalism that illuminates the contradictoriness of these political and intellectual concerns but has been absent from critical discussion is the problem of the theological or epistemological distortions brought about through the rendering of Sanskrit into English. Although the Orientalists distinguished themselves from the evangelical deists in India, their own deistic leanings are evident in their writing, characterized by an insistence on a single God separate from but knowable through the phenomenal world.[36] Nevertheless, it has been difficult to label the Orientalists theologically. Regarding Jones, Wilhelm Halbfass notes that he was not a deist as such, pointing out that Jones 'nevertheless came close to deistic thinking'.[37] For both Jones and Wilkins, the line drawn between Creator and phenomenal world – in spite of their attraction to the dissolution of this line – is what aligns them with deism.

That ancient India was a fundamentally monistic culture was a happy discovery for the Orientalists, since they condemned what they claimed to be polytheism in the Hinduism of their day. The Orientalists pointed to the ancient texts such as *The Bhagavad Gita* to support their claim that the ancient Hindus held that a single God reveals himself in and through nature, a central tenet of deism. Yet such texts, in radical difference from deism, state that the Creator is no different from the creation. One of the most striking examples of this Eastern nondualism is at the climactic moment of the *Gita*, in which Krishna, an avatar of God, reveals himself as the Creator present in everything. Krishna says,

> I am the origin and the dissolution, the ground, the resting place, and the imperishable seed.
> . . . I am immortality and also death; I am being as well as non-being.

Krishna not only reveals himself through all things, but he is all things. This is the ideal of the undifferentiated state so alien and threatening to Western philosophy. It points to the essential difference between the monism of the Western tradition and the nondualism of the Sanskrit texts: while monism connotes a single, static principle, nondualism suggests a more dynamic principle in which differentiation dissolves into a oneness that subsumes diversity.

The Orientalists thus blurred the line between deism, the belief that the Creator reveals himself through his creation, and pantheism, the belief that

the Supreme is a single consciousness pervading the universe. In Charles Wilkins's own preface to his translation of *The Bhagavad Gita*, he expresses his concern with the problem of the Hindu customs of idolatry and sacrifice, attempting to clear the ancient texts of advocating these customs:

It seems as if the principal design of these dialogues was to unite all the prevailing modes of worship of those days; and, by setting up the doctrine of the unity of the Godhead, in opposition to idolotrous sacrifices, and the worship of images, to undermine the tenets inculcated by the *Veds*; [the author's] design was to bring about the downfall of Polytheism; or, at least, to induce men to believe God present in every image before which they bent, and the object of all their ceremonies and sacrifices.[38]

In 1787, Jones Westernizes Indian philosophy in a yet more complex way that reveals his ambivalence toward both East and West:

I hold the doctrine of the Hindus concerning a future state to be incomparably more rational, more pious, and more likely to deter men from vice, than the horrid opinions inculcated by Christians on punishments without end.[39]

His description of the Hindus as more 'rational' than the Christians para-doxically anticipates Macaulay's criticism. Yet in his *Hymns to the Hindu Deities*, Jones draws not only from Indian sources, but freely from the legacy of Western literature: Plato, Pindar, the Bible, Milton, Pope and Gray.[40]

Although Jones's 'Hymn to Narayana' itself appears to celebrate the pantheism discovered through the avatar Narayana, Jones's ambivalence is implicit in his preface to the poem:

The inextricable difficulties attending the vulgar notion of material substances concerning which 'We know this only, that we nothing know', induced many of the wisest among the ancients, and some of the most enlightened among the moderns, to believe that the whole Creation was rather an *energy* than a *work*, by which the Infinite Being, who is present at all times in all places, exhibits to the minds of his creatures a set of perceptions . . . so that all bodies and their qualities exist . . . only as far as they are *perceived*; a theory no less pious than sublime, and as different from any principle of Atheism as the brightest sunshine differs from the blackest midnight.[41]

It is curious that Jones defends Indian philosophy from charges of atheism, since what is most uncomfortable for his Enlightenment contemporaries about the East is that its divinity is *too* immanent. Jones associates the term 'sublime', then, with the Western term 'pious'. Jones, in fact, superimposes deism upon the Eastern nondual idea that the Supreme is an energy not a work. To call the Supreme an energy in all phenomena is essentially pantheistic and quite different from the phrase that follows in which Jones states that the Creator is separate from the creation, thus speaking through

the creation. It is significant, therefore, that Jones never says that the Creator itself is this energy, a notion fundamental to Indian philosophy, as seen earlier in the passage from the *Gita*. By limiting this 'energy' to the creation, Jones adjusts the idea to impose a deistic separation between Creator and creation. As Jerome McGann notes in his discussion of Jones's 'Hymn to Su'rya': 'It is the "Mind" of a certain kind of rationalist neoplatonism – distinctively English, distinctly Enlightened.'[42] Jones's ambivalence toward such an 'Enlightened' identity informs his preface to the 'Hymn to Narayana', which reveals his simultaneous attraction to and fear of the dissolution of subject–object boundaries he finds in the Sanskrit texts.

Along with Wilkins's translation of *The Bhagavad Gita*, Jones's Hymns were as influential among British writers as were his translations.[43] In discussing the influence of these texts on British writers, their ambivalence needs to be considered along with what Suleri has shown to be the ambivalence of colonial rhetoric in 'narratives of anxiety' among colonial and post-colonial writers. Suleri notes that in the context of colonialism

English India represents an ambivalence that addresses the turning point of such necessary imbrications as those between the languages of history and culture; of difference and fear. As a consequence, its trajectory is extensive enough to include both imperial and subaltern materials and in the process demonstrates their radical inseparability.[44]

This notion of 'inseparability' has significant implications for the relationship between the Sanskrit texts and the representations of India in the poetry of the period. The depictions of the East by Charlotte Smith and William Blake, in marked difference from each other, contribute to the range of representations of the East by British poets through their individual perspectives on the idea of inseparability.[45] Smith deftly superimposes an Indian sublime onto a didactic anti-imperialism, while Blake cries out for England to overcome its habits of separation and fear by learning from the 'philosophy of the east', one which he shows to value the 'human divine'.

Simultaneously condemning British imperialism while celebrating the visionary imagination embodied by the East, Charlotte Smith's *Beachy Head* grapples with the implications of the enslavement of the colonized in the name of the British commercial interest. Yet complicating her portrayal of imperial abuse is the recognition she weaves into the poem's imagery of what she, as a poet, has gained from the discovery, enacting a powerful revision of the images of conquest in the course of the poem.

As Smith gazes at the harbour at the opening of *Beachy Head*, a series of associations causes the tranquillity that initially inspires a straightforward, painterly description of the harbour to give way to a troubled meditation.

Smith's contemplation of the English Channel spans out from a nearby group of fishing boats to a distant merchant ship bound for Asia:

> [L]ike a dubious spot
> Just hanging in the horizon, laden deep,
> The ship of commerce richly freighted, makes
> Her slower progress, on her distant voyage,
> Bound to the orient climates, where the sun
> Matures the spice within its odorous shell,
> And . . .
> Bursts from its pod the vegetable down;[46]
> Which in long turban'd wreaths, from torrid heat
> Defends the brows of Asia's countless casts.

The quaint and unthreatening English vista is replaced by the exotic and 'torrid' projection of an Asia of multitudes. The transformation of the landscape from a tranquil description of fishing boats to the visionary sublime is typically Romantic, but setting Smith apart from her contemporaries is her chosen agent of transformation, the merchant ship. This vessel of commerce appears in the distance as a 'dubious spot', suggesting Smith's ambivalence: although she condemns the British exploitation of 'the sacred freedom' of 'Asia's countless casts', she is fascinated by what Hastings had recognized to be all but unpursuable in the Eastern sublime. The transformed seascape begins with Smith's imagining the port of entry in India for the merchant ship: 'where the sun/Matures the spice within its odorous shell', from there imagining still further what is invisible to the human eye: 'There the Earth hides within her glowing breast/The beamy adamant', going on still further to the sea which houses 'the round pearl/Enchased in rugged covering; which the slave/With perilous and breathless toil, tears off/From the rough sea-rock, deep beneath the waves'. For Smith, the 'toys of Nature' found in the Orient are inextricably linked to enslavement.

Smith's imagining of the 'countless casts' in this passage gives rise to her reflection on the relationship between foreign merchants and the Asian people:

> . . . they who reason, with abhorrence see
> Man, for such gauds and baubles, violate
> The sacred freedom of his fellow man –
> Erroneous estimate . . . !
> . . . So the brightest gems,
> Glancing resplendent on the regal crown,
> Or trembling in the high born beauty's ear,
> Are poor and paltry, to the lovely light
> Of the fair star, that as the day declines
> Attendant on her queen, the crescent moon.

The exotic imagery, typical of British depictions of the East, is coloured by references to class structure: the 'regal crown' on 'the high born beauty's ear' is seen as poor and paltry compared with the sublime landscape of the India she envisions.

But by the end of the description, the sublimity of the seascape is coloured by the riches acquired by the imperialist plundering of Asia in the earlier passage:

> ... transparent gold
> Mingles with ruby tints, and sapphire gleams,
> And colours, such as Nature *through her works*
> Shews only in the ethereal canopy.
> Thither aspiring Fancy fondly soars,
> *Wandering sublime thro' visionary vales* ...
> (italics added)

In the course of Smith's description of the scene, in fact, the projection of the Eastern land- and seascape becomes superimposed on the present view of Beachy Head: the 'gold' and 'ruby tints' of the sun sinking westward, significantly, give way to an apocalyptic image of flood and the last sun ray that 'fires the clouds/With blazing crimson' (94–5). Not only does this imagery give a double message about appropriating the Eastern sublime, but like Jones and the Orientalists, Smith Westernizes the imagined Eastern landscape when she observes that 'Nature through her works' shows herself, thus superimposing on the Eastern setting the deistic separation of Creator and creation. Smith's transcendent vision emerges out of and dissolves back into an ordinary moment, challenging Stuart Curran's statement that Smith's Romanticism 'seeks not to transcend or to absorb nature but to contemplate and honor its irreducible alterity' (xxviii). Nevertheless, Smith's astute perceptions of the political implications of the Oriental venture stand apart from representations of the East by her contemporaries. Indeed, Smith is keenly aware of the materialist interest behind the humanitarian claims of the British government in India. By the time she wrote *Beachy Head*, Smith seems to ask the question Suleri raises regarding the myth of surplus in the East: '[W]as legislative discourse itself exempt from the mythmaking of that era's cultural imaginings, in which the distant exoticism of India could be conceived and represented only by a metonymic extravagance with descriptions of the miraculous fashion in which money was seen to reproduce itself in the remoteness of that land?'[47]

While *Beachy Head* thus speculates upon the relationship between commerce and 'cultural imaginings', Blake's poetry draws on *The Bhagavad Gita* to help stand Enlightenment deism on its head by portraying as illusory nature's otherness, a central tenet of materialist thought. Although Blake does not refer to Sanskrit texts directly, evidence points to his familiarity

with Wilkins's translation of the *Gita*. In his 1806 'Descriptive Catalogue' of his paintings, Blake describes a now-lost portrait he had painted of Wilkins translating the *Gita*. Charu Sheel Singh points out that Blake may have come in contact with Jones and Wilkins through James Basire, to whom Blake was apprenticed, an official engraver to the Royal Society to which Jones and Wilkins were elected in 1772 and 1788.[48]

As Northrop Frye observes, Blake was 'among the first of European idealists able to link his own tradition of thought with the *Bhagavadgita*'.[49] An example of how the *Gita* finds its way into Blake's poetry is given by Kathleen Raine, who notes Blake's repeated use of the image of the inverted tree in his poetry: 'My roots are brandish'd in the heavens, my fruits in earth beneath', he writes in his prophetic book, *Europe*. Raine draws a parallel between this and the inverted tree in *The Bhagavad Gita*, an image Krishna uses to show Arjuna the illusory nature of the physical world: 'the tree *Aswattha*, whose root is above and whose branches are below' ... Krishna goes on to explain that 'its branches growing from the three *Goon* or qualities, whose lesser shoots are the objects of the organs of sense, spread forth some high and some low'.[50]

By integrating Eastern thought into his own mythos, Blake is doing more than adding its rich imagery to that of the Western tradition: he uses it to convey his message of nonduality, in which human perception expands to dissolve its separation from the phenomenal world. Blake represents non-dualism most fully in the apocalypse of *The Four Zoas* in which '[t]he stars consumd like a lamp blown out, & in their stead, behold/The Expanding Eyes of Man behold the depths of wondrous worlds'.[51] Blake emphasizes that such an apocalypse neither destroys nature nor does it take place at the end of time. This radical revision of Biblical apocalypse is central to Blake's challenge to Enlightenment materialism, since apocalypse comes about through a shift in perception that expands out from individual to city, nation and world community.[52]

In *The Marriage of Heaven and Hell*, Ezekiel tells Blake, during their dinner party, that '[t]he philosophy of the east taught the first principle of human perception' (Plate 12). That first principle is nondualism, which becomes apparent as Ezekiel continues: 'The Poetic Genius (as you now call it) was the first principle and all the others merely derivative.' For Blake, the Poetic Genius is the recognition that divinity is present in everything. This is best illustrated in the same 'Memorable Fancy' which begins with Isaiah, Blake's other dinner guest, answering the narrator's question of what the God was like to whom Isaiah had spoken. Isaiah responds, 'I saw no God. nor heard any, in a finite organical perception; but my senses discover'd the infinite in every thing.' The Supreme, in other words, is that First Principle, a con-sciousness that pervades 'every thing'. Blake discovers in India's texts a

means for both the individual and the communal recovery of what he sees as the nondual roots of the divine lost in the deistic Enlightenment.

Between Blake's celebration of the *Gita's* dissolving of boundaries and Macaulay's warning against the dangers of the Indian 'absorption into the Deity' lies the more typical ambivalence of the British towards the discovery of Sanskrit, in which literary gestures of enthusiastic welcome are qualified by various levels of Westernizing. Promising and threatening to be a powerful mode of revolt against the Western materialist tradition, Sanskrit became associated with the annihilation of a separate and autonomous ego. Hastings anticipated this ambivalent reception when he described the Indian sublime as unpursuable in his introduction to Wilkins's *Gita*.

Thus, when the impact of the publications arriving from India to England during the period is considered as a significant aspect of the Orientalist phenomenon, the question of the Orientalists' complicity in the imperial conquest becomes more vexed, since it splinters into a range of motivations and effects. Among the Orientalists themselves, figures such as Jones and Wilkins, who celebrate the discovery of Sanskrit, are distinguished from those such as Colebrooke, who disdain it. For Jones and Wilkins especially, this earliest venture into the transmission of Sanskrit is double-edged: what they hold dear in the discovery is that which threatens the very lifeblood of Enlightenment epistemology.

Notes

1. It should be noted that Orientalism is capitalized throughout this essay to distinguish it, as the specific historical phenomenon that preceded Anglicism, from a general Western interest in the East.

2. For examples of this wave of Orientalist scholarship, see Raymond Schwab, *The Oriental Renaissance* (New York: Columbia UP, 1984); Wilhelm Halbfass, *India and Europe* (Albany: State University of New York Press, 1988); John Drew, *India and the Romantic Imagination* (Delhi: OUP, 1987). The misrepresentations of the East from the Middle Ages through the eighteenth century are based on accounts from travellers and missionaries who did not know the language or culture, resulting in the caricatured depictions seen in popular works such as the *Arabian Nights*. One of the first works to move beyond the caricatures of Western depictions of the East was William Beckford's *Vathek* (1787). As Roger Lonsdale points out, '*Vathek* looks ahead in its awareness of the genuine oriental scholarship which was beginning to appear through such scholars as Sir William Jones, for example, and which would eventually inhibit the purely fanciful "oriental" fiction which had been popular for so long'; see Lonsdale, ed., *Vathek* (Oxford: OUP, 1983: xxv). Before these British Orientalists, as David Kopf notes, in *British Orientalism and the Bengal Renaissance* (Berkeley: University of California Press, 1969): 38:

 > German scholars . . . increasingly viewed the *Vedanta* as a unique manifestation of the 'Aryan genius' [while] Jones reacted to [such Indian texts] by stressing similarities between them and other comparative works of philosophy. It was not possible for him, for example, to read the Vedas or the many fine compositions in illustration of it, without believing that Pythagoras and Plato derived their sublime theories from the same fountain with the sages of India.

 Of course, a certain irony attaches to Jones's project, as more recent post-colonial scholars have suggested: although Jones replaced the German Aryan bias, the British impulse is no less ethnocentric. Indeed, perhaps even more problematic than attempting to link East and West philosophically is the more prevalent attempt by the mid- to late-eighteenth-century Orientalists

to look for Judeo-Christian roots in Indian texts. See Joseph Priestley, *Comparison of the Institutions of Moses with those of the Hindus* (Northumberland: n.p., 1799) as well as Edward B. Hungerford on the 'lunatic fringe of mythologists' (in *Shores of Darkness*, New York: Columbia UP, 1941: 10).

3. This essay goes on to discuss significant differences among post-colonial theorists, particularly between Edward Said and more recent scholars.

4. Kopf, *British Orientalism*: 156. This description is not to be held as a rigid sequence of events. Colebrooke, for instance, was working along with Jones during the early period, but his influence became apparent after he succeeded Jones as director of the Asiatic Society. The purpose here is to open up the perspective of the Orientalist phenomenon to allow for the differences among the Orientalists as well as the significant changes that took place during its brief history. For a thorough history of the Orientalist period and its aftermath, see Kopf, who documents Colebrooke's disparaging of the early Orientalist project with such statements as Wilkins being 'Sanskrit-mad' and the early translations 'a repository of nonsense'; see Knopf, *British Orientalism*: 28.

5. Because of the constraints of this essay's length, the two examples of Smith and Blake are chosen because their voices offer different perspectives from the canonical writers discussed elsewhere in the context of Eastern representations. See Nigel Leask, *British Romantic Writers and the East* (Cambridge: Cambridge UP, 1992) for portrayals of the East by Byron, Shelley and De Quincey.

6. For an overview of the sublime during the period, see Samuel H. Monk, *The Sublime: A Study of Critical Theories in Eighteenth-Century England* (Ann Arbor: University of Michigan Press, 1960).

7. P.J. Marshall, ed., *The British Discovery of Hinduism in the Eighteenth Century* (Cambridge: Cambridge UP, 1970): 186. Gauri Viswanathan notes in *Masks of Conquest: Literary Study and British Rule in India* (New York: Columbia UP, 1989) that

> Warren Hastings unwittingly opened the door to historical approaches to literature when he sought to popularize the translation of the *Bhagavad Gita* by Charles Wilkins . . . Hastings had a difficult time reconciling the literati of the West to a poem so wholly different in structure, style, and substance from the classical models of Greece and Rome that centuries of study and imitation had consecrated.

Though Hastings's motive was to have the *Gita* read 'without undue comparisons to Western literature', Viswanathan continues, 'his argument had the effect of referring critics to that "system of society with which we have for ages been unconnected" to derive those principles empirically' (121). In light of what Viswanathan shows to be the incompatibility of the two epistemologies, their intersections through the early Romantic writers is a particularly significant phenomenon.

8. Marshall, *The British Discovery of Hinduism*: 259.

9. Sir William Jones, *Poems* (Chiswick: C. Whittingham Press, 1822): 204.

10. As will be discussed later in this essay, the term *nondualism* is chosen over *monism* to suggest the dynamic dissolution of apparent duality, whereas *monism* connotes a static principle of unity.
 Because the extent of the late-eighteenth-century Orientalists' knowledge of India's varied tradition is still under investigation among Indologists, this study focuses on the direct responses of the Orientalists to the texts they translate and discuss rather than speculating about what is not mentioned directly in their writings. There is no evidence to date that Jones and the early Orientalists were aware of the many sects and doctrines of the Indian tradition, including that of *dvaita*, or dualism. According to Schwab, in 1786 'Charles Wilkins assumed that there was nothing left [of the *Vedas*] but incomprehensible fragments'; see *Oriental Renaissance*: 29. Schwab asserts, in fact, that '[a]lthough a good many preliminary Indic studies had undoubtedly circulated before those of Wilkins and Jones, their primary virtue was to heighten the desire for what was not yet grasped' (30–31).
 The question becomes more vexed during the period between 1825 and 1860, as Jonardon Ganeri points out in 'The Hindu Syllogism: Nineteenth-Century Perceptions of Indian Logical Thought', *Philosophy East and West* 46 (January 1996): 1–16, Colebrooke and others who succeeded Jones attempted to exclude 'texts dealing with the canons of sound argument, or with the criteria governing rational assent' as a means of creating the impression of 'a radically non-European mode of thought' (2). Ganeri's thesis is that the 'devaluation of rationalist elements in Indian philosophical thought arose because of "nativist" trends in the Indian nationalist movement, attempts to find in India's past something radically non-European with which to confront the colonial intrusion' (2). Although this is a strong argument for the manipulations of

Colebrooke and others succeeding Jones, it is to be stressed that the argument would not apply to Jones and Wilkins.

11. *Nondualism* is not synonymous with *transcendence*: the latter connotes a line to be crossed which, from the perspective of the former, is illusory. The fact that British readers of the period described the Indian texts in terms of a transcendental sublime should reveal their Westernizing of the texts.

12. Frances Ferguson, *Solitude and the Sublime: Romanticism and the Aesthetics of Individuation* (New York: Routledge, 1992): 46.

13. Sara Suleri, *The Rhetoric of English India* (Chicago: University of Chicago Press, 1992): 28.

14. Sertoli's interpretation of Burke's sublime 'delight' is especially interesting in light of Suleri's reading of 'colonial terror'. Such delight, Sertoli writes, is not 'the relief that subjects feel when they discover themselves at a distance from the object that, threatening them with death, terrorizes them [but rather] it is the thrill felt as they draw near to it; in other words, as they masochistically approach death'. See Giuseppi Sertoli, 'Edmund Burke', in Michael Groden and Martin Kreiswerth, eds, *The Johns Hopkins Guide to Literary Theory and Criticism* (Baltimore: Johns Hopkins UP, 1994): 123–4.

15. The East is, of course, not the sole source of nondualism that threatens the dualistic tradition of the Enlightenment: other mystical sources, such as Plotinus, Boehme and Spinoza, are indisputably at work. As Raymond Schwab notes, 'the accumulation of coincidences among the intellectual fashions which promoted Boehme, Schelling, and the Upanishads simultaneously is striking'; see Schwab, *Oriental Renaissance*: 197.

16. Jones, who had in England been dubbed by Horace Walpole a 'staunch whig, but very wrongheaded', betrays his own ambivalence through his manipulation – conscious or not – of the texts he translates; see S.N. Mukherjee, *Sir William Jones: A Study in Eighteenth-Century British Attitudes to India* (Cambridge: Cambridge UP, 1968): 49. Jones was made a judge in India because of the strength of his reputation as a lawyer in England. This, of course, put him in a double bind: his reputation in England was for defending the working class against the abuses of the aristocracy.

17. For more on Jones's double life in India see, for instance, Garland Cannon's discussion of his correspondence with American revolutionaries, 'Foundations of Oriental and Comparative Studies: The Correspondence of Sir William Jones', *Comparative Criticism: A Yearbook* 3 (1981): 163–4.

18. Cannon, ed., *The Letters of Sir William Jones* (Oxford: Clarendon Press, 1970): 631.

19. Ibid., 635.

20. Ibid., 636.

21. In the same letter, Jones continues, 'As to Mr. *Hastings*, my particular friendship with him is wholly unconnected with his publick rank, and has grown up from a similarity in our amusements and in our fondness of Asiatick literature; but he well knows, that the richest gem in Hindostan would not purchase an opinion of mine.' It is noteworthy that this letter, in which Jones carefully tries to extricate himself from the adversarial relationship between Burke and Hastings, predates Burke's impeachment of Hastings by three years.

22. Edward Said, *Orientalism* (New York: Random House, 1978): 76, 78, 79.

23. Said, *Culture and Imperialism* (New York: Knopf, 1993): 153.

24. Another example of this generalizing about the aims of the Asiatic Society is the claim that underlying the relationship of Orientalism to the political situation is a 'reverse acculturation' intended to assimilate British government officials and civil servants:

> [T]he great scholars produced by eighteenth-century Orientalism . . . entirely owed their reputations to a happy coincidence of pioneering achievement and official patronage. Their exhaustive research had ambitious goals, ranging from the initiation of the West to the vast literary treasures of the East to the reintroduction of the natives to their own cultural heritage, represented by the Orientalists as being buried under the debris of foreign conquests and depredations (Viswanathan, *Masks of Conquest*: 28).

Such a statement includes figures such as Jones and Wilkins among the more politically motivated Orientalists such as Colebrooke. This essay, by contrast, seeks to distinguish among the Orientalists in order to avoid attributing to some the motives of others, particularly those of Jones to Colebrooke.

25. Madhava Prasad, 'The "Other" Worldliness of Postcolonial Discourse: A Critique', *Critical Quarterly* 34 (Autumn 1992): 80.

26. Rosane Rocher, 'British Orientalism in the Eighteenth Century: The Dialectics of Knowledge and Government', in Carol A. Breckenridge and Peter van der Veer, eds, *Orientalism and the Postcolonial Predicament: Perspectives on South Asia* (Philadelphia: University of Pennsylvania Press, 1993): 215, 216.

27. Homi Bhabha, *The Location of Culture* (New York: Routledge, 1994): 85–6.

28. Suleri, *The Rhetoric of English India*: 4.

29. Thomas Macaulay, 'Minute on Indian Education', in *Prose and Poetry*, ed. G.M. Young (Cambridge, Mass.: Harvard UP, 1967): 719.

30. Viswanathan, *Masks of Conquest*: 121.

31. Kopf, *British Orientalism*: 240. Sara Suleri points out that Mill, ideologically driven to distort India's culture and philosophy, is 'impervious to the possibility of cultural sympathy' (*The Rhetoric of English India*: 33). The political element is further complicated by Burke's shift from endorsing Hastings in order to protect the Bengalis from the oppression of the British to blaming him for that oppression. Suleri focuses on Burke's use of the rhetoric of the sublime in his speech about India as part of Hastings's impeachment, suggesting that 'Burke's conflation of India as a conceptual possibility with the operation of the sublime works less to defamiliarize that idea than to render it canny through the very depictions of its difficulty . . . [T]he Indian sublime becomes indistinguishable from the intimacy of colonial terror' (28).

32. Kopf, *British Orientalism*: 13–14.

33. Viswanathan, *Masks of Conquest*: 27.

34. Kopf, *British Orientalism*: 15.

35. Suleri observes as well that while Hastings's preface argues 'for the autonomy of the Indian aesthetic tradition . . . how could Burke stop to acknowledge a congruence that merely confirms the inefficacy of his discourse to locate in its most horrific form the uncontainable nature of guilt?' Suleri, *The Rhetoric of English India*: 52.

36. See Kopf's discussion of the Orientalists' contention with the deists in India in *British Orientalism*: 139.

37. Halbfass, *India and Europe*: 56.

38. Sir Charles Wilkins, trans., *The Bhagavat-Geeta, or Dialogues of Kreeshna and Arjoon* (London: n.p., 1785): 24.

39. Drew, *India and the Romantic Imagination*: 47.

40. Cannon, *Sir William Jones, Orientalist* (Honolulu: University of Hawaii Press, 1952): 68.

41. Sir William Jones, *Poems*: 202.

42. Jerome McGann, 'Enlightened Minds: Sir William Jones and Erasmus Darwin', in *The Poetics of Sensibility: A Revolution in Literary Style* (Oxford: Clarendon Press, 1996): 128. See also Niranjana, who is interested in the 'outwork' of Jones's translations, 'to show how he contributes to a historicist, teleological model of civilization that, coupled with a notion of translation presupposing transparency of representation, helps construct a powerful version of the "Hindu" that later writers of different philosophical and political persuasions incorporated into their texts'. Tejaswini Niranjana, *Siting Translation: History, Post-Structuralism, and the Colonial Context* (Berkeley: University of California Press, 1992): 13.

43. These Hymns exerted a potent influence on the first German Romantics and 'a passion for Asia among the poets of the Lake School', according to Quinet in 1828; see Schwab, *Oriental Renaissance*: 195. The most widely known of these Hymns was 'Hymn to Narayana', which influenced Shelley's 'Hymn to Intellectual Beauty', and, as Garland Cannon notes, Keats's *Hyperion* (*Sir William Jones*: 70).

44. Suleri, *The Rhetoric of English India*: 3.

45. See Fatma Moussa-Mahmoud, *Sir William Jones and the Romantics* (Cairo: n.p., 1962), Drew, *India and the Romantic Imagination*, and Leask, *British Romantic Writers and the East* on British writers and the East.

46. Stuart Curran, ed., *The Poems of Charlotte Smith* (Oxford: OUP, 1993): 217–47. In his editorial note to the poem, Curran comments on the trade in cotton essential to Britain's commercial pre-eminence in clothmaking (219).

47. Suleri, *The Rhetoric of English India*: 25.

48. Charu Sheel Singh, 'Bhagavadgita, Typology and William Blake', in T.R. Sharma and Shastri Nagar, eds, *Influence of Bhagavadgita on Literature Written in English* (Meerut: Shalabh Prakashan, 1988): 28.

49. Northrop Frye, *Fearful Symmetry* (Princeton: Princeton UP, 1947): 173.

50. Kathleen Raine, *Blake and Tradition*, vol II (Princeton: Princeton UP, 1968): 34.

51. David Erdman, ed., *The Complete Poetry and Prose of William Blake* (New York: Doubleday, 1982): 406 11 24–5.

52. See Kathryn S. Freeman, *Blake's Nostos* (Albany: State University of New York Press, 1997), for a fuller account of Blake's nondualism in *The Four Zoas*.

Cameron's photographic double takes

Jeff Rosen

During the years 1867 and 1868, Julia Margaret Cameron's photographic career reached its fullest stride. Until then, she was known in the photographic press and among her friends and colleagues primarily for her intimate family portraits and suggestive Madonna studies. Yet only four years after first taking up photography, Cameron deliberately abandoned such imagery to seize upon global events of primary importance to the British Empire, political activities which captivated colonialists at home and abroad. These events included the public debates surrounding the condemnation and defence of Edward John Eyre, the ex-Governor of Jamaica; the expanding scope of covert British interventions into colonial territories; and the preparations for and execution of the war in Abyssinia. Cameron contributed to the public discourse surrounding these significant events by creating and displaying photographs that referred directly to these colonial incidents. In doing so, she used her photography overtly to affirm both the justness and the justice of British imperialism. At the same time, however, she also articulated the internal inconsistencies, multiple anxieties, and double articulations inherent in the expression of colonialist discourses of power.

Cameron produced photographs during this period that articulate both the 'discourse of otherness' which we commonly associate with Orientalism and the discourse of displacement, which is characterized by those conflicts and crises which arise from concurrent yet different cultural productions of otherness. Central to my argument is a theory of Orientalism, which I employ here to refer to Cameron's active manipulation of colonialist discourses of power. On the one hand, Orientalism emerged as the study of cultural artifacts and formal expressions of so-called primitive cultures; they were defined by their status as economically and culturally inferior to the

West.[1] More recently, Homi Bhabha has amplified this definition by characterizing the multiple discourses of Orientalism as indeterminable and ambivalent, especialiy as they were expressed by colonialists who recorded their impressions in pen, or for that matter, with the camera. Indeterminacy actively manifested itself as ambivalence in the act of representing subjugated peoples, according to Bhabha, because such representations were the direct outgrowth of the colonialist finding himself 'tethered to, not confronted by, his dark reflection, the shadow of the colonized man, that splits his presence, distorts his outline, breaches his boundaries, repeats his actions at a distance, disturbs and divides the very time of his being.'[2]

Bhabha theorizes that a palpable kind of displacement and instability lies at the root of the colonialist's ambivalence because it arises from 'the disturbing distance in-between [the colonialist Self and the colonized Other] that constitutes the figure of colonial otherness'.[3] For Bhabha, this discursive space is characterized by its continual inscription and by the colonialist's anxiety over its inherent instability; such contested terrains arise from 'the idea of man as his alienated image', because it results from 'the white man's artifice inscribed on the black man's body'.[4] As I shall demonstrate, during the years 1867 and 1868, Julia Margaret Cameron embarked upon photographic projects that consciously set out to create such spaces of otherness, including spaces of intolerance, infiltration, and colonialism. In her photographs of Eyre and his supporters, in her depictions of disguised British spies, and in her photographs of the aftermath of the Abyssinian War, Cameron directly confronted the colonial subjects of the Caribbean islands, India, and North Africa, of necessity causing her viewers to do the same. In creating such imagery, her works inscribe the colonialist's world view, one which accepted without question Europe's domination of colonial lands. Yet, both in her exhibition spaces and within the magical terrain of her constructed imagery, she also created contested, unstable, and indeterminate spaces, places of ambivalence and displacement that created opportunities to contest this dominant world view, enabling possible reinscriptions of her imagery.

In representation, ambivalence is apparent when imagery is reduced to the mining of a stock-house of stereotypes, and, as we shall see, Cameron's celebration of the 'heroic' members of the Eyre Defence Committee helps us to establish her conscious political position in relation to the prevailing conventions of photographic portraiture. Camouflage and doubling are also central to her images of disguised political operatives, another way in which she chose subjects that themselves wilfully challenged or shifted the sites of inscription. And finally, in her photographs of the orphaned Prince Alamayou of Abyssinia and his attendants, yet another important instance of ambivalence and displacement emerges. Each of these bodies of work

engages and promotes a 'double articulation' of colonial representation. According to Homi Bhabha, such a dialectic appears where 'a complex strategy of reform, regulation, and discipline [emerges], which both "appropriates" the Other as it visualizes power' on the one hand, while simultaneously representing, on the other hand, what Bhabha has termed 'the inappropriate Other', a reference for a (real or imagined) counter-discursive symbol which is capable of contradicting the unquestioned superiority of colonial power. By actively shifting the sites of inscription, such symbols are able to challenge otherwise unquestioned formulations of colonial superiority, or in Bhabha's words, they may emerge 'to pose a threat to both "normalized" knowledge and disciplinary power'.[5]

Reinscribing Cameron's Critical Terrains

By analysing Cameron's double articulations I hope also to interrogate 'the discursive and disciplinary place from which questions of identity are strategically and institutionally posed' in Cameron's work.[6] Following Foucault and inspired by Bhabha, Lisa Lowe has called these mutable places 'heterotopias', or spaces of otherness and crisis in which multiple and overlapping articulations alter the terms and conditions of the discursive terrain itself.[7] Some may reiterate Orientalist formulations; others may contest them, and, as we shall see, both statements are true of Cameron's imagery. Yet Cameron's complex role in this history has itself been displaced by scholars intent on interpreting the photographer narrowly as a religiously inspired or simply 'maternal' artist, a compiler of idiosyncratic albums for family and friends.

But in 1867 and 1868, Cameron was producing work to be exhibited and judged publicly in London, both on the walls of her print dealer, Colnaghi's, and in a one-person exhibition planned for January–February 1868 at the German Gallery. In promoting her work in this way, Cameron was not filling a personal album to give away. For this reason, perhaps, her images from this period have been overlooked or misinterpreted by scholars, as Cameron's photographs have been validated historically largely as a result of their appearance in such volumes. Scholars have recognized that she constructed her albums carefully, giving them to family and friends as tokens of affection.[8]

In 1984, Mike Weaver complained: 'Too much attention has been given to the personal characteristics of this remarkable woman and her family, and too little to their intellectual background.'[9] In agreeing with Weaver I would also add: and too little to her active participation and involvement in contemporaneous political events that affected her life and artistic production. It is important that we reinscribe Cameron herself in terms of the

colonial world of which she was a part: Julia Margaret Cameron was an ex-colonist, born in 1815 in Calcutta and educated in Versailles. She met her future husband, Charles Hay Cameron, on the Cape of Good Hope, and married him in 1838 in Calcutta, where they lived. As a jurist, Charles wrote the penal and educational codes for India and Ceylon until his retirement in 1848 at the age of 53, while Julia Margaret organized social events on behalf of Lord Hardinge, India's Governor-General.[10] Meanwhile, they acquired sizeable plantation estates in Ceylon, making them, by 1850, the largest private landowners on the island.[11]

The Camerons have been written into the history of Freshwater Bay (Isle of Wight) as if they were committed lifetime residents, or as if they longed to be.[12] But this view of the Camerons as happily landed retirees is also false; the two did not rest easily on the Isle of Wight after flourishing as a society couple in Calcutta. As early as January 1851, in fact, they even made plans to return to the East and live in Ceylon, at least until Charles was offered a much-anticipated position as Governor of Malta or the Ionian islands.[13] When Charles was ultimately passed over for both of these posts, it appears that the family settled in England by default, for clearly, had he been appointed to govern either colony, Julia Margaret and the family had already decided to follow. Moreover, the Camerons' Freshwater years were marked by constant correspondence with their sons in Ceylon and regular communication with their land overseers.[14] As is recounted by her friend Lady Anne Thackeray Ritchie, from 1859 through the 1870s the period preceding each of Charles's journeys from England to Ceylon was met with concern, anxiety, and flurries of activity. According to Lady Ritchie, Cameron found solace in her continued work, her photography.[15] And in 1867–8, the interrelated world events which placed the British at the centre of political, territorial, and cultural conflicts in the Caribbean, the Middle East, West India, and North Africa excited a dormant political activity previously untapped by her camera. Julia Margaret Cameron's ambivalence emerges in her first major exhibition of 1868, on Bond Street.

Heroes – and Anti-Heroes – in Bond Street

Ambivalence may be detected, according to Bhabha, when imagery vacillates uneasily 'between what is always "in place", already known, and something that must be anxiously repeated . . . [which] can never really, in discourse, be proved'.[16] For Julia Margaret Cameron, ambivalence characterizes the choice of subjects, the selection of images, and the context and timing of her solo exhibition in January–February 1868 at the German Gallery on Bond Street, London. The gallery was visited by her many

Freshwater friends, notably Anne Thackeray and William Allingham, a poet in the literary circle of the Tennysons and the Thackerays.[17]

Julia Margaret Cameron's ambivalence was manifested in this exhibition in several important ways. First, she created works especially for display in this exhibition and took pains to include examples of her portraits and her allegories, the two principal pursuits of her photographic work to date. She did this in spite of the fact that she knew that such inclusiveness disturbed her critics in the press, who could not abide such blurring of the artistic boundaries in photography.[18] Second, she chose to display several already decorated photographs of her heroes, such as her portrait of Herschel, which was therefore already validated and 'safe',[19] but she also included what we may recognize as untested and risky images, fraught with potential political conflict, such as her portraits of Edward John Eyre and Thomas Carlyle. As I hope to show, these photographs, and their display in the exhibition amidst allegories of virtue, goodness, and justice, reveal Cameron's anxious repetition of heroic virtue, which ultimately lent support to the 'justice' of Eyre's cause. Moreover, Cameron's display of the literary and mythological heroines who sacrificed themselves for honour, duty, or noble concerns analogically referred to other contemporaneous arguments supporting Eyre. As Carlyle had argued, and as Dickens, Ruskin, and Tennyson would later echo, Eyre's suppression of the Jamaican Rebellion was 'just' because in saving British lives and property, he preserved and even strengthened colonial rule in the island, all while selflessly putting his own life in danger.

As Bhabha writes, ambivalence is often expressed through anxiety, and it has been often remarked that Cameron's contemporaries characterized her working methods and her choice of subjects as anxiety-filled and excessive. Tennyson, Allingham, Edward Lear, and Dante Gabriel Rossetti, among many others, complained about the photographer's dogged persistence in trying to get them before her camera.[20] Once she succeeded in obtaining a sitting, moreover, Cameron would repeatedly photograph and re-photograph the faces of her heroes, often using them to create allegorical arrangements. By and large, her critics were unwilling or unable to join together the two dominant strands of her imagery. In spite of them, Cameron defied easy categorizations, making portraits of Alfred, Lord Tennyson as 'himself' *and* as 'The Dirty Monk'; Sir Henry Taylor as 'himself' *and* as 'King David' and 'Prospero'; and George Frederick Watts as 'himself' *and* as the inspired artist in 'Whisper of the Muse'. When she assembled these works in albums or for exhibition, Cameron often included both versions, as she did in 1868.[21]

In June 1867, in preparation for her exhibition, Cameron took her photographic apparatus and developing equipment from her home on the Isle of

Wight and visited her sister Sara Prinsep, who lived in Little Holland House, in Kensington, London, there to take photographs of one of her heroes, Thomas Carlyle.[22] On 8 June, Cameron registered her copyright for not one, but two extraordinary portraits, one portraying Edward John Eyre, the ex-Governor of Jamaica, and another of Carlyle, then Eyre's most visible public supporter as Vice-President of the 'Eyre Defence and Aid Fund'[23] (Figures 8.1, 8.2). Eyre had been recalled from Jamaica, his Governorship withdrawn pending the inquiry of a Royal Commission into the circumstances of his lethal reaction to riots in Morant Bay in October 1865. When Eyre imposed martial law, British troops had killed more than 400 native islanders, flogged more than 600 men and women, and burned more than 1000 homes. Eyre's most egregious retaliation took the form of court-martialling and executing a native islander, George William Gordon, an effective and outspoken critic of his administration. When news of these reprisals reached England late in 1865, John Stuart Mill helped to form a 'Jamaica Committee' and worked hard to recall Eyre to London with the eventual aim of prosecuting him for what he regarded as Eyre's brutal and unlawful actions. Thomas Carlyle, by contrast, wrote of Eyre as a 'Hero who had, with such promptitude, sagacity and intrepidity, trampled out *fire in the powder-room*, and saved the whole West Indies *ship* from flying aloft amid the deep seas . . .' In his audacious reactions to Mill's Jamaica Committee, Carlyle spoke crudely and offensively against what he called 'a small loud group . . . of Nigger-Philanthropists, barking furiously in the gutter', sentiments which reflected his well-documented racial intolerance and disdain.[24]

During the mid-century and for several decades thereafter, the cult of hero-worship and honouring of men of power was associated with Carlyle's influential book, *On Heroes*.[25] Carlyle believed that the portraits of his heroes actually revealed the character traits that he admired; working with a portrait by his side afforded him 'a permanent reminder that language, whether historical or pictorial, is tied to the fact of the bodily and psychological presence of those about whom it is written'.[26] Cameron shared Carlyle's faith in heroism. Of her photographs of Carlyle and others whom she also considered heroic, Cameron herself wrote: 'When I have had such men before my camera my whole soul has endeavoured to do its duty towards them in recording faithfully the greatness of the inner as well as the features of the outer man.'[27] But Carlyle even went further: 'Every student of history', he wrote, who strove to comprehend the deepest motivations of men, must 'search eagerly for a portrait – for all the reasonable portraits there are; and [should] never rest till he had made out, if possible, what the man's natural face was like.'[28] For Carlyle as for Cameron, then, photographs were valued because of their direct connection to their referent: Cameron's photographs (many of which were printed life size) were always about her

subjects' superiority as individuals. And Carlyle and Cameron both shared ideas about the indexicality and iconicity of photography: as Carlyle wrote, a photographic portrait revealed its status as an index, as 'that face and figure which [a photographer] saw by his own eyes', but he recognized too that photographic portraits also acquired iconic and symbolic value, standing emblematically for an individual's timeless or universal greatness.[29]

Six months after copyrighting her portraits of Carlyle and Eyre, Cameron readied them for display at the German Gallery. The timing of Cameron's sessions with both Carlyle and Eyre in June 1867 and the exhibition six months later are highly significant, as during the intervening period two prominent events fuelled outrage and public debate concerning the Eyre affair: first, in August 1867, Carlyle's essay 'Shooting Niagra, And After?' was published, and second, in February 1868, Carlyle finished writing the petition of the Eyre Defence Committee and submitted it to Parliament.[30] This period, in other words, was one of persistent visible activity for the defenders of Edward John Eyre and the cause of British imperialism. It marked the beginning of a backlash of public sentiment on Eyre's behalf and against John Stuart Mill, the Liberal Member of Parliament for Westminster who led the efforts to prosecute Eyre.

Carlyle and Mill had clashed earlier in *Fraser's Magazine* in 1849–50 over questions of racial dominance and imperialism stemming from the abolition of black servitude in the West Indies. Carlyle's 'Occasional Discourse on the Nigger Question', for example, regarded the black man as effeminate and primitive, and therefore unworthy of self-determination; in response, Mill's 'The Negro Question' condemned Carlyle and Caribbean plantation owners alike for their inept moral defence of living off the labour of others, and for their view that 'one kind of human beings are born servants to another kind'.[31] If Carlyle's use of the term 'nigger' was a lone voice in 1849, the term gained more common usage in England by 1857, the year of the Sepoy Rebellion in India.[32] By 1865, news of the American Civil War had polarized English society even more; while Carlyle supported the South and idealized the slaves' actual conditions, Mill decried any effort to legitimize slavery.[33] In 1867, Carlyle declared the permanency of an enslaved condition for the Negro race as part of his defence of Eyre's actions in Jamaica. In 'Shooting Niagra: And After?', he reasserted his earlier position from the 'Occasional Discourse', insisting: 'One always rather likes the Nigger ... he is the only Savage of all the coloured races that doesn't die out on sight of the White Man [sic]; but can actually live beside him, and work and increase and be merry. The Almighty Maker has appointed him to be a Servant.'[34] Eyre himself maintained this racist point of view; in his own defence against the charges brought by the Jamaica Committee before the Royal Commission,

Eyre justified his actions with the following statement, declaring as if it were incontrovertible evidence,

That the negroes form a low state of civilization and being under the influence of superstitious feelings could not properly be dealt with in the same manner as the peasantry of a European country . . . That as a race the negroes are most excitable and impulsive, and any seditious or rebellious action was sure to be taken up by and extend amongst the large majority of those with whom it came in contact.[35]

Finally, in his Petition to the House of Commons in support of Eyre, Carlyle wrote that the Governor in fact deserved commendation rather than scorn, that 'Governor Eyre, by his courageous, prompt, and skilful conduct, quenched down a Savage Insurrection in Jamaica, which threatened to envelope that Island in nameless horrors; and which, many judge, might have kindled into conflagration all our West Indian Possessions together.'[36] To Carlyle, Eyre was a certifiable Hero. According to Catherine Hall, both Carlyle's Defence Committee and Mill's Jamaica Committee manufactured their own stunts for manipulating public opinion: 'They set up meetings, wrote to the newspapers, published pamphlets, organized lecture tours, established committees with official positions, organized finances, sent delegations to the appropriate places, kept up pressure in Parliament, and made themselves as publicly prominent as they could.'[37]

With her fresh portraits of Eyre and Carlyle now added to her pantheon of great men, Cameron's January–February 1868 exhibition at the German Gallery therefore emerges as one such public relations effort to help promote Eyre's cause. Moreover, the exhibition included Cameron's photographs of other prominent members of and subscribers to the Eyre Defence Committee. The published list included prominent literary figures like Alfred, Lord Tennyson, the jurist and entrepreneur Henry Thoby Prinsep and his son Valentine Prinsep, and the author Anthony Trollope, among many others. In 1868, Cameron displayed images of these four men in her exhibition to accompany Eyre's and Carlyle's images. Their positions were well known. In his book, *The West Indies* (1860), for example, Trollope agreed with Carlyle about the debased 'nature' of the black man.[38] Henry Thoby Prinsep served on various internal committees of the India Office, notably the Political and Secret Department, arguing repeatedly on behalf of conservative causes.[39] Prinsep was also Julia Margaret Cameron's brother-in-law, married to her sister Sara. And once his name had been recruited to support Eyre's cause, Alfred, Lord Tennyson lent perhaps the greatest legitimacy to the aims of the Eyre Defence Committee.[40]

In her German Gallery exhibition, Cameron displayed the portraits of her heroes: Herschel and Carlyle, Eyre and Trollope. Also figuring prominently

was Henry Taylor, who was not listed as a subscriber to Eyre's fund but was nevertheless an articulate spokesman for the Colonial Office's pro-slavery positions in his debates against Mill and the Benthamites.[41] But in this exhibition, she did not confine the imagery to portraits of her heroes; rather, she also displayed allegories of authoritarian men, who were, Weaver noticed, also 'compulsive and compelling in the manner of Carlyle's heroes'. In fact, Weaver claimed that the allegories displayed there 'consciously displayed the dark side of male authority'.[42] In the context of Cameron's portraits of heroic men, we might even extend the reference and suggest that these allegories represent the anti-hero: all of them involve harsh, severe, or callous father-figures and their virtuous and pure daughters who have been placed in uncompromising predicaments, or who portray the oppression of their overbearing and inflexible fathers. They included *Beatrice*, modelled on the Beatrice Cenci created by Percy Shelley, who plotted her father's murder after having been cruelly abused by him; *Christabel*, from an unfinished poem by Samuel Taylor Coleridge, the heroine struck by a demon's spell only to be ignored by her obtuse father, Sir Leoline; *Prospero and Miranda*, from Shakespeare's *The Tempest*, the daughter shielded from the world as a reflection of her father's repressive control; and *Friar Laurence*, whom Cameron depicted with Juliet from Shakespeare's *Romeo and Juliet*, the agent of the two youths' destruction. Other women displayed in 1868 in these allegories fare equally poorly in consequence of their absent or neglectful fathers: *Rosalba*, for example, a character from Thackeray's *The Rose and the Ring* (1855), becomes a type of beggar-maid once she has been lost to her father. Or men alone and their rule over women are portrayed, as in Cameron's *King Cophetua*, who transformed the menial life of yet another servant girl, as modelled upon the title character of Tennyson's 1842 poem, *The Beggar Maid*.[43]

Weaver apparently came to terms with the stark recognition that Cameron's male allegorical figures were unthinking and callous, brutish and coarse, charitably calling her representations of the 'dark side' of these men little more than human nature: 'With the insight of genius as well as affection, she recognized dark forces in the greatest of men.'[44] But ironically, Weaver was referring to her *allegorical* representations of men. The public and atrocious 'dark side' of Cameron's real 'heroes', on the other hand, her lionizing of Eyre and Carlyle, have however remained unconsidered. Nor did he consider their appearance together within an exhibition assembled by Cameron herself. But Homi Bhabha's analysis of the ambivalence inherent in the colonialist's condition may help us reconcile the extreme and seemingly incompatible presence of the heroic and anti-heroic within this exhibition. In another context, Bhabha wrote:

To be the father and the oppressor; just and unjust; moderate and rapacious; vigorous and despotic: these instances of contradictory belief, doubly inscribed in the deferred address of colonial discourse, raise questions about the symbolic space of colonial authority. What is the image of authority if it is civility's supplement and democracy's despotic double?[45]

Because ambivalence is characterized by indeterminacy in the colonialist's discourse, each instance of such indeterminacy is capable of throwing conventional forms of representation into crisis. A space is opened up, then, to reinscribe Cameron's male heroes as anti-heroes. Like the male allegorical figures, they too are both fair and intolerant; humanized and barbaric; strong and unfit; able and inept. The Orientalist discourse of inexorable Western power as found in the portraits is likewise destabilized by the presence in the allegories of contemptible men who deny their humanity (*Friar Laurence*); are willfully cruel (*Beatrice*); perpetuate a master/slave relationship (*Rosalba, King Cophetua*); or who are negligent in combating evil flourishing in their midst (*Christabel, Prospero*).

Cameron did not solely exhibit portraits of heroic men, nor was she confident in displaying her allegories of male anti-heroes by themselves. The solution was to combine the two forms, unwittingly enunciating an anxious dialogue between virtue and vice, offering mutual contradictions – both purity and sinfulness, innocence and evil – in her literal portraits and allegorical studies. Bhabha theorized that such ambivalence actually undermined the cultural priority given the metaphoric as a dominant form of representation, which we may find confirmed in the criticism from this exhibition. Writing in the *Athenaeum*, for example, one critic wrote, 'Of these [photographs] we dismiss at once such as bear "fancy" names, and pretend to subjects of the poetic and dramatic sorts.'[46] Simultaneously, the once-unimpeachable role of the formal portrait was weakened as well, as the evident artificiality of the one form was now thought capable of staining the other. Staining, the leaving of a resistant trace, is an apt metaphor for the resilient 'mark' of that which has become destabilized.[47]

The Double Face of Infiltration and War

Julia Margaret Cameron's interest in depicting colonial themes and subjects grew dramatically following her German Gallery exhibition. Much of the imagery associated with her family albums was abandoned, including the drooping Madonnas and treacly children posed asleep or in prayer. These were replaced by new compositions using Freshwater's most recent visitors, fresh from North Africa, including both emissaries of the Empire and refugees from the war in Abyssinia.

The Abyssinian War of 1867–8 was the linchpin of this diverse photo-graphic activity. Initially a conflict of words and misunderstandings between the Abyssinian King Theowodrus II (whom the English called Theodore) and British diplomats in the Colonial Office, the 'Abyssinian difficulty' began in 1865 when the Abyssinian King imprisoned the Queen's envoy, Charles Duncan Cameron (no relation to Charles or Julia Margaret); it escalated when further emissaries sent to mollify King Theodore and release the envoy were also imprisoned. The Abyssinian War was a 'popular' war in England, designed to 'save face' by rescuing the British captives by force, thereby teaching the Africans 'a lesson'.[48] The campaign itself was also an over-whelming display of power, skill, and will, as Robert Cornelis Napier, then the most decorated Field Colonel of the Royal Engineers, commanded an army of almost 4000 English and Indian soldiers by sea and over rough terrain to release the British captives.[49] The progress of Napier and his forces was chronicled throughout 1867 in regular dispatches in *The Times* and in pictorial reports in the *Illustrated London News*; in 1868 the latter journal produced a luxuriously bound commemorative volume of excerpts and field reports, illustrated with lush engravings.[50]

Napier's final push at Magdala left King Theodore dead by his own hand. The conquest itself left his son, the child-Prince Alamayou,[51] orphaned and his country occupied. Under the patronage of Queen Victoria herself, young Alamayou, the British officer Captain Speedy, and one of the Prince's servants were brought to England, first settling on the Isle of Wight in July 1868.[52] Cameron's colonial subjects therefore unwittingly came to her: she made a formal portrait of Napier on the occasion of his visit to the Queen at Osborne House, and on two occasions in July, a total of thirteen photographs of the Abyssinian refugees. Despite the fact that the presence of her subjects on the Isle of Wight that summer was recorded by Queen Victoria, Emily Tennyson, William Allingham, and others, the narrative of the Abyssinian Expedition and its aftermath on Freshwater Bay has been considered inci-dental to most of the historical accounts of Cameron's photography.

Nevertheless, Cameron made photographs of the young Prince Alamayou of Abyssinia, the Prince's African attendant, and the Prince's appointed guardian, Captain Tristram Speedy, in several different poses. The three visitors stayed at Afton Manor, the home of Mrs Cotton, Captain Speedy's mother-in-law. Speedy attained some celebrity during the war as Napier's translator and trusted aide; prior to this military role, however, he actually lived in Abyssinia as a hunter, mercenary, and 'adventurer', at one point even pressed into serving King Theodore as *his* translator. As a multilingual man of imposing size, who was also fond of wearing native Abyssinian costume, Speedy was depicted in reports and images published in the *Illustrated London News* as a colourful figure serving Napier.[53] Once they

settled in England, Speedy and Alamayou frequently visited Queen Victoria at Osborne, her summer residence, and called upon the Tennysons at Farringford and the Camerons at their home, Dimbola. The Prince caused 'something of a sensation' among the island's residents, according to Captain Speedy's notebooks, where 'everyone was very interested in the Abyssinian Expedition and wanted to catch sight of Alamayehu'.[54]

Cameron copyrighted her photographs of Alamayou and quickly sent them off to London, there to be displayed in the window of her print dealer, P. & D. Colnaghi's, in anticipation of receiving orders. 'Study No. 2', for example (Figure 8.3), depicting the Prince and Captain Speedy, bears the inscriptions, 'From life registered photograph taken at Freshwater 20 July 1868', 'Copyright registration of July 23, 1868', and 'For the window immediately orders will be taken.'[55] Such activities reflect both Cameron's business-like approach and her ambitious goals; they stake an immediate, if not urgent, claim over her imagery, suggesting a desire to assert her prior entitlement to the works and control their dissemination, revealing a personal investment in the success of her project.

Cameron's investment was of a political nature, too, for she was not simply content to confine her imagery of the Abyssinian group to the few portraits sent to Colnaghi's and registered for copyright on 23 July. In fact, the following week, she organized another portrait session with the same subjects, registering an additional five photographs of the Abyssinian subjects on 27 July and another five just two days later.[56] The ten photographs of the Abyssinian group which resulted from the second and third sittings were not formal portraits like the first, but instead were *tableaux vivants* of her subjects acting out roles. If the first session of July resulted in three closely cropped arrangements with the Prince as the primary subject, the subsequent sessions shunned conventional portraiture in favour of producing three dramatic figure-groups, much in the same way that Cameron's maid was transformed into the Madonna. Moreover, props surrounding the figures, who were arranged in front of a curtained stage, are prominent in the results of the second and third sittings, suggesting a new approach to social relationships or an emphasis on metaphoric associations which are not at all present in the formal portraits of July (Figure 8.4).

In his diary entry dated 21 August 1868, William Allingham wrote of witnessing the preparations for these remarkable photographs. Although he himself never sat for Cameron, Allingham's narrative reveals telling observations which shed light on the photographer's working methods as well as on the fascinating series which resulted:

Mrs. Cameron's: Captain Speedy opens the door. Little Alamayu, pretty boy, we make friends and have romps, he rides on my knee, shows his toys. His Abyssinian

attendant. They dress to be photographed by Mrs. C., the Prince in a little purple shirt and a necklace, Captain Speedy in a lion-skin tippet, with a huge Abyssinian sword of reaping-hook shape ('point goes into your skull'). Photographing room – Speedy grumbles a little, Mrs. C. poses them. Photograph of Tennyson's maid as 'Desdemona'.[57]

As Allingham indicated, Cameron included in her imagery an additional figure, present in Figure 8.4, who was Prince Alamayou's 'Abyssinian attendant', an individual whose origins and identity are uncertain and not recorded in the copyright registrations, but who was identified as 'Casa' by Roger Fry and Virginia Woolf.[58] The discrepancy between the dates of Cameron's actual copyright registrations and Allingham's apparent witnessing of the photographic session might be reconciled by the poet's recording the events after the fact, or by his confusion over yet another session of August, when Cameron's model Mary Killaway (who was, perhaps, Tennyson's maid?) posed in an Abyssinian costume.[59]

The most unusual and perplexing photograph of the entire series is the one depicting Speedy, the costumed soldier, and the Prince's African attendant (Figure 8.5), which has come to be known by the suggestive title *Spear or Spare* since it was first described by Helmut Gernsheim in 1948. In the photograph, Prince Alamayou does not appear. Instead, Cameron has depicted an image of arrested conflict: she has positioned Speedy hierarchically above Casa, his right foot placed on Casa's hip, forcing Casa into a supine position; in addition, Cameron has directed Speedy to push back against Casa's head with his left hand and for the reclining man to stare up towards Speedy. A spear held in Speedy's right hand is positioned near the throat of the wide-eyed Casa, and yet, in contrast to his expression of extreme alarm, the supine man offers no resistance; instead, his right arm is draped limply over a decorative shield in the foreground. In this image, Cameron has constructed her version of the Abyssinian conflict, depicting a standstill of sorts in the relations between white and black, between colonizer and colonized. Yet this image has been obscured historically, largely because it contradicts the reigning interpretation of Cameron as a woman preoccupied with depicting Biblical and literary imagery or men of literary and scientific brilliance. Omitting any context of the 1868 war in Abyssinia, Gernsheim believed *Spear or Spare* to be an out-take from Cameron's illustrations to Tennyson's *Idylls of the King*. In his efforts to confirm that notion, he even misdated the photograph to 1874, six years after it was actually made, a date which has not been challenged in the literature on Cameron since 1948.[60] More recently, however, in personal correspondence, Gernsheim retracted this earlier analysis, even affirming that he alone appended the title *Spear or Spare* to this image, and that it was *not* inscribed by Cameron.[61]

Cameron's photographs of the Abyssinian refugees have been termed anomalous, rejected as important singular images, largely because they appeared to be unprecedented in her *oeuvre* given its associations with portraits of great men and allegories of morality and virtue. Yet if we return this imagery to the colonial situation upon which it comments, we may profitably connect Cameron's project to her other photographs, especially to those celebrated portraits of significant colonial figures who in some way contributed to the covert activities of the imperial forces in general, or to the expedition in Abyssinia in particular.

For example, in 1868, Cameron made portraits of celebrated explorers including Richard Francis Burton, Austen Henry Layard, and William Gifford Palgrave. Other portraits of important colonial figures, like Henry Taylor and Thoby Prinsep, had already been exhibited on Bond Street, along with her well-known study of the painter William Holman Hunt that she had taken several years earlier. All of these were available for purchase at Colnaghi's. Cameron's portraits of these men praise their cultural superiority, but her new works owed more to the Orientalist tradition in portraiture than to any Biblical reference or typological connection one might infer; in depicting men associated directly with disguise, subterfuge, and infiltration, they celebrate concealed power. William Holman Hunt, for example, was photographed in the costume he wore while in Egypt and Palestine, his attire chosen, according to the painter, the better to fit in, but also as a kind of spiritual identification with his subjects. Like Hunt, Cameron also portrayed William Gifford Palgrave in his Eastern disguise, depicting him in the turban he used while crossing Arabia in 1862–3. Disguised as a Syrian doctor and merchant, Palgrave was paid in part by Napoleon III, to whom he reported on the Arabians' attitudes towards the French.[62]

Richard Francis Burton, who became famous for translating the *Arabian Nights*, first won fame in 1853 as the first Westerner to penetrate the Great Mosque of Mecca, his exploits subsidized by the Royal Geographic Society. As a disguised Arabian, Burton's usefulness to the Empire was well chronicled, as he informed the British army about planned revolts, and his field reports functioned as avant-garde military updates.[63] Layard, too, hoped to serve the Empire beyond his status as a Member of Parliament. Much as Edward John Eyre had first been known as an explorer and adventurer in Australia, Layard, too, acquired a reputation for his voyage into ancient Assyria and his archaeological treatise on the ruins of Nineveh and Babylon. In his political life, however, Layard declined the post of Consul-General of Egypt that he was offered in 1853. Hoping for greater political fortune, he helped bring to a head in Parliament the conflict between Britain, France, Russia, and Turkey over the control of Jerusalem,

and later, the Crimea.[64] Years later, in 1865, Layard and Palgrave both tried to help resolve the emerging conflict in Abyssinia, and Layard, who became Under-Secretary in the Foreign Ministry, emerged as a key figure who was instrumental in sending Palgrave to Egypt in preparation for going on to Abyssinia.[65] Cameron's photographs of these men in 1868 therefore appear to respond more to their timely importance to colonialist interests in North Africa than to some emerging idiosyncratic collection of supposedly heroic adventurers.

Rather, Cameron's portraits of these men present a kind of photographic evidence of the twin reality of an undercover operator: when depicted in their disguises as Eastern subjects of the British Empire, Palgrave and Holman Hunt, for example, are presented photographically as active subjects but also as passive objects, or, in Edward Said's terms, as 'both exhibit and exhibitor, winning two confidences at once, displaying two appetites for experience'.[66] Cameron's imagery refers not only to her sitters' duplicity but explicitly to double identity: all four of these men wore disguises to obscure their British identity. In their letters and published accounts of their travels to the Middle East, moreover, both Layard and Holman Hunt revealed the necessity to keep their mouths shut because they spoke no Arabic. Both men were forced to rely instead upon the quality of their external disguise, as well as their native guides, not only to safeguard them physically but to do their speaking for them.[67] On the other hand, because of their evident command of Arabic, Palgrave and Burton literally assumed 'other' identities: at various times, for example, Palgrave was known as Père Michel Sohail; (Reverend Father) Michael Cohen; an unnamed Sheikh; and 'Seleem Abou Mahmood-el-'Eys, the Quiet One'.[68] For his part, Burton accomplished his missions under the more modest pseudonym 'Shaykh Abdullah'.[69] We may conclude that Cameron's photographs of these men also do double duty: they conceal the violence of their infiltration and celebrate the success of their deception.[70] In these images, the subterfuge being commemorated has since passed, and the image marks its aftermath, its successful finale.

The political collaboration which brought together Layard and Palgrave as would-be settlers of the Abyssinian dispute was understood in 1867 in the British press as a kind of political ultimatum. In a cartoon from *Punch* (Figure 8.6), for example, the bold, gladiator-like personification of the Imperial Army threatens a cowering and fearful Abyssinian King. Outside an imagined prison holding Britain's consul and her envoys, Britannia holds a spear to Theodore, and cries: 'Now, then, King Theodore! How about those prisoners?'[71] Once war had actually been declared, the editors of *Punch* brashly speculated on what Britain might do should Field Marshal Napier actually succeed in capturing King Theodore (although this was never articulated as an *official* goal of the war). In order to recompense the British

taxpayer for the trouble of subduing him, they reasoned, the 'Negus' should be turned into a 'circus African'.[72] If the Abyssinian King were captured and made the centrepiece of a live exhibition that would tour the country, funds could be raised to restock the royal coffers:

First catch your Negus, of course; but having caught him, bring him away and constitute him an exhibition. In so doing there would be no need to keep him in a cage or den; he might be made perfectly comfortable, only open to public inspection during certain hours daily at the Egyptian Hall, Piccadilly, or some other place equally commodious. Admission on the five days out of the six . . . might be one shilling, the sixth day being a half-crown day, for the accommodations of the superior classes. After having been shown in London . . . he might be conveyed throughout the rest of the United Kingdom.[73]

Two months later, another cartoon appeared, mocking the 'King of the Lion Kingdom', the historical title that Theodore claimed for himself. The lion's two jailkeepers were portrayed as the British Royal Court, on one side, and on the other, in the person of the mustachioed Field Marshal Napier, the Imperial Army.[74]

In Cameron's photograph of the white, costumed soldier and the black, African attendant (Figure 8.5, *Spear or Spare*), she enlarged upon these and other discursive strategies depicting the struggles and frustrations of the Abyssinian conflict. This image makes sense in terms of Cameron's colonialist attitude towards the Abyssinian Campaign, as evidenced by her contemporaneous heroic portrait of Field Marshal Napier, but also in terms of her political affiliations as manifested earlier that year, exhibited on the walls of the German Gallery. Casting her white and black subjects in opposing roles, Captain Speedy, the British officer, is portrayed threatening the life of his captive, holding a spear to the throat of 'Casa', Prince Alamayou's dark-skinned attendant. The black man lies prostrate, gazing up, alarmed, a portrayal of fear and powerlessness effectively resembling the cartoon from Punch described above (Figure 8.6).

By August 1868, such a photograph referred unambiguously to the armed combat in Abyssinia, yet it also reveals double articulations, or hybrid references, for the power conflicts and social instability of war and its representations. Fear and control, threat and violence, vanquished and conqueror, death and life: all are represented here, as we are confronted symbolically with a powerful instance of colonialist discourses of power as they are both articulated and denied. For Bhabha, hybridity is produced by such instability and displacement in the shifting ground that characterizes the discursive space of the image:

Hybridity is the sign of the productivity of colonial power, its shifting forces and fixities; it is the name for the strategic reversal of the process of domination through

disavowal (that is, the production of discriminatory identities that secure the 'pure' and original identity of authority).[75]

The hybrid is therefore a site of continued inscription of meaning, unsettled, shifting, and indeterminate, in Bhabha's and Lowe's theoretical construct. And so it is fascinating that the photograph itself became a concrete example of continuing inscriptions. The photograph called *Spear or Spare* by Helmut Gernsheim was actually inscribed *Báshá Félika*, the Amharic name taken by Captain Speedy in Abyssinia; moreover, it is possible that the inked signature was even appended by Speedy himself. On the mount of the print, a line was drawn underneath *Báshá Félika*, and an additional inscription penned: *Captn. Speedy* is marked, apparently by a different hand, perhaps that of Cameron herself. Other photographs from this series are also marked in Amharic, the native language of Abyssinia used by Prince Alamayou and his father, King Theodore. This language was mastered by Speedy, but also belongs to Alamayou, giving these multi-dimensional images further marks of their inscribed status as culturally hybrid works of art.

Bhabha writes that 'the twin figures of narcissism and paranoia' may be found within such active and unstable discursive spaces, as they bind together 'contradictory articulations of reality and desire'. Such an ambivalence is exemplified in this photograph and is discernible in at least three ways. First, we have a representation of conflict and of difference, embodying for Cameron's audience a narcissistic attachment to the foreign-costumed Speedy, the white British officer, and a paranoid fear of the black African, Casa. For Bhabha, such imagery represents an 'attempt to dominate in the name of cultural supremacy, which is itself produced only in the moment of differentiation'.[76] As a result, ambivalence is revealed, unwittingly helping to undermine the supposedly clear expressions of cultural authority in the representations and the discursive practices of the dominant group. Cameron's placement of the major actors, her excessive use of exotic props, and her creation of a scene of power and domination, cannot operate as 'a faithful sign of the historical memory' concerning Abyssinia, as it reduces the British war with Abyssinia into a one-on-one conflict, a weak and untenable substitution of her sitters for the complicated political, territorial, and cultural warfare they supposedly represent. Rather, Cameron's image emerges as a product of a distanced abstraction, an artificial construct ultimately open to shifting ground because of its status as a hybrid image.

Second, this scene of conflict unwittingly reenacts a legendary narrative central to Abyssinian history, depicting one version of Abyssinia's historical civil war prior to the unification of its warring chieftains under King Theodore.[77] In the image, it is Captain Speedy, actually a mercenary who was employed by Theodore prior to Napier's landing, who is represented

subduing a native son of Abyssinia. Like Cameron's other costumed explorers (William Holman Hunt; William Gifford Palgrave), Speedy has concealed his 'true' identity under the cloak of camouflage, thereby manifesting yet another type of hybridity. This dual role – in the photograph, Speedy is not always immediately recognized as European, much less British – is characteristic of the consequences of ambivalence in colonialist discourses of power as theorized by Bhabha: 'Such contradictory articulations of reality and desire are the effects of a disavowal that denies the differences of the other but produces in its stead forms of authority and multiple belief that alienate the assumptions of "civil" discourse.'[78] In this way, the colonialist discourse maintained its authority, ultimately turning from mimicry to menace: Alamayou, the young Prince, might have been accepted by Queen Victoria, but only as a powerless, foreign-born potentate who was dependent upon her largesse; his future lay in an English boarding school, there to be 'civilized' as he had been torn from his language of origins, his land, and his history. 'Casa', on the other hand, could only be represented as dominated, subservient, supine. There is no mistaking the hostility, controlled rage, and even blood lust lying thinly veiled behind the surface of this image. In the words of Bhabha, 'And in that other scene of colonial power, where history turns to farce and presence to "a part", can be seen the twin figures of narcissism and paranoia that repeat furiously, uncontrollably.'[79]

And third, the Abyssinian War itself is represented here, with the imperial forces represented by Speedy, who occupied the land, released the British captives, and deposed the African monarch, his one-time sovereign. Rather than depicting an act of explosive violence, however, Cameron's characters are represented as strangely passive, even static. Her desire to represent the dramatic immediacy of armed combat is undermined by her actors' obvious resignation and her uninspired direction. We might even say the image is overdetermined in its artificiality, a consequence of Cameron's own ambivalence. In this image of Captain Speedy as Báshá Félika and Prince Alamayou's Abyssinian attendant, Casa, Cameron could not escape the prevailing strategies 'of representing authority in terms of the artifice of the archaic', as Bhabha might term her dilemma.

In the photographs that she produced for her German Gallery exhibition, particularly her portraits of Eyre and Carlyle, in her portraits of disguised colonialist infiltrators made throughout the year, like Palgrave and Burton, and in her many photographs of the Abyssinian refugees, ambivalence and displacement dominated her work. It is because of these dilemmas that where she attempted to portray the prevailing Orientalist stereotypes of her time, she made hybridized images instead; where she attempted to create a convincing dynamic struggle representing the war in Abyssinia, she could

only create tenuous and unstable sites of inscription that effectively under-mined her otherwise unquestioned assumptions expressing the colonialist's world view.

Notes

Versions of this essay were delivered in April 1995 at the annual meeting of the Association of Art Historians (London), and in February 1996 at the College Art Association annual conference (Boston). I would like to thank Mike Weaver, Mark Haworth-Booth, and Joel Snyder for their encouragement.

1. See Edward Said, *Orientalism* (New York: Vintage, 1978) and *Culture and Imperialism* (New York: Vintage, 1993).

2. Homi Bhabha, 'Interrogating Identity', in Bhabha, *The Location of Culture* (New York: Routledge, 1994): 44.

3. Ibid., 45.

4. Ibid.

5. Bhabha, 'Of Mimicry and Man: The Ambivalence of Colonial Discourse', in *October: the First Decade*, ed. Annette Michelson *et al.* (Cambridge, Mass.: MIT Press, 1987): 318.

6. Bhabha, 'Interrogating Identity', in *The Location of Culture*: 47.

7. Lisa Lowe, *Critical Terrains: French and British Orientalisms* (Ithaca: Cornell UP, 1991): 15.

8. The critical discourse regarding Cameron's photography has devolved from such perspectives: Helmut Gernsheim's views lauding her 'big heads' and disparaging her allegorical studies resulted from his analysis of the Herschel album of 1864–67, *Julia Margaret Cameron* (New York: Aperture, 1975) (2nd edition): 69). Mike Weaver's typological analysis of the Overstone Album of 1866 (*Whisper of the Muse: The Overstone Album and Other Photographs by Julia Margaret Cameron*, Malibu: J. Paul Getty Museum, 1986): 26, reconciled the portraits and allegories under a unified interpretive schema, drawn from Anna Jameson's approach to religious imagery; see her *Legends of the Madonna as Represented in the Fine Arts* (London: 1852, 2nd edn 1857; Detroit: Omnigraphics, 1990). In Carol Mavor's analysis of the 'Mia album' of 1863 (*Pleasures Taken: Performances of Sexuality and Loss in Victorian Photographs*, Durham, NC: Duke UP, 1995: chapter 2), she declared that Cameron's unresolved attitudes about sexuality, family and motherhood, life and death, emerged and became paradigmatic themes for the photographer. And Carol Armstrong, in 'Cupid's Pencil of Light: Julia Margaret Cameron and the Maternalization of Photography', *October* 76 (1996): 115–41, used Cameron's albums to assert her 'excessive behaviors' and sublimated desires.

9. Mike Weaver, *Julia Margaret Cameron, 1815–1879* (London: John Hansard Gallery, 1984): 89.

10. See Brian Hill, *Julia Margaret Cameron: A Victorian Family Portrait* (London: Peter Owen, 1973): 47.

11. Charles Hay Cameron was recorded to have purchased several estates in Ceylon: the largest was in Dimbula, near Kogatala Railway Station, and another was called Rahatungoda Estate at Hevahata. His son Ewen apparently lived on and ran the Rahatungoda Estate, while his eldest son Hardinge, a career officer in the Ceylon Civil Service, often hosted his parents in his quarters near Kalutara and Colombo. See G.C. Mendis, ed., *The Colebrooke–Cameron Papers: Documents on British Colonial Policy in Ceylon, 1796–1833* (London: OUP, 1956), vol. 1: xxxiii. In the Cameron archive at the Getty Center for the History of Art and the Humanities (GCHAH), Box 1, log books from the Rathoongodde Estate for the months of July through September 1854 indicate that 320 acres were planted with coffee plants, containing 384 000 plants. In a letter from Charles Hay to Julia Margaret, dated first 8 November 1850 and then, later, 11 November, Charles wrote the following: 'Col. Braybrook tells me that I am the largest proprietor of land in the Island and I feel no doubt that the boys will one day be very thankful to me for providing them with this resource against dependence and place hunting. But I am afraid your [illeg.] for English literary society will always prevent you enjoying a protracted residence at Rathoongodde and the occasional visits which will certainly be necessary in default of a protracted residence will be too expensive. This consideration troubles me much and at present I see no way out of the difficulty.' GCHAH, Cameron papers, Box 11.

12. See Cameron's contemporary, Anne Isabella Thackeray Ritchie, *From Friend to Friend* (London: John Murray, 1919), esp. 2–37, and her biographers, including Amanda Hopkinson, *Julia Margaret*

Cameron (London: Virago Press, 1986); Virginia Woolf and Roger Fry, *Victorian Photographs of Famous Men and Fair Women* (London: Chatto and Windus, 1992).

13. In a letter from Charles Hay to Julia Margaret Cameron, dated 28 January 1851, Charles confided: 'I am in high spirits this morning Juley love for the last night I received your letters of the 24 Dcr. which give me a much improved account of yourself and an excellent one of the children and also satisfy me that you will be ready to accede to my plan of eighteen months in Ceylon and then eighteen months in England . . . If Malta or the Ionian islands is given to me then my plan must be postponed, but of that there is very little chance'; Cameron papers, GCHAH, Box 11.

14. These included the management and shipping firms of Clerihew; Pitts and Gavin; Wilson Ritchie and Co.; and Keir Dundas & Co. See the Cameron Papers, GCHAH, Boxes 1 and 11.

15. Ritchie, *From Friend to Friend*: 16–21, 29–30.

16. Bhabha, 'The Other Question', *Screen* 24 6 (1983): 18.

17. Allingham visited the Gallery on 4 February, and discussed it on 7 February with Anne Thackeray. In his diary entry of that date, he wrote: 'Mrs. Cameron's Exhibition – "I blew the trumpet for it in the Pall Mall [*Gazette*]" ', a reference to the unsigned review that appeared in that journal on 29 January 1868. See the *Pall Mall Gazette*, 29 January 1868: 10, and William Allingham, *William Allingham's Diary*, Introduction by Geoffrey Grigson (Fontwell, Sussex: Centaur Press, 1967): 171. Although Joanne Lukitsch takes the author of this statement, and therefore the author of the review in the *Gazette*, to be Allingham – see her *Julia Margaret Cameron: Her Work and Career* (Rochester: International Museum of Photography, 1986): 65, n. 18 – Allingham's use of internal quotes in his diary suggests that this comment was made in conversation *with* Ritchie, to reflect *her* words, and not his, which are written without the convention of quotation marks throughout the diary itself. In fact, Ritchie makes more sense as the author of the *Gazette* review, first because such interest would have been exceptional for Allingham, who considered Cameron an eccentric, whereas Anne Thackeray Ritchie had written art criticism before; and second, because it was Ritchie who took up Cameron's cause later (see her essay, 'A Book of Photographs,' *Toilers and Spinsters and Other Essays*, London: Smith, Elder & Co., 1876), and Allingham never responded seriously in his diary to Cameron's efforts, simply ignoring her illustrations of Tennyson's *Idylls of the King*.

18. See Lukitsch, *Cameron: Her Work and Career*, esp. 47–66.

19. Herschel's portrait won 'honourable mention' for Cameron at the Universal Exhibition of 1867 in Paris (see the report, 'Photography at the French Exhibition,' *Photographic News* 11 (21 June 1867): 278–9); and her portraits of Herschel, Henry Taylor, and Sir David Brewster were exhibited at the London Photographic Society in November 1867, see *Photographic News* 11, (15 November 1867): 545–6.

20. See Gernsheim, *Julia Margaret Cameron*, esp. 34–5; and Woolf, 'Julia Margaret Cameron', in *Victorian Photographs of Famous Men and Fair Women*: 18.

21. See, for example, the Overstone Album, as reprinted in Weaver, *Whisper of the Muse*; and in Lukitsch, 'List of Photographs Displayed in the French Gallery, 1865', *Cameron: Her Work and Career*: 98.

22. This visit is noted by Cameron herself in her 'Annals of My Glass House' (1874), reprinted in Beaumont Newhall, ed., *Photography: Essays and Images* (New York: Museum of Modern Art, 1980): 137. At the time, Carlyle was regularly visiting Little Holland House for portrait sessions with George Frederic Watts. See M.S. Watts, *George Frederic Watts* (New York: Hodder and Stoughton, 1903), vol. 1, 248–50.

23. On the Eyre Case and the role of Carlyle in the Eyre Defence and Aid Fund, see W.F. Finlason, *The History of the Jamaica Case* (London: Chapman and Hall, 1869), esp. 368ff. On Cameron's records at the Public Record Office, the photographer took out several copyrights on each image: 'Photograph. Portrait of Governor Eyre, Nos 1–3' and 'Portrait of Carlyle Nos 1–3'. See Public Record Office documents, COPY/3/108. Helmut Gernsheim recorded that Eyre autographed the signed portrait of him and dated it 4 June 1867; of Carlyle, Gernsheim reports that the writer said: 'It is as if suddenly the picture began to speak, terrifically ugly and woe-begone, but has something of a likeness – my candid opinion' (Gernsheim, *Julia Margaret Cameron*: 189, 190).

24. On the Governor Eyre controversy, see Bernard Semmel, *Jamaican Blood and Victorian Conscience* (Boston: Houghton Mifflin Co., 1963); Gillian Workman, 'Thomas Carlyle and the Governor Eyre

Controversy: An Account with Some New Material', *Victorian Studies* 18 1 (1974): 77–102 ('Eyre as Hero', 93 , original emphasis); George H. Ford, 'The Governor Eyre Case in England', *University of Toronto Quarterly* 17 3 (1948): 219–33 ('Nigger-Philanthropists', 223); and Catherine Hall, 'The Economy of Intellectual Prestige: Thomas Carlyle, John Stuart Mill, and the Case of Governor Eyre', *Cultural Critique* 12 (1989): 167–96.

25. Thomas Carlyle, *On Heroes, Hero-Worship, & the Heroic in History*, was published in 1841 and reprinted in 1842, 1846, 1852, 1858, 1870, 1872, and 1897.

26. See Paul Barlow, 'The Imagined Hero as Incarnate Sign: Thomas Carlyle and the Mythology of the "National Portrait" in Victorian Britain', *Art History* 17 4 (1994): 523.

27. Cameron, 'Annals of My Glass House', in Newhall, ed., *Photography: Essays and Images*: 137.

28. In 1856, Earl Stanhope quoted Carlyle at length in his efforts to establish a National Portrait Gallery; quoted in Barlow, 'The Imagined Hero as Incarnate Sign': 522.

29. See Barlow, 'The Imagined Hero as Incarnate Sign': 522. Carlyle's familiarity with this dual status was revealed in an exchange with his wife Jane when she recognized her portrait in a shop window, seeing in it its status as both index and identity: 'The greatest testimony to your fame', she wrote, 'seems to me to be the fact that my photograph is stuck up in Macmichael's window ... It proves the interest, or curiosity, you excite; for being neither a "distinguished authoress", nor a "celebrated murderess", nor an actress, nor a "Skittles", it can only be as Mrs. Carlyle that they offer me for sale.' (Quoted by Gernsheim, *Julia Margaret Cameron*: 58.)

30. See 'Document #7' in Workman, 'Thomas Carlyle and the Governor Eyre Controversy': 98–100.

31. See Thomas Carlyle, 'Occasional Discourse on the Nigger Question', in *Critical and Miscellaneous Essays* (Boston: Dana Estes, 1884), vol. 16, esp. 299, 302, 317. Mill is quoted in Hall, 'The Economy of Intellectual Prestige': 181.

32. See Victor Kiernan, *The Lords of Human Kind* (London: Weidenfeld and Nicolson, 1969): 48–9.

33. For a recapitulation of these issues, see Hall, 'The Economy of Intellectual Prestige': 181–2.

34. Carlyle, 'Shooting Niagra: And After?' (1867), in *Critical and Miscellaneous Essays*, vol. 16: 424–5.

35. Quoted in Hall, 'The Economy of Intellectual Prestige': 189.

36. 'Petition to the House of Commons by Thomas Carlyle', in Workman, 'Thomas Carlyle and the Governor Eyre Controversy': 98.

37. Hall, 'The Economy of Intellectual Prestige': 184.

38. Quoted in Ford, 'The Governor Eyre Case in England': 228, n. 27.

39. See Donovan Williams, *The India Office, 1858–1869* (Hoshiarpur: Vishveshvaranand Vedic Research Institute, 1983).

40. Tennyson wrote: 'I sent my small subscription as a tribute to the nobleness of the man [Eyre], and as protest against the spirit in which a servant of the State who has saved to us one of the islands of the Empire, and many English lives, seems to be hunted down. In the meantime the outbreak of an Indian mutiny remains as a warning to all but madmen against the want of vigour and swift decisiveness.' Quoted in Finlason, *The History of the Jamaica Case*: 368bbb. See also Hamilton Hume, *The Life of Edward John Eyre, Late Governor of Jamaica* (London: R. Bentley, 1867): 291.

41. See Leslie Stephen and Sidney Lee, eds. (London, OUP, 1964), *Dictionary of National Biography*, vol. 19: 410.

42. Weaver, *Whisper of the Muse*: 58.

43. Cameron returned again and again to these themes after 1868. See, for example, Victoria C. Olsen, 'Idylls of Real Life', *Victorian Poetry* 33, 3–4 (1995): 371–89, on Cameron's photographs of *King Cophetua and the Beggar Maid* and *Vivien and Merlin*.

44. Weaver, *Whisper of the Muse*: 58.

45. Bhabha, 'Sly Civility', in *The Location of Culture*: 96.

46. Quoted in Lukitsch, *Cameron: Her Work and Career*: 65.

47. See Bhabha, 'Interrogating Identity', in *The Location of Culture*: 49.

48. See Williams, *The India Office, 1858–1869*: 30.

49. See the composition of the Abyssinian Field Force in Appendix B of Darrell Bates, *The Abyssinian Difficulty: The Emperor Theodorus and the Magdala Campaign, 1867–68* (Oxford and New York: OUP, 1979): 224–5, and Major Trevenen J. Holland and Captain Henry Hozier, *Record of the Expedition to Abyssinia, compiled by order of the Secretary of War*, 2 vols. (London: HMSO, 1870).

50. Roger Acton, *The Abyssinian Expedition, with engravings from the Illustrated London News* (Illustrated London News Office, 1868).

51. 'Alamayou' is a phonetic rendering of the Prince's name; this spelling is adopted in this paper only as a convention and because it was used by Cameron. The Prince's name may also be found in English sources as Alámáyou, Alamayehu, Alamayu, and Alameeo.

52. 'Prince of Abyssinia on His Way to England', *The Times*, 2 July 1868: 10, col. 2. On Alamayou and Speedy, see also: Darrell Bates, 'The Abyssinian Boy', *History Today* 29 (1979): 816–23; Lord Amulree, 'Prince Alamayou of Ethiopia', *Ethiopia Observer* 13 1 (1970): 8–15; Richard Pankhurst, 'Captain Speedy's "Entertainment": the Reminiscences of a Nineteenth Century British Traveller to Ethiopia', *Africa* (Rome) 38 3 (1983): 428–48; and Jean Southon, 'Prince Alamayou and Captain Speedy', Addis Ababa, 1–6 April 1991, *Proceedings of the Eleventh International Conference of Ethiopian Studies*, Bahru Zewde, Richard Pankhurst and Taddese Beyene (Institute of Ethiopian Studies, Addis Ababa University), vol. 1: 251–63.

53. See Pankhurst, 'Captain Speedy's "Entertainment" ', and Southon, 'Prince Alamayou and Captain Speedy'.

54. Quoted by Southon, 'Prince Alamayehu and Captain Speedy': 257.

55. Julia Margaret Cameron, 'Dejátch Alámáyou and Báshá Félika King Theodore's son and Captain Speedy', inscriptions, albumen print, National Gallery of Canada, Ottawa (cited in Lukitsch, *Cameron: Her Work and Career*: 92).

56. According to copyright registrations at the Public Record Office, Kew, Cameron registered her photographs of the Abyssinian subjects in the following way:
 23 July 1868:
 a) 'Dejátch Alámayou full face and Basha Félika profile, No. 1'
 b) 'Dejátch Alámayou full face and Basha Félika 3/4 face, No. 2'
 c) 'Dejátch Alámayou and Basha Félika both 3/4 face, No. 3'
 27 July 1868:
 d) 'Dejátch Alámayou full face and Basha Félika nearly profile, No. 1'
 e) 'Dejátch Alámayou 3/4 face and Basha Félika profile, No. 2'
 f) 'Dejátch Alámayou 3/4 face holding doll in arms, No. 1'
 g) 'Dejátch Alámayou 3/4 face left hand to necklace, No. 2'
 h) 'Dejátch Alámayou 3/4 face right hand to necklace, No. 3'
 29 July 1868:
 i) 'Captn Speedy with spear and shield profile, No. 1'
 j) 'Captn Speedy with spear and shield 3/4 face, No. 2'
 k) 'Captn Speedy with spear and shield profile, No. 3'
 l) 'Captn Speedy standing with spear over hand to head of Abyssn Native, lying down, No. 1'
 m) 'Captn Speedy standing with spear over hand to head of Abyssn Native, lying down, No. 2'
 Copyright Registrations, Public Record Office, COPY/3/108.

57. Allingham, *William Allingham's Diary*: 185–6.

58. Fry and Woolf, eds, *Victorian Photographs of Famous Men and Fair Women*, plate 34; description and identification on page 32. Identification of 'Casa' is very unclear. Apparently only two Abyssinians were recorded to have left the country on 11 June 1868, in attendance on the Prince: Gabra Medin, identified as a eunuch, and the boy's tutor, Alaca Zarat. They both accompanied Speedy and Alamayou (and Napier and his command) aboard the HMS *Feroze*, but at the Suez Canal, Napier dismissed both tutor and eunuch, sending them back to Mombassa (Lord Amulree, 'Prince Alamayou of Ethiopia': 9). The origins and identity of Casa are not recorded by any of these sources. But it is very clear, however, from Cameron's inscriptions on the actual prints (cf. fn. 57), that 'Basha Felika' (sometimes 'Báshá Féliká') is most certainly the *other* identity for Captain Speedy, and *not* for the African attendant, which contradicts Hopkinson's observations in her *Julia Margaret Cameron*: 128.

59. Cameron registered the following photographs for copyright on 17 August 1868:
 a) 'Mary Killaway full face in Abyssn Costume, No. 1'
 b) 'Mary Killaway 3/4 face in Abyssn Costume, No. 2'
 Copyright Registrations, Public Record Office, COPY/3/108.

60. Gernsheim's *Julia Margaret Cameron: Her Life and Photographic Work*, 2nd edition (1975), does not alter his interpretation of this image from the first, 1948, edition; see: 194.

61. In a letter to the author dated 18 January 1994, Gernsheim wrote, 'Concerning *Spear or Spare* this was certainly not indicated by Mrs. Cameron and is clearly a remark made by me for which I must have had good reasons in 1947, yet which I cannot remember today.' On the copy of this image conserved by the Victoria and Albert Museum (PH19–1939), the words 'Báshá Féliká / Captn. Speedy' appear in ink below the print; 'Spear or Spare' appears in pencil, and appears not to be in Cameron's hand.

62. Leslie Stephen and Sidney Lee, eds, *Dictionary of National Biography*, vol. 15: 109–10.

63. See Rana Kabbani, *Europe's Myths of Orient* (Bloomington: Indiana UP, 1986): 91.

64. On Layard, see Gordon Waterfield, *Layard of Nineveh* (New York: Frederick A. Praeger, 1968).

65. Ibid., 301.

66. Said, *Orientalism* 160.

67. For Hunt's account of his rudimentary grasp of Arabic and consequent fears of traveling alone and disguised, see Judith Bronkhurst, ' "An interesting series of adventures to look back upon": William Holman Hunt's visit to the Dead Sea in November 1854', in Leslie Parris, ed., *Pre-Raphaelite Papers* (London: Tate Gallery, 1984): 111–25, along with his own reminiscence, *Pre-Raphaelitism and the Pre-Raphaelite Brotherhood* (New York: E.P. Dutton and Co., 1914). In 1840, in and around Baghdad, Layard wrote to his aunt that European dress was then considered 'indecent' and that he needed to dress as a Persian; he could 'pass' as one only 'provided he kept his mouth shut'. See Waterfield, *Layard of Nineveh*: 49.

68. See Mea Allan, *Palgrave of Arabia* (London: Macmillan, 1972).

69. Richard F. Burton, *Personal Narrative of a Pilgrimage to Al-Madinah & Meccah* (London: George Bell & Sons, 1898), vol. 1: 14.

70. On the theoretical role and implications of the infiltrator, see the provocative works by Mireille Rosello, especially 'The Infiltrator Who Came In from the Inside: Making Room in Closed Systems', *Canadian Review of Comparative Literature* 22 2 (1995): 241–54.

71. 'The Abyssinian Question', *Punch, or the London Charivari*, 10 August 1867: 57.

72. This term is borrowed from Bernth Lindfors, who coined the image to describe how African men and women were transported to Europe for grotesque public displays during the colonial era. See his 'Circus Africans', *Journal of American Culture* 6 2 (1983): 9–14. These sentiments were connected to the ideas of display at the Universal Exhibitions; see Zeynep Çelik and Leila Kinney, 'Ethnography and Exhibitionism at the Expositions Universelles', *Assemblage* 13 (1990): 35–59.

73. 'An Abyssinian Exhibition', *Punch, or the London Charivari*, 2 May 1868: 192.

74. Anon., 'Great Lion Show. 1868', *Punch, or the London Charivari*, 18 July 1868.

75. Bhabha, 'Signs Taken for Wonders', in *The Location of Culture*: 112.

76. Bhabha, 'The Other Question': 18.

77. See Bates, *The Abyssinian Difficulty*, chapter 2.

78. Bhabha, 'Of Mimicry and Men': 324.

79. Ibid.

8.1 Julia Margaret Cameron, *E. Eyre*

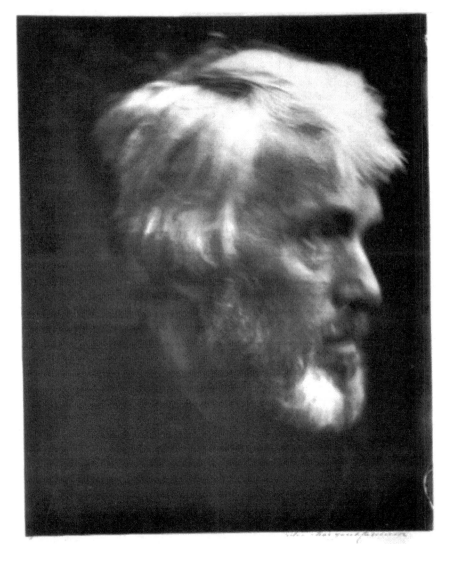

8.2 Julia Margaret Cameron, *Thomas Carlyle*

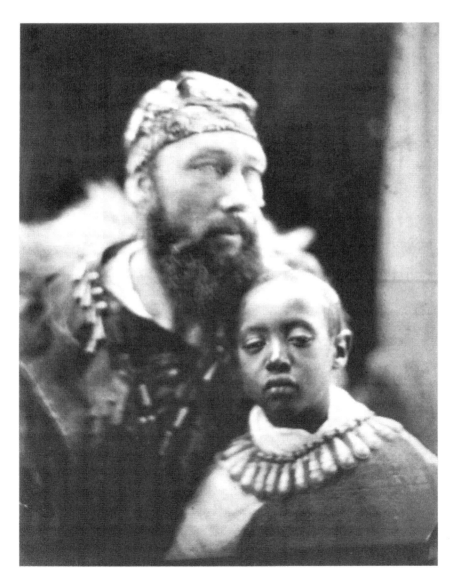

8.3 Julia Margaret Cameron, *Dejatch Alamayou and Báshá Félíká*

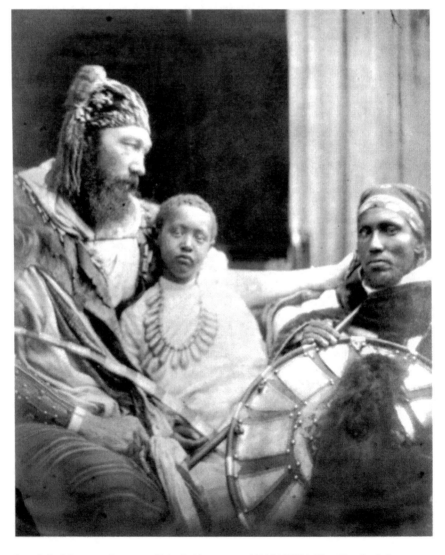

8.4 Julia Margaret Cameron, *Dejatch Alamayou and Báshá Féliká, King Theodore's Son*

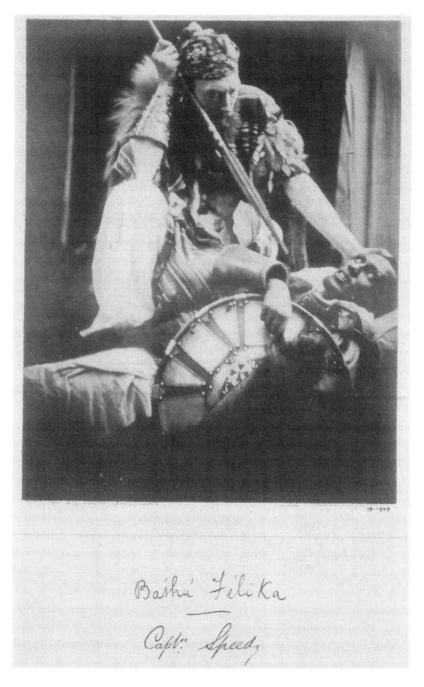

8.5 Julia Margaret Cameron, *Báshá Féliká / Captn Speedy*, otherwise known as *Spear or Spare*

THE ABYSSINIAN QUESTION.

Britannia. "NOW, THEN, KING THEODORE! HOW ABOUT THOSE PRISONERS?"

8.6 Anon., 'The Abyssinian Question', *Punch, or the London Charivari*

III

Intercoloniality

Death, glory, empire: art

Barbara Groseclose

What is interesting, and useful, about the many sub-discourses that feed into the project known as postcolonialism is that together they enable the re-imagining of Empire. 'Death, glory, empire: art' takes up one, effectively double-barrelled, instance: colonial sites are recast as related rather than individual objects of imperialism's visualizations, specifically by suggesting that imagery conducive to the shape Empire took in Canada informed the lineaments of art produced of/for India; and the interrogations of art history are reconsidered, proposing a webbing of iconography intercolonially, between colonies, rather than between colony and imperial centre.

There are a number of disclaimers to make immediately. In offering an instance of intercoloniality in the visual arts, I do not mean to collapse Canadian and Indian histories into one seamless colonial saga nor to imply that the British viewership in either place or in London constituted an undifferentiated audience. (I do want to designate the viewers as Britons: other potential audiences call for another story than the one I want to tell here.)

On the other hand, although I shall be addressing particular examples of painting and sculpture, so that my interpretations should be regarded in the light of each individual work, it is necessary to caution the reader not to over-discriminate among the different strands of art. Because the East India Company properties on the subcontinent – essentially around the central administrative areas of Madras, Calcutta, and Bombay – grew up as British towns, the importation of art from London began earlier there, around the end of the eighteenth century, than in Canada, where the settlements tended to be more on the order of forts or trading posts. Nonetheless, no huge differences in style are to be discerned between British art destined for or about Canada and that destined for or about India. For one thing, during the time periods with which I am concerned here, the art produced in regard to

Canada and India was commissioned from a relatively small pool of artists in London. Moreover, like their compatriots, many of the artists barely distinguished one colony from another, a consequence and symptom of which was the conflation of Empire's 'Indians', portraying identical 'natives' for each site. The sculptor John Flaxman, for example, designed a figure of an American Indian for a Canadian monument (which ended up in Essex) to General John Graves Simcoe (d.1806), first Governor-General of Canada, that is, except for costume, the very same figure he created to represent a Hindu for a monument to Josiah Webbe (d.1804) in St Mary's Church, Madras.

This essay looks at painting and sculpture commemorating a British national hero who died in Canada during the Seven Years' War and relates these works to imagery memorializing a soldier who fell in one of the many battles of the Mysore Wars in India. The comparison was not, of course, plucked from the ether. I had noticed that early memorials sent from London to India, i.e., in the 1770s and 1780s, made no connections between patriotism and the demise of a Company soldier in battle other than the duty which obliged every officer to serve his King and Country; the obligation to be in India had everything to do with the Crown's financial interest in the East India Company. Then the emphasis of Anglo-Indian commemorative art turns from commercial advantage to overt appeals to patriotism, a shift occurring just after Canada was won. Could imagery of victory in Canada help to formulate the terms of Britain's Empire in India?

Canada

In terms of British colonial history, Canada could be called a special, though not unique, case, in that conquering the land meant conflict not only with the indigenous inhabitants but more significantly (in terms of political geography, at least) with the French colonizers already in possession. The site of a risky but profitable mercantile endeavour for the British from the start, almost all of what is now the Canadian portion of North America came into the Empire in part as a result of victory over the French in the 1759 Battle of Quebec.

A confrontation which took the lives of the commanders of both sides, the Battle of Quebec was staged outside the city on the Plains of Abraham, which the British reached from their ships moored in the St Lawrence River by scaling high cliffs and hauling up their equipment. The pre-battle preparations lasted longer than the actual fighting, which was over in about ten minutes. Brevity aside, it was a glorious moment in the annals of warfare due to the unexpectedness of the British victory against a foe better equipped and with superior numbers. It was a profoundly significant triumph for the British commander, Major-General James Wolfe, who, though previously

unknown to the public, became a national hero. The victory itself was heralded as an event to be celebrated by the nation. What is interesting is that 'national' and 'nation' were, at the time, barely emergent concepts.

In a 1981 article, Dennis Montagna laid out the features instrumental to Wolfe's secular canonization: Wolfe openly recognized the grim odds against him as the battle formed; he engineered a victory that many thought miraculous; in taking Quebec, Wolfe took the capital of New France; he died.[1] Outweighing any other consideration, of course, except possibly Wolfe's death, was that the British wrested Canada from the French.

I say 'of course' not only in the light of the longstanding enmity between England and France but also in reference to conflicts between the two that erupted later in the eighteenth century. The effect, it is possible to say, of so much hatred was British unity: of the influences coalescing in the idea of 'nation' which Linda Colley enumerates in her important book, *Britons, Forging a Nation, 1707–1837*, the taking of Quebec in 1759 was crucial, because going to war against French Catholics forced men and women from England, Scotland, and Wales to consider what they had in common – that is, they were not Catholic but all (or almost all) Protestant.[2] In taking account of their commonalities rather than their differences, Britons moved closer to the idea of 'nation' that the 1707 Act of Union had adumbrated.

No wonder the visual rhetoric of Canadian colonization, what there was of it, figured the enterprise as 'conquest' of French foes *and* North American Indian resisters. Benjamin West, most prominently, created a scenario, rather than a scene, of Wolfe's dying moments in which he pushed to advantage these very points and in so doing contributed to this nascent nationalist sentiment (Figure 9.1). As Montagna observes, in *The Death of General Wolfe* West depicts events that range over the course of the entire battle, not merely its denouement, and by including the personae of soldiers as well as sailors, English as well as Scottish and Irish troops, the artist appears to emphasize a unity that is national, in which instance he adds a powerful element of reinforcement to the patriotic sentiment that accompanied commemorations of the battle of Quebec – and Wolfe's role in it – in literature and art.

That these tributes to Wolfe were so plentiful accounts for the liveliness of his legend as late as 1771, the year West exhibited his painting at the Royal Academy.[3] Soon after Wolfe's death at least one play, *The Conquest of Canada*, by George Cockings, elevated the general's 'Patriotic Deeds' to a level of action befitting the 'much admired ancient *Greeks* and *Romans*!' Poets likened him to Achilles and to Caesar. Unsurprisingly, sculptors vying to win a commission from Parliament to raise a monument in commemoration of Wolfe in Westminster Abbey envisioned the soldier as a classical hero. In 1772 the winner of the commission, Joseph Wilton, produced a free-standing monument on which a nude and dying Wolfe, accompanied by two officers

in contemporary clothing, gazes yearningly at a hybrid Fame/angel delivering a victor's wreath and a martyr's palm (Figure 9.2).

Appearing so closely together in time, the two portrayals of Wolfe have somehow become dichotomous: West's image praised as (proto)modern; Wilton's marble figure misjudged as neoclassical. They are distinctly different constructions of Wolfe, certainly, but do they represent polar opposites interpretively? Ann Abrams has considered Cockings's play, contemporaneous poetry and other mythologizing accounts of Wolfe, as well as some literature subversive to the myth, in addressing Wilton's statue in relation to West's canvas. In both, she sees elements that come 'within the parameters of classicism' (for both artists, she notes, had studied in Italy), such as the nudity of the sculptured Wolfe or the resemblance of the painted Wolfe's dying posture to the *Dying Gaul*, that serve to enhance the universal implications of Wolfe's heroism. Both works imply a connection between martyrdom and the Christian religion but neither implies that Wolfe's death had any other purpose than the good of the State. Finally, both works stage death as theatre.[4]

If we take it that Wilton's and West's pictorializations of Wolfe are, conceptually, more alike than different, then what they have in common makes for potent stuff. The hero, in the service of a secular goal, undergoes a sort of death experience that carries the moral weight of Christian sacrifice – and the eternality that is promised for such sacrifice – but he does not really die: as a result of his death, Empire lives on. As terms for dying, the message and form of Wolfe's memorials found wide expression in India, where many more Britons were doomed to perish.

India

More than thirty years after Wolfe's sensational death and half a world away, in India, a young lieutenant colonel in the Madras Coast Artillery of the East India Company, Joseph Moorhouse by name, was called upon to attack the *pettah* (or civilian) gate in Bangalore held by forces loyal to Tipu Sultan, against whom the Company was pursuing its third Mysore War. Moorhouse died during the battle, but his courage on the field drew the attention of India's Governor-General Charles Cornwallis, who ordered that Moorhouse's remains should be carried to St Mary's Church in Madras and buried there. The Court of Directors of the East India Company, sitting in London, commissioned Charles Peart, a sculptor of some repute, to supply St Mary's with a relief memorial, which was duly sent out a few years later (Figure 9.4).

Of the few monuments I know by Peart, this one is well-suited to demonstrate his various talents. Atop a claw-footed, emblem-laden tomb

chest, an oval medallion relief pictures Britannia extending a wreath toward a bust representing the deceased. Particularly eye-catching are the trophies which ease the transition between the monument's two parts and the pot-bellied putto who shoulders the disembodied head of Moorhouse (Figure 9.5). Though neither section could be called well-executed or even well-designed, the upper portion boasts some very nice, classically infused features and is sprightly as well, conveying something of the disconcerting liveliness of eighteenth-century English tomb sculpture.

Moorhouse had been a Grand Master of the Freemasons in Madras, and they, mostly fellow officers of the East India Company, likewise planned a memorial to their compatriot, employing Robert Home to paint a large canvas depicting Moorhouse's death at Bangalore. Funds for the project were raised by subscription among the British in India. The painting, which Home finished in 1793, now belongs to the National Army Museum in London (Figure 9.3). Like Peart, Home could not be called an artist of the first rank, but he managed to invest the central dramatic focus with a degree of pathos, primarily because the figure of the kneeling sepoy, not lost amid a welter of posturing and wooden Europeans, possesses emotional credibility. All of the figures surrounding the dying Moorhouse, as well as the histrionically dead men on the left, were said to be portraits, thus endowing the scene with another kind of credibility. Unfortunately, the composition breaks down into isolated vignettes, some more interesting than others (like the group of sepoys in the background carrying a wounded officer). On the left, the bovine calmness of the statue of Nandi, the god Shiva's bull, adds an ironic element.

Whatever their merits aesthetically, in terms of their commemorative identity, that is, as reference points of Empire, the monuments to Moorhouse by Peart and Home cannot be called unique. Sadly, Moorhouse merely numbered one among the multitudinous victims of the seemingly interminable fighting between the British and the rulers of Mysore. East India Company monuments in remembrance of officers in this and later Indian conflicts can sometimes be far more elaborate, and more bluntly illustrative of Empire, than Moorhouse's wall slab, as in the case of a Westminster Abbey sculptural ensemble by Thomas Banks honouring General Sir Eyre Coote (who died in 1783). Here the immortality of the deceased Briton, symbolized by his medallion portrait in the care of Fame, triumphs over the Indian captive, the spoils of whose lands are chillingly symbolized as a cornucopia spilling forth bounty as copiously as the captive weeps.

Even as the centrepiece of a contemporary history painting, Moorhouse is unusual but not alone, since a few other Anglo-Indians, most notably Cornwallis, played a similar starring role in India's history, as in Home's large-scale 1793 canvas, *Lord Cornwallis Receiving the Sons of Tipu Sultan as*

Hostages, Madras, which is in London's National Army Museum, and a painting from 1805 of the same topic by Arthur William Devis. The story concerns the Mysore War again, this time a visualization of a clause in the 1792 treaty that called for the transfer of Tipu Sultan's sons as hostages, to be held by Britain in the person of Cornwallis until indemnity terms were fulfilled. Like the dying Moorhouse, a living Cornwallis anchors a British-Indian throng, although in Cornwallis's case the thrust of historical idealization has to do less with claiming the imperial moment through an extraordinary act than with naturalizing imperialism's claim, propelling Tipu's son toward the General – arms outstretched on both sides – as though a shy nephew were meeting a magnanimous uncle.

Intercoloniality

Looking at the memorials to Moorhouse by Peart and Home from another perspective, however, reveals their distinctiveness in regard to British India. Both commemorations of Moorhouse demonstrate a shift in the rationale for the British presence in India from a material purpose to a moral value – in other words, from exploitation, benign or otherwise, to patriotic service.

For instance, *General* Cornwallis stands in for Britain when receiving the hostages, but Moorhouse, a lower-ranking officer, can be said in dying only to stand *by* Britain. Or in comparison with Coote's monument, one might observe that on Moorhouse's monument Britannia is being offered something far more precious than spoils being disgorged from an overstocked cornucopia – that is, a human life.

Occurring with glacial slowness and forever incomplete, changing the rationale for Britain's domination of India endowed imperialism with an inspiring, unifying, and inherently useful patriotic aura. The material purpose of Indian colonization never disappeared; but decades before the governing of British India was taken from the East India Company and assumed by the Crown in 1858, commerce lost ground to patriotism, rhetorically speaking.

There is a connection to be made through the very strong visual and conceptual proximities of Moorhouse's memorials to monuments raised to honour General Wolfe. What makes the Indo-British subject matter in Moorhouse's painted and marble monuments special (with respect to the topic of this essay at any rate) is that it does not come only from Empire's hub outward to the colonial periphery but relates to Canada in two ways, as hub to secondary colonial periphery or as colony to colony.

Home's painting of the death of Moorhouse intentionally resembled West's masterpiece. The call for subscriptions announced that the completed work would be akin to West's famous canvas 'in size and manner'. And

indeed it is – in manner, at least; it is hard to know what was indicated by the reference to 'size', as West's four canvases of *The Death of Wolfe* range from 151.1 × 213.3 cm (the original painting, now in the National Gallery of Canada at Ottawa) to 189.2 × 265.4 cm (the last replica, in Ann Arbor, Michigan), while Home's painting is only 149.9 × 201.9 cm. Perhaps the idea was just that the proposed painting would be big.

In any case, Home did not understand scale as well as West did. His doll-like figures with rather too-large heads do not dominate the picture as West's well-proportioned heroes do, but otherwise Home applied himself faithfully to his source. In particular, the fallen leader in each, collapsed in similar though not identical poses and surrounded by carefully delineated portraits of fellow officers, is accompanied by a locating element, the Mohawk in North America and the sepoy in India.

Less obviously and apparently without intention, Peart's monument to Moorhouse in Madras and Wilton's Westminster Abbey monument to Wolfe mutually resonate. Their visual similarities, aside from the proffered wreath and the quite convincing lion in each, are nil, but they utilize the antique in the same way. The medallion format enclosing the personification of Britannia and the bust of the deceased in Peart's work, like the nude body of Wolfe in Wilton's relief, is a classical device that aims to elevate the specific to the loftier realm of the universal.

Although there are religious overtones in Wolfe's commemorations but scarcely nothing of the sort to Moorhouse's, the shared point of these memorials is that they offer a secular reward rather than a heavenly one, a reward given for earthly effort rather than Christian belief. They are not the first monuments with imagery designed in such a way as to favour the idea of a temporal celebrity while ignoring or downplaying the notion of a Christian afterlife. They are, however, among the first to promote this idea *à propos* death in the service of Empire.

Conclusion

To open up new ways of thinking about colonial art, it seems to me requisite to crack the monolith 'Empire'. Reading commemorations of Wolfe as a way of imagining a cohesive and coherent idea of British Empire gains force, rather than otherwise, then, by the intercolonial elements in commemorations of Moorhouse. Or, to put it another way, the visual construction of Empire in Canada, a construction made in terms of a patriotism that generated and reinforced an idea of nationality, informed the making of British art for India because it helped to invent the lineaments of duty for imperialism.

Notes

1. Dennis Montagna, 'Benjamin West's *The Death of General Wolfe*: A Nationalist Narrative', *American Art Journal* 8 (1991): 77ff.

2. Linda Colley, *Britons, Forging a Nation, 1707–1837* (New Haven and London: Yale UP, 1992): 356.

3. Ann Uhry Abrams, *The Valiant Hero, Benjamin West and Grand-Style History Painting* (Washington, DC: Smithsonian Institution Press, 1985), provides an excellent contextualization of West's work in this regard.

4. Ibid., 165–74; in offering Abrams's comparative structure as evidence of the interpretive correlation between West's painting and Wilton's marble, I do not endorse her conclusions, which differ, in fact, from my own.

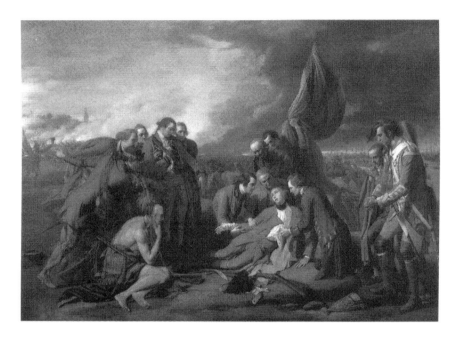

9.1 Benjamin West, *The Death of General Wolfe*

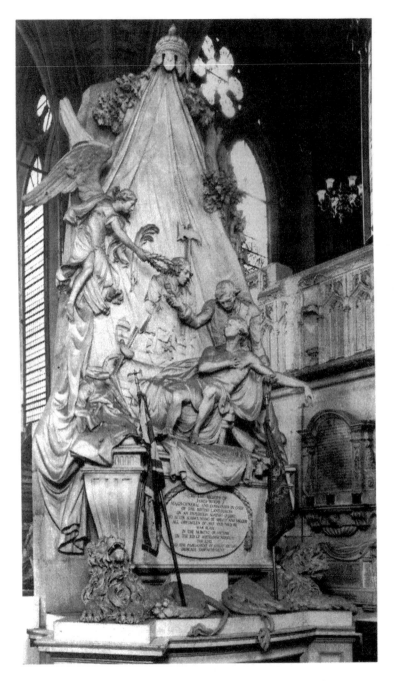

9.2 Joseph Wilton, monument to General Wolfe, Westminster Abbey

9.3 Robert Home, *The Death of Colonel Moorhouse, Madras Artillery, at the Siege of Bangalore, 8 March 1791*

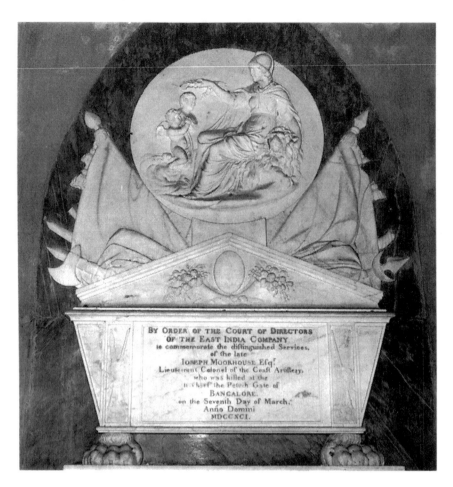

9.4 Charles Peart, monument to Lieutenant Colonel Joseph Moorhouse, Madras, St Mary's Church

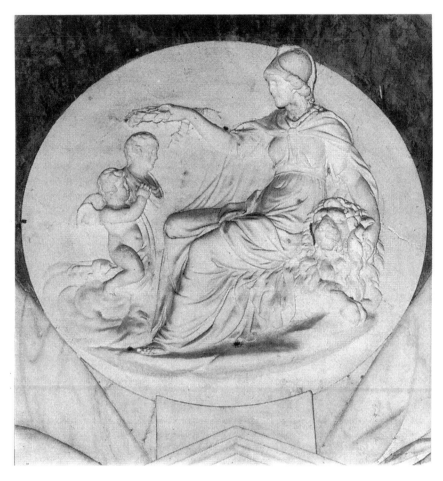

9.5 Detail, Charles Peart's monument to Lieutenant Colonel Joseph Moorhouse

Tipu Sultan of Mysore and British medievalism in the paintings of Mather Brown

Constance C. McPhee

In November of 1792 Mather Brown exhibited two small Indian subject paintings at the Morland Gallery in London. These presented Tipu Sultan of Mysore as a calculating and heartless tyrant and the British conquerors of his domain as messengers of peace and justice. To underscore his message the artist inserted references to fifteenth-century English royalty into what appear, at first glance, to be factual renderings of recent colonial events. Even as they celebrated the successful conclusion to a long military campaign, Brown's ingenious compositions helped justify the unpleasant consequences of conquest for Britons at home.

The departure of the sons of Tippoo from the zenana (Figure 10.1) describes the separation of Tipu's two young sons from their parents on 26 February 1792. The princes leave the women's quarters at the palace fortress of Seringapatum and prepare to set off for the British camp to surrender themselves to Lord Charles Cornwallis.[1] *The delivery of the definitive treaty by the hostage princes to Lord Cornwallis* (Figure 10.2) shows the boys a few weeks later, on 19 March, presenting to their captors the punitive peace treaty which the absent sultan has finally agreed to ratify.[2] The novelty and exoticism of these subjects would immediately have appealed to London viewers and increased the chances that the reproduced engravings, planned by Brown and his publisher Daniel Orme, would sell briskly.[3]

To guide Londoners towards an interpretation of his material, the artist modelled Tipu's pose and expression on a well-known representation of Richard III, and compared the plight of the sultan's sons to Richard's persecuted nephews, the Little Princes in the Tower. By equating Tipu with one of England's most venal kings, Brown shifted the implied blame for the captivity of the Indian princes onto their father's shoulders. As a result, Cornwallis, who actually instigated the hostage plan, could assume the role of beneficent liberator of Mysore.

The visual characterization of Tipu as a disreputable schemer was so effective that Brown reused it six years later in a completely non-Indian context. In 1798 Charles Howard, the 11th Duke of Norfolk, commissioned from the artist an ancestral history scene for Arundel Castle, Sussex. *Thomas, Earl of Surrey, defending his allegiance to Richard III after the battle of Bosworth field, 1485* (Figure 10.3) shows one of the Duke's most illustrious forebears being stripped of his lands and titles and condemned to a long imprisonment by the soon-to-be-crowned Henry VII.[4] The latter figure sits at the centre of the composition wearing a jewelled turban and pointed shoes based on Tipu's garb in *The departure from the zenana*. Brown introduced these items, which were definitely not part of the Tudor royal regalia, to point to the injustice of English kings past and present.

It is my intention to explore these hitherto unremarked Anglo-Indian cross-currents in Brown's paintings. His decision to make sense of Mysori events by conflating them with late-medieval English prototypes, in order to create lively imaginative constructions of distant colonial events, demonstrates a willingness to treat physical and historical distance as synonymous.[5] Since the average viewer of the period was equally uninformed about the political and cultural realities of both medieval England and contemporary India, he or she apparently had no difficulty in accepting the equation of an Indian sultan with the villainous Richard III. However, the tenor of these particular trans-cultural associations suggests their creator was troubled by the conquest of Tipu's domain and turned to familiar historical paradigms to cast it in an acceptable light.

The Third Mysore War, whose conclusion provided the artist with his material, was a conflict the British fought between 1790 and 1792 to bring a stubbornly independent southern Indian state into submission.[6] Its progress was followed avidly in England where Tipu's final surrender was greeted with rejoicing and relief.[7] The greatest public attention was directed towards Lord Cornwallis's decision to take two of the sultan's sons hostage until all of Britain's punitive terms were met.[8] The separation of ten-year-old Abdul Khaliq and eight-year-old Muiz-ud-din from their father, their arrival in the camp of their enemies and subsequent participation in the treaty ceremony were described by the London press and even presented on the stage.[9] Not surprisingly, a large number of artists moved quickly to explore the visual possibilities of this dramatic material.[10]

Brown's own colonial origins qualified him to understand British imperial expansion in India from more than one perspective. He had come of age in Boston during the American War of Independence as a member of a large family which contained both Loyalists and Revolutionaries.[11] After moving to London in 1781, he would have been attuned to the way Indian successes might help salve the wounds to national pride caused by North American

losses. Cornwallis's triumph in Mysore, for example, must have seemed even sweeter when viewed against the background of his devastating loss at Yorktown, Virginia, a decade before. On the other hand, the artist's war-time experiences in Boston, a city attacked and occupied by British troops, enabled him to empathize with the plight of the people of Mysore. It is not surprising that a transplanted American was the first to exhibit works devoted to Tipu and his sons which both celebrated British military actions and sought to minimize their unpleasant effects.

The speed with which Brown responded to incoming news is demonstrated by the following dates. Unofficial reports of Cornwallis's February victory at Seringapatum reached London in May 1792.[12] By early August, several weeks before the ratified peace treaty arrived in the capital, the artist had contacted the East India Company and asked permission to dedicate to them an engraving of a proposed painting of 'the late important events in India'.[13] This design became *The delivery of the definitive treaty by the hostage princes to Lord Cornwallis.*[14] By mid-November Brown had placed this oil, together with his second Tipu subject, on display at the Morland Gallery at 14 Bond Street.[15] Daniel Orme, one of the gallery's proprietors, took charge of the publication process.[16] Unfortunately, the finished stipple engravings (Figures 10.1 and 10.2) were not issued until December 1793, a delay which allowed competing designs by Henry Singleton to reach the market first.[17]

Brown and Orme realized that topical and dramatic Mysori subjects which represented the sultan, members of his harem and young sons as well as victorious British soldiers would appeal to a wide public. Tipu's long-standing provocations of the East India Company and tenacious resistance to foreign influence had fascinated Britons for more than a decade. A large financial return could be expected from publishing, in a timely fashion, reproductions of events related to the recently concluded war. Hence Brown's haste in the summer of 1792.

Sixteen years earlier, the astounding sales of William Woollett's engraving after Benjamin West's *The Death of General Wolfe* (Figure 10.1) had demonstrated the enormous financial potential of prints celebrating pivotal colonial victories.[18] Orme's and Brown's determination to follow the same path to success is suggested by newspaper advertisements of 1792 which emphasize that the prints of Brown's Tipu subjects were to be identical in size to Woollett's original.[19] Potential buyers were encouraged to think of these new designs as part of a series of imperial triumphs initiated by West. Brown, however, made no attempt to imitate the monumental scale of West's painting. At 41.9 by 58.4 cm, his two oils ended up being slightly smaller than the 48.2 by 60.9 cm engravings which reproduced them.

In *The departure of the sons of Tippoo from the zenana* (Figure 10.1) Brown gave his imagination free rein in order to entertain his viewers. The sultan is

shown standing to the left of a group of wives and harem women who lament their impending loss. His tense posture and reluctance to release the hand of the elder prince indicate an anxiety over separating his sons from their overwrought female supporters. Clad in white and wearing a feathered turban, the mother of Abdul Khaliq, the elder prince, stands guard over her child and raises her left arm in protest, while the younger boy, Muiz-ud-din, is embraced by a woman who may be one of the sultan's lesser wives, or possibly a nurse.[20] Brown set the final separation outside Seringapatum's main walls, at the entrance to the women's quarters. This allowed him to include narrative details such as the fortress's formidable battlements, which testify to the strength of Britain's defeated enemy, and the two elephants which refer to the princes' impending captivity. Brown, however, did not completely invent this scene. A useful description of the separation was published in 1793 by Major Dirom, an officer who participated in the British campaign. He mentioned that 'the uneasiness in the seraglio became extreme in parting with the boys,' a phrase which sums up the feeling conveyed by Brown's image, and went on to describe the royal retinue as it left the palace:

The Princes were each mounted on an elephant, richly caparisoned, and seated in a silver howder [sic], and were attended by their father's vakeels ... The Princes were dressed in long white muslin gowns, and red turbans. They had several rows of large pearls round their necks, from which were suspended an ornament consisting of a large ruby and an emerald of considerable size, surrounded by brilliants.[21]

Although this text was published a year after Brown's painting was exhibited, the artist must have had access to a comparable account because he included many of the same descriptive details.

Brown continued his dramatization of these events in *The delivery of the definitive treaty by the hostage princes to Lord Cornwallis* (Figure 10.2), a work describing the peace ceremony which took place in the British camp three weeks later. In the interim, the boys had been formally received by Cornwallis and placed under comfortable house arrest.[22] Once their father accepted the final version of the treaty, the princes were deputized to present the ratified document. This they did before a gathering of British military élite, several representatives of neighbouring Indian states and a group of Tipu's *vakils*. Ghulam Ali Khan, the princes' chief attendant, had to sit throughout the proceedings because of his physical disabilities. Again, Dirom's eyewitness account corresponds to the scene as Brown rendered it:

the young Princes, attended and escorted in the same manner as when they first arrived in camp, came to perform the ceremony of delivering the definitive treaty to Lord Cornwallis and the allies. They ... were received by his Lordship, as formerly,

with the greatest kindness and attention. The boys had now gained more confidence; the eldest in particular, conducted himself with great ease and propriety; and, after some general conversation, having a parcel handed to him, which contained the definitive treaty in triplicate, he got up and delivered the whole to Lord Cornwallis.[23]

Since Brown was seeking to satisfy Londoners' hunger for information about Tipu and his sons, he created images which, at least on the surface, appeared to be faithful recreations of contemporary Mysore. This meant providing as many accurate details as possible. A 1792 pamphlet which advertised his paintings listed the artist's sources as including 'authentic Information from an Officer of high Rank, who brought over the Dispatches from Earl Cornwallis and was in the Suite of His Lordship during the Principal Scene in India.'[24] This officer was probably Major W.C. Madan, with whom Brown discussed his idea for *The definitive treaty* in the summer of 1792 and who went on to act as a go-between with the East India Company.[25] Among the visual sources the artist used were miniature portraits of Cornwallis and other British participants, drawings of Mysori costumes and actual battle trophies.[26] His efforts at information-gathering notwithstanding, Brown's compositions must ultimately be seen as imaginative constructions. This becomes apparent when they are compared to paintings of the princes by artists such as Arthur William Devis and Robert Home who actually travelled to Mysore and pursued a more strictly documentary approach.[27]

Since he aspired to be a history painter, Brown's underlying concern was to produce idealized images which rose above simple reportage. To imbue his subjects with moral resonance, he borrowed poses and compositional elements from elevated models. If *The departure from the zenana* is an exotic court scene, *The delivery of the definitive treaty* is a modern history belonging to the genre West had helped launch in 1770 with *The Death of General Wolfe*.[28] Brown was well acquainted with his countryman's achievements, having studied with West for a year upon first arriving in London in 1781.[29] A decade later, when attempting a modern military subject himself, the younger man freely borrowed insights from his former master.

The definitive treaty substitutes a pivotal Indian colonial victory for the North American one represented by West. To contemporary viewers, Tipu Sultan's surrender at Seringapatum must have seemed comparable on several levels to Wolfe's triumph over the French outside Quebec in 1759. It was expected that southern India would now quickly submit to British control, just as dominion over Canada had followed the capitulation of Quebec. Britons would have taken particular delight in the fact that Cornwallis's success compromised the power of their greatest European rival, France, which had long supported Mysore.

Formal similarities between Brown's and West's compositions underscore thematic connections. Both works are set on the edge of a battlefield in an exotic locale, and the primary participants include heroically idealized British soldiers gathered in a shallow semicircle around the central action. Although the 1793 image substitutes a subdued treaty exchange for a military martyrdom, it resurrects several details from West's image. Cornwallis's downcast profile and stance, for instance, with his weight thrown onto the left leg, resemble those of the handsome grenadier who stands near the right edge of *The Death of General Wolfe*. Moreover, each painting includes a native observer in the left foreground seated with his back to the viewer: Ghulam Ali Khan, the lame *vakil* on a palanquin, takes the place of the thoughtful American Indian in West's image. In addition, a large military standard punctuates the sky over the central action in each work, and an architectural landmark enlivens the left background. Brown exchanged the cathedral tower of Quebec city for Seringapatum's watchtower. Clearly indebted to West, Brown nevertheless set out on an independent course when he turned to medievalizing sources.

To establish the character of his primary participants the artist drew upon late-fifteenth-century prototypes. During the 1780s and early 1790s, themes from medieval history had grown increasingly popular with artists working or exhibiting in London. Most of these images were derived from Shakespeare's plays or from multi-volume national histories written by authors such as David Hume and Paul de Rapin-Thoryas.[30] Brown himself had contributed to the emerging trend when he completed a large painting of *Richard II resigning his crown to Bolingbroke* from *King Richard II* (Act IV, scene i) for John Boydell's Shakespeare Gallery in Pall Mall in 1791.[31] The following year, he exhibited two royal Tudor scenes at the Morland Gallery, together with his Mysori paintings.[32] Working with both medieval and modern colonial material simultaneously, the artist then began inventively to draw connections between the two eras.

To delineate the personalities of Tipu Sultan and his sons, Brown turned to recent depictions of *King Richard III*, one of Shakespeare's most popular plays during this period. His primary source was a large painting by James Northcote entitled *The interview of the young princes in London* (Act III, scene i) (Figure 10.4), which had been on display at Boydell's Gallery since 1789.[33] Northcote's painting showed Richard, who at this point in the drama was still Duke of Gloucester, urging his two nephews to depart for the Tower of London for supposed safe-keeping. Those familiar with the action knew that the defenceless Prince Edward and Richard, Duke of York, would never return from this enforced imprisonment but would be smothered in their sleep so that their uncle could seize the throne.

Following both West and Northcote, Brown placed *repoussoir* figures close to the picture plane at both sides of *The delivery of the definitive treaty.* Also, noting how the youth of the boys in *The interview of the young princes* had been exaggerated to increase their emotional appeal, Brown made Abdul Khaliq and Muiz-ud-din appear less than their ten and eight years. Echoing Northcote, the supporting figures in Brown's composition are divided into two groups. To the left of the Indian princes, Tipu's followers and the representatives of neighbouring states take the place of the English princes' sinister plotting uncles and their military guard. To Cornwallis's right, attendant British officers stand in for the supporters of Prince Edward and the Duke of York. Wishing to characterize the Governor-General as benevolent and fatherly, Brown took over elements of his pose from Northcote's Lord Hastings, the protective escort figure who leans upon his staff. Like Hastings, Cornwallis stands to the right of the princes with his head shown in profile, his right knee bent and the Order of the Garter displayed below his left knee. Several of the officers beside Cornwallis resemble members of the Lord Mayor's train assembled behind Hastings. Finally, the features and position of the elderly bearded Indian who oversees the treaty exchange owe something to Northcote's sage-like Cardinal Bourchier.

Since Tipu was not present at the peace ceremony Brown could not include a villain comparable to the Duke of Gloucester in *The delivery of the definitive treaty.* Instead, he distributed malevolent elements among the Indians who did attend. Gloucester's disfiguring hump, for example, re-appears on the back of Ghulam Ali Khan. This representative of the sultan was indeed disabled, but Brown exaggerated his deformities to a grotesque degree. The variously attired warriors and *vakils* who fill the left side of the composition scowl or stare as they hold their weapons at the ready. As a group, they project a feeling of menace which contrasts strongly with the smiling and relaxed composure of the bare-headed, uniformly dressed British officers. Brown manipulated the compositional division between good and evil laid down by Northcote to characterize the populace of Mysore as either dangerous or deluded, in contrast to their conquerors who are virtuous and well-intentioned. He patriotically emphasized Cornwallis's kindliness toward the Indian princes to foreshadow the quality of colonial rule he would establish.

Northcote's powerful vision of Gloucester became instead a source for Tipu's pose in *The departure from the zenana.* In the latter work, the sultan, like his British counterpart, bends from the waist and gestures with his right hand as he attempts to persuade his sons to consign themselves willingly to captivity. This depiction was intended to assuage British consciences troubled by Cornwallis's political power-play involving children. Brown's clever

equation of the sultan with Richard III suggests such means were not only acceptable but necessary when dealing with a barbarian and a tyrant.

When he cast Tipu as an unalloyed villain, Brown lent credence to opinions which had been circulating in England since the late 1780s. Tales of the sultan's cruelty towards captured enemy soldiers had been published in memoirs and found visual expression in caricatures by James Gillray and Isaac Cruikshank.[34] The greater Tipu's military success, the more exaggerated such images became. However, officers such as Cornwallis, who possessed a first-hand knowledge of Mysore, usually took a more balanced view. They certainly criticized the sultan for his cruelty, but also praised him as a brave warrior, skilled military tactician, and beneficent ruler of his own subjects.[35] Brown's portrayal gives no hint of these positive qualities.

In *The departure from the zenana*, Tipu is depicted as a master manipulator working his wiles upon children, lamenting women, and servants. Brown creates emotional tension by suggesting the sultan's willingness to sacrifice his own flesh and blood to the demands of political expediency. In this instance, Brown based the interaction between the central figures on another familiar 'Little Prince' subject, the separation of Richard, Duke of York from his mother, the dowager queen of Edward IV. Versions of this theme had been exhibited regularly in London since the early 1760s and frequently engraved.[36] Brown's primary source was a watercolour design by Giovanni Battista Cipriani entitled *Richard, Duke of York, taking leave of his mother, Elizabeth Woodville, in the sanctuary of Westminster* (Figure 10.5) which had been issued as a stipple engraving in 1786.[37]

Cipriani showed the Archbishop of Canterbury coaxing the young Duke of York away from his mother while the Archbishop of York looks on. This sad parting took place in Westminster Abbey, whither Elizabeth had fled for sanctuary after being forced to cede control of her elder son, Prince Edward, to his uncle. Incensed at being thwarted, Gloucester dispatched the two prelates to retake the younger boy. Referred to in Shakespeare's play, although not staged, the episode is described at length by Rapin and Hume.[38] After leaving his mother, the Duke of York was reunited with his brother, in the scene Northcote painted for Boydell (Figure 10.4), before both were sent off to the Tower.

In *The departure from the zenana*, the interaction between the sultan, his sons, and the second kneeling mother corresponds roughly to that between Cipriani's archbishop, prince, and queen. Tipu's gesture, holding the hand of Abdul Khaliq, and the boy's backward glance, echo the interaction between the Archbishop of Canterbury and Duke of York. Brown necessarily opened up the latter arrangement to include Muiz-ud-din embracing his mother (deriving the prince's winsome expression from the choirboy who stands between Cipriani's two archbishops).[39] He also added the standing Indian

princess, whose figure, together with those of the two boys, forms a strong central pyramid. Her raised arm, dramatic expression and feathered head-dress were based on those of a Shakespearean heroine Brown had seen in Boydell's Gallery.[40]

Medieval England and contemporary Mysore had become so firmly intertwined in Brown's work in 1792 that it is not surprising to find him revisiting the connection several years later. To condemn tyranny closer to home, he inserted a reference to Tipu Sultan into a fifteenth-century English setting: *Thomas, Earl of Surrey, defending his allegiance to Richard III after the battle of Bosworth field, 1485* (Figure 10.3) was one of two works Brown painted for the 11th Duke of Norfolk in the late 1790s.[41] Both illustrated the life of Thomas Howard (1443–1524) and were intended for a gallery dedicated to 'some of the most remarkable actions of [the Duke's] ancestors,' conceived around 1795. This room was part of the extensive Gothic Revival rebuilding of Arundel Castle begun in 1791.[42] The subject chosen for the larger composition refers, by means of analogy, to a political disgrace the 11th Duke suffered in January 1798 which provides us with an *a priori* date for the work's conception.

At the centre of *Surrey defending his allegiance to Richard III*, the Earl stands before Henry, Duke of Richmond, the victor of Bosworth who will shortly be crowned Henry VII. Since the Howards fought on the losing side in the battle, they forfeited their lands and titles as a result. Instead of succeeding his slain father as the 2nd Duke of Norfolk, Surrey had his estates confiscated by the new king and he was imprisoned in the Tower of London. Brown painted this edifice looming in the background as a reminder of the Earl's fate.

To make the injustice of Henry's condemnation clear, and to suggest that his actions resembled those of an oriental tyrant, the artist dressed the future king in a jewelled velvet turban and pointed golden shoes similar to those worn by Tipu Sultan in *The departure from the zenana* (Figure 10.1). More generally, his headgear, fur-edged robe and slippers recall the stereotype of the cruel and sensual Turkish pasha, which had long been a commonplace in European art.[43] By surrounding the future king with women and children, just as he had the sultan, the artist made him resemble the lord of an English harem rather than a victorious warrior fresh from battle. To Henry's left stands Elizabeth of York, his reluctant bride-to-be, whose pose was partly based on Tipu's aggrieved chief wife. Brown even strengthens the connection by softening Elizabeth's cap and veil to make them resemble the sultana's feathered turban. The woman clad in black on Henry's right is Surrey's dispossessed spouse who, together with her small son, seems to have been taken into the royal household as a trophy of war.

Brown emphasized Surrey's innocence and Henry VII's villainy because he intended the painting to operate as a silent defence of his patron, the 11th Duke, whose republican sympathies had led him, since the mid-1770s, to support American independence, British electoral reform and, most recently, the establishment of a constitutional government in France.[44] This put him at odds with George III and the repressive Tory regime recently instituted by his chief minister William Pitt the Younger, who feared the spread of French Revolutionary influences in Britain.

At a Whig Club anniversary dinner held on 24 January 1798, the Duke seriously misjudged the political climate when he toasted 'The Majesty of the People' and evoked George Washington as a model for action. When George III heard of these remarks, he stripped Norfolk of all non-hereditary royal appointments.[45] With these events in mind, it is hard *not* to see the unfortunate Thomas Howard as speaking on behalf of his dispossessed descendant Charles, the 11th Duke of Norfolk. Oriental imagery was called on to clarify the equation between the tyrannous Henry VII and George III. By this circuitous route, the ruler of Mysore can be said to have taken his revenge upon a British king whose forces had humiliated him six years before.

Together, Brown's Indian subjects and Arundel Castle commission illuminate the ways in which Britain's conquest of Mysore was manipulated in art to make it palatable for viewers at home. A foe such as Tipu could not be praised as a just ruler, military genius and lover of independence, even though Britons might prize such qualities themselves. Instead, he was compared to Richard III and vilified. *The departure from the zenana* and *The delivery of the definitive treaty* suggest that the sultan was a scheming, ignoble father and thoughtless husband who happily turned his young sons over to his enemies just as Richard had callously consigned his own nephews to the Tower. The forces of Lord Cornwallis, on the other hand, are portrayed as benign liberators rather than as the conquerors of Mysore. The way Brown layered information about contemporary India upon medieval prototypes helped Britons of the 1790s accept colonialism's unsavoury consequences. The artist's subsequent decision to revive his distorted characterization of Tipu in order to make a statement about domestic politics demonstrates its effectiveness and power.

Notes

1. Oil on canvas, 16½ × 23 in. (50 × 58.4 cm), private collection, Nagpur, India; see Dorinda Evans, *Mather Brown, early American artist in England* (Middletown, Conn.: Wesleyan UP, 1982): 111–15 and cata. no. 246, p. 244. This is the primary source on Brown's *oeuvre*.

2. Oil on canvas, 16½ × 23 in. (50 × 58.4 cm), private collection, Nagpur, India; see Evans, *Mather Brown*, cata. no. 245, p. 243.

3. Details of these are given in the list of figures.

4. See list of figures for details. Evans, *Mather Brown*: 133–5 and cata. no.304, p.255 dates this work to circa 1795. As I will argue below, references to contemporary events suggest it was painted in 1798.

5. Edgar Wind, 'The revolution in history painting', *Journal of the Warburg Institute* 2 (1938–9): 117–20, demonstrates how Benjamin West and John Singleton Copley had used American locations, in paintings of the 1770s and 1780s, to create a degree of psychological distance which allowed them to elevate contemporary subjects to an heroic level. Brown applied their insights to even more exotic material.

6. Sir Penderel Moon, *The British conquest and dominion of India* (Duckworth, Indiana: Indiana UP, 1989): 246–61; Denys M. Forrest, *Tiger of Mysore, the life and death of Tipu Sultan* (London: Chatto and Windus, 1970): 149–93; Major Alexander Dirom, *A narrative of the campaign in India which terminated the war with Tippoo Sultan in 1792* (London: W. Bulmer and Co., 1793).

7. The suspense was heightened by Cornwallis's forced retreat from Mysore during the winter monsoon season of 1791 and the false reports of victory which reached London early in 1792.

8. The princes were not released until May of 1794.

9. Evans, *Mather Brown*: 111 and notices entitled 'Tippoo Saib' and 'Sadler's Wells . . .' in *The London Times*, 9–26 May, 1792, indicate a piece called *Tippoo Saib; or, East India campaigning* and containing 'Song, Dance, Pantomime, Action, and Spectacle', appeared at Sadler's Wells Theatre in April and May of 1792. Charles Beecher Hogan, ed., *The London Stage, 1660–1800*, part 5 (Carbondale, Ill.: South Illinois UP, 1968): 1361–4, indicates that a musical play by Mark Lonsdale, *Tippoo Saib; or, British valour in India*, was staged earlier in the course of the war, between 6 and 10 June 1791, at the Theatre Royal, Covent Garden.

10. Numerous images of Tipu and his sons painted between 1792 and the early 1800s are listed in Mildred Archer, *India and British portraiture, 1770–1825* (London and New York: Sotheby Parke Bernet; Karachi and Delhi: OUP, 1979: 218–19, 259–67, 299–303, 307–10, 419–35, and by Forrest, *Tiger of Mysore*, Appendix IV, 346–53; and Forrest, 'Tipu Sultan in the homes of his enemies', *Country Life* 149 (18 February 1971): 352–3.

11. Brown's maternal relatives, the Byles, were Tories who remained loyal to Britain but his father and step-brother supported independence. Evans, *Mather Brown*: 10–11, 19–41, notes that the artist maintained contact with both groups.

12. A notice appeared in *The Diary, or Woodfall's Register*, 10 May 1792.

13. The treaty reached London on 20 August and a description of the princes' surrender appeared under 'East India Intelligence' in *The Gentleman's Magazine*, vol. 62, pt 2: 760–61, the same month. Evans, *Mather Brown*: 111, notes that Brown asked one of Cornwallis's aides-de-camp, Major W.C. Madan, to write to the Company on his behalf and this letter was read at a directors' meeting on 8 August, at which time permission for the dedication was granted and 40 of the proposed engravings ordered.

14. Evans, *Mather Brown*: 111, points out that Robert Smirke was simultaneously at work on a print design of Cornwallis receiving the hostage princes. At the same August directors' meeting at which Brown's letter was read, Smirke asked the East India Company if he could dedicate to them his own planned image and was given comparable encouragement.

15. Newspaper notices advertising the exhibition and soliciting subscriptions to the engravings were issued by Messrs Orme & Co. on 17 November and 5 December 1792. Examples appear in Victoria and Albert Museum, *Album of press clippings from English newspapers on matters of artistic interest, 1686–1835*: 3 608, and Archer, *India and British portraiture*: 421. Evans, *Mather Brown*: 111, notes that similar notices in French were taken out in a London newspaper in January, presumably to appeal to potential Continental buyers.

16. Named for the artist George Morland, the gallery was run by the brothers Edward and Daniel Orme, the latter a miniature painter, stipple engraver and publisher. The Orme family also published books of Mysori and other Indian views during the 1790s. These are described by Martin Hardie *et al.*, eds, *Watercolour Painting in Britain* (London: B.T. Batsford Ltd, 1968): 3 44.

17. Archer, *India and British portraiture*: 422–4, mentions engravings by J. Gozier after Singleton's two Tipu subjects were issued in August 1793. The original oils, *The hostages presented by the vakeel to Lord Cornwallis* and *The departure of the hostages from Seringapatum*, were exhibited at the Royal Academy in 1793 and 1794.

18. Details of the painting are given in the list of figures. Charles Mitchell, 'Benjamin West's *Death of General Wolfe* and the popular history piece', *Journal of the Warburg and Courtauld Institutes* 7

(1944): 32–3, and Helmut Von Erffa and Allen Staley, *The paintings of Benjamin West* (New Haven and London: Yale UP, 1986): cata. no.93: 211–13, discuss the significance of the print, a line engraving with etching issued in January 1776 by Woollett, Boydell and Ryland, which helped lay the foundations of John Boydell's fortune.

19. The dates and locations of these advertisements are given in note 15.

20. Brown may have intended to increase the pathos of the scene by referring to contemporary reports which stated, mistakenly, that Muiz-ud-din was the son of the sultan's favourite wife, 'a beautiful delicate woman who had died of fright' during the British attack. These are discussed by Dirom, *A narrative of the campaign in India*: 230, and Forrest, *Tiger of Mysore*: 188.

21. Dirom, *A narrative of the campaign in India*: 227–9.

22. It is important not to confuse images of the March treaty exchange with those which depict Cornwallis's initial reception of the princes on 28 February 1792. Brown's own 1793 painting of the latter subject is discussed by Evans, *Mather Brown*, cata. no.237: 115–17, 242. Representations of the February event by Smirke, Singleton, George Carter, Arthur William Devis, Robert Home and James Northcote are mentioned in notes 14 and 17 and by Archer, *India and British portraiture*: 260–6, 279, 300, 307–9, 421–4, and Evans, *Mather Brown*: 111.

23. Dirom, *A narrative of the campaign in India*: 247.

24. Evans, *Mather Brown*: 112–13, quotes a copy at the American Antiquarian Society, Worcester, Massachusetts.

25. Madan's association with the artist is described in note 13.

26. Evans, *Mather Brown*: 112–13.

27. Archer, *India and British portraiture*: 263–5, 308–9 and pls 187–8, 213–14, discusses and reproduces relevant works by Devis and Home and notes that the latter personally witnessed the surrender of the princes to Cornwallis on 26 February 1793.

28. Von Erffa and Staley, *The paintings of Benjamin West*: 211–13, Mitchell, 'West's *Death of General Wolfe*: 20–33, and Wind, 'The revolution in history painting': 117–21, all discuss the significance of West's painting.

29. Evans, *Mather Brown*: 15–18, notes that Brown received a letter of introduction to West from Benjamin Franklin, whom he visited in France on his way to London.

30. The rising number of medieval images, their sources and significance are discussed by Constance C. McPhee, *The exemplary past? British history subjects in London exhibitions, 1760–1810* (PhD dissertation, University of Pennsylvania, 1995): chs. 5 and 6.

31. Oil on canvas, 1791, first exhibited by Boydell in 1792, unlocated but engraved in stipple by Benjamin Smith and issued 6 June 1801. Further details are given by McPhee, *The exemplary past?*: Appendix G, 421, Winifred Friedman, *Boydell's Shakespeare Gallery* (New York: Garland, 1978): 221, and Evans, *Mather Brown*: cata. no. 295, 100–4, 253.

32. *The union of the houses of York and Lancaster: the marriage of Henry VII with Elizabeth of York*, oil on canvas, 1792, 84 × 109 in., Tallow Chandlers' Company, London, and *The baptism of Henry VIII*, oil on canvas, 1792, 83 × 106½ in., City of Bristol Museum and Art Gallery, Bristol, Avon. More information on these works may be found in Evans, *Mather Brown*: 105–8, cata. nos. 227, 276, pp. 240, 250, and McPhee, *The exemplary past?* Appendix H, 470.

33. Oil on canvas, 1787, unlocated. Information about the engraving is given in the list of figures. This was one of five Little Prince subjects Northcote painted between 1785 and 1791, derived from passages in *Henry VI, part II* and *Richard III*. All were bought by Boydell for the Shakespeare Gallery and are discussed by McPhee, *The exemplary past?*: 246–50, 311–14 and Appendix G, 428–30, and Friedman, *Boydell's Shakespeare Gallery*: 162, 164, 168–70, 173–4, 230–31. They are also listed by John Boydell, *A collection of prints . . . illustrating the dramatic works of Shakespeare* (London: John and Josiah Boydell, 1803): vol. 2, XXI–XXIV, and *Boydell's graphic illustrations* (London: Messrs Boydell & Co., 1804): no. LXV.

34. Written accounts are found in James Bristow, *A narrative of the sufferings of James Bristow, belonging to the Bengal artillery* (London: J. Murray, 1793), and William Thomson, *Memoirs of the late war in Asia* (London: J. Murray, 1788). Representative caricatures are Gillray's *The coming-on of the monsoons; – or – the retreat from Seringapatum*, issued by H. Humphrey on 6 December 1791, and Cruikshank's *How to gain a compleat* [sic] *victory, and say, you got safe out of the enemy's reach*, issued by S.W. Fores on 15 December 1791; both are described by M. Dorothy George, *Catalogue*

of prints and drawings in the British Museum: political and personal satires, 1784–92 (London: Trustees of the British Museum, 1938): vol. 6, nos. 7929, 7932: 830–32.

35. Comments of this kind contained in Cornwallis' dispatches are mentioned by Forrest, *Tiger of Mysore*: 194–7, and Archer, *India and British portraiture*: 420, 425.

36. William Pressly, ed., 'A memoir of J.F. Rigaud by Stephen F.D. Rigaud', *Walpole Society* 50 (1984): 73 and 147, note 66, describes John Francis Rigaud's small oil, *The queen dowager of England, widow of Edward IVth, delivering her son, the Duke of York, to the cardinal,* which was shown at the Royal Academy in 1786 (116) and engraved by Bettelini before 1786. Alfred Whitman, *Valentine Green* (London: A.H. Bullen, 1902), no. 253: 162, mentions Valentine Green's mezzotint after J.G. Huck entitled *Elizabeth, queen dowager of Edward IV, delivering her son Richard, Duke of York to Cardinal Bourchier,* issued by V. & R. Green, March 21 1789, as part of the 1786–92 series *Acta Historica Reginarum Anglia.* There is a copy in the Metropolitan Museum of Art, New York, accession no. 62.602.215.

37. Information on the watercolour is given in the list of figures. Francesco Bartolozzi's engraving, *The dowager queen of Edward IV parting with the Duke of York to the two archbishops by order of Richard III,* was issued by W. Palmer on 14 February 1786; see Alexandre De Vesme and Augusto Calabi, *Francesco Bartolozzi, catalogue des estampes* (Milan: G. Modiano, 1928), no. 527: 138–9.

38. *King Richard III* (Act III, scene i), Paul de Rapin-Thoryas, *The history of England, as well ecclesiastical as civil* (trans. Nicholas Tindal, London: J. and J. Knapton, 1726–47), vol. 4: 174, and David Hume, *The history of England from the invasion of Julius Caesar to the revolution in 1688* (Indianapolis: Liberty Classics, 1983 reprint of London 1778 edition), vol.2: 498–9.

39. The embracing pair are also indebted to the weeping queen and her son in Green's 1789 mezzotint after Huck described in note 36.

40. She resembles the protesting Katherine in Francis Wheatley's *Petruchio and Katherine* from *The Taming of the Shrew* (Act III, scene ii), engraved by P. Simon, and issued by J. and J. Boydell, 1 January 1795. This work is listed in Boydell, *A collection of prints,* 1, no. XXIX.

41. The second was a small oil sketch, *The Duke of Norfolk receiving from Henry VIII an augmentation to his coat-of-arms in consequence of the victory of Flodden field, 1513,* exhibited at the Royal Academy in 1797 as *A composition for the history of England.* Details of this work are given by Evans, *Mather Brown,* cata. no. 284: 251.

42. Work on the castle, which continued until after the 11th Duke's death in 1815, is discussed by James Dallaway, *A history of the western division of Sussex* (London: T. Bensley, 1815–30), vol. 2 (1): 90–165, and by John Martin Robinson, 'Gothic revival at Arundel, 1780–1870', *Connoisseur* 197 (March 1978): 162–71, and 'Magna Charta and pretty ladies' maids', *Country Life* 174 (7 July 1986): 46–9. Little is known about the now dismantled gallery, but plans for it are indicated in a letter of 19 June 1795 from Horace Walpole to the duke's representative, Edmund Lodge, which includes a list of possible themes. A letter of 21 November 1802 from Lodge to Charles Bedford confirms that the gallery was actually set up. Both are published in Horace Walpole (W. S. Lewis, ed.), *The Yale edition of Horace Walpole's correspondence* (New Haven: Yale UP, 1937–83), vol. 42: 420–2.

43. Brown had adapted this type to a Mysori setting when he formed his 1792 image of Tipu. John Sweetman, *The oriental obsession: Islamic inspiration in British and American art and architecture, 1500–1920* (Cambridge: Cambridge UP, 1988): 60–66, discusses Turkish imagery in English and French art of the eighteenth century.

44. 'The most noble Charles, Duke of Norfolk', *Annual Biography and Obituary,* 1817: 104–24, and Robinson, *The Dukes of Norfolk, a quincentennial history* (Oxford: OUP, 1982): 171–82, summarize the Duke's political career.

45. Gerald Brenan and Edward Stratham, *The house of Howard* (New York: D. Appleton & Co., 1908): 635–6, and Arthur Aspinall, ed., *The later correspondence of George III* (Cambridge: Cambridge UP, 1967), vol. 3: 1678, 1680, describe how the Duke lost the Lord Lieutenancy of the West Riding and the command of his regiment.

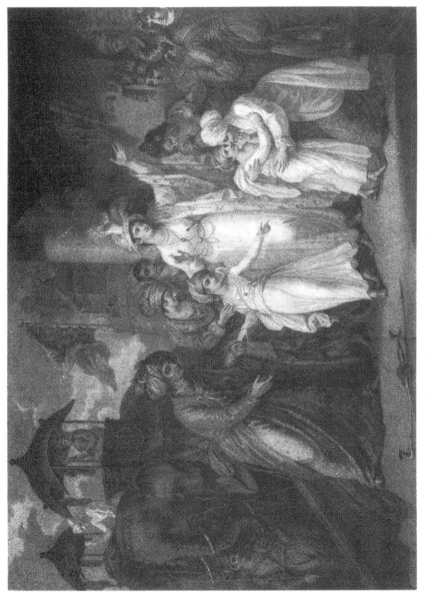

10.1 Francesco Bartolozzi after Mather Brown, *The departure of the sons of Tippoo from the zenana*

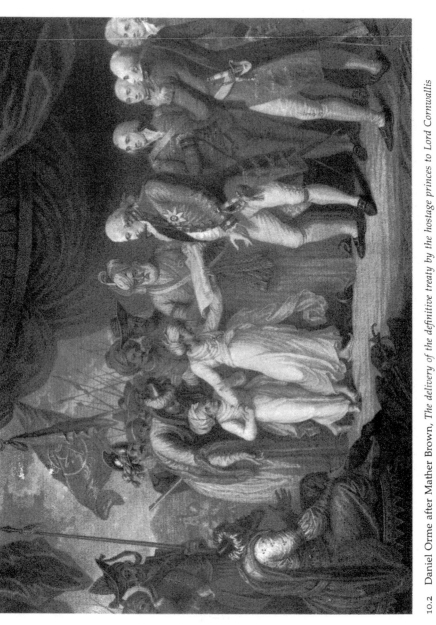

10.2 Daniel Orme after Mather Brown, *The delivery of the definitive treaty by the hostage princes to Lord Cornwallis*

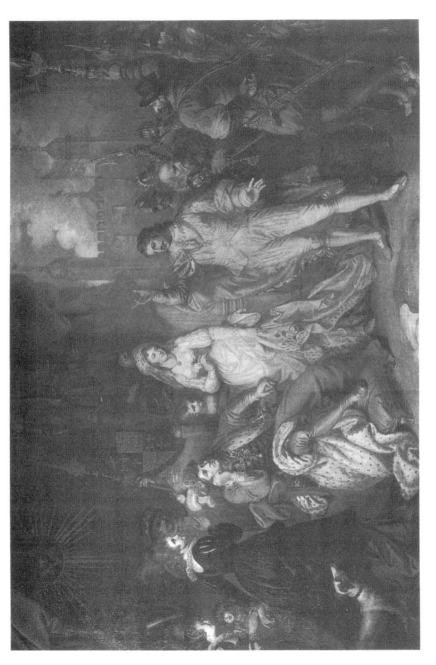

10.3 Mather Brown, *Thomas, Earl of Surrey, defending his allegiance to Richard III after the battle of Bosworth field, 1485*

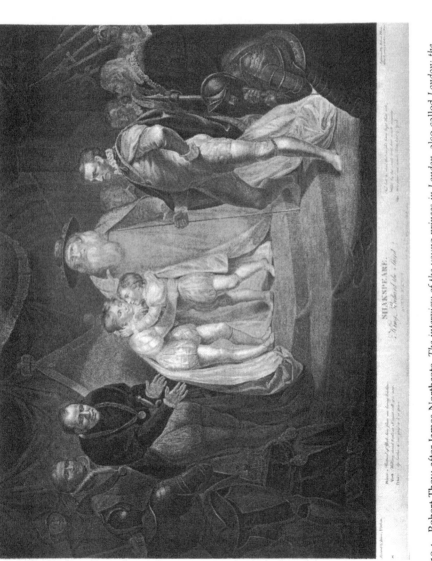

10.4 Robert Thew after James Northcote, *The interview of the young princes in London, also called London: the Prince of Wales, Duke of York, Dukes of Gloucester and Buckingham, Cardinal Bourchier, Lord Hastings, Lord Mayor and his train*

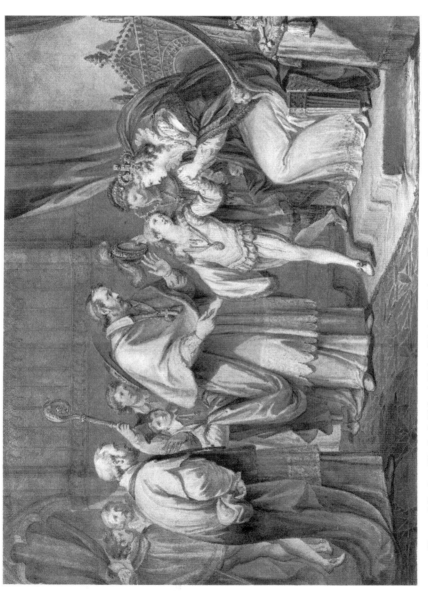

10.5 Giovanni Battista Cipriani, *Richard, Duke of York, taking leave of his mother Elizabeth Woodville, in the sanctuary of Westminster*

Bibliography

Abbey, J.R. *Travel in Aquatint and Lithography 1770–1860: From the library of J.R. Abbey.* London: Dawsons, 1972.

Abrams, Ann Uhry. *The Valiant Hero, Benjamin West and Grand-Style History Painting.* Washington DC: Smithsonian Institution Press, 1985.

Acton, Roger. *The Abyssinian Expedition, with Engravings from the Illustrated London News.* London: *Illustrated London News* Office, 1868.

Aiyer, H.R. *His Highness Sayaji Rao III, Maharaja Gaekwar of Baroda (The Story of his Life).* Book VIII: Men of To-day Series; Baroda: C.S. Raja and Co. [193?].

Allan, Mea. *Palgrave of Arabia.* London: Macmillan, 1972.

Allen, Charles. *A Glimpse of the Burning Plain: Leaves from the Indian Journals of Charlotte Canning.* London: Michael Joseph, 1986.

———— and Sharada Dwivedi. *Lives of the Indian Princes.* New York: Crown, 1984.

Allingham, William. *William Allingham's Diary.* Introduction by Geoffrey Grigson. Fontwell, Sussex: Centaur Press, 1967.

Altick, Richard D. *The Shows of London.* Cambridge, Mass., and London: Belknap Press of Harvard UP, 1978.

Amulree, Lord. 'Prince Alamayou of Ethiopia', *Ethiopia Observer* 13, 1 (1970): 8–15.

Anderson, Benedict. *Imagined Communities: Reflections on the Origin and Spread of Nationalism.* London: Verso, 1983; New York: Verso, 1991.

Anderson, M.S. *The Eastern Question 1774–1923: A Study in International Relations.* London: Macmillan, 1974.

Andrews, Malcolm. *The Search for the Picturesque: Landscape Aesthetics and Tourism in Britain, 1760–1800.* Aldershot: Scolar Press, 1989.

Anon. 'An Abyssinian Exhibition', *Punch, or the London Charivari* (2 May 1868): 192.

———— 'Prince of Abyssinia on His Way to England', *The Times* (2 July 1868): 10.

———— 'Photography at the French Exhibition', *Photographic News* 11 (1867): 278–9.

———— 'The Abyssinian Question', *Punch, or the London Charivari* (10 August 1867): 57.

———— 'The London Photographic Society', *Photographic News* 11 (1867): 545–6.

Archer, Mildred. *British Drawings in the India Office Collection.* Volumes I and II. London: HMSO, 1969.

———— *Company Drawings in the India Office Library.* London: HMSO, 1972.

———— *India and British portraiture 1770–1825.* London: Philip Wilson, 1979.

———— *Indian Paintings for the British 1770–1880.* London: OUP, 1955.

———— *Natural History Drawings in the India Office Library.* London: HMSO, 1962.

Armstrong, Carol. 'Cupid's Pencil of Light: Julia Margaret Cameron and the Maternalization of Photography', *October* 76 (1996): 115–41.

Aspinall, Arthur, ed. *The later correspondence of George III.* Cambridge: Cambridge UP, 1967.

Athenaeum 7 May 1842.

Atkinson, George Franklin. *Curry and Rice: or the Ingredients of Social Life at 'Our' Station in India.* London: n.p., 1860.

Auster, Paul. *The Invention of Solitude.* London and Boston, Mass.: Faber and Faber, 1988.

Baines, Barbara Burman. *Fashion Revivals.* London: Batsford, 1981.

Bakhtin, Mikhail. *Problems of Dostoyevsky's Poetics.* Minneapolis: University of Minnesota Press, 1984.

Bal, Mieke. 'Telling Objects: a Narrative Perspective on Collecting', in John Elsner and Roger Cardinal, eds., *The Cultures of Collecting.* Cambridge, Mass. : Harvard UP, 1994: 97–115.

Ballhatchet, Kenneth. *Race, Sex and Class under the Raj.* London: Weidenfeld and Nicolson, 1980.

Barlow, Paul. 'The Imagined Hero as Incarnate Sign: Thomas Carlyle and the Mythology of the "National Portrait" in Victorian Britain', *Art History* 17, 4 (1994): 517–45.

Barr, Pat. *The Memsahibs: The Women of Victorian India.* London: Secker and Warburg, 1976.

Bates, Darrell. 'The Abyssinian Boy', *History Today* 29 (1979): 816–23.

———— *The Abyssinian Difficulty: The Emperor Theodorus and the Magdala Campaign, 1867–68.* Oxford and New York: OUP, 1979.

Battersby, Martin. 'Diaghilev's Influence on Fashion and Decoration', in Charles Spencer, *The World of Serge Diaghilev*. London: Paul Elek, 1974: 149–62.

Baudrillard, Jean. 'The System of Collecting', in John Elsner and Roger Cardinal, eds., *The Cultures of Collecting*. Cambridge, Mass.: Harvard UP, 1994: 7–24.

Bayly, C.A. *Indian Society and the Making of the British Empire*. The New Cambridge History of India, vol. II. I. Cambridge, Cambridge UP, 1988.

———— *Imperial Meridien: The British Empire and the World 1780–1830*. London and New York: Longman, 1989.

———— ed. *The Raj: India and the British 1600–1947*. London: National Portrait Gallery, 1990.

Bell, Leonard. 'Nicholas Chevalier: The Fortunes and Functions of his Paintings', *Art New Zealand* 44 (1987): 78–81.

———— *Colonial Constructs: European Images of Maori 1840–1914*. Auckland and Melbourne: Auckland UP and Melbourne UP, 1992.

———— 'Nicholas Chevalier's Journey through Canterbury in 1866: Contexts and Connections', *Bulletin of New Zealand Art History* 14 (1993): 97–106.

———— 'Augustus Earle's *The Meeting of the Artist and the Wounded Chief, Hongi, Bay of Islands, New Zealand, 1827* and his depictions of other New Zealand encounters: Contexts and Connections', in Jonathan Lamb, Bridget Orr and Alex Calder, eds., *Voyages and Beaches: Europe and the Pacific 1769–1840*. Honolulu: University of Hawaii Press (forthcoming).

Bellew, Captain. *Memoirs of a Griffin*. London: n. p., 1813.

Belnos, S.C. *The Sundhyas, or the Daily Prayers of the Brahmins*. Allahabad: n.p., 1851.

———— *Twenty-Four Plates Illustrative of Hindoo and European Manners in Bengal*. London: n.p., 1832.

Bendiner, Kenneth Paul. *The Portrayal of the Middle East in British Painting, 1835–60*. PhD dissertation, Columbia University, 7908580. Ann Arbor: UMI, 1979.

Bendix, Deanna Marohn. *Diabolical Designs: Paintings, Interiors, and Exhibitions of James McNeill Whistler*. Washington DC: Smithsonian, 1995.

Benstock, Shari. *Women of the Left Bank: Paris, 1900–1940*. Austin: University of Texas Press, 1986.

Berger, Maurice, Brian Wallis and Simon Watson, eds. *Constructing Masculinity*. New York and London: Routledge, 1995.

Bhabha, Homi K. 'Of Mimicry and Men', *October* 28 (1984): 125–33.

———— 'Sly Civility', *October* 34 (1985): 71–80.

———— 'The Other Question: the Stereotype and Colonialist Discourse', in Francis Barker *et al.*, eds, *Literature, Politics, Theory*. London: Methuen, 1986: 148–211.

———— ed., *Nation and Narration*. London and New York: Routledge, 1990.

———— ' "Race", Time and the Revision of Modernity'. *The Oxford Literature Review* 13 (1991): 193–219.

———— ed., *The Location of Culture*. New York: Routledge, 1994.

———— 'Interrogating Identities', in *The Location of Culture*, q.v.

———— 'Signs Taken for Wonders', in *The Location of Culture*, q.v.

Bicknell, Peter. *Beauty, Horror and Immensity: Picturesque Landscape in Britain*. Cambridge: Cambridge UP, 1981.

Blanchard, Mary. 'Boundaries and the Victorian Body: Aesthetic Fashion in Gilded Age America', *American Historical Review* 100 (1995): 21–50.

Blunt, Lady Fanny Janet Sandison. *The People of Turkey: Twenty Years' Residence among the Bulgarians, Greeks, Albanians, Turks and Armenians, by a Consul's Daughter and Wife*, ed. Stanley Lane Poole, 2 vols. London: n.p., 1878.

Boime, Albert. *The Magisterial Gaze: Manifest Destiny and American Landscape Painting c. 1830–1865*. Washington and London: Smithsonian Institution Press, 1991.

Bonyhady, Tim. *Images in Opposition: Australian Landscape Painting 1801–1890*. Melbourne: OUP, 1985.

Boydell, John. *A collection of prints from pictures painted for the purpose of illustrating the dramatic works of Shakespeare, by the artists of Great Britain*. 2 vols. London: John and Josiah Boydell, 1803.

———— *Boydell's graphic illustrations of the dramatic works of Shakespeare, consisting of a series of prints forming an elegant and useful companion to the various editions of his works, engraved from pictures purposely painted by the very first artists and lately exhibited at the Shakespeare Gallery*. London: Messrs Boydell & Co., 1804.

———— *The American edition of Boydell's illustrations of the dramatic works of Shakespeare, by the most eminent artists of Great Britain, restored and published with the original descriptions of the plates*, 2 vols. New York: Shearjasub Spooner, 1854.

Brake, Laurel. *Subjugated Knowledge: Journalism, Gender and Literature in the Nineteenth Century*. London: Macmillan, 1994.

Brenan, Gerald, and Edward Phillips Stratham. *The house of Howard*. New York: D. Appleton & Co., 1908.

Bristow, James. *A narrative of the Sufferings of James Bristow, belonging to the Bengal artillery, during ten years captivity with Hyder Ally and Tippoo Saheb*. London: J. Murray, 1793.

Bronkhurst, Judith. ' "An interesting series of adventures to look back upon": William Holman Hunt's visit to the Dead Sea in November 1854', in Leslie Parris, ed., *Pre-Raphaelite Papers*. London: Tate Gallery, 1984: 111–25.

Buckingham, James Silk. *Travels in Mesopotamia*. London: H. Colburn, 1827.

Bunn, David. ' "Our Wattled Cot": Mercantile and Domestic Space in Thomas Pringle's African Landscapes', in W.J.T. Mitchell, *Landscape and Power*. Chicago: University of Chicago Press, 1994: 127–74.

Burton, Richard F. *Personal Narrative of a Pilgrimage to Al-Madinah & Meccah*. London: George Bell & Sons, 1898.

Butler, Judith. *Gender Trouble*. New York and London: Routledge, 1990.

Calder, Alex. 'Maning's Tapu: Colonialism and Ethnography in New Zealand', *Social Analysis* 39 (1996): 3–26.

Cameron, Julia Margaret. 'Annals of My Glass House' (1874), reprinted in Beaumont Newhall, ed., *Photography: Essays and Images*. New York: Museum of Modern Art, 1980.

Campbell, Janey Sevilla. 'The Woodland Gods', *Woman's World* 1 (1888): 1–7.

Cannon, Garland. 'Foundations of Oriental and Comparative Studies: The Correspondence of Sir William Jones', *Comparative Criticism: A Yearbook* 3 (1981): 157–78.

—— *Sir William Jones, Orientalist*. Honolulu: University of Hawaii Press, 1952.

—— ed. *The Letters of Sir William Jones*. Oxford: Clarendon Press, 1970.

Cannon, Susan Faye. *Science in Culture: The Early Victorian Period*. New York: Dawson and Science History Publications, 1978.

Carlyle, Thomas. 'Shooting Niagra: And After?' (1867), in *Critical and Miscellaneous Essays*. Boston: Dana Estes and Charles E. Lauriat, 1884.

—— 'Occasional Discourse on the Nigger Question' (1849), in *Critical and Miscellaneous Essays, q.v.*

—— *On Heroes, Hero-Worship, & the Heroic in History* (1841). Introduction by Michael K. Goldberg. Berkeley: University of California Press, 1993.

Çelik, Zeynep. 'Colonialism, Orientalism and the Canon', *Art Bulletin* 78 (1996): 202–5.

—— and Leila Kinney. 'Ethnography and Exhibitionism at the Expositions Universelles', *Assemblage* 13 (1990): 35–59.

Chatterjee, Partha. 'Gandhi and the Critique of Civil Society', *Subaltern Studies* 3 (1984): 153–95.

Chaudhuri, Nirad C. 'The Influence of British and European Literature on Hindu Life', in Robert Cecil and David Wade, eds., *Cultural Encounters, Essays on the interactions of diverse cultures now and in the past*. London: The Octagon Press, 1990: 55–71.

Chaudhuri, Nupur. 'Memsahibs and Motherhood in Nineteenth-Century Colonial India', *Victorian Studies* 31 (4) Summer 1988: 517–35.

Chavda, Vidya K. *Gaekwads and the British: A Study of their Problems (1875–1920)*. Delhi: University Publishers, 1921.

—— *Sayaji Rao Gaekwad III*. New Delhi: Thomson Press, 1972.

Chiego, William J., ed. *Sir David Wilkie of Scotland 1785–1841*. Raleigh, NC: North Carolina Museum of Art, 1987.

Chirol, Valentine. *The Occident and the Orient*. Chicago: University of Chicago Press, 1924.

Cohn, Bernard S. *An Anthropologist among the Historians and Other Essays*. Oxford: OUP, 1996.

—— *Colonialism and its Forms of Knowledge: The British in India*. Princeton: Princeton UP, 1996.

—— 'The Command of Language and the Language of Command', *Subaltern Studies* IV, Delhi: OUP, 1985: 276–329.

Colley, Linda. *Britons, Forging a Nation, 1707–1837*. New Haven and London: Yale UP, 1992.

Condor, Josiah. *The Modern Traveller*, vol. V. London: n. p., 1827.

Connell, R.W. *Masculinities*. Berkeley: University of California, 1995.

Coombes, Annie E. *Reinventing Africa: Museums, Material Culture and Popular Imagination in Late Victorian and Edwardian England*. New Haven and London: Yale UP, 1994.

Crinson, Mark. *Empire Building: Orientalism and Victorian Architecture*. London: Routledge, 1996.

Cunningham, Allan. *The Life of Sir David Wilkie with His Journals, Tours and Critical Remarks on Works of Art and a Selection from His Correspondence*, vol. 3. London: n. p., 1843.

Curran, Stuart, ed. *The Poems of Charlotte Smith*. Oxford: OUP, 1993.

Dallaway, James. *A history of the western division of Sussex, including the rapes of Chichester, Arundel and Bramber*. London: T. Bensley, 1815–30.

Dandekar, Vishvanath Pandurang. *Sayajirava Gayakavada* (in Marathi). New Delhi; n.p., 1962.

Denker, Eric. *In Pursuit of the Butterfly: Portraits of James McNeill Whistler*. Washington DC: Smithsonian, 1995.

Desmond, Ray. Kew: *The History of the Royal Botanic Gardens*. Kew: Harvill Press with the Royal Botanic Gardens, 1995.

De Vesme, Alexandre, and Augusto Calabi. *Francesco Bartolozzi, catalogue des estampes*. Milan: G. Modiano, 1928.

The Diary, or Woodfall's Register, 10 May 1792.

Dickinson, Violet, ed. *Miss Eden's Letters*. London: Macmillan, 1919.

Dictionary of National Biography, ed. Stephen, Leslie, and Lee, Sidney. London: OUP, 1964.

—— , ed. Sidney Lee. London: Smith, Elder & Co., 1909.

Dirks, Nicholas B. 'From Little King to Landlord: Colonial Discourse and Colonial Rule', in Dirks, ed., *Colonialism and Culture*. Ann Arbor: University of Michigan Press, 1992: 175–208.

Dirom, Major Alexander. *A narrative of the campaign in India which terminated the war with Tippoo Sultan in 1792*. London: W. Bulmer and Co., 1793.

Dorment, Richard, and Mary Macdonald. *James McNeill Whistler*. London: Tate Gallery, 1994.

Drew, John. *India and the Romantic Imagination*. Delhi: OUP, 1987.

Dunbar, Janet. *Golden Interlude: The Edens in India 1836–1842*. London: John Murray, 1955.

Earle, Augustus. *Narrative of a Nine Months' Residence in New Zealand in 1827, together with a Journal of a Residence in Tristan da Cunha, an Island situated between South America and the Cape of Good Hope*. London: Longman, Rees, Orme, Brown, Green and Longman, 1832.

'East India Intelligence', *The Gentleman's Magazine* 62 part 2 (August 1792): 760–61.

Eden, Emily. *Portraits of the Princes and People of India*. London: n.p., 1844.
———— *Up the Country*. London: Virago, 1997.

Eldridge, C.C. *Victorian Imperialism*. Atlantic Highlands, NJ: Humanities Press, 1978.

Elliott, F.A.H. *The Rulers of Baroda*. Delhi: Baroda State Press, 1934.

Elsner, John, and Roger Cardinal, eds. *The Cultures of Collecting*. Cambridge, Mass.: Harvard UP, 1994.

Erdman, David. ed. *The Complete Poetry and Prose of William Blake*. New York: Doubleday, 1982.

Evans, Dorinda. *Mather Brown, early American artist in England*. Middletown, Conn.: Wesleyan UP, 1982.

Ferguson, Frances. *Solitude and the Sublime: Romanticism and the Aesthetics of Individuation*. New York: Routledge, 1992.

Finlason, W.F. *The History of the Jamaica Case*. London: Chapman and Hall, 1869.

Fisher Michael. *Indirect Rule in India*. Delhi: OUP, 1991.

Flaubert, Gustave. 'Dictionary of Received Ideas' [compiled from 1850], in *Bouvard and Pécuchet*. Harmondsworth: Penguin, 1976.

Fleming, G.H. *Lady Colin Campbell: Victorian 'Sex Goddess'*. Gloucester: Windrush, 1989.

Ford, George H. 'The Governor Eyre Case in England', *University of Toronto Quarterly* 17, 3 (1948): 219–33.

Forrest, Denys M. *Tiger of Mysore, the life and death of Tipu Sultan*. London: Chatto and Windus, 1970.

———— 'Tipu Sultan in the homes of his enemies', *Country Life* 149 (18 February 1971): 352–3.

Foucault, Michel. 'The Eye of Power' in *Power/Knowledge: Selected Interviews and Other Writings 1972–77*. Brighton: The Harvester Press, 1977.

Freeman, Kathryn. *Blake's Nostos: Fragmentation and Nondualism in The Four Zoas*. Albany: State University of New York Press, 1997.

Friedman, Winifred. *Boydell's Shakespeare Gallery*. New York: Garland, 1978.

Frost, Alan. 'New South Wales as a Terra Nullius: The British Denial of Aboriginal Land Rights', *Historical Studies* 19, 77 (1981): 513–23.

Frye, Northrop. *Fearful Symmetry*. Princeton: Princeton UP, 1947.

Gaekwad, Fatesinghrao, Maharaja of Baroda. *Sayajirao of Baroda: The Prince and the Man*. Bombay: Popular Prakashan, 1989.

Ganeri, Jonardon. 'The Hindu Syllogism: Nineteenth-Century Perceptions of Indian Logical Thought', *Philosophy East and West* 46 (January 1996): 1–16.

Garafola, Lynn. 'The Travesty Dancer In Nineteenth-Century Ballet', in Lesley Ferris, ed., *Crossing the Stage: Controversies in Cross-Dressing*. London: Windrush, 1989.

Garber, Marjorie. *Vested Interests: Cross-Dressing & Cultural Anxiety*. New York: Routledge, 1992.

Garnett, David. *The Flowers of the Forest*. London: Chatto & Windus, 1955.

George, M. Dorothy. *Catalogue of prints and drawings in the British Museum: political and personal satires, 1784–92*. London: Trustees of the British Museum, 1938.

Gernsheim, Helmut. *Julia Margaret Cameron: Her Life and Photographic Work*. 2nd edition. New York: Aperture, 1975.

Getty Center for the History of Art and the Humanities. Cameron Papers. Boxes 1–11. Malibu: J. Paul Getty Museum.

Gilbert, Sandra M. 'Costumes of the Mind: Transvestism as Metaphor in Modern Literature', *Critical Inquiry* 7 (1980): 391–477.

The Grand Master or Adventures of Qui Hi in Hindostan. A Hudibrastic Poem in Eight Cantos By Quiz. London: Thomas Tegg, Cheapside, 1816.

Greenhalgh, Paul. *Ephemeral Vistas: The Expositions Universelles, Great Exhibitions and World's Fairs, 1851–1939*. Manchester: Manchester UP, 1988.

Grewal, Inderpal. *Home and Harem: Nation, Gender, Empire and the Cultures of Travel*. Durham, NC and London: Duke UP, 1996.

Grove, Richard H. *Green Imperialism: Colonial expansion, tropical island Edens and the origins of environmentalism, 1600–1860*. Cambridge: Cambridge UP, 1995.

Gubar, Susan. 'Blessings In Disguise: Cross-Dressing as Re-Dressing for Female Modernists', *Massachusetts Review* 22 (1981): 477–508.

Guha, Ranajit. 'Dominance without Hegemony and its Historiography', *Subaltern Studies* VI. Delhi: OUP, 1987: 210–309.

Gunn, Peter. *Vernon Lee: Violet Paget, 1856–1935*. London: CUP, 1964.

Hackforth-Jones, Jocelyn. *Augustus Earle: Travel Artist*. Martinborough, NZ: Alister Taylor, 1980.

Halbfass, Wilhelm. *India and Europe*. Albany: State University of New York Press, 1988.

Hall, Catherine. 'The Economy of Intellectual Prestige: Thomas Carlyle, John Stuart Mill, and the Case of Governor Eyre', *Cultural Critique* 12 (1989): 167–96.

Hardie, Martin, Dudley Snelgrove, Jonathan Mayne and Basil Taylor, eds. *Watercolour Painting in Britain*. London: B.T. Batsford, Ltd, 1968.

Hardiman, David. 'Baroda: The Structure of a Progressive State', in Robin Jeffrey, ed., *People, Princes and Paramount Power*. Delhi: OUP, 1978: 113–26.

Harris, Frank. *Contemporary Portraits*. London: Methuen, 1915.

Hentsch, Thierry. *Imagining the Middle East*. Montreal: Black Rose Books, 1992.

Hill, Brian. *Julia Margaret Cameron: A Victorian Family Portrait*. London: Peter Owen, 1973.

Hogan, Charles Beecher, ed. *The London Stage, 1660–1800*, Part 5. Carbondale, Ill.: South Illinois UP, 1968.

Honour, Hugh. *The Image of the Black in Western Art: From the American Revolution to World War One*, Part One. Houston: Menil Foundation, 1989.

Hopkinson, Amanda. *Julia Margaret Cameron*. London: Virago Press, 1986.

Howard, Major Trevenen J., and Holzer, Captain Henry. *Record of the Expedition to Abyssinia, compiled by order of the Secretary of War*. 2 vols. London: HMSO, 1870.

Hume, David. *The history of England from the invasion of Julius Caesar to the revolution in 1688*. 5 vols. London: Robert Bowyer, 1806.

——— *The history of England from the invasion of Julius Caesar to the revolution in 1688*. 6 vols. Indianapolis: Liberty Classics, rpt of London 1778 edition, 1983.

Hume, Hamilton. *The Life of Edward John Eyre, Late Governor of Jamaica*. London: R. Bentley, 1867.

Hungerford, Edward B. *Shores of Darkness*. New York: Columbia UP, 1941.

Hunt, William Holman. *Pre-Raphaelitism and the Pre-Raphaelite Brotherhood*. 2 vols, 2nd edition. New York: E. P. Dutton and Co. , 1914.

Hutcheon, Linda. *A Theory of Parody: The Teachings of Twentieth Century Art Forms*. London: Methuen, 1985.

Inden, Ronald. *Imagining India*. Oxford: Basil Blackwell, 1990.

Jacobs, Michael. *The Painted Voyage: Art, Travel and Exploration 1564–1875*. London: British Museum Press, 1995.

James, David. 'An English Painter in First Empire Brazil, with a catalogue of the Brazilian works of Augustus Earle' (trans. G. Brodsky), *Revista do*

Patrimonio Historico ed Artistico Nacional 12 (Rio de Janeiro, 1955)
 (unpaginated typescript, National Library of Australia).
Jameson, Anna. *Legends of the Madonna as Represented in the Fine Arts.*
 London: 1852, 2nd edn 1857; Detroit: Omnigraphics, 1990.
Jones, Sir William. *Poems.* Chiswick: C. Whittingham Press, 1822.
Kabbani, Rani. *Europe's Myths of Orient: devise and rule.* London: Macmillan;
 Bloomington: Indiana UP, 1986.
Kahrl, George. *Tobias Smollett: Traveller-Novelist.* Chicago: University of
 Chicago Press, 1945.
Kaul, H.K. *Traveller's India: An Anthology.* Delhi: OUP, 1979.
Kennedy, Dane. *The Magic Mountains: Hill Stations and the British Raj.* Los
 Angeles and Berkeley: University of California Press, 1996.
Kestner, Joseph A. *Masculinities in Victorian Painting.* Aldershot: Scolar
 Press, 1995.
Kew, Royal Botanic Gardens. *A Vision of Eden: The Life and Work of Marianne
 North.* New York: Holt, Rinehart and Winston, in collaboration with the
 Royal Botanic Gardens, Kew, 1980.
Kidwell, Claudia Brush, and Valerie Steele, eds. *Men and Women: Dressing
 the Part.* Washington DC: Smithsonian, 1989.
Kiernan, Victor. *The Lords of Human Kind.* London: Weidenfeld and
 Nicolson, 1969.
Kopf, David. *British Orientalism and the Bengal Renaissance.* Berkeley:
 University of California Press, 1969.
Krishnamachari, V.T. 'Introduction', in Mehta, *Maharaja Sayajirao III*: v–x.
Kumar, Krishna. *Political Agenda of Education. A Study of Colonialist and
 Nationalist Ideas.* New Delhi: Sage Publications, 1991.
Kunzle, David. *Fashion and Fetishism: A Social History of the Corset. Tight-
 Lacing and other Forms of Body-Sculpture in the West.* Totawa, NJ: Rowman
 and Littlefield, 1982.
*Landscape Paintings in the Victoria Memorial Collection, Chiefly by European
 Artists.* Introduction by Giles Eyre, Catalogue by Charles Greig. Calcutta:
 The Trustees of the Victoria Memorial, 1991.
Lane, Edward William. *An Account of the Manners and Customs of the
 Modern Egyptians.* 3 vols. London: C. Knight, 1846.
Lavery, Sir John. *The Life of a Painter.* London: Cassell, 1940.
Leask, Nigel. *British Romantic Writers and the East.* Cambridge: Cambridge
 UP, 1992.
Levitt, Sarah. 'From Mrs Bloomer to the Bloomer: The Social Significance of
 the Nineteenth-Century English Dress Reform Movement', *Textile History*
 24 (1993): 27–37.
Lindfors, Bernth. 'Circus Africans', *Journal of American Culture* 6, 2 (1983):
 9–14.

Loewe, Louis, ed. *The Diaries of Sir Moses and Lady Montefiore*. London: Jewish Historical Society of England: Jewish Museum, 1983.

Lokke, Kari Elise. '*Orlando* and Incandescence: Virginia Woolf's Comic Sublime', *Modern Fiction Studies* 38 (1992): 235–53.

Lonsdale, Roger, ed. *Vathek*. Oxford: OUP, 1983.

Lowe, Lisa. *Critical Terrains: French and British Orientalisms*. Ithaca: Cornell UP, 1991.

Lukitsch, Joanne. *Julia Margaret Cameron: Her Work and Career*. Rochester: International Museum of Photography at the George Eastman House, 1986.

Macaulay, Thomas. 'Minute on Indian Education', in *Prose and Poetry*, ed. G.M. Young. Cambridge, Mass.: Harvard UP, 1967.

McCormick, Eric. Introductory essay and annotations to Earle, Augustus, *Narrative. . .* London: OUP, 1966.

McGann, Jerome. 'Enlightened Minds: Sir William Jones and Erasmus Darwin', in *The Poetics of Sensibility: A Revolution in Literary Style*. Oxford: Clarendon Press, 1996.

Mackenzie, John. *Orientalism: History, Theory, and the Arts*. Manchester: Manchester UP; New York: St Martin's Press, 1995.

Macleod, Dianne Sachko. *Art and the Victorian Middle Class: Money and the Making of Cultural Identity*. Cambridge: Cambridge UP, 1996.

Macmillan, Margaret. *Women of the Raj*. London: Thames and Hudson, 1988.

McPhee, Constance C. *The exemplary past? British history subjects in London exhibitions, 1760–1810*. PhD dissertation, Philadelphia: University of Pennsylvania, 1995.

Madhava Rao, T. *Minor Hints: Lectures delivered to H.H. Maharaja Gaekwar*. Bombay: Indian Press, 1881.

Marsh, Jan. *Bloomsbury Women: Distinct Figures in Life and Art*. London: Pavilion, 1995.

Marshall, P.J., ed. *The British Discovery of Hinduism in the Eighteenth Century*. Cambridge: Cambridge UP, 1970.

Maugham, W. Somerset. *The Moon and Sixpence*. New York: G.H. Doran, 1919.

Mavor, Carol. *Pleasures Taken: Performances of Sexuality and Loss in Victorian Photographs*. Durham, NC: Duke UP, 1995.

Mehta, J.M., ed. *Maharaja Sayajirao III Centenary Commemoration Volume*. Baroda: Maharaja Sayajirao UP, 1964.

Mellman, Billie. *Women's Orients: English Women and the Middle East, 1718–1918: Sexuality, Religion and Work*. London: Macmillan, 1992.

Mendis, G.C., ed. *The Colebrooke–Cameron Papers: Documents on British Colonial Policy in Ceylon, 1796–1833*. 2 vols. London: OUP, 1955.

Metcalf, Thomas R. *An Imperial Vision: Indian Architecture and Britain's Raj*. Los Angeles and Berkeley: University of California Press, 1988.

Miller, Angela. *The Empire of the Eye: Landscape Representation and American Cultural Politics, 1825–75*. Ithaca and London: Cornell UP, 1993.

Minson, Marion. *Encounter with Eden: New Zealand 1770–1870: Paintings and Drawings from the Rex Nan Kivell Collection, National Library of Australia*. Wellington: National Library of New Zealand, 1990.

Mitchell, Charles. 'Benjamin West's Death of General Wolfe and the popular history piece', *Journal of the Warburg and Courtauld Institutes* 7 (1944): 20–33.

Mitchell, Paul, and Lynne Roberts. *Frameworks: Form, Function and Ornament in European Portrait Frames*. London: Merrell Holberton, 1996.

Mitchell, Timothy. 'Orientalism and the Exhibitionary Other', in Nicholas Dirks, ed., *Colonialism and Culture*: 289–317.

Mitchell, W.J.T. 'Imperial Landscape' in *Landscape and Power*. Chicago: University of Chicago Press, 1994: 5–34.

Mithad, Ahmet. *Avrupa'da Bir Cevelan*. Istanbul: Terc uman-a Hakikat-i Gazete, 1980.

Mitter, Partha. *Much Maligned Monsters: A History of European Reactions to Indian Art*. Chicago and London: University of Chicago Press, 1977.

Money, John, *Gay, Straight, and In-Between: The Sexology of Erotic Orientation*. New York: OUP, 1988.

Monk, Samuel H. *The Sublime: A Study of Critical Theories in Eighteenth-Century England*. Ann Arbor: University of Michigan Press, 1960.

Montagna, Dennis. 'Benjamin West's *The Death of General Wolfe*: A Nationalist Narrative', *American Art Journal* 8 (1981): 72–85.

Montagu, Lady Mary Wortley. *The Complete Letters of Lady Mary Wortley Montagu*, ed. Robert Halsband. 2 vols. Oxford: Clarendon, 1965.

Montefiore, Lady Judith Cohen. *A Private Journal of a Visit to Egypt and Palestine*. Jerusalem: Yad Izhak Ben Zvi, 1975.

Moon, Sir Penderel. *The British conquest and dominion of India*. Duckworth, Indiana: Indiana UP, 1989.

Morgan, Susan. *Place Matters: Gendered Geography in Victorian Women's Travel Books about Southeast Asia*. New Brunswick, NJ: Rutgers UP, 1996.

Morgan, Thaïs E. 'Violence, Creativity, and the Feminine: Poetics and Gender Politics in Swinburne and Hopkins', in Anthony H. Harrison and Beverly Taylor, eds., *Gender and Discourse in Victorian Literature and Art*. De Kalb: Northern Illinois UP, 1992: 84–107.

Morrell, Lady Ottoline. *Ottoline at Garsington: Memoirs of Lady Ottoline Morrell, 1915–1918*, ed. Robert Gathorne-Hardy. London: Faber and Faber, 1974.

—————— *Ottoline: The Early Memoirs of Lady Ottoline Morrell*, ed. Robert Gathorne-Hardy. London: Faber and Faber, 1963.

'The most noble Charles Duke of Norfolk', *Annual Biography and Obituary* 1 (6) (1817): 96–124.

Moussa-Mahmoud, Fatma. *Sir William Jones and the Romantics*. Cairo: n.p., 1962.

Mukherjee, S.N. *Sir William Jones: A Study in Eighteenth-Century British Attitudes to India*. Cambridge: Cambridge UP, 1968.

Mukhopadhyay, Adyanath. *Emily Eden's Sketches in Victoria Memorial, A Descriptive Catalogue*. Calcutta: Victoria Memorial, 1988.

Mulligan, Therese *et al*. *'For My Best Beloved Sister, Mia': An Album of Photographs by Julia Margaret Cameron*. Albuquerque: University of New Mexico Art Museum, 1994.

Munhall, Edgar. *Whistler and Montesquiou: The Butterfly and the Bat*. Paris: Flammarion, 1995.

Munshi, Shri K.M. 'Sayajirao Gaekwad: Memories' in Mehta, *Maharaja Sayajirao III*: 67–72.

Murray-Oliver, Anthony. *Augustus Earle in New Zealand*. Christchurch: Whitcombe & Tombs, 1968.

Muskau, Prince Puckler. *Egypt Under Mohammed Ali*. London: n.p., 1845.

Nanavati, Manilal B. 'Maharaja As I Knew Him', in Mehta, *Maharaja Sayajirao III*: 18–34.

Nanda, B.R., ed. *Essays in Modern Indian History*. Delhi: OUP, 1980.

Nandy, Ashis. *The Intimate Enemy: Loss and Recovery of Self Under Colonialism*. Delhi: OUP, 1993.

Naravane, V.S. *The Elephant and the Lotus: Essays in Philosophy and Culture*. New York: Asia Publishing House, 1965.

Newton, Stella Mary. *Health, Art and Reason: Dress Reformers of the Nineteenth Century*. London: John Murray, 1974.

Niranjana, Tejaswini. *Siting Translation: History, Post-Structuralism, and the Colonial Context*. Berkeley: University of California Press, 1992.

Nochlin, Linda. 'The Imaginary Orient', *Art in America* (May 1983) 118–31; and in *The Politics of Vision*. New York: Harper and Row, 1989: 33–59.

North, Marianne. *Recollections of a Happy Life: Being the Autobiography of Marianne North*, ed. Mrs John Addington Symonds. 2 vols. London: Macmillan and Co., 1892.

O'Hanlon, Rosalind. 'Recovering the Subject: Subaltern Studies and Histories of Resistance in Colonial South Asia', *Modern Asian Studies* 22 (1988): 189–224.

Olsen, Victoria C. 'Idylls of Real Life', *Victorian Poetry* 33, 3–4 (1995): 371–89.

The Oxford Companion to the English Language. Oxford and New York: OUP, 1992.

Paget, Lady Walburga. *The Linings of Life.* 2 vols. London: Hurst & Blackett, 1928.

Pal, Pratapaditya, ed. *Changing Visions, Lasting Images: Calcutta through 300 Years.* Bombay: Marg Publications, 1990.

—— and Vidya Dehejia. *From Merchants to Emperors: British Artists and India, 1757–1930.* Ithaca and London: Cornell UP, 1986.

Pankhurst, Richard. 'Captain Speedy's "Entertainment": the Reminiscences of a Nineteenth Century British Traveller to Ethiopia', *Africa* (Rome), 38, 3 (1983): 428–48.

Pannikar, Sardar K.M. 'Maharaja Sayajirao – A Pathfinder of Modern India' in Mehta, *Maharaja Sayajirao III*: 59–61.

Pardoe, Julia. *The City of the Sultan and the Domestic Manners of the Turks in 1836.* 2 vols. London: Henry Colburn, 1837.

Parks, Fanny Parlby. *Wanderings of a Pilgrim, in Search of the Picturesque, During Four-and-Twenty Years in the East: with Revelations of Life in the Zenana.* London: Pelham Richardson, 1850.

—— *Grand Moving Diorama of Hindostan, Displaying the Scenery of the Hoogly, the Bhagirath, and the Ganges, From Fort William, Bengal to Gangoutri, in the Himalaya.* London: Asiatic Gallery, 1851?

Piper, David. *The English Face.* London: National Portrait Gallery, 1978.

Pointon, Marcia. *Hanging the Head: Portraiture and Social Formation in Eighteenth-Century England.* New Haven: Yale UP, 1993.

—— 'Killing Pictures', in John Barrell, ed., *Painting and the Politics of Culture: New Essays in British Art.* Oxford and New York: OUP, 1992: 39–72.

Pollock, Griselda. *Avant-Garde Gambits: Gender and the Colour of Art History.* London: Thames and Hudson, 1992.

Ponsonby, Laura. *Marianne North at Kew Gardens.* Exeter: Webb and Bower, 1990.

Poole, Sophia Lane. *The Englishwoman in Egypt: Letters from Cairo.* London: C. Cox, 1851.

Prakash, Gyan. 'Writing Post-Orientalist Histories of the Third World: Perspectives from Indian Historiography', *Comparative Studies in Society and History* 32/9 (1990): 383–408.

Prasad, Madhava. 'The "Other" Worldliness of Postcolonial Discourse: A Critique', *Critical Quarterly* 34 (Autumn 1992): 74–139.

Pratt, Mary Louise. 'Scratches on the Face of the Country or, What Mr Barrow saw in the Land of the Bushmen', *Critical Inquiry* 12, 1 (1985): 119–43.

——— *Imperial Eyes: Travel Writing and Transculturation*. London and New York: Routledge, 1992.

Pressly, William, ed. 'A memoir of J.F. Rigaud by Stephen F.D. Rigaud', *Walpole Society* 50 (1984).

Priestley, Joseph. *A Comparison of the Institutions of Moses with Those of the Hindoo and Other Antient Nations*. Northumberland: n.p., 1799.

Prinsep, Valentine. *Imperial India: An Artist's Journals*. London: Chapman and Hall, 1879.

Public Record Office, Kew, Surrey. Copyright Registrations, 1864–1874. Series: COPY 1/2/3.

Raine, Kathleen. *Blake and Tradition*, vol II. Princeton: Princeton UP, 1968.

Ramusack, Barbara N. 'The Civil Disobedience Movement and the Round Table Conferences: The Princes' Response', in B.R. Nanda, ed., *Essays in Modern Indian History*. Delhi: OUP, 1980: 10–53.

Rapin-Thoryas, Paul de. *The history of England, as well ecclesiastical as civil*. 28 vols, trans. Nicholas Tindal. London: J. and J. Knapton, 1726–47.

——— *History of England written in French . . . translated into English with additional notes by N. Tindal*. 5 vols. London: J. and P. Knapton, 1743–7.

Reynolds, Henry. *Frontier: Aborigines, Settlers and Land*. Sydney: Allen & Unwin, 1987.

——— *Law of the Land*. Ringwood, Victoria: Penguin, 1987.

Rice, Stanley. *Life of Sayaji Rao III, Maharaja of Baroda*. 2 vols. London: Humphrey Milford, 1931.

Richmond, J.C.B. *Egypt 1798–1952: Her Advance Towards a Modern Identity*. London: Methuen, 1977.

Ritchie, Anne Isabella Thackeray. *From Friend to Friend*. London: John Murray, 1919.

——— *Toilers and Spinsters: and Other Essays*. vol 7 of *The Works of Miss Thackeray*. London: Smith, Elder & Co., 1876.

Roberts, Emma. *The East India Voyager or Ten Minutes Advice to the Outward Bound*. London: J. Madden and Co. , 1839.

Robinson, John Martin 'Gothic Revival at Arundel, 1780–1870', *Connoisseur* 197 (March 1978): 162–71.

——— *The Dukes of Norfolk, a quincentennial history*. Oxford: OUP, 1982.

——— 'Magna Charta and pretty ladies' maids', *Country Life* 174 (7 July 1986): 46–9.

Rocher, Rosane. 'British Orientalism in the Eighteenth Century: The Dialectic of Knowledge and Government', in Carol A. Breckenridge and Peter van der Veer, eds., *Orientalism and the Postcolonial Predicament: Perspectives on South Asia*. Philadelphia: University of Pennsylvania Press, 1993.

Rodkey, Frederick Stanley. 'The Turco-Egyptian Question in the Relations of England, France and Russia, 1823–41', *University of Illinois Studies in the Social Sciences* 11, 3–4 (Sept-Dec 1923).

Rosello, Mireille. 'The Infiltrator who Came In from the Inside: Making Room in Closed Systems', *Canadian Review of Comparative Literature* 22, 2 (1995): 241–54.

'Sadler's Wells: Tippoo Saib; or East India Campaigning', The London Times (9, 14, 19, 21, 26 May 1792): (all) 1.

Said, Edward W. *Orientalism: Western Concepts of the Orient*. London: Penguin, 1978; New York: Random House, Vintage, 1978.

———— *The World, the Text, and the Critic*. Cambridge, Mass.: Harvard UP, 1983.

———— *Culture and Imperialism*. New York: Knopf, Vintage, 1993.

San Francisco Chronicle, 23 December 1996.

Sayaji Rao Gaekwad, *Speeches and Addresses of Sayaji Rao, the Third Gaekwar of Baroda, 1877–1938*. 4 vols. Cambridge: Cambridge UP, 1927–38.

———— 'My Ways and Days in Europe and in India', *The Nineteenth Century and After* 49 (1901): 215–25.

———— *Notes on the Famine Tour*. London: Macmillan, 1901.

Schama, Simon. *Landscape and Memory*. London: HarperCollins, 1995; Fontana, 1996.

Schlack, Beverly Ann. *Continuing Presences: Virginia Woolf's Use of Literary Allusion*. University Park: Pennsylvania State UP, 1979.

Schwab, Raymond. *The Oriental Renaissance*. New York: Columbia UP, 1984.

Searight, Sarah. *The British in the Middle East*. London: Weidenfeld and Nicolson, 1969.

Sedgwick, Eve. *Between Men: English Literature and Homosocial Desire*. New York: Columbia UP, 1985.

Semmel, Bernard. *Jamaican Blood and Victorian Conscience*. Boston: Houghton Mifflin Co., 1963.

Sengupta, Anjali. *Cameos of Twelve European Women in India*. Calcutta: Rddhi, 1984.

Sergeant, Philip W. *The Ruler of Baroda: An Account of the Life and Work of the Maharaja Gaekwar*. London: John Murray, 1928.

Sertoli, Giuseppi. 'Edmund Burke', in Michael Groden and Martin Kreiswerth, eds., *The Johns Hopkins Guide to Literary Theory and Criticism*, Baltimore: Johns Hopkins UP, 1994: 122–5.

Seymour, Miranda. *Ottoline Morrell: Life on the Grand Scale*. London: Hodder & Stoughton, 1992.

Sharpe, Jenny. *Allegories of Empire: The Figure of Woman in the Colonial Text*. London and Minneapolis: University of Minnesota Press, 1993.

Singh, Charu Sheel. 'Bhagavadgita, Typology and William Blake', in T.R. Sharma and Shastri Nagar, eds, *Influence of Bhagavadgita on Literature Written in English*. Meerut: Shalabh Prakashan, 1988: 23–36.

Sinha, Mrinalini. *Colonial Masculinity*. Manchester: Manchester UP, 1995.

Skinner, John. *Constructions of Smollett: A Study in Genre and Gender*. Newark, NJ, and London: University of Delaware Press and Associated University Presses, 1996.

Slatter, Enid M. 'The Princess, the Sultan and the Pasha'. *Art and Artists* (Nov 1987): 14–17.

Smith, Bernard. *European Vision and the South Pacific 1768–1850: A Study in the History of Art and Ideas*. Oxford: OUP, 1960.

Smith, Lindsay. 'The Politics of Focus: feminism and photographic theory', in Isobel Armstrong, ed., *New Feminist Discourses*. London: Routledge, 1992.

Smith-Rosenberg, Carroll. 'Discourses of Sexuality and Subjectivity: The New Woman 1870–1936', in Martin Duberman, Martha Vicinus and George Chauncey Jr. *Hidden from History: Reclaiming the Gay and Lesbian Past*. New York: New American Library, 1989: 264–80.

Sontag, Susan. *On Photography*. New York: Farrar, Straus and Giroux, 1978.

Southon, Jean. 'Prince Alamayou and Captain Speedy', in Addis Ababa, 1–6 April 1991. *Proceedings of the Eleventh International Conference of Ethiopian Studies*, ed. Bahru Zewde, Richard Pankhurst and Taddese Beyene. Institute of Ethiopian Studies, Addis Ababa University. 1: 251–63.

Spalding, Frances. *Roger Fry: Art and Life*. London: Granada, 1980.

Spear, Percival. *India, Pakistan and the West*. New York: OUP, 1967.

——— *The Nabobs: A Study of the Social Life of the English in Eighteenth-Century India*. Calcutta: Rupa, 1991.

Spencer, Harold. 'Augustus Earle: A Study of Early Nineteenth Century Travel Art and its Place in English Landscape and Genre Traditions'. Harvard: PhD thesis, 1967.

Spivak, Gayatri Chakravorti. *The Post-Colonial Critic: Interviews, Strategies, Dialogues*, ed. Sarah Harasym. London and New York: Routledge, 1990.

Stafford, Barbara. *Voyage into Substance: art, science, nature and the illustrated travel account, 1768–1840*. Cambridge, Mass.: MIT Press, 1984.

Steele, Valerie. *Fashion and Eroticism: Ideals of Feminine Beauty from the Victorian Era to the Jazz Age*. New York and Oxford: OUP, 1985.

Stein, Gertrude. *The Autobiography of Alice B. Toklas*. New York: Literary Guild, rpt Vintage, 1961.

Stevens, Mary Anne, ed. *The Orientalists: Delacroix to Matisse*, exh. cat. London: Royal Academy of Arts, 1987.

Stewart, Frederick William Robert (Lord Castlereagh, Marquess of Londonderry). *A Journey to Damascus, through Egypt, Nubia, Arabia Petraea, Palestine and Syria.* London: Henry Colburn, 1947.

Suleri, Sara. *The Rhetoric of English India.* Chicago: Chicago UP, 1992.

Swallow, Deborah. 'The Raj: India 1850–1900', in John Guy and Deborah Swallow, eds., *Arts of India: 1550–1900.* London: Victoria and Albert Museum, 1990: 209–33.

Sweetman, John. *The Oriental Obsession: Islamic Inspiration in British and American Art and Architecture 1500–1920.* Cambridge and New York: Cambridge UP, 1987.

Thomson, William. *Memoirs of the late war in Asia with a narrative of the imprisonment and sufferings of our officers and soldiers: by an officer of Colonel Baillie's detachment.* London: J. Murray, 1788.

Tidrick, Kathryn. *Empire and the English Character.* London: I.B. Tauris, 1992.

Tillotson, G.H.R. 'The Indian Picturesque: Images of India in British Landscape Painting, 1780–1880', in C.A. Bayly, ed., *The Raj: India and the British 1600–1947.* London: National Portrait Gallery, 1990: 141–51.

'Tippoo Saib', *The London Times* (1 May 1792); 3.

Torri, Michelguglielmo. ' "Westernized Middle Class", Intellectuals and Society in Late Colonial India', *Economic and Political Weekly* 25/4 (1990): PE-2–11.

Turner, Walter. *The Aesthetes.* London: Wishart, 1927.

Twitchell, James. *Romantic Horizons: Aspects of the Sublime in English Poetry and Painting.* Columbia: University of Missouri Press, 1983.

Victoria and Albert Museum. *Album of press clippings from newspapers on matters of artistic interest, 1686–1835.* 6 vols.

Viswanathan, Gauri. *Masks of Conquest: Literary Study and British Rule in India.* New York: Columbia UP, 1989.

Von Erffa, Helmut, and Allen Staley. *The paintings of Benjamin West.* New Haven and London: Yale UP, 1986.

Waghorne, Joanne Punzo. *The Raja's Magic Clothes: Re-Visioning Kingship and Divinity in England's India.* Philadelphia: University of Pennsylvania, 1994.

Wake, Jehanne. *Princess Louise: Queen Victoria's Unconventional Daughter.* London: Collins, 1988.

Walker, Mary Edwards. *Hit.* New York: American News Company, 1871.

Wallach, Alan. 'Making a Picture of a View from Mount Holyoke', in David Miller, ed., *American Iconology.* New Haven and London: Yale UP, 1993: 80–91.

Walpole, Horace. *The Yale edition of Horace Walpole's correspondence*, ed. W.S. Lewis. 48 vols. New Haven: Yale UP, 1937–83.

Ware, Vron. *Beyond the Pale: White Women, Racism and History.* London and New York: Verso, 1992.

Warmington, L. Crispin, ed. *Stephens Commentaries on the Laws of England.* 4 vols. London: Butterworths, 1950.

Waterfield, Gordon. *Layard of Nineveh.* New York: Frederick A. Praeger, 1968.

Watts, M.S. *George Frederic Watts.* 3 vols. New York: Hodder and Stoughton, 1903.

Weaver, Mike. *Whisper of the Muse: The Overstone Album and Other Photographs by Julia Margaret Cameron.* Malibu: J. Paul Getty Museum, 1986.

—— *Julia Margaret Cameron, 1815–1879.* London: John Hansard Gallery and the British Council, 1984.

Weeden, Rev. Edward St Clair. *A Year with the Gaekwar of Baroda.* London: Hutchinson and Co., 1912.

Welch, Stuart Cary. *Room for Wonder: Indian Painting during the British Period 1760–1880.* New York: The American Federation of Arts, 1978.

Whistler–Campbell Correspondence. Glasgow University Library, B.P. II.

Whitman, Alfred. *Valentine Green.* London: A.H. Bullen, 1902.

Widgery, Alban. *Goods and Bads: Outlines of the philosophy of life of Sayaji Rao.* Baroda: n.p., 1920.

—— 'An Appreciation', in J.M. Mehta, *Maharaja Sayajirao III*: 1–5.

Wilde, Oscar. *The Letters of Oscar Wilde,* ed. Rupert Hart-Davis. London: Rupert Hart-Davis, 1962.

Wilkie, Sir David. *Sir David Wilkie's Sketches in Turkey, Syria and Egypt 1840–41,* drawn on stone by Joseph Nash. London: Graves and Warmsley, 1843.

Wilkins, Sir Charles, trans. *The Bhagavat-Geeta, or Dialogues of Kreeshna and Arjoon.* London: n.p., 1785.

Williams, Donovan. *The India Office, 1858–1869.* Hoshiarpur: Vishveshvaranand Vedic Research Institute, 1983.

Wilson, Elizabeth. *Adorned in Dreams: Fashion and Modernity.* Berkeley: University of California Press, 1987.

Wilton, Andrew. *Turner and the Sublime.* London: British Museum Publications, 1980.

Wind, Edgar. 'The revolution in history painting', *Journal of the Warburg Institute* 2 (1938–9): 117–21.

Wollen, Peter. 'Fashion/Orientalism/the Body', *New Formations* (1987): 5–33.

Woolf, Virginia. *Orlando.* New York: Harcourt Brace, 1928.

—— and Roger Fry. *Victorian Photographs of Famous Men and Fair Women.* London: Chatto and Windus, 1992.

Workman, Gillian. 'Thomas Carlyle and the Governor Eyre Controversy: An Account with Some New Material', *Victorian Studies* 18, 1 (1974): 77–102.

Young, Robert. *White Mythologies: Writing History and the West*. London: Routledge, 1990.

Yule, Henry, and A.C. Burnell. *Hobson-Jobson: The Anglo-Indian Dictionary*. Ware, Herts; Wordsworth Editions, 1996.

Index

Page references in *italic* type indicate illustrations

relationship 63–4, 68–9; legal status of 63, 65, 69, 70, 71, 75–6; and the male gaze 99; and purdah 23–4; as travel painters 92–101, 102–5; as travel writers 68–9; Turkish 63–4

Woodburn, William 49
Woolf, Virginia 75, 170; *Orlando* 67, 77
Woollett, William, *The Death of General Wolfe (after* Benjamin West) 204
Wordsworth, William 141

Made in the USA
Middletown, DE
04 October 2022

11917578R00148